THE ARTS OF
INDIA

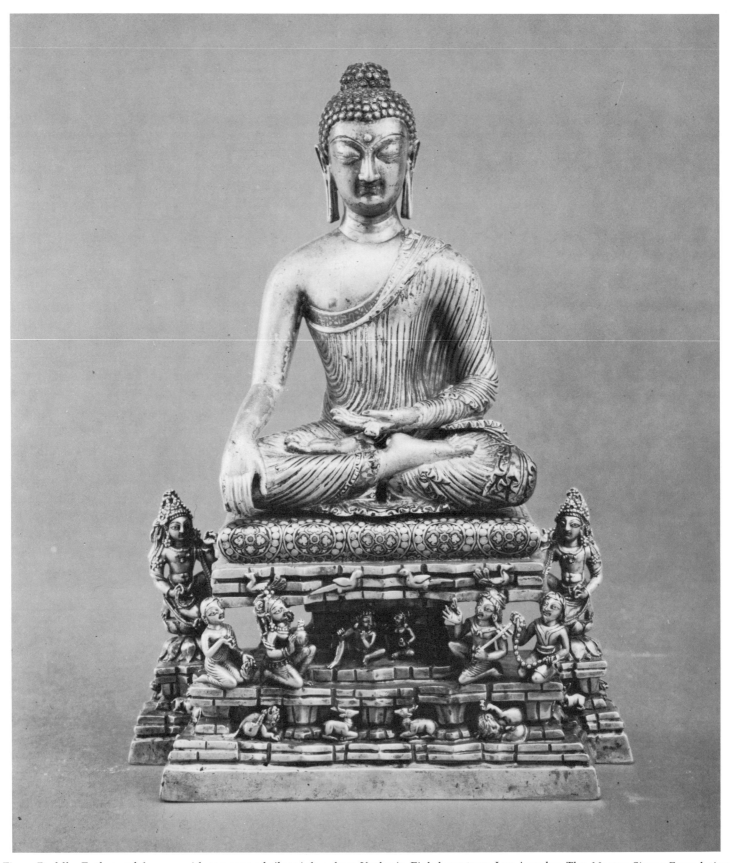

Fig. 1 Buddha Enthroned, bronze with copper and silver inlay, from Kashmir. Eighth century. Los Angeles, The Norton Simon Foundation

THE ARTS OF
INDIA

Edited by Basil Gray

VIKAS PUBLISHING HOUSE PVT LTD

The editor and the publishers would like to express their gratitude to Dr Raymond Allchin, Professor Burton-Page, Simon Digby, Dr James Harle, Robert Knox, Robert Skelton, Wladimir Zwalf, and the Library of the Oriental Institute, University of Oxford, for their assistance in the preparation of this book.

VIKAS PUBLISHING HOUSE PVT LTD
Regd. Office: 5 Ansari Road, New Delhi
H.O. Vikas House, 20/4 Industrial Area, Sahibabad 201010
Distt. Ghaziabad (U.P.)

First published 1981
© 1981 by Phaidon Press Limited, Oxford, England
First published in India 1982
ISBN 0–7069–1571–2
1V2G5517

Printed in Great Britain

Contents

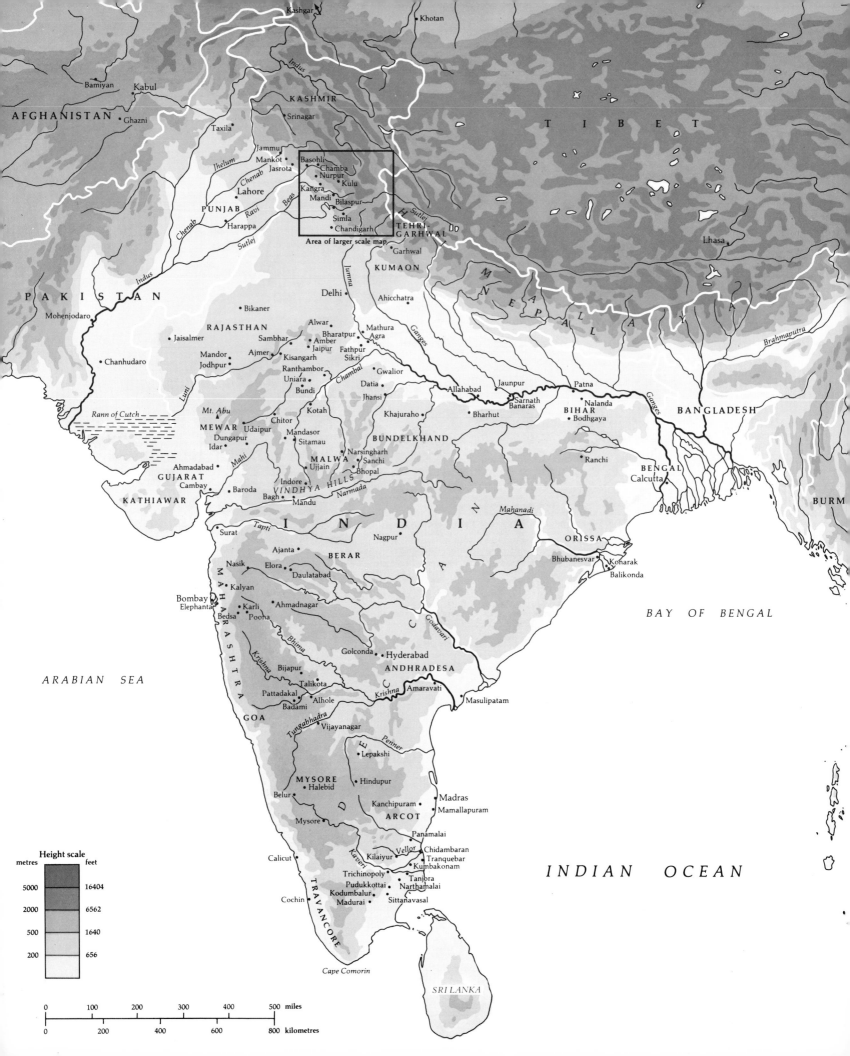

Kashgar

Khotan

AFGHANISTAN • Ghazni

• Bamiyan • Kabul

Indus

KASHMIR

TIBET

• Taxila

Jhelum Srinagar

Jammu

Mankot Basohli

Chenab Jasrota • Chamba

Lahore Nurpur • Kulu

PUNJAB Beas Kangra

Ravi Mandi Bilaspur

Chenab • Harappa Simla

• Chandigarh

Sutlej TEHRI-

GARHWAL

Area of larger scale map

• Garhwal

Lhasa

PAKISTAN

Mohenjodaro

KUMAON

N E P A L

Brahmaputra

Indus

• Delhi

• Bikaner

Ahicchatra

Ganges

• Jaisalmer

RAJASTHAN Alwar

Bharatpur Mathura

• Chanhudaro Sambhar Amber Agra

Mandor Ajmer Jaipur Fathpur

Jodhpur Kisangarh Sikri

Ranthambor Gwalior

Luni Uniara Chambal Datia

Bundi Jhansi

Rann of Cutch Kotah Khajuraho

Mt. Abu Chitor Bharhut

MEWAR Udaipur Mandasor BUNDELKHAND

Dungapur Sitamau Narsingharh

Idar Sanchi

Ahmadabad MALWA Bhopal

GUJARAT Mahi Ujjain

Cambay Bagh VINDHYA HILLS

KATHIAWAR Baroda Narmada

Mandu

Tapti

Surat I N D I A

Nagpur

Allahabad Jaunpur Patna

Sarnath Nalanda

Banaras BIHAR Bodhgaya

Ganges BANGLADESH

• Ranchi

BENGAL

Calcutta

BURM

Mahanadi

Ajanta ORISSA

Nasik Elora BERAR Bhubanesvar Konarak

Kalyan Daulatabad Balikonda

M A H A R A S H T R A

Bombay Karli

Elephanta Bedsa Ahmadnagar

Pooha Bhima BAY OF BENGAL

Godavari

ARABIAN SEA Golconda Hyderabad

Krishna Bijapur ANDHRADESA

Talikota

Pattadakal Krishna Amaravati

Badami Alhole

GOA Masulipatam

Tungabhadra Vijayanagar

Penner

Lepakshi

MYSORE

Belur Halebid • Hindupur

Madras

Mysore Kanchipuram Mamallapuram

ARCOT

Panamalai

Vellor Chidambaran

Kilaiyur Tranquebar

Height scale Kaveri Kumbakonam

metres feet Calicut Trichinopoly Tanjora

Pudukkottai Narthamalai

5000 16404 Kodumbalur Sittanavasal

Cochin Madurai

2000 6562 TRAVANCORE

INDIAN OCEAN

500 1640

200 656 Cape Comorin

SRI LANKA

0 100 200 300 400 500 miles

0 200 400 600 800 kilometres

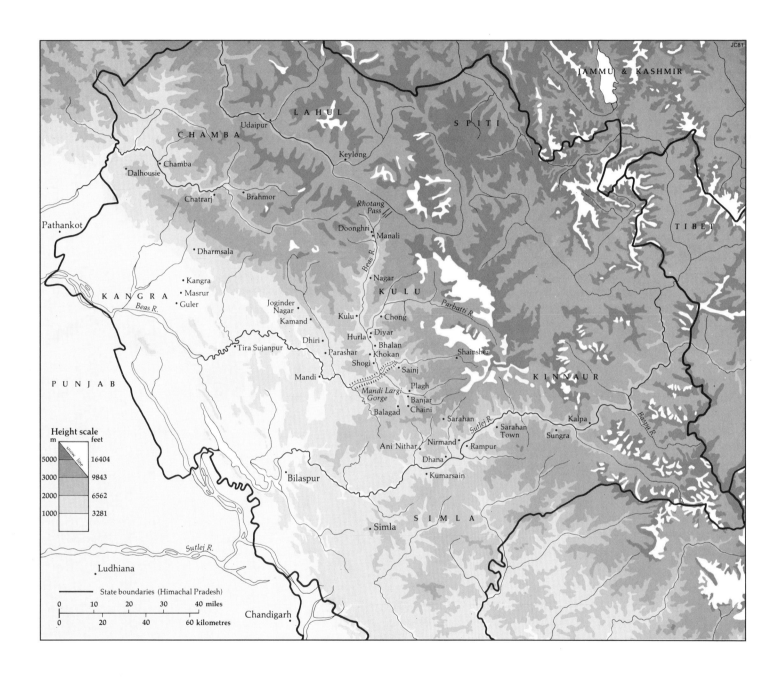

JC81

JAMMU & KASHMIR

LAHUL

SPITI

CHAMBA

Udaipur

Keylong

Chamba

Dalhousie

Chatrarj

Brahmor

Rhotang
Pass

TIBET

Pathankot

Doonghri

Manali

Dharmsala

Beas R.

Nagar

Kangra

KULU

Parbatti R.

Masrur

Guler

Joginder
Nagar

KANGRA

Kulu

Chong

Beas R.

Kamand

Hurla

Diyar

Dhiri

Bhalan

Shainsher

Tira Sujanpur

Parashar

Khokan

KINNAUR

Shogi

Sainj

PUNJAB

Mandi

Plagh

Mandi Largi
Gorge

Banjar

Balagad

Chaini

Kalpa

Sarahan

Sutlej R.

Baspa R.

Sarahan
Town

Sungra

Ani Nithar

Nirmand

Rampur

Height scale

Dhana

m feet

Kumarsain

5000 16404

3000 9843

Bilaspur

2000 6562

1000 3281

SIMLA

Simla

Sutlej R.

Ludhiana

State boundaries (Himachal Pradesh)

0 10 20 30 40 miles

0 20 40 60 kilometres

Chandigarh

Buddhist, Hindu and Jain Art

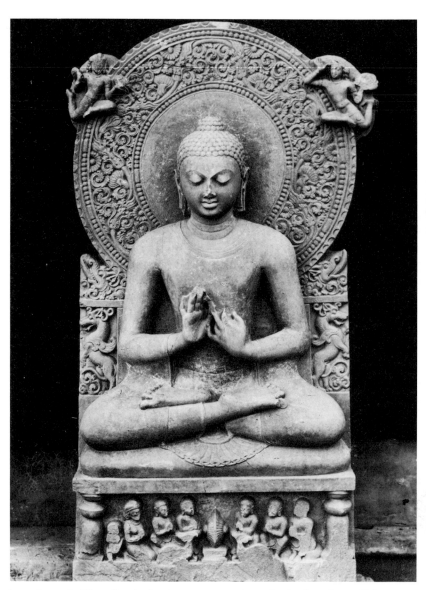

Fig. 2 Buddha Preaching, from Sarnath, Uttar Pradesh. Gupta, *c.* 470. Sarnath, Archaeological Museum

BASIL GRAY

Introduction: Prehistory and the Classic Tradition of Wall Painting

During the last half century and especially the past twenty years horizons have been greatly extended for our knowledge and appreciation of the long history of the Indian sub-continent. In the absence of early written records, it has fallen to archaeology to open up the prehistoric and protohistoric periods. No longer are we limited to seeing its peaks like islands in a sea of ignorance, but we can now descry a connected outline between them. Refinement of techniques, especially the use of Carbon 14, has even permitted the charting of a provisional fixed chronology within the limits of centuries rather than millennia.

What emerges is a cultural history of a continent with a continental mixture of races and languages; but geography has imposed regional differences and allowed the survival of large pockets of submerged cultures. At the same time there appears a kind of pan-Indian unity and a conservative life style, fostered by the predominance of village life and the extraordinary persistance of caste hierarchy from the time of the Rigveda (before 1000 BC) until recently. In such societies memories are conditioned to retain national epics in unaltered form for two millennia without the need for written record. This kind of situation is unfavourable to the composition of history; and the earliest records are not historical but moral and religious edicts like the Asokan inscriptions and the dedications of sanctuaries and shrines.

Long before these appeared, India had produced towns and large areas of common culture. This is not the place to plot the long development of Indian prehistory, which is now known to extend to at least 5000 BC, or to attempt to measure the slow opening up of the great plains by control of rivers and the huge rainfall of the annual monsoon. In the consideration of Indian art we are concerned only with man-made products that evidence a wish for elegance of form and of decoration; and with the beginnings of traditions of sculpture and painting. We now have a considerable body of painting in rock shelters, which are considered to extend over a period from about 5000 BC to modern times. With the aid of some Carbon 14 dating of pigments and by the association of pottery finds, some reasonably secure dating within wide limits for the earliest types has been achieved and periodization established. Unexpectedly, the earliest phase appears to show animal paintings on the largest scale. At Adamgarh, in Central India, an elephant is drawn without outline on the rock

Fig. 3 Rock painting of a buffalo, in Adamgarh, Bhopal, Madhya Pradesh. Fourth millennium BC

Fig. 4 Grey limestone figure of a male dancer from Harappa, Punjab. *c.* 2000 BC. New Delhi, National Museum of India

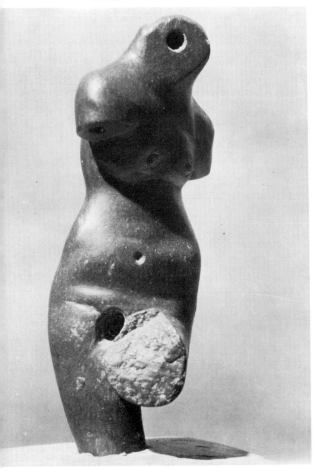

and is 4 feet 8 inches in length; and in a later phase but still in the mesolithic period at the same site, a buffalo is drawn with red outline no less than 10 feet in length (Fig. 3). This site has yielded a vast accumulation of microlithic tools, which may go back as far as the sixth millennium BC.

In the Southern Deccan at Badami a bison is drawn in the same style 5 to 6 feet in length. Rock shelters in Central India, in an area east of Bhopal, around Raisen, have been identified from before the close of the mesolithic period, in the third millennium BC. Here the animal art is more advanced, in that numerous deer are depicted, with hatched shading and outlined, so as to bring out the structural forms of the animals. Human figures do not appear in the rock shelters until much later, when it is possible to relate them to the major pottery site of Navdatoli (Fig. 5), datable to about 1500 BC, elegant and sophisticated shapes; they are painted with geometric patterns, which can also be paralleled in the rock paintings. Here the human figures of hunters are depicted in profile outline. All these types of rock painting can be associated with the extensive remains scattered over the temperate areas of the Old World and nothing specifically Indian predicated of them; nor do the Indian examples add to the material for resolving the speculation as to the meaning or intention of the rock paintings. In India there is as yet no indication of the small carvings in bone that are found in Europe associated with cave paintings; but it has been argued that neolithic tool carvers of India by their choice and use of materials such as agate and carnelian showed an aesthetic interest in the shaping of their tools. Even when it is possible to date rock paintings in India in historic periods and they begin to include figures of horsemen, there is no stylistic parallel with the thematic figural painting of the historic Buddhist, Jain and Brahmanic caves, which were of course in man-made caves and not natural rock shelters.

It is in fact still not possible to estimate the cultural condition of most of India before the irruption of the waves of invaders from the north-west, conveniently identified as the Aryan invasions. Still the one period of extensive and advanced civilization preceding that period, that of the Harappa or Indus Valley, cannot be clearly placed in the context of general historical development. The dating of that period is indeed now more precise and reliable than it was at the time of the original excavations of the major sites of Mohenjodaro and Harappa in the 1920s to 1940s and placed between about 2150 and 1750 BC, rather later than it was then thought; and its extension is now seen to cover an area as great as that of Western Europe, between Sind and the Punjab and the upper valleys of the Jumna and the Ganges. It still belongs to pre- or proto-history because the script, found only on the steatite seals, remains undeciphered. Although archaeological evidence now points to a more advanced level of agriculture and social life in the pre-Harappan period, and to the absence of a complete cultural break at its end, yet its origins remain obscure. What is clear, however, is its considerable trading contacts with Mesopotamia through the entrepôt of Bahrain in the Gulf. The uniformity of its material culture throughout its wide area is taken to imply a strong central government, able to impose modular planning, extensive storage of grain and the maintenance of drainage and sanitation. The use of fired brick on a massive scale in these cities implies the control of a continuing supply of wood fuel, while it made possible a measure of flood control. There are indications of a peak of achievement for the culture around 2000 BC, with some decline before a final violent destruction, certainly due to invaders. Production was stereotyped even in the fine art of the carved steatite seals; the number of

animal types depicted was limited to about six, which indicates a single control and perhaps a central 'mint', even though the quality of execution varies greatly. Similarly the polished stone quadrangular weights were strictly standardized. The only exceptional finds have been a very small number of sculptures in stone and bronze: their rarity has suggested that they might be imports; but it is now generally accepted that they are indeed local work.

A puzzling feature is that these masterly miniature sculptures are carved in different stones, but none local; they are, however, at one in the provision of dowel holes drilled in the head for the attachment of features and on the torso for joints. A grey limestone figure of a male dancer from Harappa (Fig. 4) has holes drilled in the head, which is now featureless but was once completed in some other material, perhaps ivory. There is also a hole drilled in the left thigh and others under the shoulders, presumably for the attachment of lower leg and arms, perhaps movable, as are the joints on some of the Indus Valley terracotta animal figurines. A red sandstone male torso, also from Harappa, has again drill holes on the shoulders and neck. Both these polished stone figures are remarkable for their accomplished and sophisticated modelling; the dancer also so for the indication of arrested movement in a pose of striking torsion. Very different are two figures found at Mohenjodaro. A bust of a bearded priest or ruler is carved in steatite in a stylized hieratic manner; the eyes rendered as long slits and the lips in a firm curve above a cropped beard. He wears a fillet with circle on his brow and a similar jewel on his upper right arm, below the bare shoulder. The robe covering the left shoulder and torso is perfectly smooth but is decorated with a trefoil design in relief, perhaps intended to be inlaid. The figure has been interpreted as a priest, god or yogi. A yellow limestone head with similar conventions for the hair, beard and features was also found at Mohenjodaro; but more remarkable is a small bronze figure (height 10.79 cms; Fig. 6) of a dancing girl standing with her right hand on her hip and a curiously supercilious look on her face. This may, however, be due to the lack of experience of the caster; for the finish is rough and the features coarse. All the same this figure is highly memorable for its naturalistic pose. The girl wears only necklace and arm-band bracelets and holds what may be castanets. The find of a second bronze dancer at Mohenjodaro, slightly larger but less well preserved, shows that this achievement was not unique. A curious point is that this remarkably tall and thin figure does not resemble either the stone sculptures or, what is perhaps more strange, the terracotta figurines from the Harappa sites, which share the modelling process with the bronzes. Yet these too, as well as the terracotta animals, which are more numerous, must have been made for the pleasure of adults as well as of children. They vary much in quality and are not completely conventionalized but show powers of observation and of the ability to design in three dimensions. I would go so far as to suggest that in them, as well as in the stone and bronze figures, we can see the native genius for sculptural form already.

The carved steatite seals (Fig. 7) are far more professional work of great precision and are well designed to allow for the inclusion of four or five script characters. Most include single animals, especially the 'brahmani' bull, buffalo, rhinoceros, wild goat or elephant; but sometimes the animals are composite creatures with part human forms, and some show animals with two or three heads, as if in several positions. Some are certainly deer, while others seem to be unicorns, though it is possible that full profile is intended, with the second horn

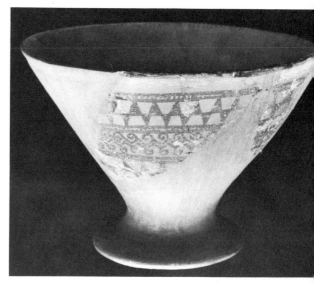

Fig. 5 Painted pottery goblet from Navdatoli, Malwa, Madhya Pradesh. *c.* 1500 BC. Poona, Deccan College

Fig. 6 Copper statuette of girl dancer from Mohenjodaro, Sind. *c.* 2000 BC. New Delhi, National Museum of India

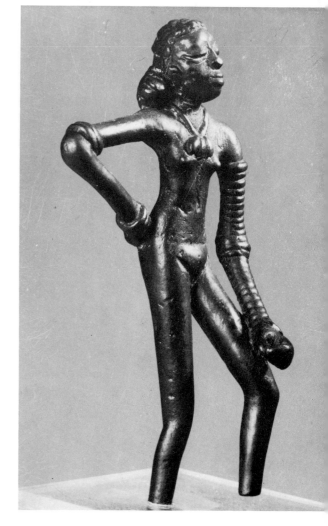

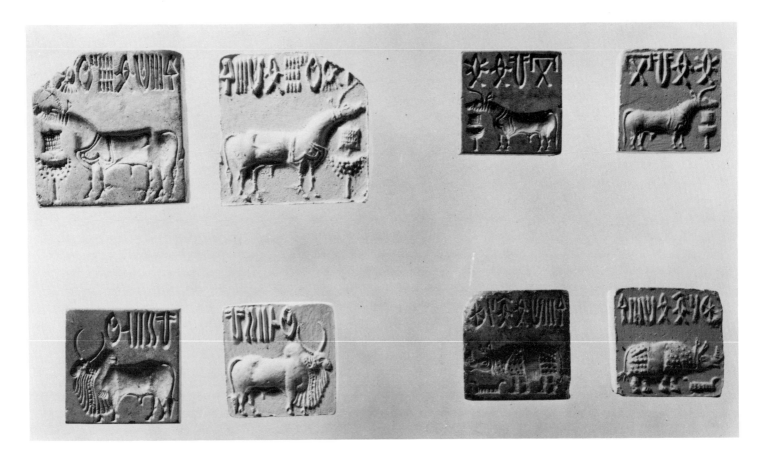

Fig. 7 Steatite seals with impressions, from Mohenjodaro, Sind. *c.* 2000 BC. London, British Museum

exactly aligned. Human figures do not appear; but one seal shows a seated horned man of supernatural size holding a tiger in one hand and with other animals in attendance, and he has been identified by Rowland as Gilgamish. The seals are carved in intaglio and have probably been hardened by baking before being polished. They are numerous, and must have been in general circulation. Original relief impressions are also frequent. It is established that the inscriptions read from right to left but remain undeciphered. There are fifty-two different glyphs; the attempt to find syllabic Rigveda parallels for them is highly conjectural and in any case most improbable on historic grounds, since we know that the invaders were illiterate.

Nonetheless, the Harappa or Indus culture is established as essentially an Indian development, founded indeed upon a long period of previous cultural borrowings from the extensive cultures of the Iranian plateau, but evincing little if any contemporary derivation from the cultures of Mesopotamia. French excavations at the site of Mergarh in Pakistani Baluchistan have now shown a continuous series of occupation levels from *c.* 5000 BC to the late third millennium, which witness to cultural continuity in this area. It is now surmised that there may well have been contemporary cultural sites in the Indus valley plains, which remain unidentified only because of the silting over of the whole region. It is noteworthy that the painted pottery associated with the Harappan period clearly descends from this long standing tradition; and an early Harappan, rather than a pre-Harappan, level has been identified on the site of Harappa itself and elsewhere in this area, which testifies to the local development of the culture, notably at Amri, on the west side of the Indus where the

Baluchi mountains most nearly approach the river basin. Here there is a smooth transition from painted pottery associated with sites in northern Baluchistan (Fig. 8) and the important centre in Afghanistan on the plateau of Mundigak, dating from about 3500 BC and into the Harappan period. At Amri the painted designs are mainly geometric but at Kot Diji on the east bank of the Indus and further north, the pipal leaves are drawn inside a bull's horns; this feature connects this type of pottery with the polychrome painted pottery of Nal (Fig. 9) in Baluchistan, now considered to date only slightly before the rise of the full Harappan culture. The Togan ware of north Baluchistan already shows painted goats: the Kulli people of the second half of third millennium decorated their pots with animals in landscape.

Indus Valley sites of pre-Harappan date are clearly more advanced. The development of wheel-thrown, painted pottery in Baluchistan begins in the first half of the third millennium BC. The Kulli people carried the development much further. The pottery of the full Harappan period was usually decorated in black on a dark red slip with all-over designs, often stylized to appear as interlocking circles or scale pattern, probably originally based on plant forms, repeated with indication of a background: hill, swamp or river. Some animals appear, especially at the Lothal site in Kathiawar (Gujarat) where they belong to a late phase of Harappan culture, after the decline had set in about 1700 BC. At Mohenjodaro itself peacocks appear as a motif and occasionally the antelope, but never the animals depicted on the seals, which must have had too great significance to be used decoratively. On the larger vessels painting is confined to the shoulders but smaller shapes have all-over painted decoration. Types are not many, the most striking being the bag shape, a tall stemmed cup and a covered wide shouldered vase (Fig. 11); all quite elegant but not finished to a high standard.

On the other hand the terracotta figurines found in quantity on the main Harappa sites do include bulls, elephants and birds among the commonest types; but also human figures that do not appear to have any cultic significance but were made for pleasure, both for children and adults. The models of two-wheeled carts and figures with movable heads are no doubt children's toys;

Left: Fig. 8 Painted pottery from Ranaghundai, Baluchistan. Late third millenium BC. London, British Museum

Right: Fig. 9 Polychrome painted pot from Nal, Baluchistan. c. 2500 BC. London, British Museum

Fig. 11 Painted pottery vase from Harappa, Punjab. Mid second millennium BC. Boston, Museum of Fine Arts

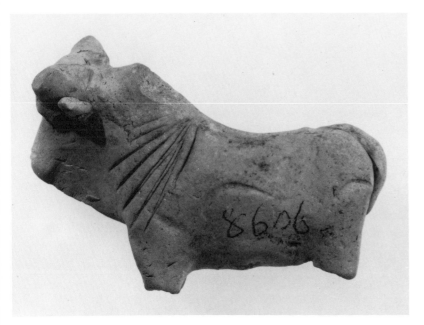

Fig. 10 Terracotta bull from Mohenjodaro, Sind. *c.* 2000 BC. London, British Museum

Fig. 12 Painted pottery sherds from Jhukar, Sind. *c.* 1200 BC. Boston, Museum of Fine Arts

14

but some of the female figurines with large head-dresses and conspicuous jewellery or who are simply seated look more like ornamental objects. The bull (Fig. 10) was clearly of special importance in this society and the bull figurines are among the most lively and naturalistic.

We have noted already the rare bronze figurines; but cuprous bronze was in general use at the time for utensils of all kinds; including daggers and knives, as well as spears and arrow heads, increasingly common in the later phase of the Harappan culture. Of greater artistic merit were the bronze vessels, especially shouldered jars and flat dishes, shapes in which the satisfactory forms are more than utilitarian. Both hammering and casting were used by the bronze workers.

There is good archaeological evidence to support the tradition preserved in the Rigveda for a violent end to the Harappan cities; burnt buildings, unburied corpses and signs of sudden flight, all correspond to the victory celebrations of the invading Aryans with their vaunted chariots and horses commemorated in the epic. But there is also some evidence for continuity of material culture, especially in the painted pottery associated with the type site of Jhukar (Fig. 12), where a new sort of seal has also been found; it is uninscribed, circular and of various materials other than steatite, but with animal designs clearly related to the Harappan seals. The invaders were illiterate and it was centuries before they had advanced to full civilized life. But the invaders were part of a great movement of peoples from inner Asia and thus cousins of those appearing in Asia Minor in about the fourteenth century BC when the names of the new Aryan gods first occur. So, too, it was with these invaders from the north-west that the Indo-European pantheon reached India and there formed the basis for the later Brahmanic or Hindu religion.

The invasions were not a swift and sudden event however, but successive waves of people moving into Sind and the Punjab and only gradually penetrating to peninsular India and the Ganges valley during the second half of the second millennium BC and the opening centuries of the first millennium. Bronze tools and weapons were their most distinctive goods and to these parallels have been found on Anatolian sites. Just before 1000 BC, iron was added to their repertory (c. 1370–1050 BC). In the third phase of the Neolithic-Chalcolithic new types of weapons were introduced, notably bronze swords with forked antennae, shaped hilts and comparable spear-heads. The swords can be of really elegant shape with an example in the British Museum of unknown provenance (Fig. 13). This type of sword can be matched by finds in the Caucasus and was no doubt introduced to India by the Aryan invaders.

The introduction of iron is associated with the spread of the Aryans into the Jumna-upper Ganges valleys and with pottery of the painted grey ware, so characteristic of the period about 500 BC. This ware is wheel-thrown above but completed by the base being beaten, a process found only in post-Harappan levels and peculiar to India. It was succeeded by an even more distinctive type of pottery, the polished black ware; it was found throughout the same area, continued into the full historic period from the fifth to the second century BC and was widely distributed from its probable source in the Ganges valley over the greater part of the sub-continent.

In South India the opening of the iron age can be placed about 950 BC, surprisingly soon after its first appearance in the north, though in scanty quantity. Here there is no long tradition of previous development and now its introduction may be connected with some colonization of the coastal areas from

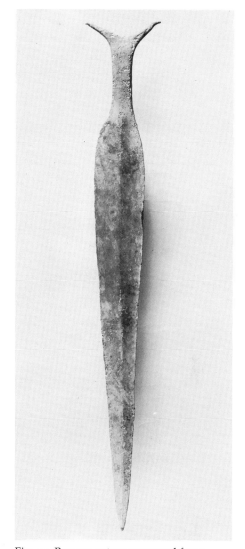

Fig. 13 Bronze antennae sword from North India. c. 1000 BC. London, British Museum

the Middle East over many centuries. On the other hand, the megalithic remains which are spread so widely in South India seem undoubtedly to predicate foreign influence from the area of Mesopotamia and the Gulf. Finally Roman influence is well established for the period from the first to the third centuries AD. Dating of earlier iron age sites in the South is still unclear; but the pit and cist burials clearly underline a culture independent of that in northern India; and this is supported by their black and red pottery types, both characterized by burnishing and the extremely restrained linear decoration in horizontal bands, which are sometimes wavy. Iron once achieved seems to have been plentiful and its find sites are widespread throughout the peninsula south and east of the Deccan.

It will be seen that, so far as archaeological evidence goes, painting in early India was restricted to the rock shelters and the decoration of pottery until the historic period. Sculpture too was limited to terracotta figurines after the fall of the Harappan culture and even these do not aim at an artistic effect until Sunga times. There is no doubt that figural sculpture in both wood and ivory was a well established art before the beginning of our era; but the climate of India has not favoured the survival of anything in these media earlier than the first century AD. A small ivory elephant carving from Kondapur and a female figure from Ter in the Deccan, to be identified with the Tagara mentioned in the *Periplus of the Erythrean Sea* (*c.* 95–130) and by Ptolemy. Ivory is included in the first source among the exports from Barygaza, the port of Tagara; and an ivory figure of good quality actually reached Roman Italy and was discovered in the ruins of Pompeii destroyed in AD 79.

More important than these finds is the cache discovered by the French archaeological team under Joseph Hackin in 1939–40 at Begram, the ancient city of Kapisa, in Afghanistan. Here was found a large group of Indian carved ivories associated with imports from the Roman world and from China and datable to the second or third centuries AD. Some of these ivory panels are incised, others carved in high relief. Some of the finds are displayed in the Musée Guimet in Paris but the major part is in the National Museum of Archaeology in Kabul. The incised panels show figure drawings of vivid scenes of girls playing a ball game and of kings hunting real or mythical animals, and were made as decoration for caskets. The linear style can give some idea of the art of secular court painting in the Deccan where they were probably made in the second century. Low relief carvings of girls seated in toilet scenes against a background of falling flower petals may be taken as translations into this small-scale medium of the court style of wall painting, which is also reflected in the Ajanta caves. The panels carved in high relief are set in frames of *torana* gate shape, an arch flanked by pillars with lion capitals, and are miniature replicas of contemporary architecture. The figures are pairs of girl dancers and musicians and recall the carvings on the sandstone railings surrounding the Buddhist stupas at Sanchi and Mathura of the first and second centuries AD. We are reminded that the ivory workers of Vidisa took part in the carving of the Sanchi gateways. They must indeed have been an important group of artists and craftsmen; for ivory was also used to inlay furniture and for the turned legs of chairs and caskets, as seen in the fragments found in the ruins at Brahminabad in Sind, destroyed in one of the early Muslim raids of the early eighth century. Both Brahmanical and Buddhist images were also carved in ivory and some of these were carried by pilgrims along the central Asian route to China, including a diptych in the form

of a king mounted on an elephant when closed and scenes from the life of Sakyamuni when opened. The king may represent Asoka the first great royal patron of Buddhism: this reliquary dates from about the fifth century.

Some later ivory Buddhist images were enclosed in carved wood frames of architectural form. Wood must indeed have been an important medium in early historic Indian art: there is good reason to think early images of the Hindu pantheon may have been wood carvings. Very little remains from this perishable material; but in 1888 the remains of a wood carved sanctuary were found in the Yusufzai country of Pakistan, including a pillar and two high relief figures in lunettes of what seem to be Saivite subjects. The date of these carvings, now preserved in the British Museum, is probably the sixth or seventh century. Carved wood was extensively used for images carried on processional cars at festivals; but only relatively late examples survive.

Our knowledge of painting from the early periods is also very incomplete and for the same reasons. To the wall-paintings in the rock-cut sanctuaries of Buddhists and Jains, which will be the subject of the remainder of this Introduction, must be added finds in Central Asia along the silk route to China, which was also followed by many Buddhist pilgrims on their way to and from the historic sites of their faith in India. The wall-paintings at these sites show differing degrees of Indian influence, but most marked at Miran on the southern route to the south of the great Taklamakan desert and at Kucha on the northern route. At Miran the paintings reflect the Hellenized art of the northern part of the Kusana empire with its centre in Kapisa (Begram). There it succeeded the Sakas (Scythians) about 75 BC in an area still dominated by the late Hellenistic art of the Bactrian/Seleucid rulers as seen in their capital at Taxila (Sirkap) in the northern Punjab between the Indus and the Jhelum. The Kushans, and especially their greatest ruler Kaniska, were great patrons of Buddhism. Through their close connections with inner Asia, Buddhist art travelled in its Indo-Greek guise from centres in the Ganges/Jumna valleys through the Kushan cities of Mathura, Peshawar and Taxila far into Central Asia. The shaded linear style of painting at Miran (third/fourth centuries) preserved the manner of this Hellenized Indian school, with its large staring eyes, high-lit flesh tints and strongly marked drapery folds. That this form continued long after the disappearance of the Kushans is to be seen in the series of wall-paintings dating from the sixth century from Qizil in the northern central Asian region of Turfan, and of which substantial parts are preserved from the Le Coq expeditions in the Berlin Museum. The strongly outlined bodies conform to an Indian canon while the high-lights have become no more than accents to indicate volume without depicting it. From the same area at Kucha comes a painted wooden domed casket, evidence for the secular art of this period. On the cover are depicted winged naked boy musicians with shaven crowns seated within pearled frame circles, between which are peacocks holding scarves in their beaks, while round the drum is a row of masked dancers linking hands. This style of decoration reflects the art of Gandhara and parallels the vogue for music and dance, a central theme in the works of Kalidasa (fourth century), who mentions dancing boys and girls, including Greeks and Persians, and even Africans, as joining in court entertainment at the great city of Ujjain in Central India.

Of course Kalidasa does more than describe contemporary court entertainments: he is concerned with the beauty of the dancers and of their movements, of their youthful community with the vitality and graces of the natural world, of

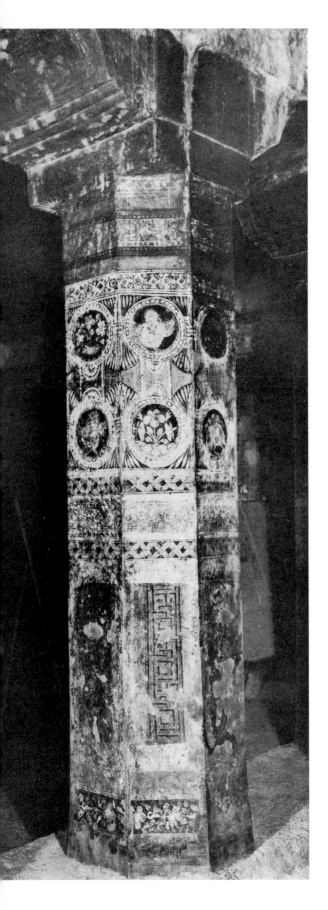

the antelope and the bee, the lotus and the mango: but behind them he is concerned with the human situation, the natural urgings of passion and the more stable enjoyment of peace and self-forgetfulness in recollection. It is the combination of modesty and sensuous pleasure, of offering and withdrawal, which is to be seen in the Ajanta paintings, as it is in the classic drama by Kalidasa, *Sakuntala*. As Rabinandranath Tagore once put it: he has here 'fully painted all the blandishments, playfulness and fluttering of the intoxicating sense of youth, the struggle between deep bashfulness and strong self-expression'. Just such feelings inspire the movements, gestures and looks of the figures painted in the Ajanta caves. The French scholar Philippe Stern used to detect the close connection between these wall-paintings and the Sanskrit drama; he saw behind them the love scenes, no doubt executed by the same hands as worked at Ajanta, which covered the palace walls at Ujjain and found nothing strange in the presence of such sensuous work in Buddhist paintings since the Bodhisattva of the *Mahayana* had vowed to remain in the world out of love for mankind. He pointed out the similarity of stance and features of the large Bodhisattvas of Cave 1 and of the court attendants in the Jataka scenes depicted in the main wall-spaces in the same cave.

The counterpart to this court life stressed by Kalidasa is that of the hermitage, the dwelling place in peaceful country of holy men who had renounced the world. In the third century BC, some wandering monks (*bhiksu*) joined together to form a *sangha* or religious order. King Asoka provided rock-cut cells for holy men, and so began the practice for Buddhist rulers to cut great *chaitya* halls for the common worship of monks, such as those at Bhaja from the earliest part of the second century BC and the most monumental at Karle, founded in the first century BC. Of the famous Ajanta caves one third belongs to this early group and date from the period between 200 BC and AD 200. The earliest caves that contain traces of wall-painting are nos. 9 and 10. (It should be understood that the numbering of the caves follows their position on a scarp of the Vindhya Hills in the North Deccan, at the head of a secluded valley, when approached from the east. The central caves were dug out of the rock and dedicated first and those in the two wings carved at a later date, so that Cave 1, the first approached, is one of the latest in date.) The remaining traces of paintings in Caves 9 and 10 are painted in a limited palette of black and white, red and yellow ochre, with terra verde, about AD 150, when the hold of the great Satavahana dynasty was relaxing in this area in face of the invading Sakas. Cave 9 is a *chaitya* hall with its interior dominated by a *stupa*, above which formerly rose a wooden umbrella and with just space enough for the ritual circumambulation, the roof being supported by twenty-one octagonal columns all cut from the rock. The cave has a splendid façade (Fig. 15) recessed from the cliff face with huge window to admit light to the interior. Cave 10 is similar but has a trabeated false wooden roof carved from the rock in form of a barrel vault.

In the last quarter of the third century a new dynasty, the Vakataka, rose to power but Ajanta was within the realm of a junior branch of this family centred in the Andhra kingdom to the east. Cave 16 was dedicated under their rule by King Harishena (475–510) and Cave 17 is of the same period as well. With the beginning of the sixth century we have reached the full development of the classic style of painting at Ajanta. Here in the unfolding of the stories of the previous lives of the Buddha (the *Jataka*) we enter a new world. The hall of the *vihara* or monastery, the cells of the monks surrounding the central pillared

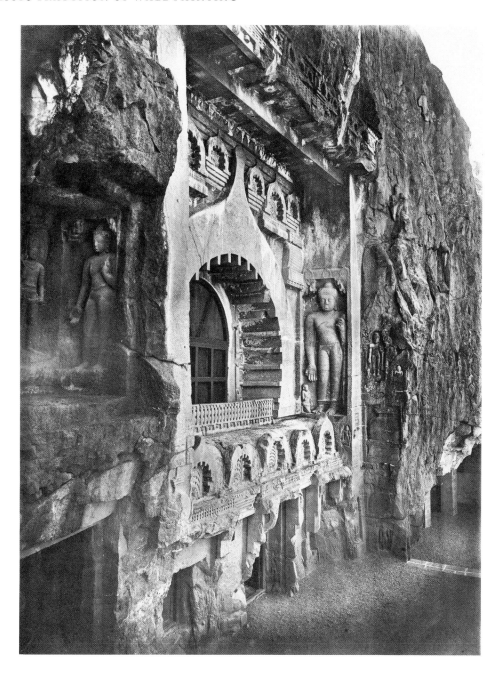

Opposite: Fig. 14 Painted column from Cave 17, Ajanta, Maharashtra. Late fifth century

Right: Fig. 15 Rock-cut façade of Caves 9/10, Ajanta, Maharashtra. *c.* AD 150

court, are entirely covered with paintings on ceiling and columns (Fig. 14) as well as walls.

The caves of the classic period from 475 to 600, while retaining the basic plan of the *chaitya* hall with its elaborate façade and feigned raftered roof, were enriched by friezes of sculpture along the architrave and by the addition of a kind of clerestory, while the columns were carved with ornamental zones and the façade with many seated or standing Buddha figures, carved from the rock in high relief. They are placed in deep niches and not related in scale to the whole façade. Now the stupa, while still dominant, is no longer plain but its front is carved with a great Buddha image. 'In Cave 17 the Buddha in the sanctum, flanked by two Bodhisattvas is shown in attitude of teaching the Law

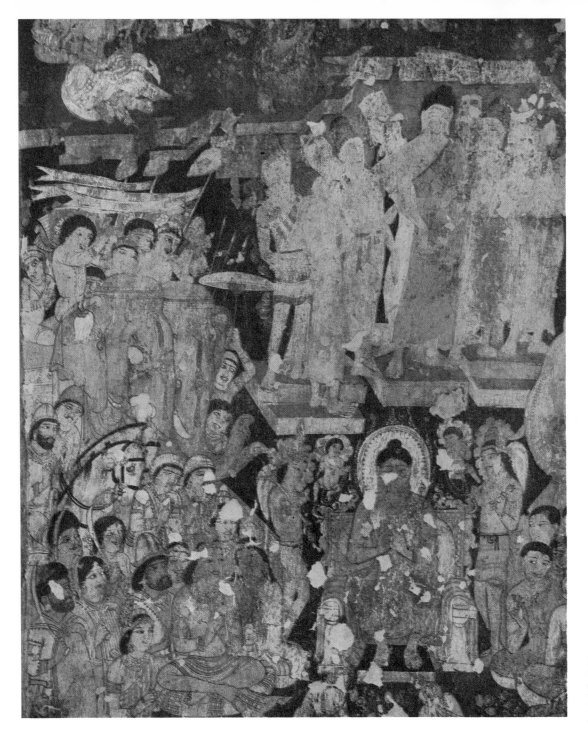

(*dharma*). The front of his throne is carved with the Wheel of the Law between two antelopes; this motif evokes the theme of the first sermon in the deer-park at Sarnath. In front, two princely figures hold bowls for alms or offerings; they probably are donors – a rare example of secular sculpture. Their reduced size corresponds to their place in the scale of emancipation and enlightenment.' (Dr Aschwin de Lippe).

In Cave 26 (Fig. 18) the whole podium of the *stupa* has been raised and covered with images of the Buddha and dominated by the overwhelming image of an enthroned Buddha preaching. This is from a supermundane extratemporal position, symbolized by the *stupa*, on a lion throne with a lotus footstool

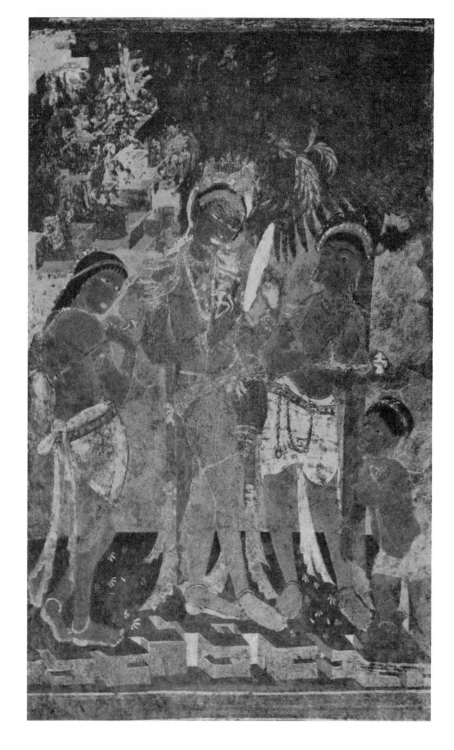

Fig. 17 'Toilet scene from the *Simhala Avadana Jataka*', detail from wall painting in Cave 17, Ajanta, Maharashtra. *c.* 500

supported by two *nagas*. The paintings in Cave 17, slightly earlier in date about AD 500, include three scenes of preaching, identified by David Snellgrove as first, in the *Tushita* (Joyful) heaven; second, on the Vulture Peak, that is, descending to earth; and third, preaching to the world, to rajas on one hand and to monks on the other. Even here, although he wears the monastic robe, Buddha remains a cosmic figure, an icon, enthroned and nimbed and attended like a king by cauri-bearers on either side (Fig. 16). Such a cosmic figure is fully expressive of Mahayana Buddhism, the unity of heaven and earth, of existence in time and outside it, thus transcending human life and the life of enlightenment. In visual terms such scenes require well populated compositions in which

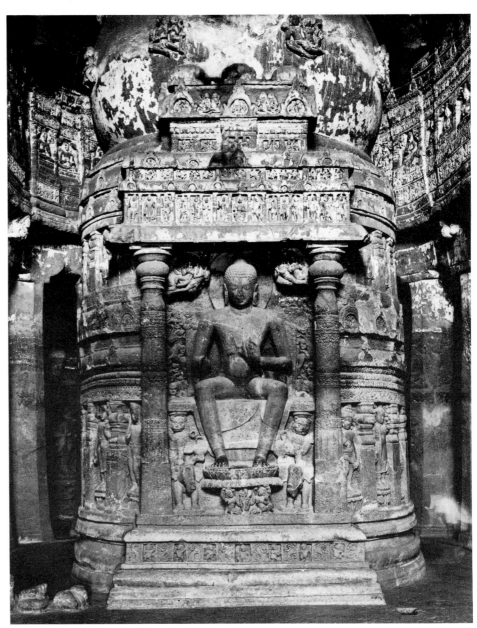

Fig. 18 Buddha Enthroned on stupa in Cave 26, Ajanta, Maharashtra. *c.* 500

celestial and terrestrial figures mingle. At Ajanta the aristocratic hierarchy of a royal court serves as a vehicle for the exaltation of the Buddha. The warriors and musicians in the first scene riding on elephants or horseback really belong to the lowest level rather than to that of the Buddha on Mount Grdhakuta; for the Lotus Sutra was delivered to Sariputra in a heavenly company, here represented above the central group.

The ceiling of this Cave 17 is laid out like a carpet or canopy, probably representing a wooden coffered roof, with successive circles filled with decorative designs, all enclosed within a square, the four spandrels filled with flying apsarases carrying lotus flowers. The scrolling designs are filled with fantastic animals developing voluminous complex vegetal tails, all in a style closely allied to Gupta relief carving, carried out in light tones on a dark ground. But the influence seen in the crowded *Jataka* scenes, which cover the walls behind the

columns and round the doorways to the cells, reflects rather the art of the school of Amaravati in the Andhradesa than of Sarnath in the north. The alliance between the senior branch of the Vakataka with the Gupta royal house was of no special significance at Ajanta, contrary to what is often suggested. No fewer than twelve *Jataka* stories are included in this series of epic scenes. One of the most extensive illustrates the *Simhala Avadana Jataka* on the walls of the right corridor. The royal army is shown in movement; while above, Simhala himself is seated and is being lustrated and saluted; the miraculous white horse, having escaped capture is honoured with banners and food-offerings by dwarfs. Later is depicted the attack by Simhala's army on the Island of the Ogresses; still mounted on elephants and horses it embarks on a fleet of boats, and Simhala manages to escape from the Ogresses despite the shipwreck of the boats. The last scenes show the Rani mourning for her absent lord Simhala before his empty throne and, finally, the return of the Raja. Above this final scene is the toilet scene (Fig. 17) reproduced here as an example of strongly outlined figures in the build-up of these well-controlled crowded scenes. Their epic quality is the Indian equivalent of the classic scenes of Mantegna. Here too each figure has its own contribution to make to a triumphal royal processional theme: but these paintings include narrative and the extra-dimension of the supernatural.

The toilet scene perhaps represents the preparation of the Rani for the return of the Raja. She holds a polished metal mirror in her left hand, while an attendant on her left holds the cosmetic jars on a tray awaiting her mistress's approval of her adornment. They stand on the square rocks that are characteristic of this Cave 17. This is one of the scenes Mukul Dey copied sixty years ago, and which he reproduced in his book *My Pilgrimage to Ajanta and Bagh*. Of the wall-paintings in this cave he writes: 'the artists found an abounding and inexhaustible joy in life and nature – in the beauty of form and movement in men and women and animals, in the freshness of leaves; in the earth and in the sunshine.' This is the verdict of an artist who spent months in close contact with the original paintings.

Caves 1 and 2 are rather later in the sixth century and here the fully modelled figures 'express the excitement and langour of an experience half spiritual and half sensuous', in the words of Douglas Barrett. In Cave 1 one of the extensive wall-paintings illustrates the *Mahajanaka Jataka* in which Queen Sivali prepares seven hundred dancing girls in order to distract King Mahajanaka from his resolve to retire from the world because of its transitoriness (Fig. 19). On the left, the young king and queen are seated under a rich canopy supported by wooden pillars. Two dwarfs are seated before their throne below the royal feet. A dancer in rich dress and jewellery is dancing with elegant hand gestures. Two flautists appear on her left and two girls play cymbals; beyond them is a girl playing a pair of large drums, while in the foreground is an older woman who plays a two-ended kettle-drum (the *mirdang*). All these players are naked to the waist. In the background is foliage. Evidently this is a court scene and it could equally well have decorated a palace wall.

It thus contrasts with the devotional paintings on either side of the back wall, the offering of flowers to two Bodhisattva figures of stately size. On the right, although Avalokitesvara wears jewellery at least as rich as the royal figures, there is an atmosphere of peace and withdrawal, which compares with the turbulance of the dance scene. Here too monks and laymen are full of awe and devotion for the supernatural figure of the Bodhisattva who holds a flower spray

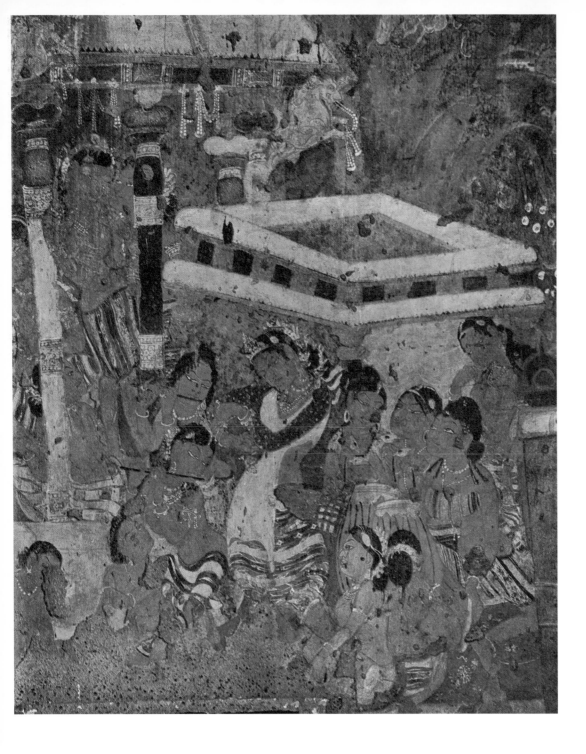

Fig. 19 'Dancing girls', detail from wall painting of the *Mahayanaka Jataka* in Cave 1, Ajanta, Maharashtra. *c.* 580

between thumb and first finger. In Cave 404 at the Tun-huang Thousand Buddha Caves, in a contemporary wall-painting, a Bodhisattva holds a flower vase with the same gesture; but this is a slimmer, less opulent figure nearer to the Chinese type at the period at the end of T'ang and Sui. As at Tun-huang the celestial figures at Ajanta always have haloes, while no haloes appear in the *Jataka* scenes.

On the left the corresponding figure is Padmapani holding his appropriate symbol a lotus flower (Fig. 20). He is the senior Bodhisattva officiating on earth in the interval between Sakyamuni and Maitreya, the next Buddha to be.

Both these stately Bodhisattvas are masterpieces of religious art; in their stance

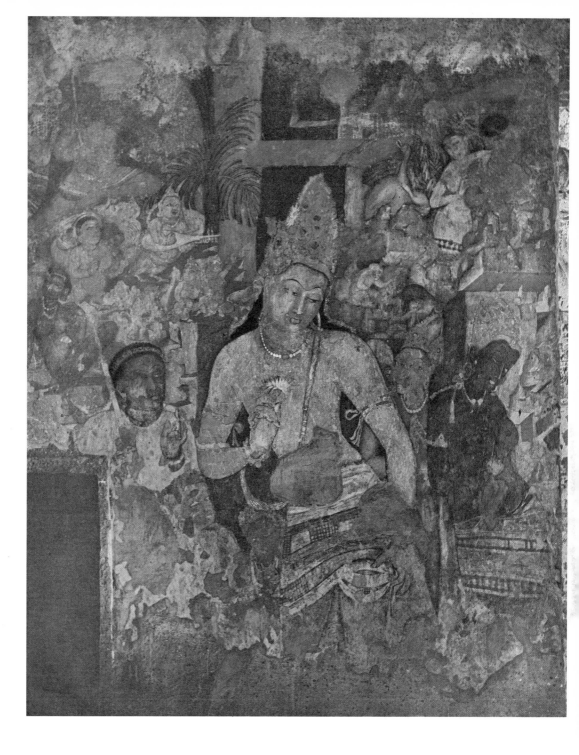

Fig. 20 'Bodhisattva Padmapani', wall
painting in Cave 1, Ajanta, Maharashtra.
c. 580

and expression they combine the transcendance of withdrawal from the struggle
and turmoil of human life with compassion for mankind. Both are accompanied
by their wives (*saktis*), who also express similar emotions; they are on the human
scale of the other figures, and are both darker in complexion. The princess of
Padmapani wears a high crown as does he; their dress too is much alike and her
expression echoes his, but perhaps intensified. The second princess is younger,
more sensuous, with heavier lips, curled hair and ropes of pearls. Behind this
group is a flowery meadow while behind Padmapani is a rocky scarp with
luxuriant palms and exotic peacocks.

Ajanta is not the only Buddhist site preserving traces of wall-paintings of this

period; but those in Cave 4 at Bagh in Dhar state on the southern slope of the Vindhyas at a height of 850 feet, are now hopelessly ruined by fire and smoke, though sixty years ago Mukul Dey thought them more mature and more perfect in technique than Ajanta and was able to make hand copies.

Badami in the southern Deccan, in another site of dramatic beauty, is the setting for the earliest Brahmanical cave-painting, Cave 3, which was dedicated in 578 by Mangalesa, brother of the Chalukyan king Kirtivarman I (566–98), to Vishnu. The walls were once completely painted but all that survives in this massive pillared temple is found under the verandah roof, which protected it from the weather. The great roof was carved and painted with cosmic scenes of the heavens, of the gods and their attendants. Now we may judge the lost beauty from the remaining heads (Fig. 22), perhaps from a group of the Chalukya royal family. They are painted in *fresco secco*, which allows of a more subtle modelling. Their delicacy agrees with the most striking sculptures in this cave, the brackets that support the verandah roof, the horned lions to the front and pairs of lovers (*mithuna*) on the inner side.

At Ellora, in the north Deccan, the Rashtrakutras replaced the Chalukya dynasty about 756, when their first ruler Krishna I started to excavate the great Kailasanatha temple (see pp. 58–60). Here there are remains of paintings on the ceiling. They are slowly emerging after cleaning, which is a complex problem because there are two or three layers from a period extending till about 950 just before the fall of this dynasty. The sculptures continue in a southern tradition and the painting of flying figures follows the style of Badami. These Brahmanical caves are in the centre of the group. At the northern edge of the scarp are five Jain caves, of which No. 32 is for us the most important. This cave dates from *c.* 814 but the ceiling paintings are of the mid century. They show again flying figures of Saivite and Vaishnavite deities in the clouds (Fig. 23). Although air-borne these figures are near to relief sculpture in their plastic quality and strongly defined movement.

It is only possible here to give some indication of the strength of a continuing tradition of wall-painting in later periods; it must be understood that all the Buddhist paintings of north India have perished with the shrines and monasteries that were destroyed by successive Muslim invaders; consequently, it is only in the south that there survive any traces of paintings in temples, mainly Saivite. The most important remains are in the great Cola temple of Rajarajesvara (ruled 1003–10) in Tanjavur (Tanjore). The ambulatory walls were covered with a series of contemporary paintings, which are being revealed as later layers are removed. Already six chambers have been cleared to show scenes from the life of Sundaramurti (Fig. 21), a leader of the Saivite revival. These paintings are in true fresco and so have survived, in spite of their being covered up: the style is energetic, full of the vital spirit of this devotional revival but with a firm, even line and complete clarity of movement.

Although later paintings survive and naturally in better condition, they tend to be more decorative and flatter, and share rather in the great tradition of textile art for which the south is famous. It is not therefore surprising that at Lepakshi the group of men in the boar hunt should depend for its impact on the swing of their skirts (Fig. 24). The strength of the tradition of wall-painting in India is once more demonstrated by its persistence even under Muslim rule. Thus Firuz Shah Tughluq (1351–83) when building his new palace at Firuzabad in Delhi employed a corps of painters to decorate the interior. His bedroom was painted

with garden scenes, though he ordered all figural subjects to be destroyed. When Mulla Daud composed his romantic poem *Laur Chanda* about 1380, he described a palace whose walls were painted with scenes from the *Ramayana*. In the mid fifteenth century in a Hindi romance, *Chhitai Varta*, the hero Ala ud-Din orders scenes from the story of Nala and Damayanti and from the *Mahabaratha* to be painted in his bedroom. It is therefore not surprising that when the emperor Akbar was creating his new city of victory, Fatehpur Sikri, he had the walls of the palace rooms painted with figural scenes.

In the Sultanate period of the late fourteenth to fifteenth century it may well be that wall-painting dominated over book-painting; but by Mughal times their roles had been reversed, so that it was now the miniaturist who was called on to decorate the walls of this palace. It is, however, worth considering whether the ancient art of wall-painting may not have formed the basis for book-painting when it was first practised under the Sultans of Jaunpur, Malwa and Bengal. The Berlin Staatsbibliothek owns a manuscript of the *Hamza-nama* in which there are many miniatures that show figures silhouetted against a plain coloured ground with only the simplest indication of architecture. This is dated by the library to the end of the fifteenth century and assigned to Gujarat (Fig. 136). A cookery book the *Nimat-nama*, now in the India Office Library, was produced at the court of Malwa, probably between 1501 and 1510, and again the figures are strongly

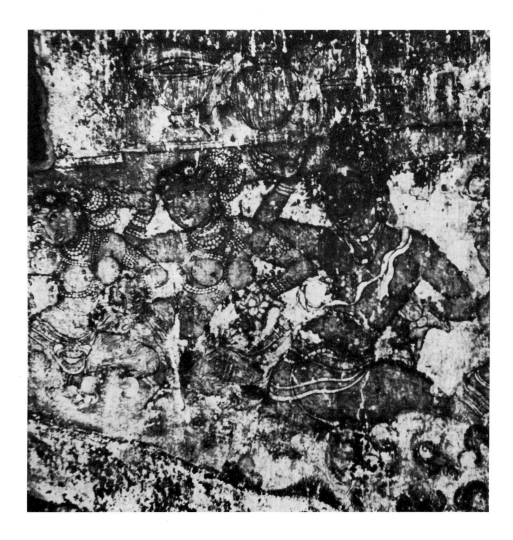

Fig. 21 'Dancers', fresco in Rajarajesvara temple, Tanjore. Early eleventh century

27

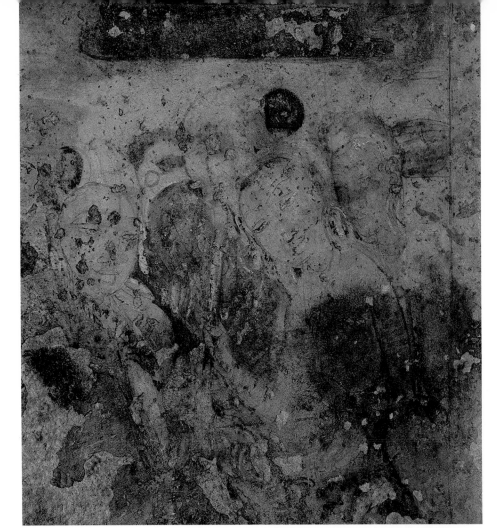

Fig. 22 'King Kirtivarman I and his family', wall painting in Cave 3, Badami, Maharashtra. 578

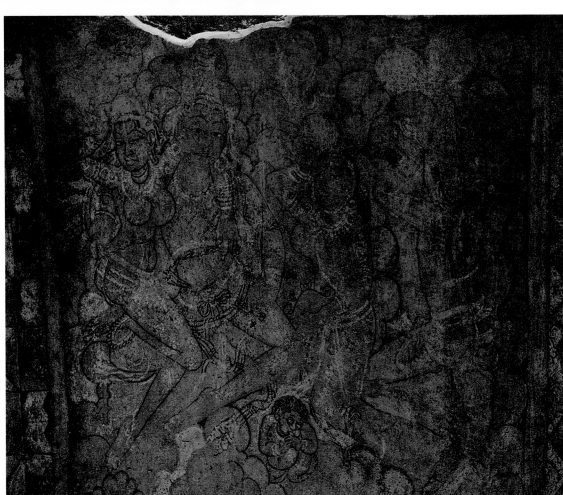

Fig. 23 'Flying Figures of Deities', wall painting in Cave 32, Ellora, Maharashtra. Mid ninth century

28

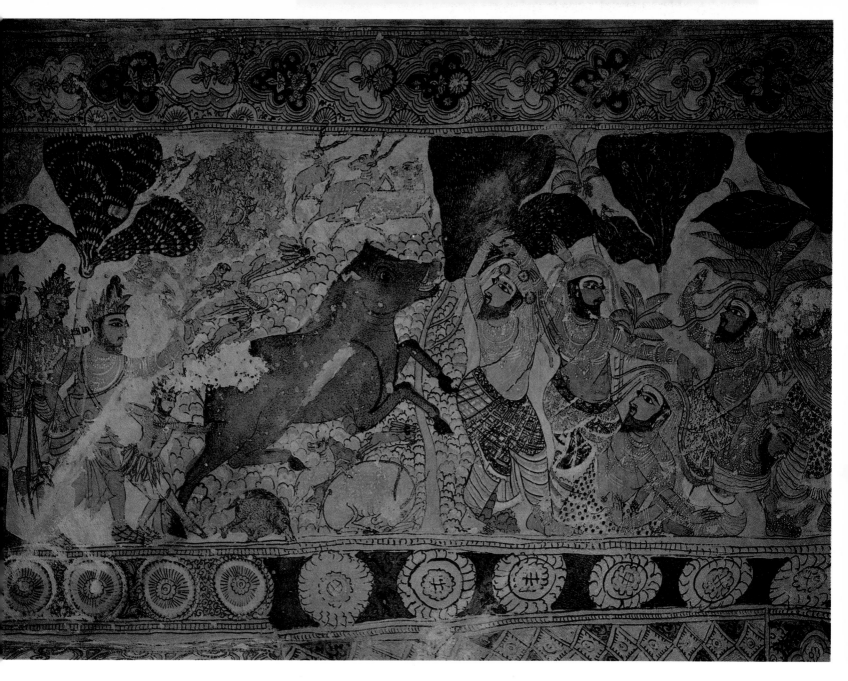

Fig. 24 'Boar Hunt', wall painting at Lepakshi, Anantapur District. *c.* 1540

silhouetted against a flat ground sprinkled with conventional plants while the architecture is in outline without structure or depth (Fig. 137). It is not surprising to see similar conventions in the contemporary or slightly later paintings for Hindu patrons.

The early manuscripts of the *Laur Chanda* share these features of silhouetted figures and flat background (Fig. 138). Such an idiom is eminently suited to wall decoration: this tradition contributed a boldness of composition and a brilliance of colour to the manuscript art of the sixteenth and early seventeenth centuries in both Muslim and Hindu India, appearing in the schools of Rajasthan and the Deccan, as well as in the few examples that survive from the Sultanate period of the generation before the Mughal conquest. Even to the Mughal school it made a contribution, clearly visible in some of the large-scale paintings of the *Dastan i Amir Hamza* and in the small-scale *Tuti-nama* (Fig. 141), both from the time of Akbar. So did a native Indian feeling and sense of form and colour prevail through all the changes of rule and subject matter.

PRAMOD CHANDRA

The Sculpture and Architecture of Northern India

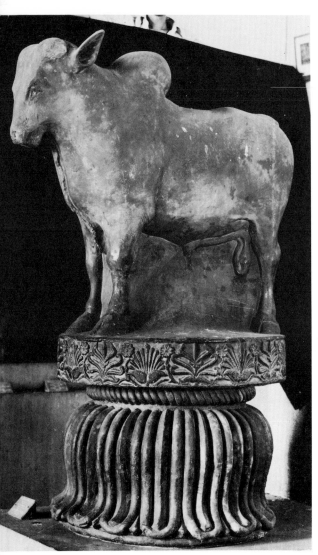

Fig. 25 Polished stone bull capital from Rampurva, Bihar. Third century BC. Calcutta, Indian Museum

The architecture and sculpture of north India, a particularly rich component in the history of Indian art, presents us with a succession of styles so distinct and vital, so rich in regional variations, that it is hardly possible to assess their achievements adequately in the brief essay attempted here. That certain monuments have been selected as exemplary or illustrative in the course of the account in no way implies a lack of appreciation for the many other marvellous achievements, which, for want of space, have been left out. However, if the outline of the general nature of artistic development is more or less correct, the reader will have been provided with enough landmarks to allow him to discover the many other wonders of north Indian art for himself.

After the collapse of the Indus Valley Civilization about the middle of the second millennium BC, there followed in India a long period of about 1500 years from which hardly any works of art are to be found. Perhaps they remain to be discovered for it is difficult to think of this extended span of time as being entirely without artistic activity. Whatever the case, no works are known, or at least so it appears, until the period of Maurya sovereignty, which roughly coincides with the third century and early years of the second century BC. All of a sudden at this point, there is a striking group of monumental sandstone columns, which are found largely from about the Delhi region on the western edges of the Gangetic valley (Uttar Pradesh) to the modern state of Bihar in the east. These columns are monolithic, circular, without bases, tapering toward the top, and crowned with campaniform lotus capitals on which rest animal sculptures. These display a pronouncedly naturalistic inclination, and the technique of handling stone approaches perfection, particularly in the painstaking finish whereby the surface is so skilfully burnished as to give the appearance of being polished.

The lion (Fig. 27), represented either singly or in groups of four, is the most popular animal, though a bull and an elephant have also been found. The accomplished nature of the style and the mature naturalism of representation, after a millennium of what seems to have been artistic inactivity, is simply amazing. Because the nature of the perception of form, particularly in carvings like the Rampurva bull, is distinctly reminiscent of the much smaller and more intimate objects like the seals (Fig. 7) from the Indus Valley cities, it is possible to speculate on a continuous tradition linking Maurya art with that of the Indus

Civilization. Even if, however, there were such a connection, the proof, at present, is totally lacking.

The material of the Maurya columns is a fine-grained sandstone from the quarries of Chunar near Varanasi, Uttar Pradesh. This would suggest that they are all the products of an imperial workshop. Of the lion capitals, the example from Sarnath is the most famous and is representative of one element in the Maurya style. The work is heraldic but also naturalistic when compared to the output of succeeding centuries; the stone is chiselled with great technical skill, so that the creatures are packed with tight energy and power.

The sudden appearance of this regal style, fully formed, as it were, at birth, has led some scholars to believe that it was of foreign origin, and some Iranian influence in the formation of Maurya art is certainly acceptable. However, even a cursory comparison makes it clear that this is not an example of foreign workmanship or mere imitation, but one involving a radical transformation of what has been borrowed in the context of a new artistic and cultural milieu. This kind of transformation occurs frequently again, as, for instance, in the foundation of the Mughal style of painting, also under Iranian inspiration, almost 1800 years later.

The indigenous foundations of Maurya art are best represented by the sculpture of a young elephant carved out of the rock at Dhauli (Fig. 26), in the eastern state of Orissa. There is epigraphical evidence to assign it to the reign of the emperor Asoka, and in marked contrast to the hard, chiselled surfaces of the lion capitals, it is distinguished by soft breathing forms seeming to swell outward from within. The puzzling and apparently contradictory nature of some Maurya sculpture is resolved if it is seen to be the result of the interplay of these contrasting forces, one represented by the Sarnath lion, the other by the Dhauli elephant, one predominating, then the other, but sometimes forming a perfect synthesis in a work like the marvellous bull capital from Rampurva (Fig. 25). From this point of view, it is also possible to understand the controversial Patna Yaksas and the famous Didarganj Yaksi (Fig. 30), a class of divine beings associated with fertility and abundance, as products of the Maurya period.

The next phase of Indian sculpture, which opens around the middle of the second century BC, is in startling contrast to what had gone just before. The key monument is the great stupa railing that once stood at Bharhut, Madhya Pradesh; for here not only is the style of the period set out clearly for the first time, but also the themes and certainly the motifs of all subsequent Indian art. The railing is covered with an infinite variety of designs and bas-reliefs illustrating the life of the Buddha, or events from the *Jataka* stories (Fig. 29). Most of the ornament is symbolic of abundance and includes the lotus creeper, the pot overflowing with flowers, elephants, the *makara*, which is a crocodile-like creature – in short, almost the entire decorative vocabulary of all Indian art. Especially striking are the large images of Yaksas and Yaksis (Fig. 28) on the rail posts, their modelling, as Ludwig Bachhofer so succinctly says, being essentially cubical in nature. Here, the pronouncedly flat planes meet each other at right angles, roundness being suggested simply by the smoothing of edges. The contours, as a result, are stiff and angular, the essentially two-dimensional figure rigidly imprisoned between the ground and an imaginary frontal plane, all in sharp contrast to the markedly voluminous and three-dimensional nature of Maurya form. Additionally, the surface is enriched by the precisely and exhaustively engraved detail of jewellery and clothing, natural to work in wood

Fig. 26 Rock relief of an elephant at Dhauli, Orissa. Third century BC.

Fig. 27 Polished stone lion capital from Sarnath, Uttar Pradesh. Third century BC. Sarnath, Archaelogical Museum

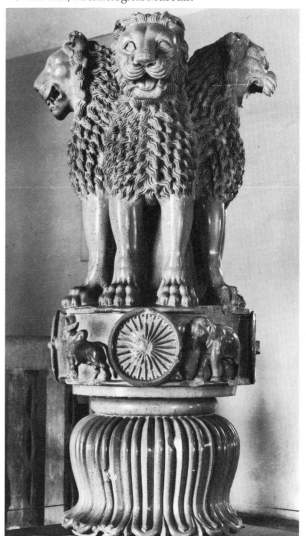

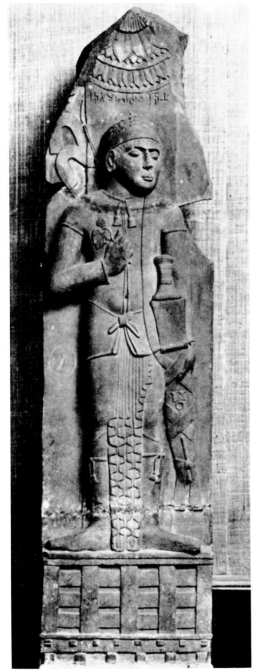

Fig. 28 Guardian Yaksa figure from the railing pillar of Bharhut, Madhya Pradesh. *c.* 150 BC. Calcutta, Indian Mus.

Fig. 29 'Maya's Dream', roundel from the stone fence at Bharhut, Madhya Pradesh. *c.* 150 BC. Calcutta, Indian Mus.

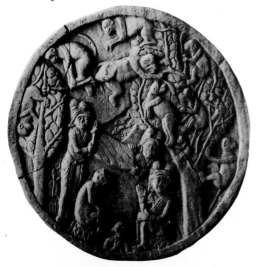

rather than stone. In expression, the figures have a mask-like aspect, beyond emotion, that lends to them a sense of hieratic dignity.

This style extends to the much smaller narrative reliefs, the compositions of which are often crowded with a number of figures generally arranged in horizontal rows. These are almost as devoid of human expressiveness as the large Yaksas, and there is little emotional interplay between them, even though sometimes the sculptor is caught in a more relaxed mood. The depiction of the animals, however, seems to have been executed with comparative ease, and they are treated as possessing the same kind of life as human beings, another feature that occurs often in all later art.

It would appear at first sight that the style of Bharhut was unique to that monument, but a few fragments, identical in execution, discovered at the city of Mathura, Uttar Pradesh, suggest that this city was also a centre of the style. Perhaps one may even conjecture, in view of the long and rich artistic history of Mathura, in contrast to that of Bharhut, the stupa of which is but an isolated occurrence, that it was actually Mathura that was the great metropolitan centre in the heartland. Stray finds suggest that several other centres of very similar artistic activity flourished in Uttar Pradesh at this time, among which, Sarnath and Kausambi are noteworthy.

Among other sculptural remains from north India of this period (mid second century BC), mention must be made of the carved railing of Stupa II at Sanchi, Madhya Pradesh. The work is similar to that of Bharhut, but on a humbler scale. The modelling is a trifle more relaxed, the planes a little softer, a significant local feature that anticipates the emphatic rendering of volume to be seen at the same site a century later.

That the mid second century BC style extended to distant Orissa in the east is indicated by a few reliefs preserved in the Alakapuri cave (forming part of the Udayagiri-Khandagiri complex), which closely parallel work at Stupa II, Sanchi. In the west too, far across the country, there is sculpture of a closely related style at Bhaja and Pitalkhora in Maharashtra. The reliefs from Bhaja (Fig. 31), probably representing the Mandhata legends, are particularly impressive; the modelling possesses an amorphous, shifting quality that seems to be derived from terracotta rather than wooden prototypes as at Bharhut. The softer treatment of the surface and the striated ornament gives the appearance of clay scratched and brushed while still wet.

A general view of early Indian sculpture in the various parts of north India clearly demonstrates that closely related schools came into existence all over the area during the second century BC. In some instances the schools extended even beyond it as is shown by work found at Amaravati, Andhra Pradesh, quite far to the south. This overall similarity of style, even granted the distinct flavour of local schools over a vast area, is a remarkable testimony to the cultural unity of India. This was apparently first established with the second urbanization, which took place about the sixth century BC from which period date very similar archaeological remains all over the country. The unity was reinforced by a system of roads much travelled by merchants in search of profit and pilgrims in search of a glimpse of God. This close communication between far-flung parts of the country was never ruptured, even in times of war, when actually, and rather perversely, communication between the warring factions was further intensified. It is no wonder then that artistic movements in one part of the country were very quickly reflected in another. This tendency is an often unstated but

nevertheless very important premise for the understanding of the history of Indian art.

Most of the surviving sculptures in this early relief style are dedicated to the service of the Buddhist religion. It is somewhat misleading, however, to characterize them as Buddhist sculpture, for there is little in the mood of the style that specifically expresses the values of the Buddhist religion. The iconography, for example, relies heavily on pan-Indian rather than exclusively Buddhist sources. The Buddha himself is never represented in human form but by means of signs such as the sacred tree, the wheel, and the *stupa*. The oft represented Yaksas and the closely associated Water Cosmology ornament testify to the wide prevalence of these cults whose worshippers include adherents of all the major religions. Additionally, at this time, and even more so in the period that follows, the nature of the style and the frank delight it takes in the world of the senses seem to be in contradiction to the nature of contemporary Buddhism as far as it is known from literary sources. The absence of Hindu remains, too, is a matter of surprise; the most reasonable explanation is that Hindu monuments were executed in a perishable material like wood, since stone was held to be ritually impure by virtue of its early association with funerary monuments.

Much of the sculpture of the second century BC is in relief, but there are a few colossal and life-size images that are free-standing representations of Yaksas and Yaksis. These follow a kind of image already produced in the Maurya period, and form the basis of later iconographic developments in which anthropomorphic representations of divinities become the general practice. The most important, no doubt, is the colossal image of a Yaksa found at Parkham, a village very near Mathura (Fig. 34). It possesses all the characteristics of the Bharhut style, to which is added a certain sense of weight, a feature of these large images. The massive body on which is a closely set head, the broad chest and the full belly are entirely appropriate to a divinity that presides over the productive powers of nature.

Sometime toward the end of the second century BC, this opening phase of the early Indian school, of which Bharhut is the typical monument, begins to give way to a new style in which the stiff contours and flat forms yield to a progressively softer and more relaxed modelling. A careful analysis of the few surviving works reveals the existence of two trends, one of them, a relatively simple and austere style, evolving in the direction of the sculptured railings of the Mahabodhi temple and the Jewel Walk at Bodhgaya, Bihar, and the other in the direction of the complex and lush sculpture adorning the gateways of Stupas I and III at Sanchi. Most work found from Uttar Pradesh (ancient Madhyadesa) at such important sites as Mathura, Kausambi, and Sarnath is of the simple type characterized by sedate compositions and a considerably restrained decorative sense. The movement toward the sumptuous idiom of Sanchi is indicated by only a few sculptures found in Mathura and Vidisa, which give us clear hints of the luxurious and joyous style that is the principal glory of early Indian art.

Sculpture of this phase at Sanchi, roughly datable to the middle of the first century BC, is largely confined to the four gateways attached to the railing of Stupa I and the single gateway of Stupa III. They consist of square posts with sculptured panels, which are topped by capitals composed of groups of dwarfs, elephants, or lions, the latter inspired by the Maurya column that stood nearby. The posts support three architraves, one above the other, which are also richly

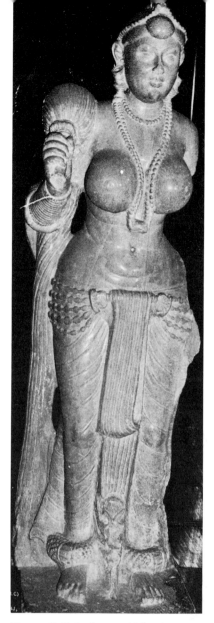

Fig. 30 Polished stone Yaksi from Didarganj, Bihar. Third century BC. Patna Museum

Fig. 31 Rock carved figure of Indra from Bhaja, Maharashtra. *c.* 150 BC

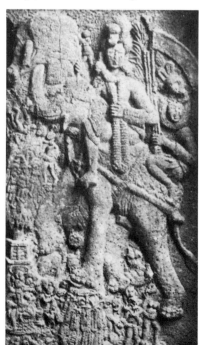

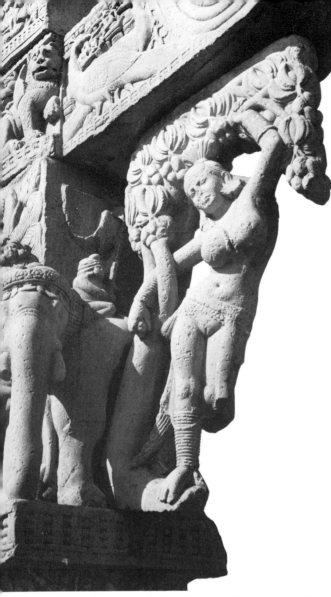

carved and are provided with brackets in the form of voluptuous Yaksis clinging to trees (Fig. 32). So profuse is all this sculptural embellishment that an empty space is hard to find, and the general impression, far from being architectonic, is that of a tree loaded with fruit and flower.

Though the subject-matter is largely that of Bharhut, the style is quite different. The gradual loosening seen in sculpture of the post-Bharhut phase has now reached full development, and there is a real understanding and rendering of massive and voluminous form. Consequently the work takes on a somewhat earthy and humane aspect quite in contrast to the hieratic formalism of Bharhut. The sap now flows copiously through the stems of plants and branches of trees, filling them to the point of bursting. And the same mundane vitality pervades the human figures, their contours smooth and rippling, bodies warm with the glow of soft resilient flesh. All these qualities are epitomized in the superb bracket Yaksis. The heavy jewellery and clothing that smothered the female form at Bharhut has been removed so that the figures, though clothed, appear nude. There is everywhere a frank acceptance of the beauty of this human world that seems, superficially at least, at variance with the Buddhist nature of the monument.

Forms which people narrative relief sculpture at Stupas I and III at Sanchi are also carved in the same fulsome style, and this together with the crowded compositions results in what has been called the overshadowing of the background so that the figures, instead of being securely fixed to it as at Bharhut, seem to flow out from a dark ambience. The narration is also no longer brief and cryptic, but leisurely and discursive. A new emotional expressiveness is additionally evident, the faces often suffused with joy; and the various participants in a scene, instead of being secluded in their own space are psychologically related to each other through posture and gesture.

The most ambitious reliefs at Sanchi are the elaborate and lengthy compositions that extend over the entire architrave of a gateway. These are particularly rich and complex, notably the superb depiction of the war for the relics, or the touchingly rendered Saddanta Jataka where a royal elephant sacrifices its tusks to save its tribe. The figures are deftly interknit, and the action takes place either in the luxuriant Indian countryside filled with blossoming trees, jagged mountains and flowing rivers, or in an architectural landscape filled with buildings. A special delight is taken in animal life, which is rendered with the sympathy and intimacy of a shared common existence.

The railing sculpture at Bodhgaya (Fig. 33), in contrast to that of Sanchi, represents the high point of the simple and austere trend in the development of the early schools. There is neither the exuberant crowded composition nor the rich ornament that occurs so spontaneously at that site, or for that matter even in the earlier work at Bharhut. This plainness of work has been generally interpreted as representing work at an earlier date than Sanchi Stupa I, but I believe that this is not the case, and that the two monuments should be near each other in time, and belong to the two strains of early Indian sculpture at about the same stage of development.

These two trends of early Indian sculpture can also be seen in the caves excavated in the twin hills of Udayagiri and Khandagiri situated not far from the Dhauli elephant in Orissa. We have already noted a phase contemporary with Sanchi Stupa II in the Alakapuri cave there. The Manchapuri, Tatowa, and Ananta caves have work remarkably close to Bodhgaya; while the Rani Gumpha

Fig. 32 Yaksi bracket from the gateway of Stupa I at Sanchi, Madhya Pradesh. First century BC

Fig. 33 'Purchase of the Jetavana Grove' on a railing pillar from Bodhgaya, Madhya Pradesh. First century BC

cave sculpture (Fig. 35) parallels work at Sanchi Stupa I in the crowded compositions and rounded modelling. At the same time, a distinct local flavour is perceptible in the preference for tall elegant proportions, and the pronouncedly agitated movement of the figures lends a sense of instability and nervous urgency to the style. The very poor state of the stone may obscure the fact that work at this site marks another high point in the development of the early schools.

At the other end of the country from Orissa lie the cave temples of Maharashtra, and here also, notably at Pitalkhora and Karle, there is yet another great idiom moving step in step with developments in the rest of north India. The sculpture at Pitalkhora, in comparison with that of Bhaja mentioned earlier, represents a more stable phase, the earlier amorphous modelling being steadied here by a greater emphasis on weight and volume. The masterpieces of the western school, however, must be the superb couples carved in the porch of the cave temple at Karle (Fig. 36). They present striking parallels to the figural sculpture of Sanchi Stupa I, but are on a grander and more heroic scale.

This early phase of Indian sculpture, characterized by a marked concentration on the narrative bas-reliefs, reaches its climax in distant Andhra Pradesh, most notably at the great site of Amaravati during the first three centuries AD. In northern India, on the other hand, the relief tradition begins to fade towards the close of the first century BC, and the sculptor becomes increasingly concerned with the individual image instead. The development is best exemplified in the formulation of the Buddha image at Mathura, a site that rapidly became the predominant artistic centre of north India during the first two centuries AD, a time generally referred to as the Kusana period. The sheer quantity of work discovered at Mathura far outnumbers the products of other previously flourishing centres, and is rivalled only by the rather curious work of the Gandhara region. This area, now mostly in Pakistan (its centre is the great city of Taxila in the Punjab), continued to produce both reliefs as well as individual sculptures in considerable amounts.

As noted earlier, in addition to bas-reliefs, there also existed, at least as early as the second century BC, an Indian tradition of carving large free-standing images of Yaksas. Besides the Parkham image (Fig. 34) two superb examples are the immense statue from Vidisa and the Yaksa Manibhadra from Pawaya, both in Madhya Pradesh. The iconography of these images is fairly well-established; they are full bellied, face to the front, and possess massive heads resting on a

Above: Fig. 34 Yaksa figure from Parkham, Mathura. Second century BC. Mathura, Archaeological Museum

Below left: Fig. 35 'Struggle with Elephants', Rani Gumpha cave, Udayagiri, Orissa. First century BC

Below right: Fig. 36 Couple (Mithuna) from the porch of the cave temple at Karle, Maharashtra. First century BC

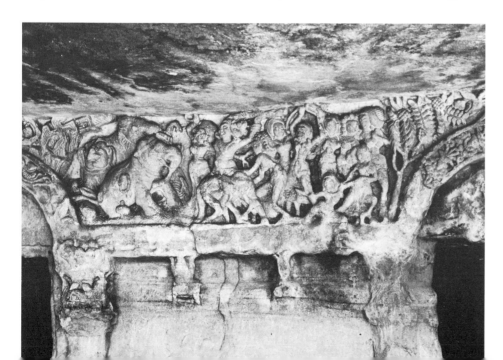

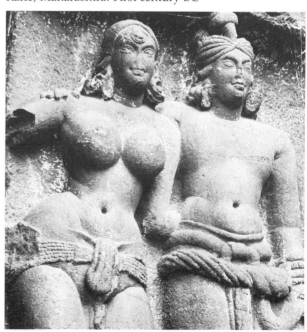

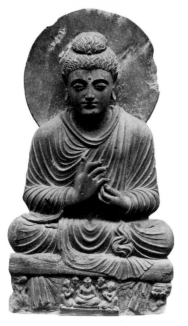

Fig. 37 Buddha Preaching, Gandhara school. Second century AD. London, British Museum

Fig. 38 Yaksi relief carving from Mathura. Second century AD. Mathura, Archaeological Museum

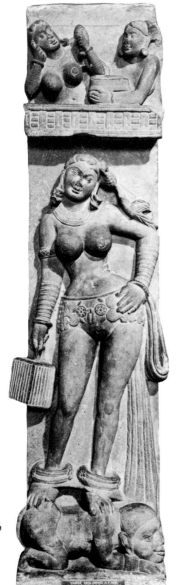

sturdy neck. The left hand is held at the waist and clasps some object, such as a bag of money, while the raised right arm generally holds a fly-whisk. The dress and jewellery consist of the usual upper and lower garments, earrings, necklaces, and armlets. When the Mathura sculptor felt the necessity of representing the Buddha-Bodhisattva in human form, it was this type of image that provided the iconographic inspiration. The dress and jewellery were felt to be inappropriate in view of the Buddha's acceptance of the monastic life, so that these were removed and substituted by garments proper to a monk, including the characteristic robe thrown over the left shoulder. The raised right arm of the Yaksa was easily converted into the gesture granting freedom from fear, and the left hand continued to rest at the waist, but, as it held no object, was treated as an empty clenched fist. In effect, the earliest Buddha images, like the remarkable sculpture made at Mathura, but installed at Sarnath by the monk Bala (Fig. 39) are little more than Yaksas in monastic dress. As such, though they are, so to say, images of the Buddha, there is specifically very little that is Buddha-like about them, and they come across as robust, extroverted divinities, and little in their mood distinguishes them from the Yaksas.

Along with the Buddha there have also been found at Mathura a large number of images of Jaina Tirthankaras and some Hindu divinities, notably Vishnu-Krishna, Varaha, Siva, and Devi slaying the buffalo-demon. A few of these have more than two arms, an innovation that in later centuries becomes a typical feature of Indian iconography.

Narrative relief is not found in any appreciable quantity at Mathura during the Kusana period, but relief sculpture on railing posts representing Yaksas and Yaksis are found in some abundance (Fig. 38). The Yaksis are cast in the image of women engaged in the daily round of a prosperous life: bathing, playing, dancing, drinking, and endlessly adorning their persons – the spiritual even more emphatically seen in the image of the sensuous. They retain to a great extent the soft, swelling forms of Sanchi Stupa I, though the surface takes on an added tension. The rhythms, too, are more complex, with pronounced swings and quick turns instead of the smooth and simple harmonies of preceding sculpture. The body is here conceived as a fully integrated unit, the movement of a single part emphatically carried through the entire figure. Emotion is also more elaborately expressed, not only by the expression of the face, but also by individual gesture so that the potentialities of the early school are brought to full maturity. The splendid series of Yaksi images from Kankali Tila and Bhutesar are strikingly representative of this aspect of Mathura sculpture.

The floral and animal motifs of the ancient tradition continue to be as popular as ever, but now the two commingle. Not only is the movement of the beasts as sinuous as a winding lotus stem, but the body itself begins to sprout foliate forms; the tail, for example, often terminates in what seems to be a leaf.

A new life animates Mathura sculpture of the first two centuries AD, and this is also reflected in the new kinds of dress and ornament. Instead of the extremely limited coiffure of earlier female figures, there is an endless array of fashionable and elaborate styles. Certain new ornamental motifs, of a somewhat geometrical aspect and making profuse use of beaded patterns, may perhaps be the result of artistic elements introduced by the Kusana migrants; but it is the remarkable group of portrait sculptures recovered from a ruined shrine situated at Mat, near Mathura, that provide the clearest idea of their contribution. Among representations of the various early rulers of the dynasty is a statue of

the great emperor Kaniska himself; it is unfortunately headless. The dress is quite foreign, with a tunic, coat, and felt boots; but more importantly, the modelling of the body is almost unrelievedly flat, and marked by a sharp, angular contour. It was not long, however, before these elements were completely absorbed and transformed by the Mathura sculptor, a process not unknown in the history of Indian art and which we have already seen at work in the Maurya period.

Mathura sculpture of the Kusana period began as an extension and refinement of the kind of work found at Bodhgaya and Sanchi I, but emphasized volume and plasticity, and added a certain subtlety in the rendering of planes and the movement of the body. In the course of time, however, the forms begin to dry out, the round swelling surfaces are tightened, and the once expressive faces acquire a frozen expression. Finally, around the end of the second and the early years of the third century, the style reaches the end of its resources. Great quantities of sculpture seem to have been produced, mostly of Jaina Tirthankaras, but the quality declines disastrously.

It is interesting to note that there seem to have been no other great centres of production in north India comparable to Mathura during the first and second centuries AD, a situation quite different from that in the previous two centuries when several centres flourished stretching from Orissa to Maharashtra. Mathura sculpture on the other hand was exported to many cities, and examples have been discovered at sites all the way from Taxila in the Punjab to Chandraketugarh in Bengal. In some of these places, Mathura works inspired a limited amount of sculpture, notably at Sarnath and Kausambi where an attempt was made to subdue the strong fleshiness of the Mathura school by treating the surface in a more abstract manner.

Contemporary with the school of Mathura, but extending in one form or another to almost the sixth century, was the prolific school of ancient Gandhara. The subject-matter is largely Buddhist and depends heavily on traditions of Indian iconography; stylistically, however, it is a world apart from Mathura, stressing, in the Indian context at least, a type of naturalistically oriented form that had never been seen before and was never seen afterwards in the rest of the Indian sub-continent. Little is known, with some exceptions, of even the correct find spots of the sculptures, and the almost total paucity of firmly dated objects make the study of this art a taxing and arduous affair. The origins of the Gandhara style are especially unclear, but should be in some way related to the contacts between India and the Greek and Roman worlds by way of Iran and West Asia from the most ancient times. Discoveries at Ai Khanum in Afghanistan suggest the existence of strongly Hellenized work on the borders of the subcontinent in the post-Alexandrian period, but its relationship to the Gandhara style proper, which is commonly thought to have flourished in the first two centuries AD, remains uncertain. Recent scholarship has emphasized the Roman rather than the Greek contribution. Gandhara also formulated its own type of Buddha image (Fig. 37), which is quite different from the Yaksa-like icons of Mathura, in that it is endowed with a somewhat affected and sentimental piety as the sculptors attempt to capture realistically what they conceived to be the personality of the Buddha. The rendering of the drapery is distinctive, the material given substance and the pleated folds emphasized so that they cover the body and conceal its contours in a very real sense. This is a technique unknown in the rest of Indian sculpture. Large numbers of images of the

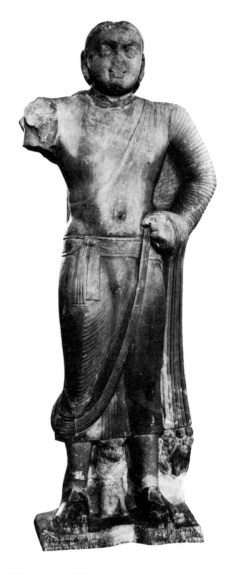

Fig. 39 Buddha, made at Mathura and dedicated by Bala at Sarnath, Uttar Pradesh. First century AD. Sarnath, Archaeological Museum

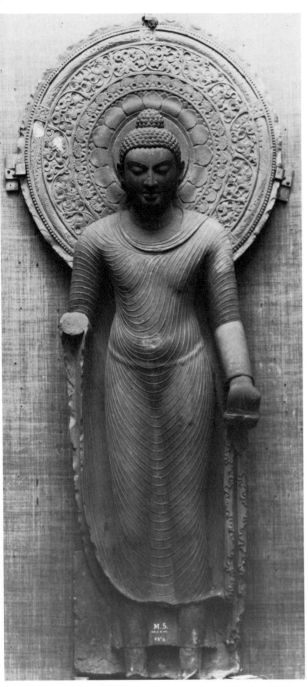

Fig. 40 Buddha in Abhaya Mudra (Giving Assurance), Mathura. Fifth century. Calcutta, Indian Museum

Buddhas and Bodhisattvas were manufactured, as were narrative reliefs that once decorated the numerous stupas of this region. There is a tendency here to move away from the technique of continuous narration, and alongside simple compositions with figures placed in rows there is elaborate work of considerable dexterity and accomplishment. The later style of Gandhara is best seen in some superb stucco heads that emphasize sweetness and grace, and which are of as late a date as the sixth century, around which time the style comes to a close. Of somewhat marginal importance to art in the rest of the subcontinent, the Gandhara style was nevertheless of great significance to the development of art in Central Asia and the Far East.

With the end of what has been called the Kusana school of Mathura sometime in the third century, the early Indian style may be said to have come to a close. The next phase of Indian art, extending from the fourth to the sixth century (a period that coincides roughly with the rule of the Gupta dynasty in northern India, and hence allows us loosely to call the art of the period Gupta), is characterized by an entirely new feeling. The earthbound, sensuous idioms of Mathura were transubstantiated into a new aesthetic vision in which the expression turns inward to take on a meditative and spiritual aspect; the works of art to that extent are more in conformity with what we conceive to have been the nature of contemporary religious feeling. Buddha statues of the fifth century, which marks the high point of this style, are no longer robust Yaksas dressed in monastic garb; rather, they are true images of the compassionate Master of the Law, unaffected by and beyond joy and sorrow (Fig. 40). The Buddha no longer confronts the worshipper with bold and open gaze, for his lowered eyes are now turned inwards, serenely contemplating the world of the spirit. The extravagant plasticity of the earlier schools is dissolved into an abstract and refined surface in which the sensuous and the spiritual are brought into harmony. Elegance and strength, ornament and form are all perfectly balanced so that the application of the term 'classic' to the style is reasonable.

So startling is the difference between the closing phases of Mathura art in the third century and what is found in the Gupta period that thinking of the changes as revolutionary may be justified; but a careful examination shows that there was no explicit rejection of past traditions, but, once again, their rapid transformation. The movement towards the new style begins to be visible in a group of three Jina statues found at Vidisa, and datable to about 360 (in the reign of Ramagupta), where the form begins to waken to new curvilinear rhythms. In the Buddha of Mathura workmanship, but discovered at Bodhgaya, and dated anno 64 (AD 384), the face though massive and heavy in the Kusana manner is nevertheless withdrawn and absorbed in meditation (Fig. 43). In images like these, where new features are seen side by side with those of the old, a style fitfully emerges, which begins to gain coherence and unity around the opening years of the fifth century AD. The type site for this phase is Udayagiri, close to Sanchi in Madhya Pradesh. Here, the earlier uncertainties are overcome, and there appears instead a consistent idiom that continues to stress strength and power, and combines with it rhythmical grace and elegance. The outstanding sculpture here is the great Varaha relief, which depicts the boar-headed divinity sweeping up the Goddess of the Earth from the watery deeps with his tusk. Another masterpiece from this region and perhaps a little earlier is a colossal image of the same god from Eran (Fig. 41), again filled with power. This early Gupta style is not just confined to this region, but extends over much of

northern India; comparable sculpture is found from Mandor in Rajasthan to Devangarh in Bihar.

This opening phase quickly achieves maturity. It is in full flower by the second quarter of the fifth century, and inspired works are produced in the revived centres of production all over northern India, each possessing its own individual flavour. Not surprisingly, Mathura seems to have taken a leading part, developing an idiom of singular strength and vitality. The great images of the Buddha discovered there rank among the finest achievements of Indian sculpture. Some of the strength and volume of the earlier period is retained but it is subdued; the ponderousness yields to a smoothly modelled and gently rhythmical form that is alive with a quiet spiritual energy. A classic iconographic type is achieved, and its influences are felt over all of India.

The same style that creates the Buddha image also finds expression in the increasingly large number of images of Hindu divinities that begin to be found from this time onwards. They too are absorbed in calm contemplation and there is little to distinguish them from the Buddha except for iconographic idiosyncrasies, the great image of Krishna-Vasudeva from the Katra being a particularly splendid achievement. A similar mood even pervades images of Kubera, the God of Wealth, where the restrained quiescent manner becomes all-embracing.

Sarnath at the eastern end of Uttar Pradesh was also an important and influential centre during this period. Artistic activity there picks up a little later than at Mathura. Its sculpture is characterized by a flatter and more meticulously abstract surface. The stance of the numerous images of the Buddha, instead of being firm and frontal, is gently flexed so that, instead of the solemn stillness of Mathura, there is present a greater elegance and movement. The fullness of modelling found at Mathura is here greatly de-emphasized, the luminous body, unhampered by the ridged folds of the monastic garment, freed from any earthly trammels. The famous seated image of the Buddha preaching (Fig. 2) is a superb example as is the group of three datable images of the Buddha standing, all of about 470, which seems to mark the most flourishing period of the school.

The neighbouring area of Bihar probably possessed its own style, which emphasized weight and volume, and which is best seen in such sculptures as the Shakund Narasimha. The style becomes greatly indebted to Sarnath in the late fifth century, and the impressive life-size bronze image of the Buddha from Sultanganj is a work that is very close to the Sarnath manner. Kausambi in Uttar Pradesh also shows the closest connections with Sarnath. The celebrated image of the Buddha from the nearby village of Mankuwar, which bears a date equivalent to 449, is indistinguishable from contemporary Sarnath work. Later sculpture from Kausambi of the late fifth and early sixth centuries, however, is more mannered and nervous in expression though still closely allied to the Sarnath school.

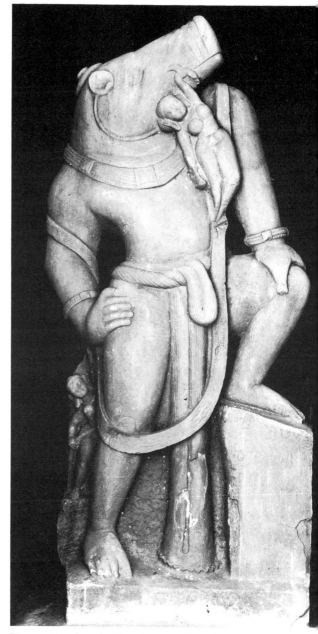

Fig. 41 Varaha (the Boar Incarnation of Vishnu) from Eran, Madhya Pradesh. Gupta, c. 400. Sagar, Madhya Pradesh University Museum

Fig. 42 'Worshippers in procession', detail of relief carving from Garhwa, Uttar Pradesh. Gupta, fifth century. Lucknow, State Museum

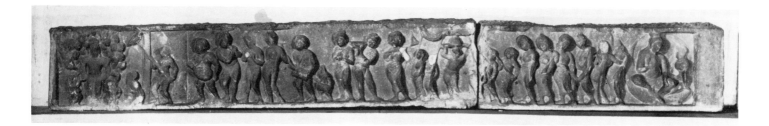

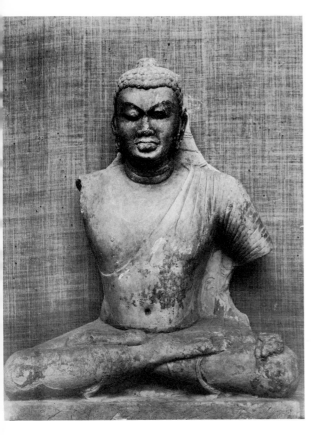

Fig. 43 Seated Buddha from Bodhgaya, Bihar, dedicated in the year 64. Gupta, 384. Calcutta, Indian Museum

Other important centres also sprang up in what is now Uttar Pradesh, though none seem to have reached the richness, productivity, and continuous activity of Mathura and Sarnath. Among the important known sites, and many surely remain to be discovered, special mention must be made of Garhwa. The fine relief showing groups of worshippers in procession (Fig. 42), with its complex swinging movement, the figures smoothly flowing forward and backward, indicates the great successes that might have been achieved in this style had the sculptors turned their attention to the carving of reliefs.

Much has been destroyed in Uttar Pradesh because its rich plains were easy prey to the invader; but areas somewhat to its south in the hilly hinterlands of a region now loosely called Central India preserve several important ruins. The Vidisa-Udayagiri area has already been described as an important centre of the early Gupta style, and fine work continued to be produced there throughout the fifth century (much of it is now housed in the Vidisa and Gwalior museums). Of the later period, are the sculptures of the Vishnu temple at Deogarh, including the relief panels illustrating incidents from the myth of Vishnu (Fig. 46). These harmonious compositions, with slow, graceful and lavishly decorated figures and dramatically presented narrative, are fine examples of the Gupta style in full if somewhat overblown maturity.

A little to the east, in the neighborhood of Bharhut, are the important sites of Khoh, Bhumara, and Nachana-Kuthara, which reveal yet another variety of the Gupta idiom. Among Bhumara sculpture, an image of Siva, represented as an Ekamukha Linga (Fig. 44), is particularly elegant; the somewhat flat rendering of form and sharply rendered ornament suggest an indebtedness to the school of Sarnath. The similar and slightly earlier image from the nearby site of Khoh is more sombre in mood, and filled with a silent meditative beauty. Sculpture from the ruined temples of Nachana is precious and exquisite, and the workmanship achieves great lyricism and delicacy. The decorative carving of this area, particularly the floral scrolls, is exceptionally good. They are exquisitely and clearly chiselled; the several receding planes are alive with vibrant light and shadow, and the movement often reaches an explosive energy as great bursts of foliage are flung across the surface.

This great renaissance of Indian art in the Gupta period is found in areas to the west as well, and there are some interesting centres of production in the modern state of Rajasthan. The stele from Mandor that shows scenes from the life of Krishna is in a style analogous to that of the early phase as represented, for example, at Udayagiri, Madhya Pradesh, and fragments from the ruined temple at Mukandara (Fig. 45) parallel the mature artistry of the mid fifth century at Mathura. Remains from Nagari, near modern Chittor, correspond to the late fifth-century phase so that, though knowledge of the style in Rajasthan is still sketchy, it is nevertheless possible to postulate an artistic evolution similar to the rest of north India.

In the last three decades or so, considerable evidence has come to light that demonstrates the existence of an extremely important school in Gujarat. The most important sites are located in the region around Samalaji, and extend to the adjacent area of southern Rajasthan. Again, the development parallels the rest of north India, but the local flavour is strong, with an emphasis on heavy, almost ponderous forms. There is also here a concern with emotional expressiveness that strikes an emphatically humane note not found in other sculptures of the period. Most striking are the numerous representations of the Mother God-

desses, and there is real tenderness in the interplay established between child and mother.

Sculpture of the great rock-cut cave temples at Ajanta in Maharashtra is in a style consistent with developments of the Gupta period in northern India, though the region itself was in no way under Gupta political domination. The famous paintings of the site (see pp. 18–25) overshadow the work of the sculptor; nevertheless, here is another splendid idiom, which shares a certain heaviness of form with the Gujarat style, a feature inherited from the monumental nature of earlier work as seen at Karle and Kanheri. The massive modelling is restrained by a balancing, classical vision, and finds its most sublime expression in the colossal image of Siva-Mahesamurti at Elephanta.

In north India, the so-called Gupta style, flourishing throughout the fifth century, begins to decline sometime in the sixth century. The unified vision becomes fragmented, and the figures are thrown out of proportion, and become either too squat, or very elongated. The various parts are still sculpted with skill, but the artist can no longer bring them together with any measure of success. The forms also begin gradually to dry out, and lose that sense of smooth and confident modelling that is characteristic of the typical works of the period.

The first surviving structural temples in stone that are of considerable significance to future architectural developments come from the Gupta period; and this would be an appropriate place to review briefly the previous history of Indian architecture.

The *stupa* (Fig. 47), perhaps the most important of early monumental forms, was architecturally a somewhat simple affair, being essentially a hemispherical piled-up funerary mound of brick or stone, within which was embedded a sacred relic. It was often raised on a terrace and provided with a parasol on the crown of the dome. The *stupa* could also be furnished with railings of varying number, one, for example, enclosing the entire *stupa*, another serving as a parapet on the terrace, and a third around the crowning parasol. (This arrangement is seen at Stupa I at Sanchi.) These railings were originally of wood,

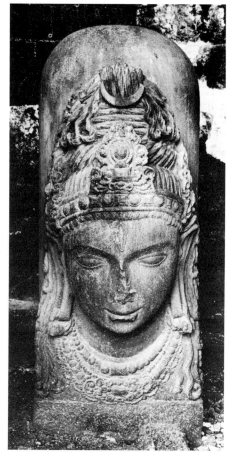

Fig. 44 Linga with Siva image from the Saiva temple, Bhumara, Madhya Pradesh. Gupta, late fifth century

Fig. 46 East doorway of the Vishnu temple at Deogarh, Uttar Pradesh. Gupta, late fifth century

Fig. 45 Candrasala with drummer from Mukandara, Rajasthan. Gupta, mid-fifth century. Kota Museum

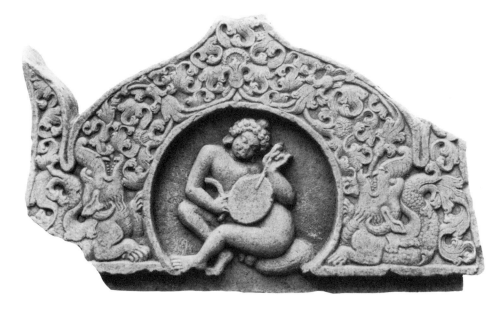

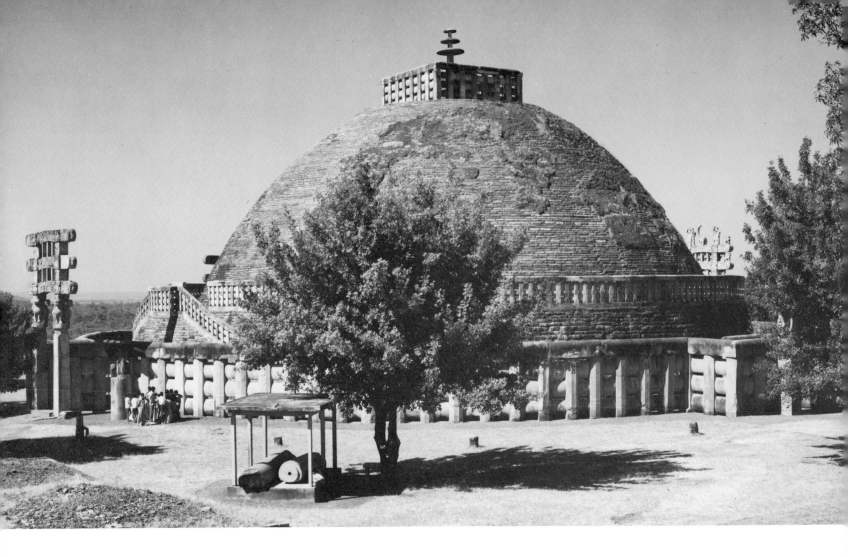

Fig. 47 Stupa I, Sanchi, Madhya Pradesh.
First century BC

for those that survive, even though of stone, are fitted together with mortice and tenon in a technique natural and appropriate to a carpenter rather than a stone mason. The construction is simple, consisting of uprights generally connected to each other with three rows of crossbars and secured at the top by a heavy coping. The railing could be quite plain as at Sanchi Stupa I or heavily decorated as at Bharhut, where the uprights usually have a circular medallion in the centre and lunates at the top and bottom, all filled with decorative or figural sculpture. With the passage of time, particularly in the early centuries AD and later, the body of the *stupa* also begins to be decorated with sculpture, and the number of terraces and parasols are multiplied, so much so that at times the monument takes on the aspect of a tower.

Stupas were also frequently provided with gateways, and these could also be heavily decorated with sculpture. They too are of wooden origin, and consist of square posts supporting a single or multiple architraves. The most famous example of these are at Sanchi. Gates of this general type were in use to at least the fifth century AD in north India. The later arched entrances to temples (very few of which survive) represent a continuation of this tradition.

Ancient India also possessed a great tradition of wooden architecture of which nothing has survived. Some idea of its nature can be gathered from pictorial representations found in early relief sculpture and from imitations excavated in the rock, of which the earliest are the caves of the Barabar Hills near Bodhgaya in Bihar (third century BC). These generally consist of two chambers, one of them

42

an elliptical or circular shrine with a domical roof, the other a hall covered by a barrel vault. The Lomas Rishi cave has a most interesting facade, which demonstrates that the pillars of the interior were raked. This is an architectural feature in clear imitation of wood. The most interesting examples of early Indian architecture, however, are the great series of caves carved into the Western Ghats and associated ranges, which stretch from southern Gujarat right through the modern state of Maharashtra. Two main types can be discerned, both much more elaborate than what has been found in the Barabar Hills. There is the temple proper, housing a representation of the divinity to be worshipped; it is very often apsidal in plan, the apse covered by a half dome, the hall in front by a barrel-vault roof, both supported by an elaborate system of beams and joists, imitating wooden construction, and sometimes vestigially of wood, as at Bhaja (Fig. 48). In the apsidal end is placed the sacred object, most often a *stupa*, while the hall shelters the congregation. At the front end of the hall is an entrance door or doors surmounted by an arched window of considerable size, and its profile coincides with the barrel vault roof of the hall. The monastery is a relatively simple affair, more or less square in plan with cells along the three inner walls and an entrance porch in front.

These rock excavations testify to the flourishing condition of wood architecture, of which they are in a sense 'petrified' examples. The Bhaja cave temple, with its raked columns is certainly the earliest (*c.* mid second century BC), while the outstanding example is the grand cave temple at Karle (*c.* late first century BC), the proud donors of which hailed it, in an inscription, as the most magnificent temple in India. Fine examples are also to be found at Kondane, Bedsa, Pitalkhora, and other sites.

Ajanta, with its numerous excavated temples and monasteries of about the fifth century, represents the high point of this development, which was

Fig. 48 Facade of the Buddhist cave monastery at Bhaja, Maharashtra. Second century BC

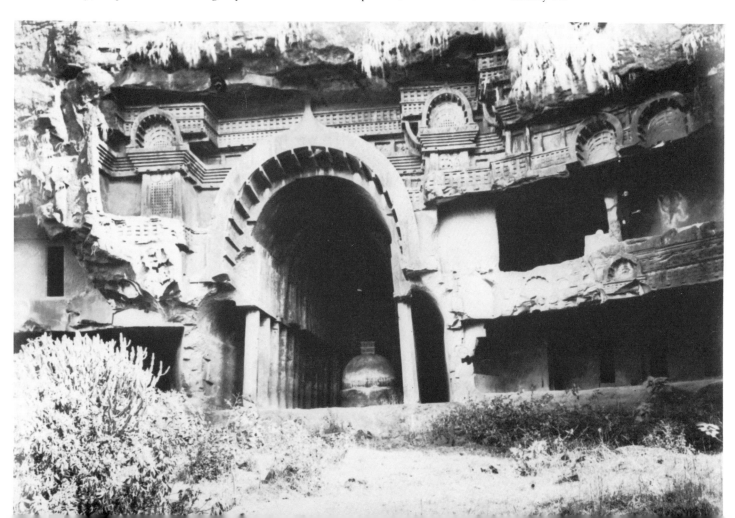

continued to some extent in the following centuries at Ellora. This tradition, deeply rooted in wooden architecture was, however, beginning to peter out, and the future belonged to a new tradition of structural architecture.

From around the opening years of the fifth century, or a little earlier, there are in north India small shrines built entirely of stone; they consist of a square sanctum, which holds an image; the only opening is a door, and often there is a small pillared porch in front. One type is thought by some to have possessed little more than a flat roof as, for example, Temple no. 17 at Sanchi; the other type is characterized by a somewhat pyramidal superstructure called a *sikhara*, a distinguishing feature of later Indian temples. The origin of the *sikhara* has been a subject of much speculation, but it can now be shown that these tower-like

Fig. 49 Brick temple at Bhitargaon, Uttar Pradesh. Gupta, fifth century

Fig. 50 Muktesvara temple at
Bhubaneswar, Orissa. Tenth century

superstructures are really condensed representations of the various storeys of a
building. A characteristic decorative element consists of courses of more or less
ornamentalized arched windows. This is a theme derived ultimately from the
arched openings above the doorways of early architecture. In later periods,
these motifs are so intricately interlaced as to form an almost abstract tracery
pattern reminiscent of a net of vines and creepers sheathing the temple spire like
the vines that lace and lash the poles of a bamboo hut built to shelter the family
hearth or the sacrificial fire. The brick temple at Bhitargaon (Fig. 49) in Uttar
Pradesh is a particularly instructive example, and with its large decorative
arched windows shows an early stage of this development. The sculptural
decoration of these temples is rather sparing; the richest portion is often the door
to the sanctum, though the walls too at times carry a small complement of
sculpture.

The fifth to the eighth centuries seem to have been, architecturally speaking, a
period of considerable experimentation with various types of temples, and it
was only about the ninth century that settled styles began to emerge in north
India. These can be most conveniently classified according to the nature of the
form of their *sikharas*, the basic and the most important type being the Latina
(provided with *lata*, creeper) of the architectural texts (Fig. 50). This is curvilinear
in outline and consists of a series of densely piled horizontal slabs covered with
the interlaced arch ornaments, which have already been described. The surface

is subjected to projections that are carried through the walls and the socle, and the edges of the *sikhara* are interrupted at regular intervals by grooved discs, each one of which is understood to demarcate a single storey. The *sikhara* is truncated at the top, above which is a circular necking supporting a large grooved disc on which rests a pot and a crowning finial.

The entire temple, by a series of general and specific allusions, is to be understood as an image of the macrocosm, the immanent and transcendent body of God, and not merely a house of God. As such, it carries the same meaning as the enshrined image and is equally holy and worthy of worship.

The Sikhari superstructure (Fig. 51), an elaboration of the Latina type, has a central *sikhara* around which are clustered half-spires with one or more rows of miniature spires at the base. Quarter *sikharas* are also to be found in the more complex constructions, so that there is often a soaring, dazzling movement in the image of a great mountain peak buttressed by a series of smaller ones. This form appears to have developed around the tenth century and became very popular throughout north India, except for Orissa, where the Latina spire was always used with hardly an exception.

A variant of the Latina is the Bhumija *sikhara*, which has a central projection on each of the four faces covered with the interlacing arch motif, the space between being filled with vertically and horizontally aligned rows of miniature Latina *sikharas*. This form was particularly popular in the Malwa region of Madhya Pradesh and in Maharashtra.

The walls of the temple are subjected, as has just been noted, to the same projections as the *sikhara*, and each of these projections carries its own complement of sculpture. The walls are also at times horizontally divided into two and sometimes three registers, each one of them again decorated with sculpture so that the total effect is one of overpowering richness — in marked contrast to the relative simplicity of earlier architecture. The base of the temple, too, with the multiple mouldings of the plinth and the socle, contributes to the vibrant texture of the whole building.

Temples of this period, on plan, most often have a square sanctum with or without a circumambulatory path. Facing the entrance of the sanctum are one or more halls, aligned with it on an horizontal axis. The *sikharas* of these halls are of the Phamsana or Samvarna types. The former is a comparatively simple form, and consists of horizontally piled tiers forming a rectilinear pyramid rather sparsely adorned with arch motifs, the top capped by a bell-shaped member. The Samvarna is a more elaborate version of the Phamsana, just as the Sikhari is a more elaborate version of the Latina. A striking feature of the decoration are the multiple miniatures of the bell-shaped member at the top.

A few north Indian temples have rectangular plans with barrel-vault roofs, the last vestiges of the traditionally wooden architecture preserved so faithfully in the cave temples of an earlier time. The two most famous are the Teli-ka-mandir (ninth century) at Gwalior, Madhya Pradesh, and the Vaital Deul (eighth century) at Bhubaneswar, Orissa; and though these are superb works, they did little to inspire a northern revival of a dying manner.

Much along the lines of the schools of sculpture, a variety of distinct regional idioms were developed, but knowledge of these is still not complete and perhaps much will remain unknown because of large scale destruction, particularly in what is now modern Uttar Pradesh, Bihar, and Bengal. The schools of Orissa, parts of Central India, Rajasthan, Gujarat, and Kashmir, however, are

Opposite: Fig. 51 Kandariya Mahadeva temple at Khajuraho, Madhya Pradesh. Mid eleventh century

fairly well documented and studied. One of the richest is the stately style of Orissa, with its uncluttered broad-shouldered *sikharas* of great dignity and strength. The greatest centre is the city of Bhubaneswar, where the Parasuramesvara temple was one of the earliest (*c.* seventh century). By the time the Muktesvara temple (tenth century; Fig. 50) was built, the initial awkwardnesses had been overcome and there is here an edifice of perfect proportions, the various parts being combined in a harmonious whole. The immense Lingaraja temple (eleventh century), with its exquisitely carved surfaces, is the grandest of the Bhubaneswara shrines, but it is overshadowed, at least in size, by the famous temple of the Sun God at Konarak (1238–64). This ambitious structure was conceived in the form of a great wheeled chariot drawn by horses. The *sikhara* over the sanctum, which must have been the largest of its kind, has entirely collapsed; but the great hall with its gigantic pyramidal spire raised in three storeys is imposing enough by itself. There was also a separate dancing hall and other subsidiary shrines within the sacred enclosure, the whole complex constituting what must have been one of the largest sanctuaries in all of northern India.

It can be demonstrated that several architectural styles flourished in some of the geographical and cultural units of ancient India encompassed by the modern state of Madhya Pradesh. A particularly graceful idiom is to be found in the environs of Gwalior, the great period of productivity being the ninth and tenth centuries. In addition to the Teli-ka-mandir at Gwalior mentioned earlier, it is worth taking note of the interesting Malade temple at Gyaraspur, its Sikhari spire still in a formative stage, and of a superbly carved temple with a unique twin spire at Barwa Sagar; both temples are datable to approximately the ninth century. The stone masonry work is excellent, and the architectural ornament boldly and crisply rendered. This phase, characterized by a variety of what appear to be experimental architectural designs, is followed by a period of consolidation in the tenth and eleventh centuries when greater regularity, uniformity, and elaboration are achieved. Outstanding examples are the Kakanmadh at Suhania (1015–35) and the several shrines at the important centres of Surwaya and Kadwaha.

The city of Khajuraho has the finest examples of the style of ancient Jejakabhukti (modern Bundelkhand). Temples at this site are characterized by *sikharas* of elongated proportions and by extremely rich sculptural decoration. Of the several surviving examples, the pleasing Laksmana temple (*c.* 941) has the most clear and coherent design. The Kandariya Mahadeva (eleventh century; Fig. 51), largest of the Khajuraho temples, has a very elaborate superstructure of the Sikhari type, the urgent architectural ascent accentuated by coalescing the successively larger spires of the three halls into the principal *sikhara* above the sanctum. Neighbouring Dahala, with Tripuri near modern Jabalpur as its capital, also possessed a noble architectural idiom of considerable variety and elegance, though only a few temples remain intact. Gurgi, near modern Rewa, must have been a great centre, but is now rather thoroughly demolished. The Siva temple at Candrehe (tenth century), with an unusual circular sanctum, and the Gola Math at Maihar (tenth century), with a superb *sikhara* of the Latina type, provide some idea of the achievements of this style.

A special contribution of the Malwa region are temples with a Bhumija *sikhara*, of which the Siddhesvara temple at Nemawar (twelfth century) is the largest, but nevertheless somewhat awkward. The wonderful Udayesvara temple at

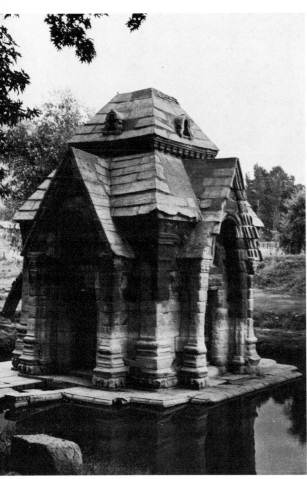

Fig. 52 Rilhanasvara temple at Pandrethan, Kashmir. *c.* twelfth century

Udaipur, Madhya Pradesh (1059–82), on the other hand, is an unblemished masterpiece of the Bhumija tradition, superbly planned and richly executed. Bhumija *sikharas* are also to be found in Rajasthan and Gujarat; one particular variety with some southern features became extremely popular in Maharashtra. An especially fine example is the Ambaranath temple near Bombay (*c*. 1060).

Recent researches have demonstrated the existence of two vigorous styles in the area covered by the states of Rajasthan and Gujarat. The opening phase of one of these, the architectural forms of which are very plastically conceived, is confined largely to northern and western Rajasthan, and is represented by a group of small but interesting temples at Osia dating to about the eighth century. The work reaches full maturity by the tenth century in the deep carving and logical forms of the Nilakanthesvara temple at Kekind. The group of temples at Kiradu, Rajasthan, mostly of the eleventh century, represent the style at its most ornate, the architectural parts, particularly the *sikhara*, being rather mechanically conceived.

Gujarat also possessed a flourishing style of considerable individuality, characterized by rigorously architectonic forms. The group of small temples at Roda (*c*. eighth century) represents an auspicious beginning remarkable for its confidence and assurance. The chaste ruins of the Sun temple at Varman (early tenth century) and the Ambika Mata temple at Jagat (961; Fig. 54), both actually situated in southern Rajasthan in which direction the Gujarat style extended, are works of high quality, remarkable for the considered and careful treatment of the parts. The damaged Sun temple at Modhera (early eleventh century) is much more elaborate, but the workmanship continues to display a certain restraint and elegance. The ruins of the Rudramahalaya at Siddhpur indicate the nature of the grand undertakings attempted in the twelfth century; while the costly marble Jaina temples at Mt Abu, the Vimala Vasahi (1031) and the Luna Vasahi (1230), have the most lavishly carved interiors. Gujarat and Rajasthan continued to produce great buildings even after the Islamic conquests of the twelfth and thirteenth centuries, when architectural activity slowed down considerably over all of north India. Some of these late temples, notably the Chaumukha temple at Ranakpur (1438), compete in size and elaborateness with the most ambitious undertakings of earlier periods.

A word may be said here of the unique style of Kashmir, confined largely to that province and its Himalayan neighbourhood. The *sikhara* is of the Phamsana kind, but close to functional wooden prototypes, consisting of two tiers of large sloping eaves. The great temples at Martand (mid eighth century) and Avantipur (mid ninth century), though now in ruins, must have been monumental achievements. Some idea of their original appearance is to be gained from the smaller but better preserved examples like the Rilhanesvara at Pandrethan near Srinagar (Fig. 52).

The need to decorate lavishly the great number of stone temples built in what is commonly called the medieval period (*c*. seventh–twelfth centuries) led to a tremendous increase in the quantity of sculptural production. The output far surpassed that of the previous centuries. As is inevitable in these circumstances, much of the work is little better than competent workshop production. The figural sculpture, for the most part, is to be regarded more correctly as a form of architectural decoration, which provided at best accents in the total decorative scheme, rather than as independent and individual works of art, carefully crafted and finished.

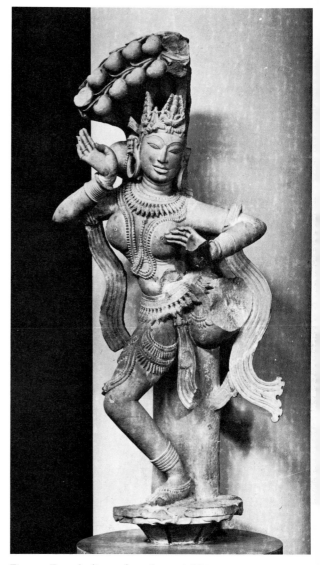

Fig. 53 Female figure from Jamsot, Uttar Pradesh. Twelfth century. Allahabad Museum

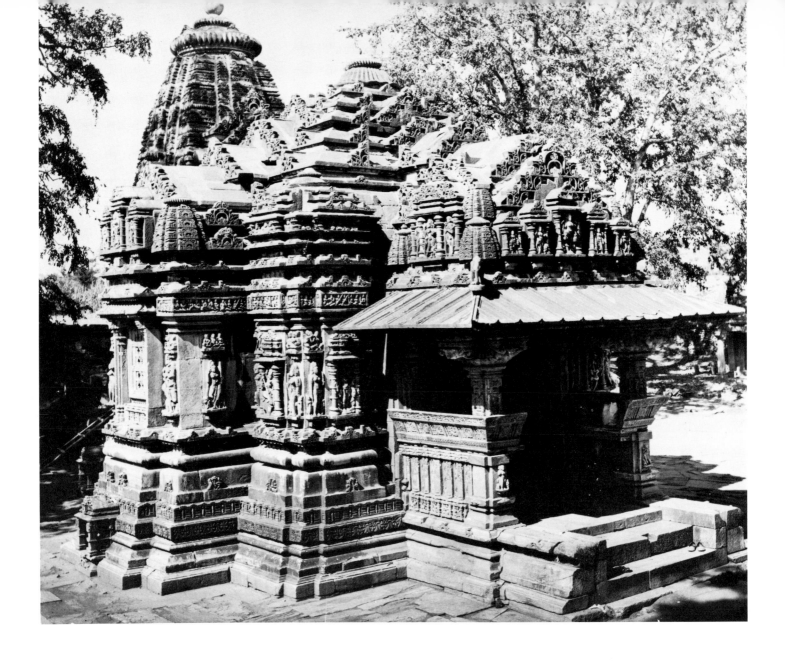

Fig. 54 Ambika Mata temple at Jagat, Rajasthan. Dated 961

It has already been described how with the end of the Gupta period a disintegration of its idioms begins to set in; but the course of this decline is difficult to chart. It seems, however, that the forms, which had become inert and ponderous, begin to waken to a fresh life around the early years of the eighth century; they culminated towards the late eighth and early ninth century in a new kind of style characterized by elaborate decorativeness, pronouncedly swaying rhythms, and a conception of form that retains at least some of the plasticity of earlier work, while it avoids the unyielding hardness and harsh angularity of later sculpture. Amid outstanding examples, is the fine sculpture from the ruined temple at Abaneri, Rajasthan. The style becomes more firmly fixed in the latter half of the ninth century when it achieves stability and full maturity, and centres of production were found all over north India. Representative works are the superb Mother Goddess images from Vadval, Gujarat, a group of distinguished sculptures from the capital city of Kanauj, Uttar Pradesh, and some magnificent works from the ancient Dahala territory in eastern Madhya Pradesh.

The next phase of medieval sculpture is marked by increasing conventionalization, which ended ultimately in an extremely angular and congealed form, and the great mass of work produced was dull and repetitive. The sculpture of the tenth century, however, still retains some sense of plasticity, though the surfaces are more tense, the contours more rigid. By the eleventh century, a great deal of the work gives the appearance of being done according to mechanical formula. The forms are entirely frozen and devoid of plasticity, and the images smothered by vast amounts of dull beaded jewellery. The execution, for the most part, is perfunctory, reminiscent of the work from Mathura towards the end of the Kusana period, though certainly some pieces of exceptional quality in the context of the style were also produced, impressive for the obsessive consistency of their hard and linear forms (Fig. 53).

Differences between one regional style and another are not as clear in the medieval period as they were earlier. Not that the differences are absent; the work of the Dahala area in Madhya Pradesh, for example, is always easier and more relaxed than the tight modelling of sculpture from Khajuraho nearby to the north. It must, nevertheless, be admitted that distinctions are often not very obvious, even though they are surely, if subtly, present.

Within this broad framework of more or less uniform idioms, the eastern Indian school that flourished in modern Bihar and Bengal has a clearer personality than most. It is not as flat and angular, and the earlier traditions of a more weighty form are clearly discerned in all its works. This feature is also characteristic of the school of Orissa, sculpture as late as the thirteenth century from Konarak, for example, retaining a certain breadth that had quite disappeared from the work of Central India and Gujarat a century earlier. The Kashmir style also tends to emphasize mass; the torso is rendered with a vague memory of muscular structure, the drapery with some concern for the texture of the cloth. Both of these features are distant survivals of the style of Gandhara.

Judging from literary references, there must have existed in India a long tradition of metal sculpture using the lost wax process. Bronze seems to have been the most popular, but relatively little has survived, either because the objects, being relatively small and precious, were secreted away in times of danger and await discovery, or that old images in disuse were melted down to make new ones. Only a scattering of images dated before the fifth century remain; and while none of those that are known are of any great quality, they do at least confirm the existence of a tradition of metal sculpture. From the fifth century onwards, however, an increasing number of works of some importance have been discovered. The life-size image of the Buddha from Sultanganj in Bihar (c. sixth century) is not only a work of surpassing beauty, but a unique technical achievement for its time. Closely allied in style to the Sarnath school, it shares with it the sense of a warm and luminous spirituality. In the following centuries, a very important Eastern Indian school of metal sculpture, paralleling the style of stone sculpture, developed in Bihar and Bengal. It is copiously documented by significant discoveries from all over the region, notably Nalanda, Kurkihar, Rangpur, and Jhewari as well as numerous stray finds. Beginning sometime in the eighth century, the school comes into full flower in the ninth century with a series of masterpieces found at Kurkihar (Figs. 55 & 56). The forms have a marked sensuous presence, differing from the somewhat drier treatment observed later. The magnificent and elaborately decorative images from Rangpur represent the great achievements of the eleventh century; and

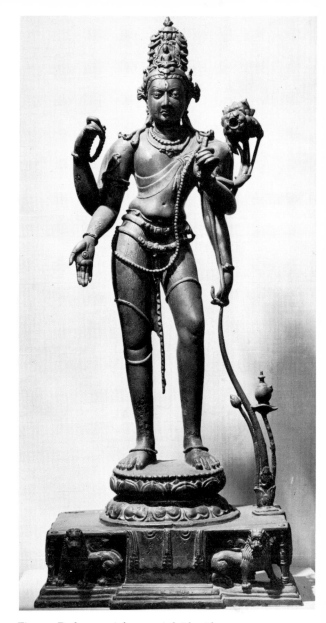

Fig. 55 Padmapani, bronze inlaid with silver, from Kurkihar, Bihar. Ninth century. Patna Museum

Fig. 56 Seated Avalokitesvara, gilt bronze, from Kurkihar, Bihar. Twelfth century. Patna Museum

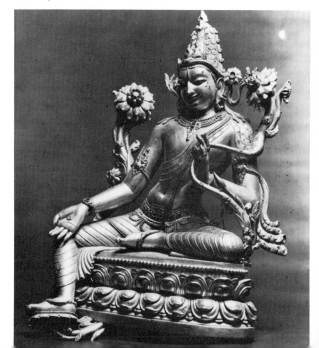

Fig. 57 Jivantasvami, bronze, from Akota, Gujarat. Sixth century. Baroda Museum and Picture Gallery

Fig. 58 Cauri-bearer, bronze, from Akota, Gujarat. Ninth century. Baroda Museum and Art Gallery

even works of the twelfth century are remarkable for virtuoso craftmanship and a sharp elegance (Fig. 56). A variant of the Eastern Indian school is to be seen in a group of images recovered from Sirpur, Madhya Pradesh. These are characterized by a most painstaking and elaborate execution, recalling the craft of a jeweller; the great image of Tara with attendants (c. early ninth century) is the most splendid example known.

A very large number of brass and bronze images from Gujarat and Rajasthan, mostly of the twelfth century and later, have been known for a long time, which suggests that this area must also have been a flourishing centre of metal sculpture. The discovery of a hoard of bronze images from Akota near Baroda takes the history of the style back to about the sixth century. Works of great beauty, notably the superb image of Jivantasvami (sixth century; Fig. 57) and the lovely cauri-bearer (c. ninth century; Fig. 58) mark the high points of the style, though it may be admitted that many of the sculptures of this hoard are awkward and lugubrious, quite at variance with the superb sculpture in stone. Further discoveries may clarify this somewhat puzzling situation.

It would be reasonable to presume that bronze sculpture was also produced in other parts of north India with strong artistic traditions, and occasional finds do tend to confirm this view. The materials discovered, however, are far too fragmentary to make any serious study possible. The case is otherwise with Kashmir, numerous recent discoveries revealing a vigorous and influential school of metal sculpture. The work, once again, parallels that in stone, and being on the whole much better preserved, actually gives us a truer idea of the sculptural achievements of Kashmir. Among outstanding examples it is necessary to mention the tremendous bronze image frame from Devsar (c. tenth century); the representations of the various incarnations of Vishnu are filled with an unbounded energy seldom to be seen in other north Indian styles. The seated Buddha with worshippers (c. eighth century; Fig. 1) in the Norton Simon Foundation collection shows the Kashmir style in another mood, the expression calm and collected. The forms are full and alive, the execution of detail exquisite. The sensitive perception of the identity of the sensuous and the spiritual seen here is also to be witnessed in the standing Buddha of the Cleveland Museum of Art (ninth century), another masterpiece of this great school whose achievements have only come to light in recent years.

ASCHWIN DE LIPPE

The Sculpture and Architecture of Southern India

The geographical boundary of South India is formed by the Narmada river, which flows into the Arabian Sea, and by the Vindhya range with its forbidding forests; further east, the Mahanadi river carries this border to the Bay of Bengal.

The political division between North and South India followed roughly along the same lines; so did the stylistic division in the realm of architecture and sculpture. The two exceptions are Maharashtra in the north-west and Orissa in the north-east of geographical South India, both of which had been infiltrated by the Aryans already before 600 BC.

The Gudimallam linga (Fig. 59) may serve to herald this chapter on South Indian art. This unusual sculpture can perhaps be dated to the second or first century, BC; it occupies the crypt-like sanctum of a remote apsidal Chola temple of the eleventh century near Renigunta in the north of Tamilnad (N. Arcot district). A stone linga of this period would be unique in South India, but comparable configurations, with a god standing on a demonic yaksha, occur at Bharhut of the Sunga dynasty (second century BC). The buck in Siva's hand reminds us of Siva as Pasupata, Lord of the Beasts. His features recall the god's non Aryan origin, as well as his ambivalent character. The conquests of the great Maurya emperor Asoka (second century BC), patron of Buddhism, had not reached beyond the northern border of the Mysore plateau. However, Hinduism as well as the Protestant cults of Buddhism and Jainism infiltrated the land south of the Vindhya forests. The worship of trees – still alive today – and of nature spirits was overlaid by the great religions, which stimulated the development of rock-cut as well as structural architecture. The excavations of Asoka in the north (Bihar) soon were echoed by those in the Deccan and Western India such as Bhaja and Karle. Buddhism flourished in the Krishna river valley (Amaravati, Nagarjunakonda), under the patronage of the royal ladies of the Later Andhra and Ikshvaku dynasties. The lovely marble reliefs of the Amaravati style are the fountainhead of South Indian sculpture.

The *stupa*,[1] for the Buddhists and Jainas a relic-mound containing some ashes of one of the great teachers, probably had very ancient religious connotations. Its site was often associated with a megalithic monument. It now became,

[1]See pp. 41–3

Fig. 59 Linga at Gudimallam, Tamilnad. Second–first century BC

especially in Buddhism, the monument *par excellence*. Worship was performed by circumambulation.

The Krishna valley *stupa* was built of plastered brick; at a later period encased by a series of sculptured marble slabs, and encompassed by a sculptured balustrade and railing (Fig. 60). A Hindu temple complex excavated at Nagarjunakonda was built of brick and timber, like the corresponding Buddhist chapels (*chaityas*) and monasteries (*viharas*). A temple dedicated to the eight-armed Vishnu (Ashtabhujasvamin) is dated 278 by the inscription on the stone pedestal, which also mentions that the icon was of wood. The temple had two cellas, one oblong and one apsidal, each with a pillared hall (*mandapa*) in front.

The reliefs of the Amaravati school are remarkable for their dense and complicated composition. The precise and deep cutting technique is ultimately derived from ivory carving. Some figures are shown in profile or semi-profile, others turn their back to us – heightening the illusion of depth. The competent use of overlapping figures and foreshortened forms, the enlarged repertory of facial and bodily movements do not necessarily justify the suspicion of Roman influence. The languorous attenuated beauty of the figures, the music of softly moving contours make the Amaravati reliefs in the words of Coomaraswamy, 'the most voluptuous and the most delicate flower of Indian sculpture'.

The Andhras did, however, trade with Rome as well as with Indonesia, Burma and China, and their art profoundly influenced that of Ceylon. The

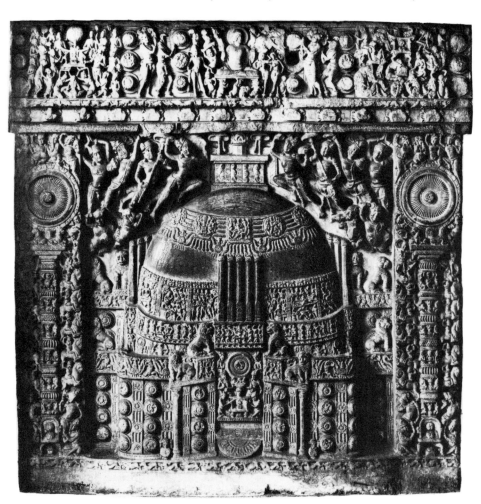

Fig. 60 'Stupa', on a facing slab from the Great Stupa, Amaravati, Andra Pradesh. Later Andhra period, AD late second century. Madras Government Museum

54

sculpture of South India still shows its Andhra ancestry, after several hundred years, at Mamallapuram (Varaha and Ranganatha panels).

The Vakataka kingdom was brought down by a revolt of its feudatories. The new dominant power in Central and West India probably was the Kalachuri dynasty.

The beautiful Ramesvara cave-temple no. 21 at Ellora was probably created by the Kalachuris. It can perhaps be dated to the second half of the sixth century. Siva as Lord of the Dance (Natesa) is surrounded by gods, celestials and musicians (Fig. 61). The relief displays a musical grace and elegance which make it one of the most beautiful realizations of this motif. The Seven Mothers (Saptamatrika), sung by Malraux, are represented as lovely young women, fondling their children, and accompanied by their cognizances; their ambivalent nature is nowhere in evidence. Although much mutilated, the group is among the most beautiful in the whole of India. We might point out that the sanctum – like the stupa in a Buddhist cave-temple – is surrounded by an ambulatory (*pradakshina*). The façade of the Ramesvara with its lovely bracket-nymphs seems to herald Badami no. 3 (see below).

Savagely mutilated by Portuguese iconoclasts, the cave-temple no. 1 on Elephanta island (near Bombay) still is one of the greatest creations of Indian sculpture. The monumental Mahesamurti – Siva as the Supreme Lord – looms at the back of the dimly lit cave (Fig. 63). The serene and powerful central face is

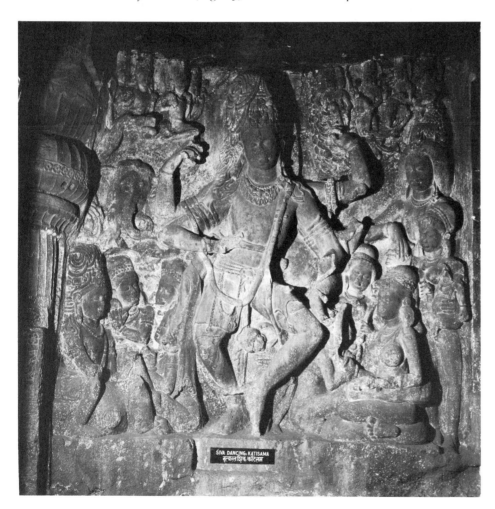

Fig. 61 Dancing Siva (Natesa), Cave 21 (Ramesvara), Ellora, Maharashtra. Late sixth century

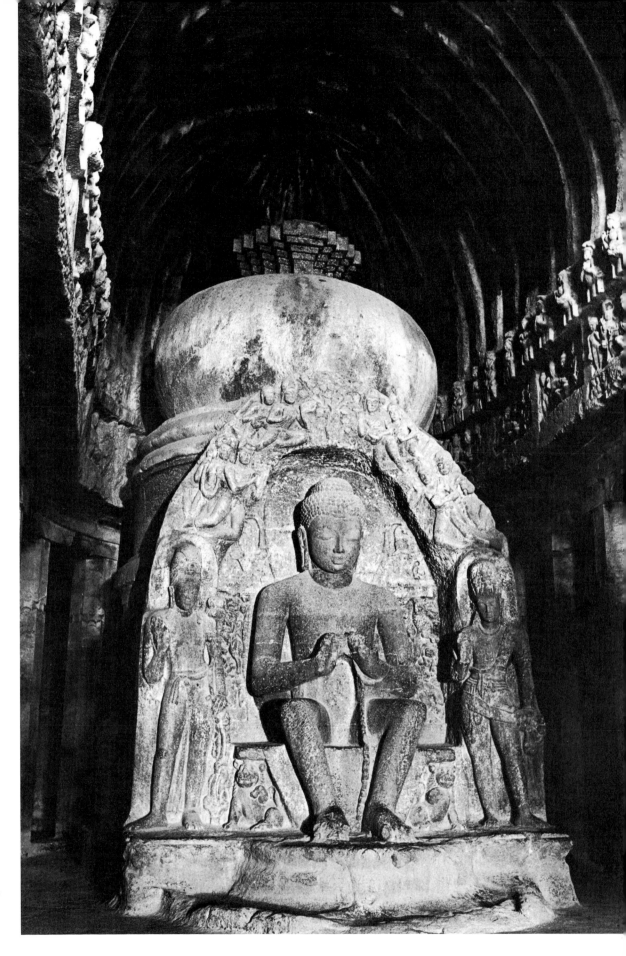

Fig. 62 Buddha and two
Bodhisattvas on a Stupa,
Cave 10, Ellora,
Maharashtra. Chalukya,
c. 620–50

flanked by the wrathful profile of Siva as the Destroyer (Bhairava), and by the beautiful and sensuous one of the feminine aspect of creation (Vamadeva).

The Elephanta cave has been dated as early as 540–55, attributed to the Kalachuris, and as late as eighth–ninth century. Other scholars associate it with the Mauryas of the Konkan and the years between 600 and 634 or 650. Between 610 and 634 the Mauryas were defeated by the Chalukya king Pulakesin II in a great naval battle which probably took place off Elephanta island (Puri). The Kalachuris were defeated by the Chalukyas about 601; in 630, the latter's rule in the Maharashtra was well established, and lasted until about 740.

I prefer an approximate date of early seventh century. The pillars of Badami no. 1 (c. 625) show the influence of Elephanta. On the other hand, the cave-temple Ellora no. 10, a *chaitya*-hall with a *stupa*, which is the finest of the later Buddhist excavations, was created under the suzerainty or patronage of the Chalukyas; we date it to about 620–50 (Fig. 62).

Fig. 63 Siva as the Supreme Lord, Cave 1, Elephanta, Maharashtra. Early seventh century

The interior still imitates wood architecture. The ribs of the arched nave-ceiling are supported by *nagas* and *naginis*, above groups of Buddhas and bodhisattvas, over a *gana* frieze. The *stupa*, originally the principal and aniconic object of worship, has become the background for a monumental relief sculpture. Under an arch carved with the bodhi-tree and garland-bearing celestials, the Buddha is seated in 'European fashion' in the attitude of teaching; he is flanked by Avalokitesvara and Maitreya or Vajrapani. The round façade window is placed in such a way that the rays of the setting sun light up, for a few fleeting moments, the serene face of the Buddha.

Cave-temple no. 7 at Aurangabad, a *vihara*-cum-*chaitya*, also was excavated under the Chalukyas; we date it to the early seventh century. In the obscure ambulatory, next to the sanctum entrance, two very large relief panels show Taras (female Bodhisattvas) and dancers. An even more unusual relief of smaller scale is placed right inside the sanctum, next to the Buddha. A young woman of great beauty, absorbed in her dance, moves gracefully to the tune of a female orchestra (Fig. 64). The musicians are grouped and recessed in a subtle and artful composition which emphasizes the role of the lovely dancer.

We note the appearance of tantric imagery.

At Ellora, the next phase of activity was sponsored by the Rashtrakutas, former feudatories of the Chalukyas in the northern Deccan, who made themselves independent about the middle of the eighth century.

The monolithic Kailasanatha (Ellora no. 16) is the most extraordinary example of 'sculptured architecture' in existence (Fig. 65). The legend says that when it was finished, the gods on their mounts and vehicles descended from the heavens in order to admire it. This largest and greatest monolithic temple complex was cut from the rocky hillside by Krishna I (756–75) but some of the lateral chapels may be a hundred years later. 'Architecturally' it is a 'southern' type of temple, carrying a *Dravida* 'superstructure' with an octagonal dome (*sikhara*), but with a 'northern' gable projection. It is said to have been inspired

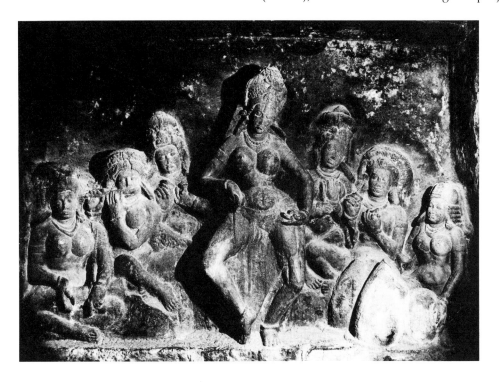

Left: Fig. 64 Dancer and Musicians, Cave 7, Aurangabad, Maharashtra. Chalukya, early seventh century

Opposite: Fig. 65 Rock-cut Temple 16 (Kailasanatha), Ellora, Maharashtra. 756–75

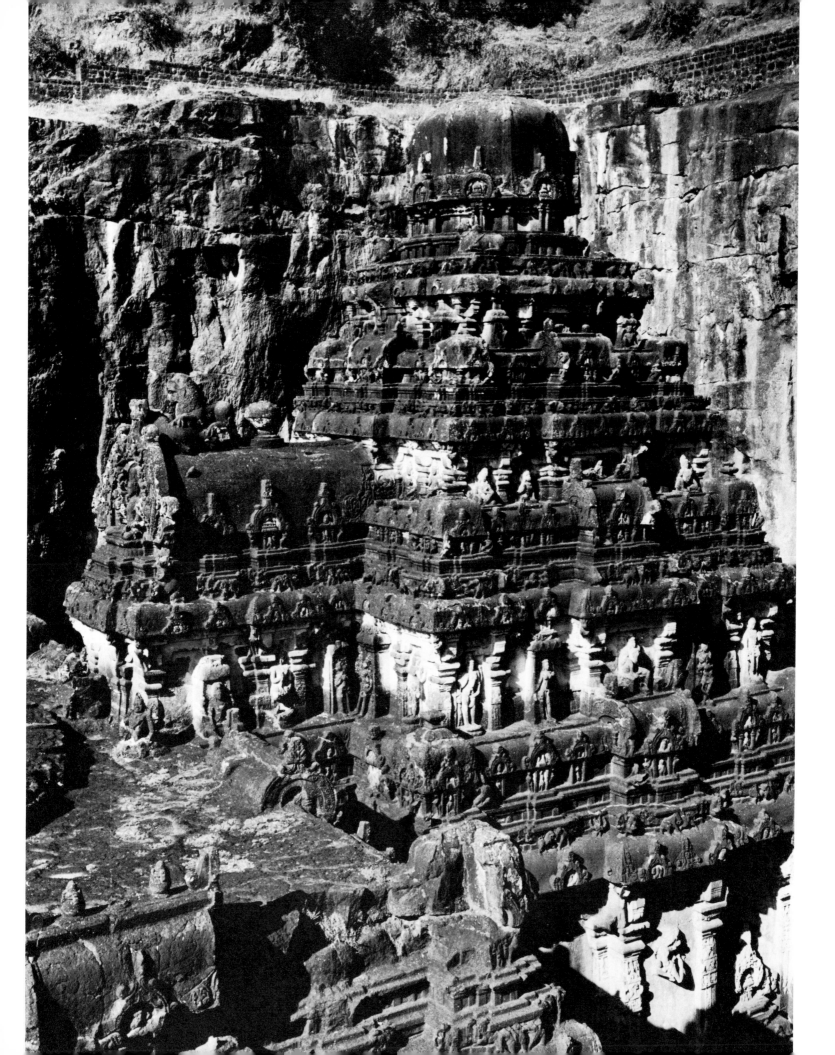

by the Virupaksha temple at Pattadakal (Chalukya), which in turn was modelled on the Kailasanatha at Kanchi (Pallava); it furnished the inspiration for the Vettuvankovil at Kalugumalai (late eighth century), way down south in the Pandya country (see below).

At the beginning of the Hindu renaissance (about 500), the three dominating powers in South India were the Chalukyas of Badami, the Pallavas of Kanchi, and the Pandyas of Madurai.

The Chalukyas were a family of the southern Deccan (Karnataka); they spoke a Dravidian language. They were of the Vaishnava persuasion; the boar, avatar of Vishnu (Varaha), was their crest. About 620 they defeated Harsha of Kanauj when he crossed the Narmada river into the south. Soon their kingdom stretched from the Arabian Sea to the Bay of Bengal. They were brought down, about the mid eighth century, by their former feudatories, the Rashtrakutas, who inherited the Deccan empire.

The Pallavas of Kanchi were the constant rivals of the Chalukyas in the contest for supremacy in the south of India. With the help of their navy, they asserted their influence in Ceylon (Sri Lanka), while in the south they battled with the Pandyas. The Chalukya wars had varying fortunes. In 642, the Pallava king Mamalla conquered and sacked Badami; the Chalukya king Pulakesin II was killed in battle. The Chalukyas repeatedly took Kanchi, the Pallava capital. The Pallava empire was finally liquidated by the Cholas.

The Pandyas of Madurai were the third of the great dynasties of South India that carried the Hindu renaissance. They repeatedly invaded Ceylon. Their main rivals were the Pallavas, their main allies the Chalukyas whose influence is ubiquitous in their architecture and sculpture.

The Chalukyas created the famous cave-temples of Badami and Aihole, of which the earliest, Badami cave 3, is dated 578. Caves 3 and 2 are dedicated to Vishnu, cave 1 and one of the Aihole caves to Siva, the other Aihole cave and Badami 4 to the Jaina cult.

The two Vaishnava caves have a rock-cut pedestal (*pitha*) in the sanctum, the Saiva caves a rock-cut linga on a square pedestal with spout (north). In Badami, a circular pit is carved out for the ablution water; at Aihole an additional gutter channels the overflow through the vestibule into the hall. Both features are found a little later, in the Pandya cave-temples of the South.

Badami 3 is distinguished by the famous bracket figures of the façade, derived from wooden prototypes. Most of them represent amorous couples (*mithuna*) – gods and goddesses, *nagas* and *naginis*, *yakshas* and *yakshis* (Fig. 66). In the somewhat later structural temples as at Aihole the *mithunas* have descended from their brackets and occupy one or more faces of the pillars and pilasters of the porch or hall. The distant descendants of the Badami 3 *mithunas* are the voluptuous bracket figures of the Late Chalukya and Hoysala temples (eleventh-twelfth century).

The large relief panels of Badami 3 all represent forms of Vishnu which are identified with the glorified and victorious king. Except for two, however, they may be somewhat later additions or replacements. Varaha, the boar-incarnation of Vishnu, was close to the heart of the early Chalukya kings who had chosen the boar as their crest. The royal dedicatory inscription is placed next to this panel.

Verandah and hall ceilings of cave 3 are decorated with reliefs – formerly painted – of the gods in their respective heavens, surrounded by the Regents of

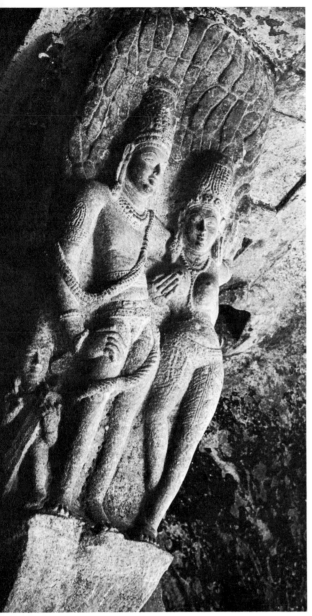

Fig. 66 Bracket Couple (Mithuna), Cave 3, Badami, Mysore. Chalukya, 578

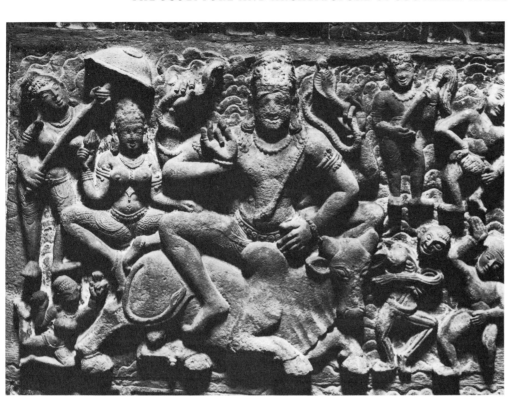

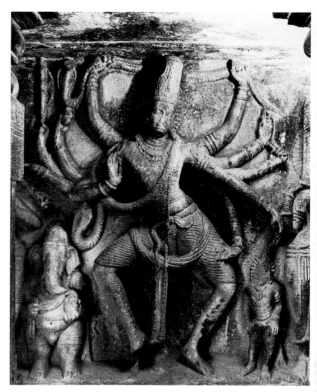

the Cosmic Directions (*dikpalas*), by flying celestial couples, and by *ganas*. Ceiling reliefs remain a salient feature of Chalukya temples. At Aihole they generally show the three great gods in their heavens (Fig. 67), while at Pattadakal the Cosmic Regents are once more prominent.

Natesa, the Dancing Siva, appears in a monumental relief outside of Badami no. 1. In the Aihole Saiva cave, we find the cosmic dance in an unusual configuration: Siva, accompanied by Parvati, Ganesa, Kumara and Bhringi, is flanked by the Seven Mothers, standing and dancing (Fig. 68). We remember that the Chalukya ancestors claimed to have been nourished by the Seven Mothers. The presence of a Varaha panel in this Saiva temple is the stamp of a Chalukya dedication. We tentatively date the cave-temple to about 670–80.

The structural temples of the Early Chalukyas include the oldest existing temples in stone masonry in the whole of South India. Here is the earliest meeting ground of 'northern' and 'southern' architecture in stone.

The principal difference between the 'northern' and 'southern' type of temple lies in the shape of the superstructure, which is curvilinear in the former[2] and storeyed in the latter; a local (Kadamba-Chalukya) variant has a stepped-pyramid superstructure of receding tiers; the earliest examples without a gable-projection, but with an *amalaka*, a 'northern' feature; there sometimes are corner *amalakas* suggesting storeys. It also occurs in the west, in the Kadamba area, as well as in the north, in the Pratihara realm (Kumaon), and toward the east (Alampur). In the 'northern' or *Nagara* model, the cella or sanctum with its superstructure is called *prasada*; the superstructure (above the cornice) alone is called *sikhara*. In the 'southern' or *Dravida* model, the cella with superstructure is

Left: Fig. 67 Siva and Consort on Nandi, sculptured ceiling, Temple 7, Aihole, Mysore. Chalukya, *c*. 650–700

Right: Fig. 68 Dancing Siva (Natesa), Saiva Cave, Aihole, Mysore. Chalukya, 670–80

[2]See pp. 45–6

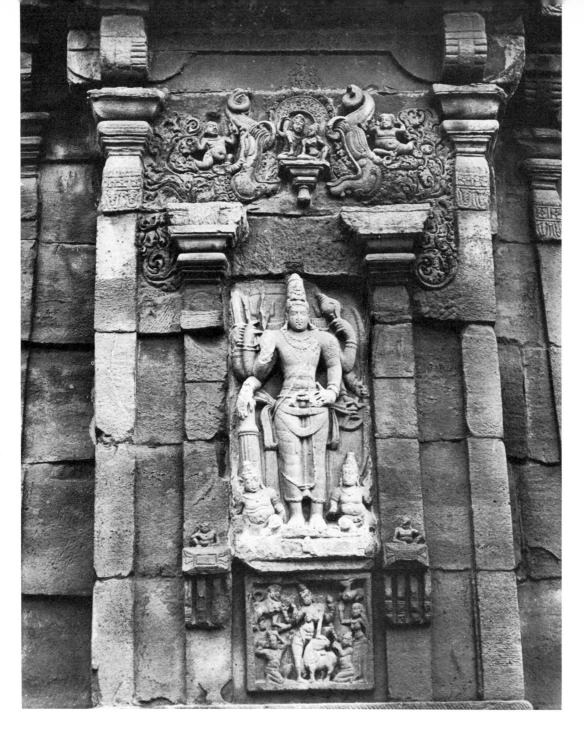

Fig. 69 Vishnu, relief on the
Virupaksha temple,
Pattadakal, Mysore.
Chalukya, *c.* 745

called *vimana*; *sikhara* is the denomination of the top part (dome) between *griva* (neck) and *stupi* (finial). In addition to the principal terms *Nagara* and *Dravida*, a third classification, *Vesara*, is the term for a round or apsidal *vimana*.

There are a few more features distinguishing 'northern' and 'southern' temples. The former generally are built on an elevated plinth or terrace; their *sikhara* is crowned by a single or double *amalaka*; they often have a free-standing big *torana* (arch) in front of the entrance, and ornate *mandapa* ceilings. The latter have, on top of each storey, a garland or string (*hara*) of miniature shrines of which there are three kinds: *kuta* (square), *sala* (wagon top) and *panjara* or *nida* (apsidal); soon after about 700, the *hara* on the *griva*-platform is replaced by the vehicles or cognizances of the principal deity. They generally have an enclosure or cloister (*prakara*), a gate-tower (*gopura*) and a flagstaff in the open court.

The gable-projection (*sukanasika*) functionally needs a vestibule to carry it. It is essential in the 'northern' style but occasionally occurs in the 'southern' type as well where the Chalukyas are generally credited with its adoption. However, in the Chalukya area it does not yet occur at Badami, Mahakut and Aihole, but only at Pattadakal, on the two biggest and latest temples, the Virupaksha and Mallikarjuna (*c.* 745).

We mention in passing that the cruciform groundplan of the Virupaksha is derived from the Svarga-Brahma (Alampur, 681–96) by way of the Papanatha and Galagnatha (Pattadakal), and the Visva-Brahma (Alampur, *c.* 690).

The relief slabs of the early temples at Badami (Malegitti-Sivalaya, *c.* 600) are neatly fitted to the construction blocks. The unfinished Meguti Jain temple (634) has empty niches as well as unfinished protruding slabs. The Pattadakal Sangamesvara (677–733) has unfinished reliefs which are in place in their niches. All this seems to imply that, originally, the unfinished or partly finished slab was inserted during construction and then finished, while now, as on the Virupaksha, only the finished relief was inserted (Fig. 69).

The Pallavas of Kanchi claimed descent from an earlier Pallava family who had been feudatories of the Andhras until they made themselves independent in the early fourth century.

The second king of the new line was the great Mahendravarman I (*c.* 580–630), who is said to have been a convert from Jainism. He called himself, in an inscription, 'curious (or inventive) minded'. And he initiated the carving of cave-temples in Tamilnad, choosing its hard granite and gneiss. The first excavation, at Mandagapattu, was designed as an abode for the Trimurti (Hindu triad), 'without bricks, timber, metal and mortar'. Mahendra was also a poet, and the author of a burlesque which ridicules the Buddhists.

Narasimhavarman I Mamalla ('the great wrestler') succeeded Mahendra and reigned from about 630 to 668. He made great contributions to rock-cut architecture and sculpture, especially at his seaport capital Mamallapuram (Mahabalipuram). Mamalla conquered and sacked Badami (642), and killed the Chalukya king in battle; he recorded his victory in an inscription on the Badami rock, in beautiful Grantha calligraphy. Narasimhavarman II Rajasimha (*c.* 700–28) had a more peaceful and prosperous reign; overseas trade flourished. He also was a great builder.

The ninth century saw the rise of the Cholas who much reduced the Pallava domain and finally put an end to the dynasty. The Pallava cave-temples are distinguished by the fact that they are carved from very hard rock. The stone was not polished (as in the Maurya caves) but stuccoed and painted (as in the Chalukya excavations). At Mandagapattu, the three icons apparently were paintings, or perhaps wood-carvings. Like several other Pallava rock-cut temples, the cave overlooks a large irrigation tank which was created in conjunction with the temple, under the protection of the gods.

The Gangadhara relief on the Tiruchirappalli rock (Fig. 70) marks the southern border of the Pallava kingdom which, under Mahendra, reached the Kaveri river. Siva is surrounded by celestials and sages whose diagonal thrust converges upon the majestic central figure. The symmetry of the composition has a mandala-like character.

Mahabalipuram, originally Mamallapuram, was the seaport of the Pallavas; it was named after King Narasimhavarman I Mamalla, 'the great wrestler'. Mamalla and his immediate successors continued the tradition of cave-temples

BUDDHIST, HINDU AND JAIN ART

in the Mahendra style; the pillars and pilasters have a tendency to become taller and thinner. At the same time, Mamalla developed a new and more ornate series of cave-temples, all at his seaport-capital Mamallapuram. The outstanding new development in this series is a fuller representation of the *mandapa* façade, a rich interior decoration, as well as slender pillars with ornate bases and full capitals, – all bringing the stone copies closer to their original models in brick and timber. At the same time, the temples now contain, in addition to the guardians, a rich sculptural decoration.

The most beautiful and most complete example probably is the Varaha-*mandapa*; it also has preserved parts of the original painting. The unfinished Mahishamardini-*mandapa* originally was dedicated to the Trimurti; the Somas-kanda relief in the central cell was added by Rajasimha (700–28). The lateral walls of the *mandapa* carry two of the most famous Pallava relief sculptures: Vishnu as Anantasayin (Ranganatha), in contemplative slumber, reclining on the cosmic serpent (Adi-Sesha), and Durga, riding her lion-mount into battle, fighting the mighty Buffalo-Titan (Fig. 71). This dramatic contrapuntal composition is one of the best examples of the large-scale relief panels, perhaps inspired by wall-paintings, which Mamalla added to the repertory of his *sthapatis* and sculptors.

In a further stage of this development, the large narrative sculpture panels have proliferated beyond any architectural frame and occupy entire rock or cliff faces, like the poetic Krishna-Govardhana relief or the magnificent Great Penance (Fig. 72).

Another innovation of the Pallavas under Mamalla are the monolithic temples – locally called *rathas* – carved out of the live rock at Mamallapuram. They are actually sculptures of architectural models, the 'originals' being brick and timber constructions. The motive surely was the same as for the cave-temples: to create shrines that would last forever. Just as Mahendra I had, for this reason, begun to

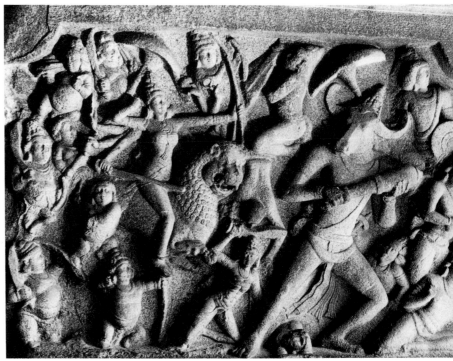

excavate cave-temples, Narasimha I Mamalla turned them inside out and created *Dravida vimana*-temples from granite rocks and boulders. The enterprise continued under Mamalla's successors but the *rathas* were finally left in different stages of completion. Wherever finished, they faithfully reproduce every architectural and decorative detail of contemporary 'southern' brick and timber constructions. The Pallava monolithic temples inspired the creations of the Pandyas (Kalugumalai), of the Eastern Chalukyas (Undavalli) and of the Rashtrakutas (Ellora) which, in their turn, radiated far afield.

The Dharmaraja-*ratha* (*c.* 650–72), mostly carved under Mamalla, is three-storeyed. The original concept would have had three cellas, one on each storey, of which only the top one was completed. The Somaskanda relief carved on its back wall dates from the later years of Paramesvara (672–700) who introduced this innovation. The somewhat heavy reliefs of the first storey probably date from the reign of Paramesvara.

Although this *ratha* remained unfinished, especially in the first storey and base, its sculptural decoration includes about fifty major figures, making it a veritable museum of Pallava iconography. Besides gods, guardians and

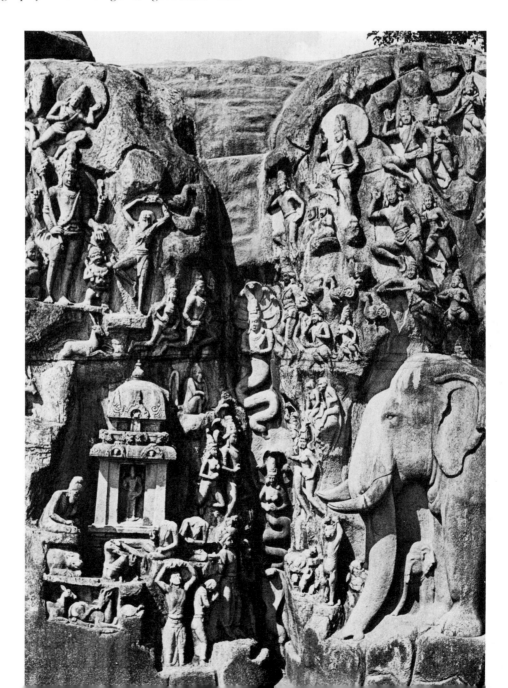

Far left: Fig. 70 Siva Gangadhara at Tiruchirappalli rock-cut temple, Tamilnad. Pallava, *c.* 625

Left: Fig. 71 'Durga killing the Buffalo Titan', Mamallapuram, Tamilnad. Pallava, *c.* 630–68

Right: Fig. 72 'The Great Penance', rock carving at Mamallapuram, Tamilnad. Pallava, *c.* 630–68

devotees it comprises four temple servants: the minstrel carrying a *vina*, the cook with offerings and temple-key, the priest's assistant with bell, and the priest with a flower basket. The majority of the figures, carved under Mamalla, are of superb quality, comparable to the Arjuna-*ratha* and the Great Penance.

Narasimhavarman II Rajasimha (700–28) sponsored the excavation of a cave-temple (the Atiranachanda *mandapa*). Last of the series, it is the only one to have a stone Somaskanda relief on the back wall of the sanctum (and two more on the back wall of the *mandapa*). In the same cave-temple a stone linga – black, polished and fluted – was planted, perhaps for the first time, on the floor of the sanctum, in front of the Somaskanda relief.

The famous Shore Temple at Mamallapuram perhaps is – at least in part – an early essay of Rajasimha's. It is a complex of three shrines. The larger *vimana* – of a slightly later date – has four storeys; it faces the sea on the east. The smaller, earlier one has three storeys; it faces the village on the west. Both are dedicated to Siva. Between the two, a rectangular *mandapa*, coeval with the western *vimana*, was built over an earlier rock-cut reclining Vishnu. The whole is enclosed by a common wall. All three buildings are named after Rajasimha.

Both *vimanas* have octagonal *sikharas* with black basalt finials. On top of the *griva* platform four conch-blowing *bhutas* (*ganas*) have replaced the miniature shrines; later they will in their turn be replaced by four Nandis, vehicles of Siva. On top of the first storey as well, the miniature shrines (*hara*) have been replaced by *bhutas*. There is no gable-projection. The relatively tall storeys help to give the attenuated building a particularly graceful charm.

The pilasters have bases of rampant lions, hallmark of Rajasimha; those of the eastern shrine have, in addition, elephant, ram, *naga* and *bhuta* forms. In both shrines, Somaskanda reliefs are placed on the rear wall of the sanctum. Siva and Uma with Skanda between them are seated on a throne, Brahma and Vishnu standing behind them. The slightly earlier western relief is not elevated; we note the elongated crowns.

In the eastern shrine, Vishnu and Brahma enthroned, this time with their consorts, reappear on the lateral walls of the *mandapa* (as at Panamalai). In front of both Somaskanda reliefs, a huge, fluted basalt linga has been inserted in the floor; at least in the case of the western shrine, it may be a slightly later addition as it blocks the view of the relief.

Rajasimha, together with his son Mahendra III, built the famous Kailasanatha temple complex at Kanchi (*c.* 725); he now used sandstone, with granite slabs for the base. The Somaskanda relief once more is placed in a special niche high up on the back wall of the sanctum, and visible above the top of the large, fluted and polished basalt linga. The latter now has a very large and high circular base which takes up almost the entire sanctum floor. The installation of a fluted black basalt linga in the sanctum, in front of the Somaskanda relief, probably was introduced by Rajasimha in the later part of his life.

We note that the *griva* platform now carries four Nandis. The outer walls of the temple, as well as the cloister, are covered with stuccoed and painted sculptures – another museum of iconography.

The Vaikunthaperumal temple at Kanchi was built by Nandivarman II Pallavamalla (731–96). The *vimana* has three superimposed shrines with idols of Vishnu standing, seated and reclining. The temple is built of sandstone, with granite slabs for top and bottom of the base. The elevated cloister is famous for the narrative reliefs illustrating the history of the Pallavas.

The ancient Pandyas of Madurai had in the Sangam period – during the first centuries of our era – ruled over one of the three kingdoms of the South. They had a lively trade with the Romans, which later passed into the hands of the Ethiopians of Aksum and of the Arabs.

About the end of the sixth century, in the course of the Hindu renaissance, the Pandya kingdom was reestablished. The Pandyas soon asserted their suzerainty over the Cheras in the south and over the Kongu country in the west. In the north, they fought the Pallavas for supremacy over Ceylon (Sri Lanka) and over the fertile Kaveri valley. In the recurrent wars between the Chalukyas and the Pallavas, they were the allies of the former.

The rise of the Cholas (ninth century) who replaced the Muttaraiyars in the Kaveri valley, brought about the end of the Pallavas and the temporary eclipse of the Pandya kingdom which was restored only in the thirteenth century. The Pandyas' emblem was the auspicious fish. They were tolerant toward the Buddhists and, intermittently, patronized the Jainas. As for the Hindu pantheon, a number of pre-Aryan deities survived. We also notice that some cults came to the Pandya country from the Chalukya area through the Ganga domain.

The Pandyas and their part-time feudatories, the Muttaraiyars, excavated about sixty cave-temples, which, until recently, generally were thought to be of Pallava origin. Some contain remnants of mural paintings (*Sittanavasal*). They generally have one or more shrine cells in the rear of the *mandapa*, as in the Pallava Mahendra style. In a few instances there is a Somaskanda or another relief-panel on the back wall of the cella. Sometimes, however, the shrine cells are cut into the side-walls. Most of the Saiva caves have a rock-cut linga and *pitha*, generally square, like the Chalukya ones. In most of these caves, a small cistern or pit is cut into the floor below the spout of the linga-*pitha*, in order to receive the ablution water. Usually, a gutter or channel takes the overflow outside through the *mandapa*. We know this feature from the Chalukya area where we find the pit in Badami no. 1, and the pit with gutter in the Aihole Saiva cave.

In the Tirumayam cave-temple (*c*. 750), a rock-cut Nandi on a raised platform occupies the centre of the *mandapa*, facing the sanctum. Behind him, a beautiful Lingodbhavamurti is carved from the rock wall. The fiery pillar from which Siva emerges reaches from the floor to the ceiling.

The Tirumayam cave-temple shares a famous musical inscription with several other excavations probably sponsored by the same king. The specific stance and gestures of its guardians, one of whom seems to be a chieftain or king, also relate it to some of this group as well as to a few other caves, including one in distant Travancore (Kerala).

The monolithic Siva temple now called Vettuvankovil, 'the sculptor's temple' at Kalugumalai (late eighth century) is, although unfinished, the loveliest jewel of Pandya sculpture. The concept probably was inspired by the Mamallapuram *rathas* as well as by the Ellora Kailasanatha; the trenching technique used was that of the Rashtrakutas in the latter temple. However, the luxuriant sculptural decoration with its abundance of sprites (*ganas*) making music, dancing and singing, and of heavenly damsels or apsarases resembling local beauties, is typically Pandya (Fig. 74).

In an unusual variant of Vinadhara-Dakshinamurti Siva is playing not the *vina* but the drum (*mridanga*), which is associated with the dance. Thus, he is shown as the Lord of Music and of the Dance. Under the eaves of the top cornice,

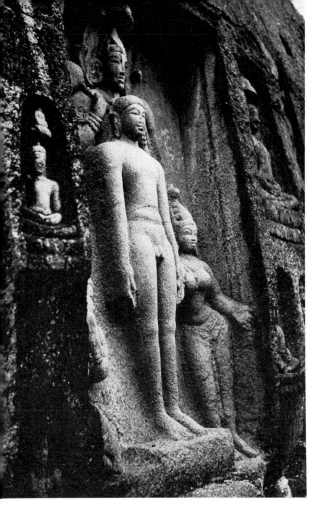

ecstatic sprites are carried away by music, song and dance, while monkey kings look out from the shadows, and heavenly damsels display their charms (Fig. 75). The next lower storey carries a string of miniature shrines (*hara*). Two rows of enraptured *ganas*, making music and dancing, are the only finished part of the porch decoration. The entire temple, from porch to *griva*, seems to be one piece of ecstatic sacred music, frozen into stone by some divine enchantment. The Vettuvankovil illustrates one characteristic feature of the Pandya structural temples: they have no *devakoshtha* icons on the *vimana* or *mandapa* walls; the sculptural decoration is concentrated on the superstructure.

Behind the huge, bald rock from which the Vettuvankovil is cut, a high cliff rises steeply. It is carved with long rows of Jaina saviours (*tirthankaras*), 'makers of the river-crossing'. Next to them is the Goddess Ambika, flanked by her lion-mount and by a dancer. The Jaina Parsvanatha, well over life-size, is protected by the *yaksha* Dharanendra and the *yakshi* Padmavati (Fig. 73). A kneeling, crowned figure perhaps represents King Varagunavarman I.

Above: Fig. 73 The Jaina Saviour Parsvanatha, rock-cut sculpture, Kalugumalai, Tamilnad. Pandya, late eighth century

Fig. 74 Rock-cut Saiva temple Vettuvankovil, Kalugumalai, Tamilnad. Pandya, late eighth century

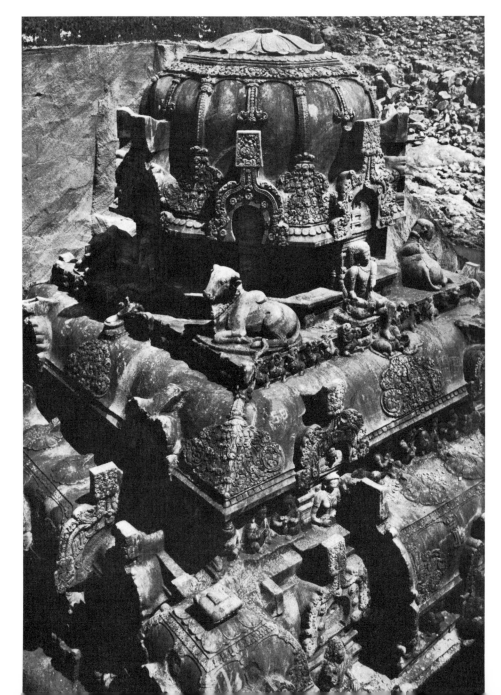

The Adigaiman chiefs were ruling, alternately under Chera, Pandya and Pallava suzerainty, over the northern part of the Kongu country. During a brief period of independence, some time between 700 and 750, their king Gunasila excavated two extraordinary cave-temples at Namakkal. Both are still in worship. The huge reclining Vishnu in the elevated open cella of the Ranganatha cave is the same subject as at Mamallapuram, treated here in a more dramatic and also more crowded composition.

The somewhat earlier Lakshmi-Narasimha cave-temple is located on the other side of the same huge rock; a whole temple compound has been erected in front of the cave, which is still an important cult centre. The principal icon, a colossal, benevolent Narasimha is seated on a raised, open, pillared platform.

Four large relief panels adorn the lateral and rear walls of the surrounding *mandapa*. Clockwise, the first is a superb Vaikuntha-Narayana group. The other panels show the fierce (*ugra*) Narasimha, Varaha rescuing the Earth, and last the story of Vamana-Trivikrama (Fig. 76). It begins at the right: King Bali is about to pour the water in order to consecrate the gift to the plump little brahmin dwarf carrying an umbrella; behind Bali, Sukra is protesting vainly. Above is the head of a horse next to a sacrificial post. It signifies that the event took place at the occasion of an *asvamedha* sacrifice, asserting Bali's claim to rule the universe. To the left, Vamana has grown into a giant who covers earth and heaven in two strides. Above him, a flying Jambavan, king of the bears, beats a drum, while an armed demon falls from the sky. In front of Vishnu, Garuda belabours a fallen Bali. Vishnu's conch floats above his head; it has tongues of flame – a feature unknown in the Chalukya cave-temples, but which in Pallava sculpture first appears on the Panamalai cave Durga. Almost the entire iconographic content of the two Namakkal caves is represented in Badami no. 3.

The powerful Muttaraiyar chieftains ruled over the ancient Chola-*mandala*, that is the Tanjavur-Tiruchi area, on both sides of the Kaveri river; they owed allegiance alternately to the Pandyas and to the Pallavas and were overthrown by the Cholas who rose to power and independence under Aditya I (871 to 907). The Muttaraiyars created a number of cave-temples which, on the whole, are not very different from the Pandya ones.

The Vaishnava cave-temple on the Melamalai hill at Narttamalai can be dated to about 865, under the suzerainty of a Pallava king. The central, rock-cut lotus pedestal in the sanctum suggests that the principal icon was a standing form of Vishnu, perhaps in wood. Twelve identical standing Vishnus, two metres high, occupy the *mandapa*; five on each back wall – flanking the sanctum (Fig. 77). – and one on each lateral wall. The tall crowns and flaming emblems recall Namakkal. The pillared front of the *mandapa* is open. Of an additional structural *mandapa* only the plinth remains; it is decorated with a lively frieze of elephants, lions, *yalis* and sphinxes.

The structural temple facing the cave is called, in a Pandya inscription of the thirteenth century, Vijayalaya-Cholisvaram, after the first Chola king. Apparently it was built by a local Muttaraiyar chief; its date probably is close to that of the neighbouring cave-temples (mid ninth century). However, there were important repairs at an early date.

The temple has no *devakoshtha* icons on *vimana* or *mandapa* – probably due to Pandya influence – and a round sanctum – which reminds us of Kerala temples in the far south. *Griva* and *sikhara* are round as well – of the *Vesara* order.

The Irukkuvel chiefs had their capital at Kodumbalur (Pudukkottai), which is

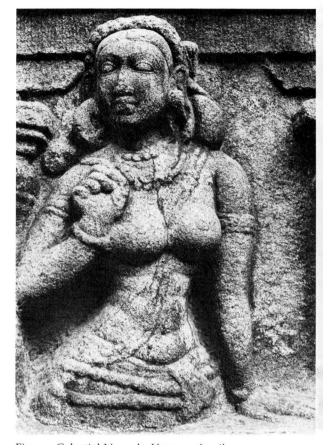

Fig. 75 Celestial Nymph, Vettuvankovil rock-cut Saiva temple Kalugumalai, Tamilnad. Pandya, late eithth century

Fig. 76 Vishnu as *Trivikramas*, Lakshmi-Narasimha Cave, Namakkal, Tamilnad. *c.* 700–50

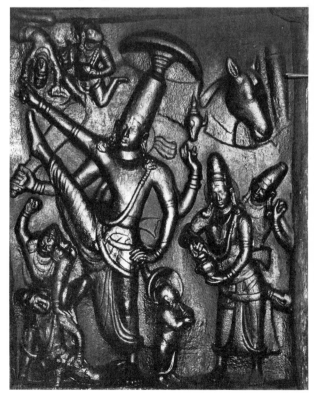

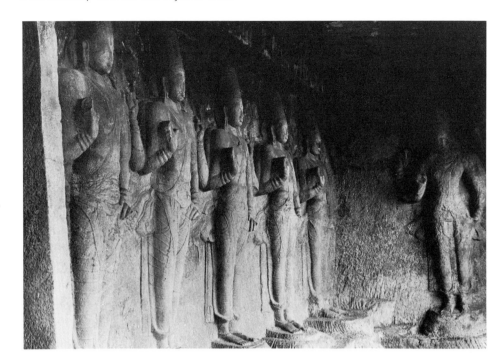

Fig. 77 Six figures of Vishnu, Vaishnava Cave, Narttamalai, Tamilnad. *c.* 865

recorded in the famous Tamil epic, 'The Lay of the Jewelled Anklet' (Silappadikaram). It was located on the great highway between the ancient Chola and Pandya kingdoms. The Irukkuvels became feudatories of the Cholas with whom they intermarried.

The Muvarkovil at Kodumbalur originally consisted of three parallel shrines – facing west – devoted to Siva; they were dedicated by an Irukkuvel prince in his own name and those of his two queens. The same prince made a large gift to the Kalamukha sect of which Kodumbalur must have been a centre.

Two of the three shrines and their porches remain. A detached pillared *mandapa* was shared by all three *vimanas*. The *mandapa* and the sixteen subshrines have disappeared, except for their bases, but much of the sculptural content still exists, at least in fragmentary form. Nandi wears a Chalukya bell-chain. The surrounding cloister has vanished but there still is a beautiful stepped well. The date now proposed for the Muvarkovil is about 880.

The twin *vimanas* are masterpieces of South Indian architecture and sculpture. They are placed on lovely inverted lotus bases. Both storeys and the *griva* platform are supported by a *yali*-frieze; under the first storey roof cornice a row of *ganas* are making music. The same pattern is found at Kilaiyur (892) and at Lalgudy (897).

The *devakoshtha* icons are echoed on the second tier and around the *griva*; Nandis are placed at the corners of the *griva* platform. The east face of the southern shrine displays an extraordinary vertical sequence of Gangadhara, Kalari and Andakasura (Fig. 78). The superb image of Kalarimurti shows Siva in one of his terrifying destructive dances, annihilating the God of Death, Kala. Despite the violent movement, a faint smile lingers on the fierce face. The fluid modelling of the graceful body makes us think of metal sculpture.

Like the Irukkuvels, the Paluvettaraiyars were powerful local chiefs; their ancestors had come from the Chera kingdom (Kerala). They became feudatories

Opposite: Fig. 78 East face of the Southern Shrine, Muvarkovil temple, Kodumbalur, Tamilnad. *c.* 880

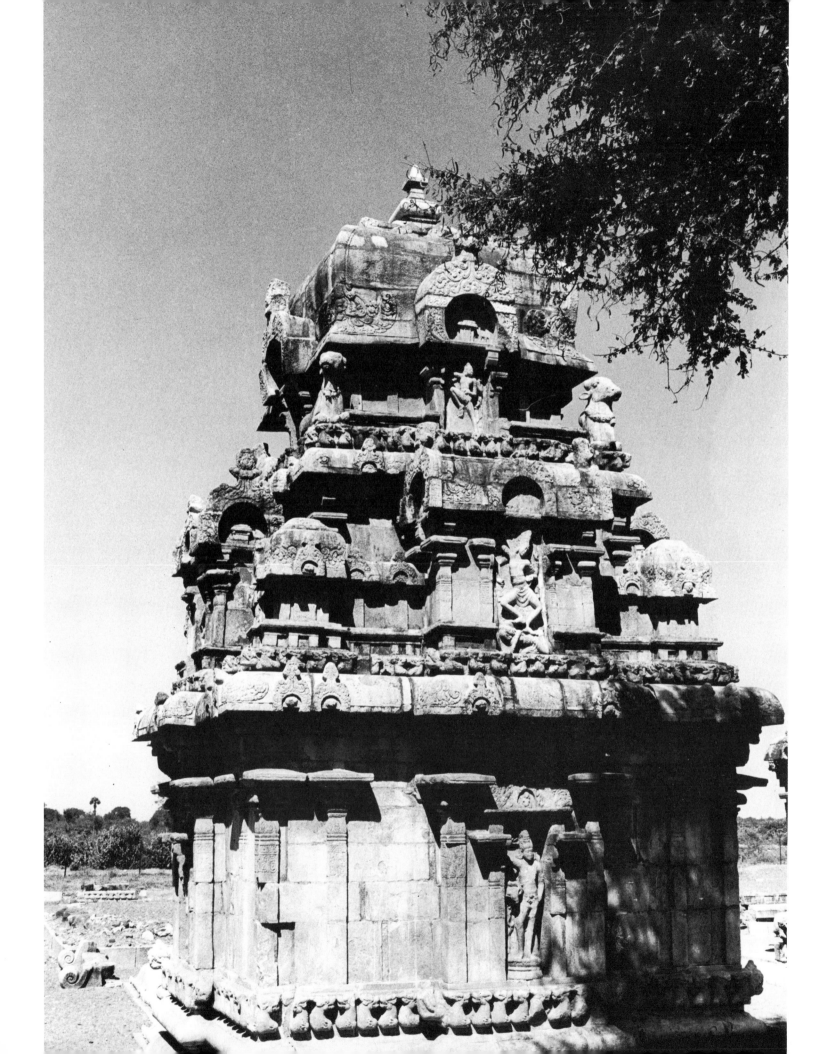

of the Cholas with whom they intermarried. The site of their capital Paluvur is now occupied by the twin villages of Kilaiyur and Melappaluvur and by Kilappaluvur, north of the Kaveri river.

The Kilaiyur temple consists of the twin shrines called Agastyesvara and Cholisvara, as well as a Nandi, four (out of eight) subshrines, enclosure and gate-tower (*gopuram*). The earliest undisputed inscription, on the Agastyesvara, is dated 892; it records a gift of land to both temples. Actually, the Agastyesvara may be a little earlier, and the subshrines a little later. The Agastyesvara has a square *sikhara*, the slightly smaller Cholisvara a round one. Moulded bases with inverted lotuses, the composition of the façades, and other features are shared by both temples with Kodumbalur.

A superb Nandi is placed in front of the Agastyesvara *mandapa*. The latter is coeval with the *vimana* but originally was not connected with it. Stylized lions carry its elegant pillars.

The four Nandis on the *griva* platform, realistic but sensitive, are adorned with festooned necklaces (Fig. 79). The frontal (western) *griva* niche houses a beautiful Vinadhara, carved almost in the round (Fig. 80). Face and body are full and rounded; his lips are open in song.

Some of the reliefs in the subshrines are intact but for the accretions due to worship. A seated Chandesa looks at us through slightly lowered eyelids, with hardly a trace of a smile. We are impressed by his spiritual dignity. The Seven Mothers are beautiful but remote and awe inspiring.

Like the Muttaraiyars, the Irukkuvels and the Paluvettaraiyars have an idiom of their own, which is reinforced by certain iconographic peculiarities. However, their family and political affinities with the Cholas are reflected in a stylistic relationship that is very close. The monuments here described can be interpreted as representing the first phase of Early Chola art. They can also be explained as a kind of transition phase between these local traditions and the emerging Chola style.

The Cholas, claiming descent from an earlier dynasty of this name, emerged from a shady interregnum in the ninth century. The founder of the new line, Vijayalaya, started as a viceroy of the Pallavas. He came to the throne (*c.* 855) by overthrowing the powerful Muttaraiyar chiefs who probably had changed their allegiance from the Pallavas to the Pandyas. Tanjavur (Tanjore) became the capital of the new Chola domain. Vijayalaya's son Aditya I was crowned in 871. Twenty years later he had defeated the Pallava king and taken possession of his country. A later copper-plate charter states that on both banks of the Kaveri river, from the Western Ghats to the wide ocean, he built in honour of Siva rows of tall stone temples which stood as monuments of his success.

Parantaka succeeded in 907; he expanded the Chola realm at the expense of the Pandyas whose kingdom he annexed. However, a successful Rashtrakuta invasion led to the battle of Takkolam (949) in which the Chola crown prince was killed. The northern parts of the Chola realm were lost, and the Pandyas once more became independent.

The accession of Rajaraja I (985) marked the beginning of the great period of Chola power. Rajaraja destroyed the kingdoms of the Pandyas and the Cheras in the south; after an amphibious expedition, the north of Lanka (Ceylon) became a Chola province. He conquered the Ganga territory in Mysore and established his supremacy over the Eastern Chalukyas of Vengi. He administered a crushing defeat to the Late (Western) Chalukyas, successors of the Rashtrakutas in the

Fig. 79 Nandi on the griva platform, Agastyesvara temple, Kilaiyur, Tamilnad. Paluvettaraiyar, *c*. 892 or earlier

Below: Fig. 80 Siva Vinadhara, Agastyesvara temple, Kilaiyur, Tamilnad. Paluvettaraiyar, *c*. 892 or earlier

Deccan. Finally, he destroyed the Chera fleet and conquered the Maldive islands. It was Rajaraja who built the great temple at Tanjavur, then called Rajarajesvara (1010). He also invited the king of Srivijaya (Malay Peninsula and Sumatra) to build a Buddhist *vihara* at Nagapattinam.

Rajaraja's son and successor, Rajendra I, completed the conquest of Lanka (Ceylon) and took its king as prisoner to Tanjavur. He installed a son as viceroy over the Pandya and Chera countries and defeated his neighbours in the north, as far as Kalinga (Orissa). He marched north until he reached the Ganges. After his northern campaign Rajendra built his new capital and the great temple at Gangaikondacholapuram (1030); into the temple tank was poured Ganges water that his war elephants had carried back from the sacred river.

Called to help by the Khmer King Suryavarman I, Rajendra launched one or two maritime expeditions against the kingdom of Srivijaya which probably

obstructed his trade with Cambodia and China. Rajendra sacked its capital and took the king into captivity. Under Rajendra's successors, the wars on land and sea continued with varying fortune. Intermarriage with the Eastern Chalukyas led to a personal union of the two kingdoms under Kulottunga I (1070–1118). Lanka was lost but the south was pacified and held at bay. Kalinga (Orissa) was invaded several times; these victorious campaigns were celebrated in a famous poem. Diplomatic relations – and trade – with Srivijaya, Burma, Cambodia and China continued. Rajaraja II was still strong enough to build the beautiful Darasuram temple (before 1167). A last outstanding ruler, Kulottunga III (1178–1218) once more delayed the disruption of the empire and built the last great Chola temple at Tribhuvanam, probably after the third conquest of Madurai (c. 1205). But the Pandya resurgence finally was victorious and brought this old kingdom once more to the peak of power in South India and Lanka (Ceylon). By 1280, the Chola kingdom had ceased to exist. This was the end of the most glorious phase of South Indian history – famous for its contributions to poetry and literature, as well as to architecture, painting and sculpture and – last but not least – to irrigation.

The first phase of Early Chola art has, until recently, been labelled 'Pallava-Chola transition'. This term does not seem to be justified by the historical situation nor by the archaeological evidence. Before and during the Chola emergence, the hold of the Pallavas over the Chola-nadu was intermittent and inefficient. As for Pallava sculpture, it had already begun to decline during the second half of the eighth century. The later ninth century saw the late flowering of a local sculptural tradition (Takkolam, Vilakkanampundi, Tiruttani). Architecturally, however, these temples are far less developed than the contemporary Chola structures.

A good many of the numerous temples built by the second Chola king (Aditya I) still exist. We recall that Aditya was crowned in 871, but that the Chola-*nadu* was occupied by the Pandyas from 864 to 878. In some of these early temples, the principal *devakoshtha* icons on the *vimana* walls are not differentiated but show the same form of Siva; they are echoed, on the second storey and the *griva*, by seated and standing images of the three gods of the Trimurti.

The Nagesvarasvami temple in the hallowed city of Kumbakonam is one of the wonders of Early Chola art. Now, the temple is dated by some scholars to 910. However, an earlier date of 886 is still widely accepted and seems defensible in view of the architectural fabric. The most striking feature of the Nagesvara are four almost life-size celestial damsels or *apsarases* (Fig. 81) who, along with two sages (*siddhas*) and two minstrels (*gandharvas*) accompany the icons on the walls of *vimana* and *mandapa*. We find here the perhaps most perfect realization of the 'sublimated realism' characteristic of Chola sculpture. The bodies of the *apsarases* are modelled with a gentle softness that is matched by the chaste and demure expression. The long arms, slim waists and heavy breasts express the age-old Indian ideal of superhuman beauty. The anatomy thus is an ideal one, but it still is close enough to nature to carry the spark of life – which has suggested an interpretation as portraits of Chola princesses and other donors.

In the second storey, of stone as well, the standing icons of the first *tala* are echoed by seated ones of the same quality. Rearing *yalis* and female dancers support the roof corners of the miniature shrines while adorers occupy others. All of them in turn echo the dancers, musicians and rearing *yalis* which support the roof cornice of the first storey, from the pilaster abaci. *Sikhara* and *griva* are

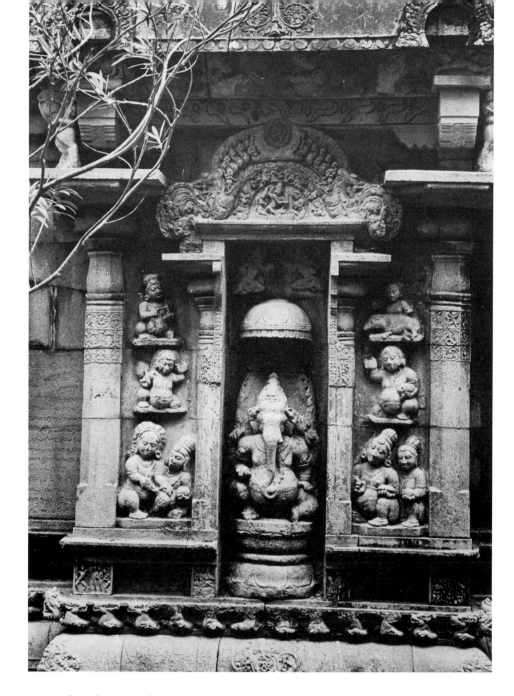

Fig. 83 Ganesa and his Host,
Brahmapurisvara temple, Pullamangai,
Tamilnad. Chola, *c*. 910–20

covered with painted stucco; the proliferating sculptural decoration of the *griva*
has overflowed onto the second storey. There also is a rare and large gable-
projection (*sukanasika*) which, if original, would be due to Chalukya influence.

If the reign of Aditya I witnessed a blossoming of what had timidly begun in
Vijayalaya's time, that of Parantaka I carried it further. The Brahmapurisvara
temple at Pullamangai (about 910–20) is one of the highlights of this period, and
one of the glories of Chola art. The *devakoshtha* icons are, stylistically, fairly close
to the Nagesvara although there is a more pronounced slenderness or elonga-
tion of the figures. As on the Nagesvara, there are two rows of miniature panels
on and above the base, and minutely carved valances on the pilasters, and on
the *toranas* (decorative relief-arches) above the icons: they have the quality of
ivory carvings.

The panel of Ganesa and his host (Fig. 83) is a delightful homage to the
'remover of obstacles'. Above the parasol are two flying celestials; they recall

Opposite top: Fig. 81 Figure of Apsaras,
Nagesvara temple, Kumbakonam,
Tamilnad. Chola, *c*. 886

Opposite bottom: Fig. 82 Brahma,
Brahmapurisvara temple, Pullamangai,
Tamilnad. Chola, *c*. 910–20

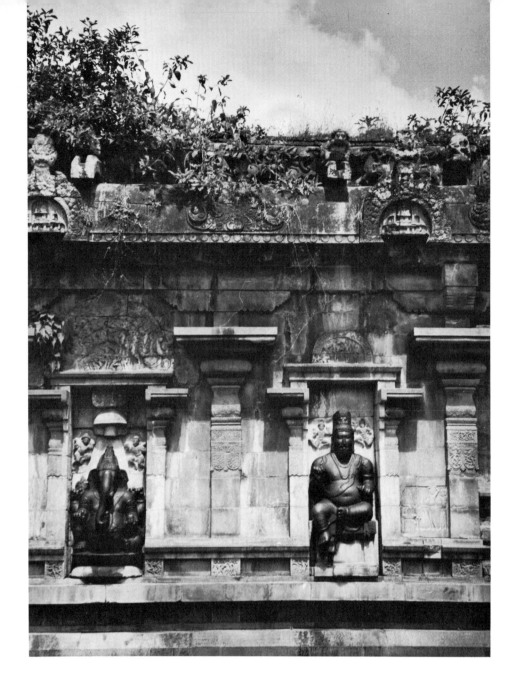

Fig. 84 Agastya and Ganesa,
Naltunai-Isvara temple, Punjai,
Tamilnad. Chola, *c.* 940

Pallava compositions. The lateral panels are inhabited by endearing and spirited *ganas* – singing and playing various musical instruments; one leads Ganesa's mount, the rat.

The Brahma of the Lingodbhava group (Fig. 82) recalls the heavenly minstrels and damsels of the Nagesvara. Standing in a rather informal pose, in semi-profile, the god here is represented as a beautiful prince; only the spiritualized expression characterizes him as a denizen of a higher sphere. These lateral reliefs flanking a principal icon are carved from the masonry blocks whereas the latter is cut from one single slab which is then inserted in its niche.

The Naltunai-Isvara temple at Punjai probably was built about 940; it represents the second phase of Early Chola sculpture. The *devakoshtha* niches of the *mandapa* (south, Ganesa, north, Durga) now receive an additional image. Agastya, the legendary saint who converted the south, makes his first appearance on the south wall; from now on he is part of the standard iconic layout.

Over both Agastya and Ganesa two flying spirits are hovering (Fig. 84). The small relief next to Agastya, with a worshipper adoring the linga, probably represents the donor; it is another novel feature. The miniature reliefs on and above the base mouldings, on pilasters and *toranas*, are once more of the highest quality.

The Dakshinamurti panel, luckily intact, is perhaps the most beautiful of all existing examples (Fig. 85). Every detail is treated with loving attention and superb skill, from the compassionate and tender expression on Siva's face to the Dwarf of Ignorance under his foot and to the writhing cobra and the two deer, one of which is asleep. Two listening sages (with their disciples) raise their right hands in the same gesture – expounding the truth – as the Lord, whose half-open lips are chanting the Vedas. The small scale of the sages underlines the greatness of the God.

Durga, Goddess of Victory (Fig. 86), stands on the severed head of the Buffalo-Titan in an elegant 'triple-bend' stance. The lateral components of the corresponding Pullamangai relief have been pulled into the central panel. Her mounts, the lion and the antelope now flank the virgin's head, like hovering spirits. The two warriors about to sacrifice their blood – or life – here are kneeling close to her feet. The number of arms has been reduced; trident and bow are magically suspended. As a result, the Goddess stands out much more clearly in all her radiant beauty.

Under the *makara-torana* above the Durga, Siva Nataraja, the Lord of the Dance, is dancing in the *ananda-tandava* mode, accompanied by three musicians. The almost three-dimensional figure is one of the earliest known representations in stone of this famous motif. In the *torana* above the Dakshinamurti at Tiruvaduturai (945), the Nataraja has become larger (about 50 cm) and once more is almost free-standing. These two sculptures seem to represent an intermediate phase on the way to the full size Nataraja in *devakoshtha* in the iconic layout of the temples built by Queen Sembiyan Mahadevi, in 970 and later.

The next phase of Early Chola art is characterized by the temples built by this pious queen, widow of Gandaraditya (949–57), who lived until 1001; it includes the reign of her great-nephew Rajaraja I (985–1014).

All the temples built by Sembiyan Mahadevi have the false vestibule or *antarala* which already appeared at Tiruvaduturai (945); they also have the standardized enlarged iconic layout.

Two trends dominate the artistic development during this phase. The first is the rapidly growing emphasis on the creation of bronze icons – to be carried in processions – which seem to have absorbed much of the artistic as well as financial capabilities. The other is the rise of bigger temples with taller *vimanas* and loftier *gopuras*, culminating in architectural masterpieces like the Rajarajesvara (1003–1010) in Tanjavur. The great temple has the highest known *vimana*; of thirteen storeys, it rises to 66 metres. The topmost stone (*griva* platform) is estimated to weigh 80 tons. The base forms a square each side of which is 28 metres long. Platform and base are extended in front to carry the string of axial *mandapas* which end, or rather begin, with a colossal Nandi. Two superimposed rather plain *salas* form a kind of gable-projection above the vestibule. Sub-shrines, including some later additions, are placed in the courtyard; others are incorporated in the cloister (*prakara*).

The linga is the largest in Tamilnad, and probably in India. The ambulatory walls are covered with murals (in fresco) of the Chola period, which only

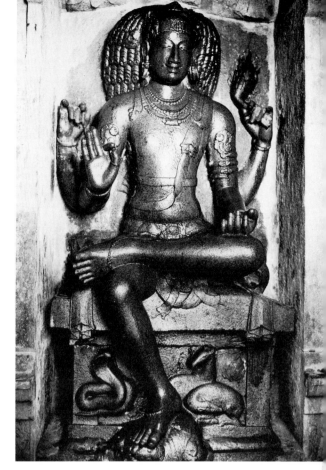

Fig. 85 Siva Dakshinamurti (as the Divine Teacher), Naltunai-Isvara temple, Punjai, Tamilnad. Chola, *c.* 940

Fig. 86 Durga 'Goddess of Victory', Naltunai-Isvara temple, Punjai, Tamilnad. Chola, *c.* 940

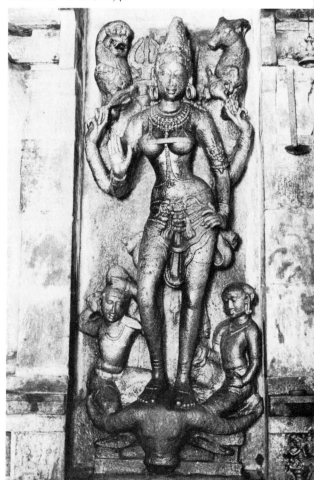

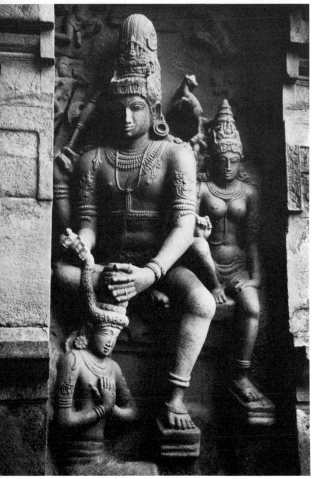

Fig. 87 Chandesanugrahamurti, Gangaikondacholapuram temple, Tamilnad. Chola, 1030

Fig. 88 Wives of the Sages, Airavatesvara temple, Darasuram, Tamilnad. Chola, c. 1160. Tanjore Art Gallery

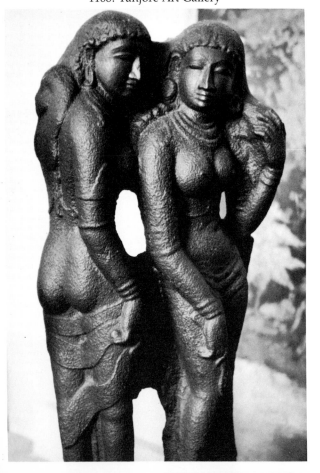

recently were discovered under a layer of Nayaka paintings. The principal subjects are Siva as Tripurantaka; the story of the Saiva saint Sundaramurti; and the king worshipping Siva Nataraja at Chidambaram. The ambulatory of the second storey is carved with 108 relief panels showing Siva demonstrating the dance poses of Bharata's Natyasastra.

The huge size of the building caused the creation of some powerful monumental sculpture, such as the guardians of the entrances. On the whole, however, the proliferation of reliefs over several storeys of the *vimana* was bound to result in a more decorative character, to the detriment of the religious and artistic power of the individual icon. This trend is even more pronounced on the Gangaikondacholapuram temple, a somewhat smaller creation of Rajendra I (1030) which has a slightly concave *vimana* profile.

The original temple compound now includes a separate Amman shrine devoted to the goddess; it became a standard component late in Rajendra's life.

The beautiful Chandesanugrahamurti (Fig. 87) is the most appealing relief on this temple. Siva crowns the faithful Chandesa with a flower garland, making him his steward, while Parvati looks on. The majesty of Siva's face is tempered by tenderness, the joy of Chandesa restrained by awe.

The expansion of the iconic reliefs was paralleled by an enlargement of the miniature panels, which gave more scope to the narrative element. The legend of the seduction of the wives of the sages (*rishis*) by Siva as a mendicant (Kankala) is illustrated by an almost life-size free-standing group (Fig. 88) from the Airavatesvara at Darasuram, built by Rajaraja II (1146–73). It may have been placed in the cloister where its black and polished basalt-like stone contrasted with the granite of the structure. A detail shows two of the dazzled wives who are loosening their girdles and letting their saris slip down, with the bewitched expression of sleepwalkers. The unique three-dimensional treatment probably was inspired by bronze sculpture.

The porch *mandapa* is conceived as a chariot on wheels. This concept – sometimes with elephants replacing the horses – is found in a number of later Chola temples; it probably inspired the Eastern Ganga King Narasimha in his creation of the famous Sun Temple at Konarak (c. 1250).

Another development in the later Chola temples is the growing prominence in size and height of the *gopuras* (gate-towers) which often overshadow the *vimana* of which they are echoes or emanations.

A great contribution of the Cholas was their bronze sculpture. These images of gods and saints, and sometimes of donors, were carried in procession during the religious festivals – dressed and covered with garlands and jewels, sometimes with golden crowns, gloves and shoes as well. It is not always possible nor easy to see them without their paraphernalia. When that privilege is granted, the impression is unforgettable. Cleaned with tamarind, their dull golden surface glows softly in the obscurity of the temple.

The cosmic dance of Siva is, at its roots, the manifestation of primal, rhythmic energy. In the specific *ananda-tandava* mode, it is, as Coomaraswamy said, 'the clearest image of the activity of God which any art or religion can boast of'. In a delicately balanced composition, the divine dancer moves with effortless grace. A vertical lift or levitation seems to propel and sustain him, for a timeless moment, suspended in the air, in a magically arrested movement full of rhythm and grace. The beautiful motif seems to have been conceived and realized in the south, under the Early Cholas – at least during the first half of the tenth century.

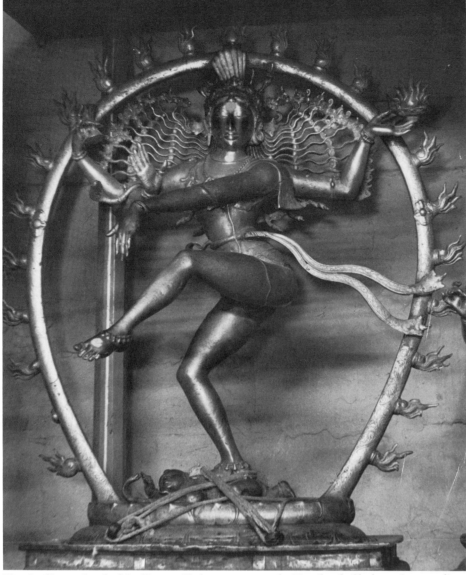

Fig. 89 Siva as Lord of the Dance, Vedaranyam temple, Tamilnad. Chola *c*. 985 or earlier

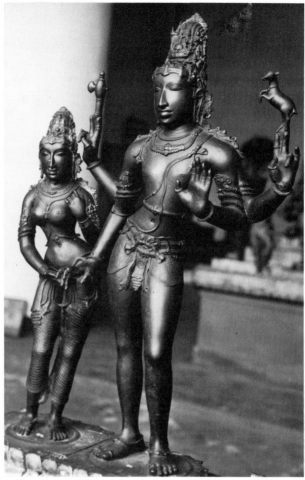

Fig. 90 Betrothal of Siva and Parvati, Tiruvelvikudi temple, Tamilnad. Chola, *c*. 975

Fig. 91 Parvati. Chola, late ninth century or later. New York, The Metropolitan Museum of Art

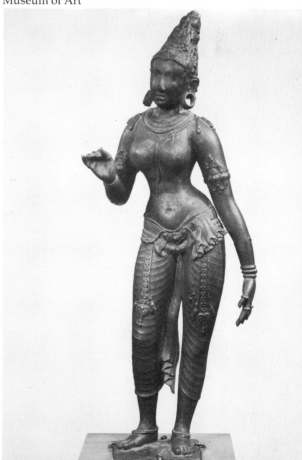

The Nataraja in the temple at Vedaranyam (about 985) is one of the most perfect large-size realizations of this concept (Fig. 89).

The Kalyanasundara group (Fig. 90) – the betrothal of Siva and Parvati – is in worship in the temple of Tiruvelvikudi. In pristine condition, it is of an extraordinary quality and can be dated to about 975.

The Parvati in the Metropolitan Museum of Art (Fig. 91) has been called 'perhaps the only Early Chola bronze masterpiece to have left India'. The bronze is close to the stone Tripurasundari from the Muvarkovil at Kodumbalur (Pudukkottai) which now is dated to about 880. I would give the Metropolitan Parvati a date of 'late ninth century'. The sensitive body of the Goddess is aglow with the refined voluptuousness of some spiritual realm. An interior life current swells the delicate forms. Her gentle and tender expression, the musical grace and flowing rhythm of her body, and the dignity of her carriage leave us in wonderment at the greatness of South Indian sculpture.

This wonderment must be shared by the majestic Siva Vishapaharana in the British Museum, a superb and awe-inspiring bronze.

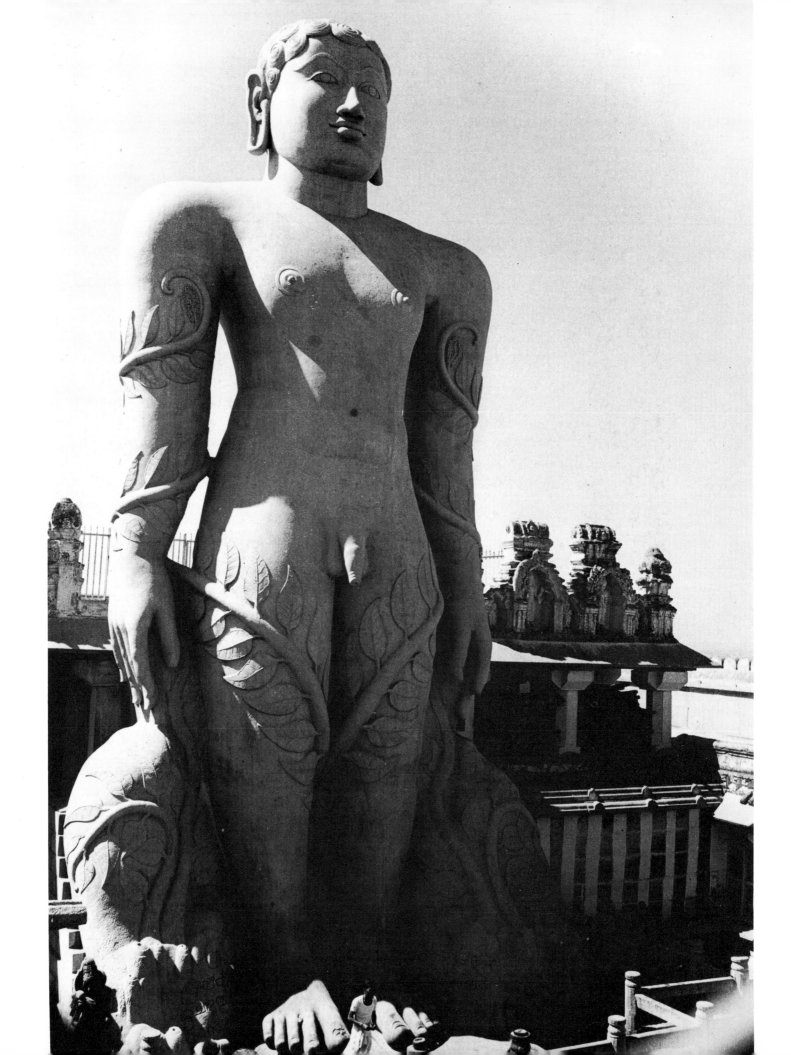

A unique, large copper image in a private collection brings us back – at least partly – into the human world. It shows the infant Krishna being nursed by his foster mother Yasoda, a cowherd's wife. Bronze sculptures of this motif are extremely rare, and no other has the size or the quality of this group, which is unsurpassed in its simple elegance and tender expression; with the utmost economy and subtlety in modelling, the sculptor has given us a remarkably realistic and animated representation of this charming domestic scene.

Several dynasties took turns in dominating the southern Deccan (Karnataka). The Gangas of Talkad (Mysore) intermarried and were allied with the Early Chalukyas, against the Pallavas and, sometimes, against the Pandyas. Eventually the old Ganga domain in Mysore was taken over by the Hoysalas (1022–1342) who threw out the Cholas in 1116, and about two years later succeeded in gradually shaking off the suzerainty of the Late Chalukyas of Kalyani (973 –1200).

The eastern and northern parts of the Ganga realm were, in the ninth and early tenth century, ruled by the feudatory Nolamba chiefs of Hemavati. The two temples at Nandi may be called Ganga-Nolamba.

The most important Ganga monument is the colossal monolithic sculpture of Gommatesvara on top of the Indragiri hill at Sravanabelgola (Fig. 92). It was carved in 983 under orders of Chavundaraya, minister of Ganga Rachamala (974–84). More than six hundred steps, cut in the rock, lead to the top of the hill and the foot of the statue, surrounded by an open-air temple. The colossus is the largest of its kind (17.5 metres) in India; it dominates the countryside. The Jaina saint of the Digambara or 'space-clad' sect stands still in meditation, his arms not touching the body, a faint smile on his face. He stood thus for so long that creepers entwined his legs and arms. A magnificent monument to asceticism and self-denial, he represents the victory of mind and soul over matter. He also represents the immense potential of the human ascetic who, by his austerities, becomes more powerful than the gods.

The Late (Western) Chalukya guardian from Kalyani (Fig. 93) was part of the booty of Chola Rajadiraja (1044–54) who conquered and sacked the Chalukya capital. It was installed in the Darasuram temple near Tanjavur. The *dvarapala*, carved almost in the round, is connected with his *prabha*-like frame in the way a bronze would be. He leans on a tree stump which has replaced the usual club; this suggestion of nature is further enhanced by a variety of wildlife in action. The Chalukya capital Kalyani (Bidar) was a creation of King Somesvara (1042–68) who, suffering from an incurable illness, drowned himself in the sacred Tungabhadra river. The *dvarapala* can be attributed to his reign.

The Hoysala temples of Belur (1117) and Halebid (1150) as well as Somnathpur (1268) are well known. The bracket figure of a dancer in the star-shaped twin temples called Hoysalesvara (Halebid) still recalls its distant ancestor in Badami cave no. 3. As in the Early Chalukya temples (Pattadakal), these and other Hoysala sculptures are often signed by the artist – a feature that hardly exists elsewhere. The brackets adorn pillars and pilasters around the dancing halls in front of the two cellas and their small vestibules. The body here has become almost pneumatic and is loaded with ornament; the pose is somewhat mannered (Fig. 94). Even so – these celestial dancers and musicians are eternal reflections in stone of the *devadasis* who 'used to dance on the polished round platforms below, for their God. The openwork floral motif on the *prabha* is derived from the simpler Nolamba version; the lathe-turned pillars from the Late (Western) Chalukya temples.

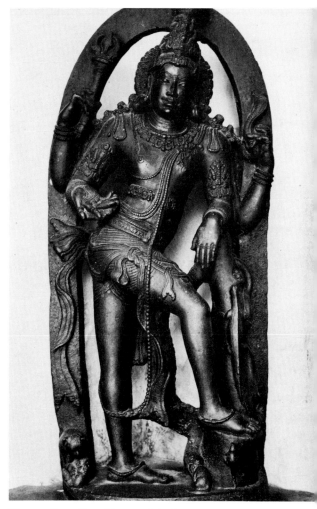

Fig. 93 Guardian (Dvarapala), from Kalyani, installed at Darasuram temple, Tamilnad. Western Chalukya, mid-eleventh century. Tanjore Art Gallery.

Opposite: Fig. 92 Gommatesvara, Indragiri hill, Sravanalbegola, Mysore. Ganga, 983

The life-size Krishna-Venugopala in the southern cella of the Kesava temple at Somnathpur is a *tour-de-force* of stone carving, worthy of this jewel of a temple donated by a Hoysala general called Somanatha. The icon has a metallic sound when struck; the soft chloritic schist or steatite permits minute carving and hardens after exposure to the air.

The last great Hindu power in South India, the Vijayanagar empire was founded in 1336 by two brothers, who were feudatories of the Hoysalas. Soon it reached from the Arabian Sea to the Gulf of Bengal, and from the Deccan to Cape Comorin (Kanya Kumari). The vast and impressive ruins of the Vijayanagar capital, at Hampi on the sacred Tungabhadra river, bear witness to its past importance. The empire was brought down, by the united Muslim kings of the Deccan, in the fateful battle of Talikota (1565). For over two hundred years, it had been a bulwark of the Hindu south.

Krishnadeva Raya (1509–29), one of the greatest kings of the dynasty, began in 1513, the Vittala Svami, a large and splendid temple complex. The monolithic multiple pillars of the *mandapa* consist of a central shaft surrounded by columnettes; some of the latter are, by adjusting their length and diameter, tuned to the seven musical notes, as an architectural xylophone.

Instead of the columnettes, the central shaft of a façade pillar may be combined with large animal sculptures or statues, all carved from the same block.

The Vijayanagar *mandapas* often are of the 'hundred-' or 'thousand-pillared' variety; a trend that was to continue under the succeeding Nayakas.

The superstructure of *vimana* and *gopura* now is of brickwork and mortar, in order to diminish the weight. Some *gopuras* rise to as many as eleven storeys. In the northern part of the empire – including Hampi – the *vimana* carries a gable-projection: one of several features showing Chalukya influence. Krishnadeva Raya gave a new main *gopura* to the Hampi Virupaksha temple; hollow and tall (52 metres), it was built in the corbelling technique.

During the seventeenth century, the Vijayanagar viceroys of the southern provinces, the Nayakas, gradually became independent; some continued these building activities which went on along the same lines, with ever larger and more elaborate multi-pillared halls and still taller gate-towers with more stucco figures proliferating on their many storeys.

The closed ambulatory may be flanked by continuous platforms carrying massive pillars with elaborately corbelled brackets on top, which span the gap above and almost meet each other. These are the famous 'corridors' as at Ramesvaram or in the northern *prakara* of the Ranganatha temple at Srirangam. These buildings of the multi-pillared type have a façade row of sculptured columns carrying almost life-size monolithic sculptures of rearing horses with warrior riders and attendants, and animal figures of the hunt. In the Madurai temple, mostly of the time of Tirumalai Nayaka (1623–59), the huge pillars carry life-size portraits of his royal ancestors with their consorts and retinue, as well as tribal hunters and huntresses and – last but not least – gods and celestials.

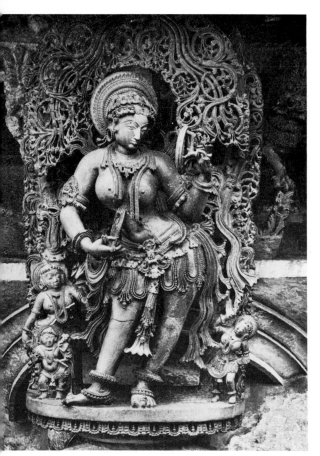

Fig. 94 Celestial with Mirror, bracket figure. Hoysalesvara temple, Halebid, Mysore. Hoysala, *c.* 1150

Some passages in this chapter have previously appeared in the author's *Indian Mediaeval Sculpture* (1978).

PENELOPE CHETWODE

Western Himalayan Hindu Architecture and Sculpture

The magnificent architecture of the valley of Kathmandu is now well known, well documented, and much visited by tourists. Similarly the Himachali districts of Lahaul, Spiti and Ladakh have been 'opened up' and the Buddhist gompas and monasteries recorded by several travellers and art historians, notably by Madanjeet Singh in his book *Himalayan Art*, illustrated by his own magnificent colour photographs.

The Hindu temples of Himachal Pradesh however are less well known, apart from a few notable exceptions such as the rock-cut temple at Masrur, and for the past sixteen years I have been trekking on mules and ponies in search of them. The experience has been infinitely rewarding but also extremely tantalizing, as I realize how many treasures still await discovery.

For the sake of clarity the architecture of the Hindu districts of this spectacular Himalayan state may be classified as follows:

Type 1: The Early and Later Medieval Stone Temples. Type 2: The Indigenous Timber-Bonded Style. Type 3: The Chalet. Type 4: The Pagoda. Type 5: The Sutlej Valley Style. Type 6: The Indo-Mughal Style.

TYPE 1: STONE TEMPLES

Stone temples in the style of the northern Indian plains are to be found all over the area, contrary to the supposition of some art historians. As architectural monuments they cannot be compared with the great temples at Khajuraho or Bhubaneswar, being on a much smaller scale and usually consisting of a *sikhara* and simple porch, without a *mandapa*. The sculpture, however, of the late Gupta to the Gurjara-Pratihara periods (seventh to eleventh centuries) can hold its own with the contemporary art of the plains, as can the exquisite early bronze images of Chamba.

Many stone fragments of classical sculpture are to be found built into the *prakaras* surrounding later temples that are in one of the typical hill styles. These fragments are relatively safe from art thieves but not so those pieces found lying in the courtyards. During the past decade several pieces have been wisely removed to the Himachal State Museum in Simla, notably some beautiful fallen tympana from the seventh-to-eighth-century temples at Hat Koti (Dt Simla), a little known site recently surveyed and put onto the classical Indian art-map by

the museum's director Dr V.V. Ohri.

Several of the medieval stone temples of Himachal are well known, especially those at Masrur, Bajaura and Baijnath, but in this short essay I propose to concentrate on the less familiar temples in the various traditional styles.

TYPE 2: TIMBER-BONDED STYLE

This is a building technique which has been used for hundreds, probably thousands of years in well wooded mountain regions such as the Caucasus, the Elburz and the Hindu Kush, and those parts of the Western Himalaya that are subject to the monsoon. In Himachal Pradesh it is still used today for both sacred and secular buildings and it is possible to observe exactly how it is constructed and how it differs from timber-framing in Europe: first two huge squared deodar trunks are laid along opposite edges of a rectangular dry stone base, then another two are placed on top of them along the other two sides. The intervening spaces are filled with rough undressed stone in the case of farmhouses, but with carefully dressed stone in the case of temples and castles. There is an exterior and an interior wall, the hollow part between them being filled with rubble. The building rises course by course: one of timber followed by one of stone. The roof is gabled with a low pitch so that the huge graded stone tiles stay on by gravitation. Immediately under the eaves runs a wooden

Fig. 95 Bhandar, Nithar Dehra, Outer Saraj

verandah supported by beams which project from the walls. Additional support is sometimes, but not always, supplied by beautifully carved brackets. This impressive type of construction is used in the Himalayan cedar belt, roughly between 5000 and 8000 feet in altitude. It is not confined to Type 2 buildings but the remaining three types of traditional temples mostly have walls bonded with timber in place of cement.

Prominent among Type 2 buildings are the *bhandars*, the store-houses to which devotees from several different villages may bring gifts of farm produce, and where the processional images and the band instruments of the *devatas* are kept. Outstanding examples of these are to be found at Dhaugi off the Sainj valley, at Shamsher Mahadev, Dogi and Nithar Dehra (Fig. 95) in Outer Saraj, and at Sungra in Kinnaur.

Among the most spectacular villages in the whole of Himachal Pradesh is Chaini, situated about 2000 feet above Banjar, Inner Saraj. To reach it you have to scramble up steep footpaths for nearly three miles, as the presiding *devata* of the area, Shringa Rishi, does not allow ponies near any of his temples, and the chief one is half a mile below Chaini. But the climb is well worth while for the village contains only buildings in the timber-bonded style: a tower-type *bhandar*, several three-storeyed farmhouses (the ground floor serving as a cattle byre, the first floor as a store and the top storey the residential quarters for the farmer and his family), a carpenter's colony of two and three-storeyed houses, a *thakur's* castle and, behind it, a detached defensive tower (Fig. 96) about 150 feet high which can be seen for miles around.

The first forty feet of this building, with its roots in the rocky hillside, consist of solid rubble faced with dressed grey stone with tie beams at wide intervals. The upper part is of dressed white stone tied together with cedar beams at regular and frequent intervals. The only means of reaching the first storey is by means of two notched tree-trunks set side by side. The remaining four storeys are connected with one another by step-ladders with wide apart treads. The top one, which commands magnificent views from the verandah, contains a *yogini* shrine with several small metal masks representing those mysterious fairies that are so loved and feared by the hill people.

Below the tower stands the *thakur's* castle. The *ranas* and *thakurs*, the barons of these regions, were once powerful landowners frequently warring with one another and with the Rajas who tried to keep control over them. Chaini Kothi consists of four blocks of buildings enclosing a tiny oblong courtyard. The main block, which faces downhill, is much taller than the others and contains a shrine of Murlidhar (Krishna the flute-player) on the first floor. The entrance to the shrine is from the courtyard and the doorways and window-frames in this block are delicately carved and closely resemble the fourteenth-century decoration at Parashar, described below.

The last timber-bonded monument that I will describe is the great palace/temple complex of Bhima Kali at Sarahan, the former summer capital of the Rajas of Rampur Basharh. This forms the subject of one of James Baillie Fraser's aquatints in his 'Views of the Himala [sic] Mountains', (Fig. 97), published in 1820 from original sketches made in 1814. A study of this picture beside my photograph taken in 1980 (Fig. 98) will show how remarkably little the complex has altered in the interval. There is a large rectangular courtyard enclosed by a variety of residential apartments and shrines, all in the timber-bonded style (apart from a small medieval stone *sikhara* temple to the north), with stone-tiled pent roofs

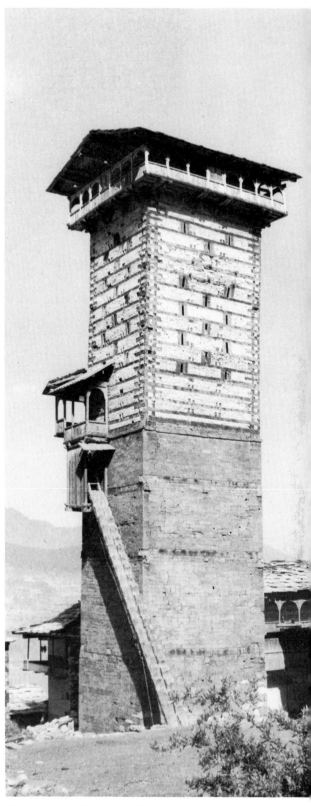

Fig. 96 Defensive tower, Chaini, Inner Saraj

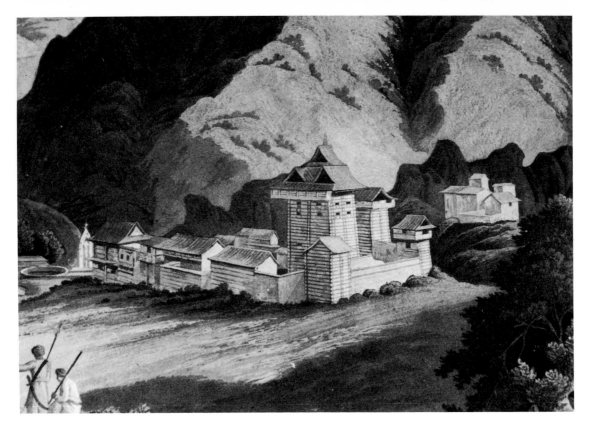

Fig. 97 Bhima Kali temple, Sarahan, Rampur Basharh. Aquatint by J.B. Fraser, published in 1820

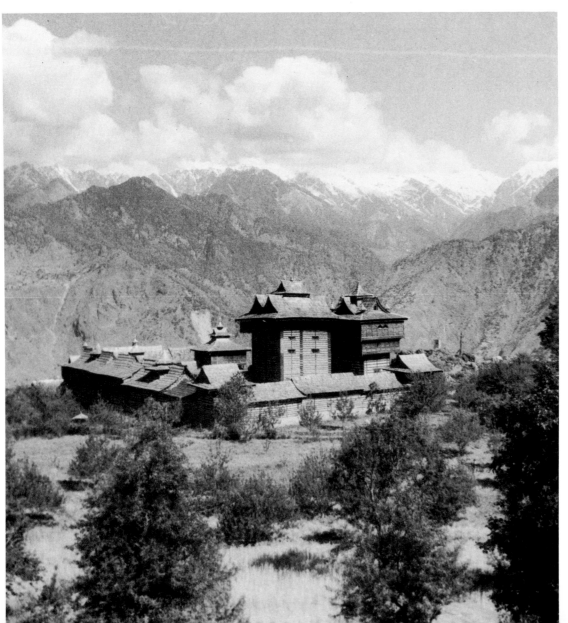

Fig. 98 Bhima Kali temple, Sarahan, Rampur Basharh. Photograph taken in 1980

curved upwards at the ends. Across the courtyard there are two successive screens of buildings with elaborate silver doors made by Kinnauri silversmiths during the reign of the last reigning Maharaja, Sir Padam Singh (1927–47). Beyond these, at the far end of the courtyard, stand two large rectangular towers which dominate all the other buildings. These comprise the temple of Bhima Kali, the last temple in the Sutlej valley to be served by Brahmin priests. The tower to the right, as you stand facing them, is the original shrine of the goddess, and possesses the finest pair of silver doors in all Himachal; they consist of panels of mythological subjects in the *repoussé* technique, made at the order of the reigning Raja in the mid-nineteenth century. The tower itself has an enclosed wooden verandah directly under the eaves and twin pent roofs side by side with a third one bestriding them, exactly as in Fraser's aquatint. But in his version the tower to the left is shown with a single pent roof whereas today it has an elaborate superstructure with a two-tiered enclosed verandah and four little pent-roofs topped by a circular one. These additions were made by the Maharaja in the 1930s when the silver image of the goddess was moved from the top storey of the first tower to the top storey of the second.

Fig. 99 Lion door-knocker, Bhima Kali temple, Sarahan, Rampur Basharh

Fig. 100 Deodar column, carved with Hanuman and snakes, Bijli Mahadev temple, Kulu

TYPE 3: THE CHALET STYLE

This type of temple is found all over the Hindu districts of Himachal Pradesh in a variety of designs. Some are simple wooden buildings with no verandahs, the walls of others are of timber-bonded stone. Some have pillared verandahs in front only, others verandahs running round all four sides. Some have no walls at all but consist simply of a roof supported by squared deodar columns. The great majority are rectangular in plan and have pent-roofs covered with either stone tiles or shingles; but in a few instances the plan is square and topped by a four-sided steep pyramidal roof.

An interesting fact about these little hill shrines is that the most humble structures may boast of the most elaborate carving both inside and out. The most striking examples are to be found at Brahmaur Chatrari and Udaipur, all in the Chamba district, where simple *pahari* shrines contain the finest wood-carving in the north of India, executed between the eighth and sixteenth centuries in the classical style of the plains. In the Beas and Sutlej valleys and in the Simla Hills many of the *pahari* temples are profusely decorated in the various folk-styles of the area, which, as Dr Goetz has pointed out, often contain motifs similar to those of Byzantine and Romanesque Europe, such as lion door-knockers (Fig. 99), reef knots and interlacings and a large variety of confronting birds. Many of the shrines are dedicated to *nags* and *naginis*, serpent gods and goddesses. These are sometimes represented in human form and sometimes as the hoodless grass snakes of the hills (Fig. 100) and not as the hooded cobras of classical Indian art.

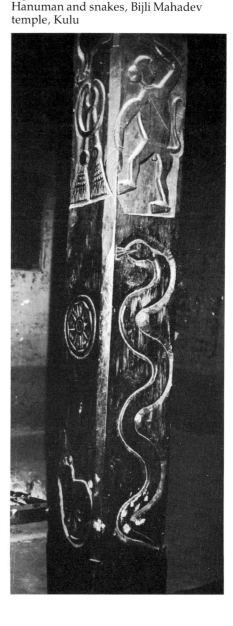

The carving on all types of pahari temples is executed by local *mistris*, a rather misleading term that can denote a simple carpenter, a highly skilled wood-carver, and today even includes a motor mechanic. These men, either singly or in groups of two or three, work within a radius of about twenty miles round their villages, though sometimes I have found evidence of similar styles further afield. They get paid for their work whereas the actual building or restoration of a temple is an unpaid communal effort by the villagers concerned. Some of the *mistris* specialize in *murtis*, panels depicting the gods and goddesses, others in *tikayee*, decorative motifs, today mostly derived from pattern books. At Manan,

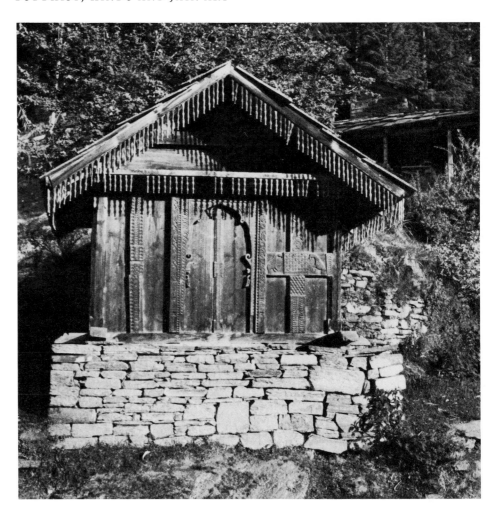

Fig. 101 Narsingh miniature chalet temple, Nagar, Kulu

on the Simla side of Narkanda, we met Mani Ram Mistri, who showed us the pattern book he uses called the *Mirror of Carpentry*, (*Vishyakarma Darpan*) by Mistri Gyan Singh, published in Lahore in 1951. The patterns are mostly floral and geometric and not so beautiful as the flowing and less formal designs of former centuries.

The wood used for decoration, as for construction, is largely deodar, only occasionally walnut or shisham. The wooden fringes, however, are sometimes made from cedar, but more often from the wood of a flowering tree locally called dali. The making of these fringes, called *khururu* in Saraj, involves husband and wife team-work: two small upright posts with holes near the top are driven into the ground about eighteen inches apart and a crosspiece is fitted into the holes. The man sits cross-legged on the ground with the tools of his trade while his wife puts a piece of rope round the crosspiece, which she pulls gently backwards and forwards. The Chaini *mistri* who told us this explained that the woman 'sets her hand', and knows exactly how much pressure to put on, while the man makes the necessary incisions round the revolving crosspiece to form the desired pattern. On this humanly propelled lathe a good team can turn out as many as a hundred fringe sticks a day. These are then attached to the fringe boards, which consist of a pair of thin planks fixed under the eaves of temples or along the bottom of balconies. Large holes are bored in the fringe sticks so that

when they are hung loosely between the boards by means of long nails, they knock together and rattle in the wind and form one of the most decorative and original features of *pahari* temples (Fig. 101). Nowadays alas, few *mistris* and their wives do this team work any more and lifeless patterns are cut out of tin and stuck under the eaves of temples as a poor substitute for the wooden fringes.

Among the many chalet-type temples with outstanding decorative wood-carving are the Devi temple at Jenog near Simla, the Thakurdvara in Nirmand, the little Nag temple at Goshal in the Upper Kulu valley, the Shiva shrine outside Bhalan above the Sainj valley, and the little temple of Chungarsi Devi in the romantically situated village of Chong on the old route up the Parbatti valley. This contains a magnificent carved screen, stretching like an *iconostasis* right across the interior of the building in front of the *garbha griha* and is the only one of its kind I have so far come across. The human figures on this screen and on the outer door of the Bhalan temple (Fig. 102), wear Mughal dress and so may date from the eighteenth century, as Mughal influence would hardly have penetrated to such remote villages before then.

TYPE 4: THE PAGODA STYLE

The Hobson-Jobson glossary has five pages of small print dealing with the several meanings of this term. I use it here exclusively in the architectural sense to describe buildings with two or more super-imposed roofs, each one a little smaller than the one below it. It is a style which is not only common in most parts of the Far East with which it is usually associated, but also in many parts of South-East Asia, in the Himalayan regions of north India and Nepal, in Kannara and Kerala in South India, in Eastern Europe, in Norway, and we even have a fine example in the detached belfry tower at Pembridge in Herefordshire, with hints of it on several other church towers along the Welsh border.

Fig. 102 Devotee in Mughal dress, woodcarving, Bhalan temple, Inner Saraj

The pioneer writer on Kulu temples, A.F.P. Harcourt in his book *The Himalayan Districts of Kooloo, Spiti and Lahool* lists only four in the pagoda style, one of which at 'Teenun' in the Parbatti valley, nobody has succeeded in identifying. H.L. Shuttleworth found several more, including the only five-tiered one so far known in Himachal Pradesh, at Shainsher in the Sainj Valley.

The following is a list of free standing pagoda temples I have so far seen in the area:

1. *Doonghri*, in the deodar forest above Manali, near the head of the main Kulu valley; the four-tiered temple of Hidimba; dated 1553 in an inscription on the facade.

2. *Nagar*, in the main Kulu valley, the three-tiered temple of Tripura Sundari; the roofs were renewed in 1970.

3. *Dhalpur*, in the lower bazaar; two-tiered temple of Sita Ram, fairly modern.

4. *Khokan*, about 1½ miles west of Bhuntar, in the main Kulu valley; dated 1753; four-tiered temple of Adi Brahma with particularly good serpentine brackets supporting the eaves; the top storey is rectangular whereas in all the other examples in Himachal it is circular.

5. *Diyar*, 2000 feet above the left bank of the Beas, opposite Bajaura in the lower Kulu valley; temple of Triyuginarayan, three-tiered with large stone tiles on the lower roofs; sketched by Harcourt in the 1860s.

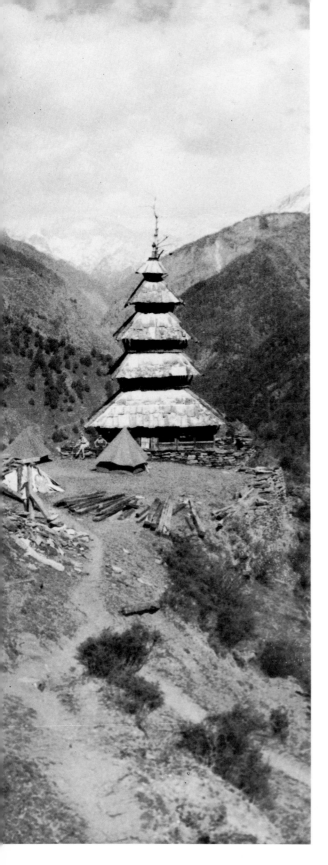

6. *Hurla*, on the left bank of the Beas below Diyar; three-tiered temple of Virnath, built in 1970 and well-proportioned; painted blue and white.

7. *Shainsher* (Fig. 103), about 2000 feet above the river near the head of the Sainj valley, Inner Saraj; the five-tiered temple of Manu Rishi, but not more than circa 50 feet in height; very steep pitch to the roofs; the large stone tiles are fixed with iron nails to wooden planks beneath them; good carving, but the whole building is badly in need of repair.

8. *Plach*, above the Tirthan Khud, Inner Saraj; three-tiered temple of Shringa Rishi, painted silver and white.

9. *Balagad*, Jalori khud opposite Banjar; three-tiered temple of Markanda Rishi; good carving spoilt by silver and white paint.

10. *Banjar*, chief village of Inner Saraj; two-tiered temple of Durga, early twentieth century and just renovated and reroofed by a local *mistri*.

11. *Shogi*, above the road leading from Bajaura to the Dulchi pass; two-tiered temple of Bari Nag; the wooden fringes are almost complete. Good serpentine brackets.

12. *Dhiri* (Fig. 104), in Mandi district between the top of the Dulchi pass and Parashar; a beautifully proportioned three-tiered temple of Brahma renovated and reroofed about twenty years ago with complete sets of wooden fringes and good samples of decorative carving done by local *mistris*; beside it stands a very nice tower-type bhandar hung with fringes.

13. *Kamand*, three-tiered temple of Parashar Rishi described below.

14. *Parashar*, three-tiered temple of Parashar Rishi described below.

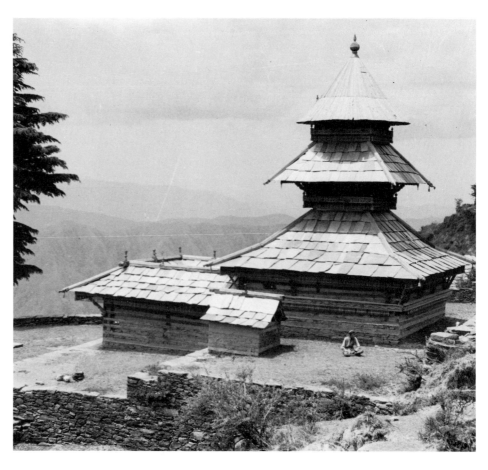

Above: Fig. 103 Manu Rishi pagoda temple, Shainsher, Inner Saraj

Right: Fig. 104 Brahma pagoda temple, Dhiri, Mandi

I have listed the last two temples together, though Dhiri lies between them, because I regard them as sister temples both dedicated to the same *devata*, Parashar Rishi, a Vedic sage, and almost certainly decorated by the same group of *mistris*. It is recorded that the temple at Parashar was built by Ban Sen, a Raja of Mandi who reigned during the first half of the fourteenth century but whose exact dates are uncertain. It is situated in a basin of green hills in the Mandi district beside a small lake with a floating island on it and remained one of the royal temples that every Raja had to visit at least once during his reign. From the ridge above there is a wide view of over two hundred snow peaks of the Great Himalayan Range. Grouped beside the temple are the priest's house and several pilgrim shelters. The nearest village is three miles away. The two lower, steeply-pitched roofs are covered with beautiful blue slates from the Mandi quarries while the topmost one is circular and composed of deodar planks.

The temple at Kamand stands in a magnificent grove of deodars some twenty miles from Parashar and only nine from Kulu town. All three roofs are of wood and were renewed about ten years ago. Between the storeys of both temples the wooden galleries, supported on square columns, are elaborately carved. At Parashar twelve square cedarwood columns form a verandah right round the bottom storey and immediately below the capitals there are panels which are neither pot and foliage nor bird and pot, but bird, pot *and* foliage (Fig. 105). Each bird has a curved beak and a ring round its neck beneath which its curiously attenuated body and stumpy tail dissolve into swirling foliage. Between each pair of confronting birds there is a wide fluted pot. Exactly the same panels are found at Kamand and in both temples the Gupta-style doorways of carved deodar with seven receding jambs and lintels are among the finest in the hills.

Fig. 105 Bird, pot and foliage panel on a column, Parashar Rishi temple, Mandi

TYPE 5. THE SUTLEJ VALLEY STYLE

This is a fusion of the Types 3 and 4, with the chalet acting as the *mandapa* of a classical temple and the pagoda tower as the *sikhara*. Longhurst thinks that this type of construction preceded the free standing pagoda, and he may well be right; but the four indigenous types of hill temple interact on one another so that an accurate chronology of the style is impossible. I have called Type 5 the Sutlej Valley style because it is found in considerable numbers in the regions bordering that river, that is Outer Saraj, the Simla Hills, Rampur Basharh and Kinnaur. It can be very simple with a single circular roof, or a large elaborate building with a two- or three-tiered roof over the sanctum, as on the temple of Dakhni Mahadev in Nirmand, Behna Mahadev near Ani (Fig. 108), and the great temple of Maheshwar in Kinnaur (Fig. 107), the district in which this style is most highly developed.

Here, there is only space to describe one such building and I have selected the small but enchanting little temple of Durga Dhanesvari at Nithar Dhana (Fig. 106) about 2000 feet above the Sutlej and eleven miles west of Nirmand. It stands to one side of the village green and has a curved roof covered with huge stone tiles and an elegant little square tower over the *garbha griha* consisting of an open gallery with four square columns supporting a circular tiled roof crowned by a metal-fringed umbrella. An open verandah runs the whole way round the building at ground-floor level supported by square cedarwood columns on which are carved fascinating and varied examples of the confronting and addorsed bird motif. The walls of the *mandapa* are of timber-bonded stone with

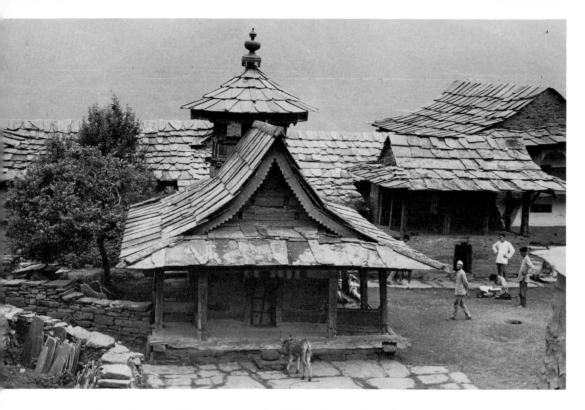

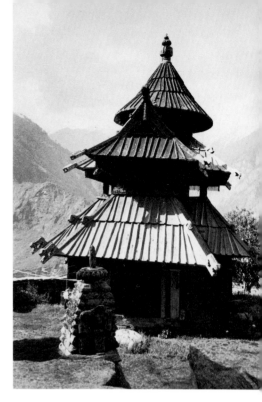

Fig. 106 Durga Dhanesvari temple, Nithar Dhana, Outer Saraj

Fig. 108 Behna Mahadev temple, Behna, Outer Saraj

Fig. 107 Maheshwar temple, Sungra, Kinnaur

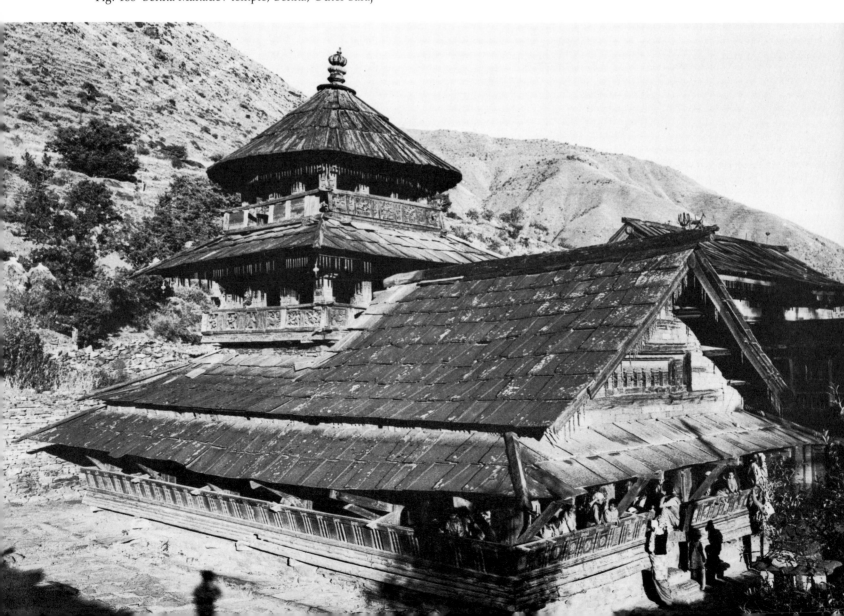

cedarwood panels let into them at irregular intervals. On these are carved representations of Shiva and Parvati, Vishnu and Lakshmi, and several versions of Durga killing the buffalo demon (Fig. 109), which are of such rhythmic beauty – and curiously Nepalese in style – that they really deserve to be ranked as fine rather than as folk art.

TYPE 6. THE INDO-MUGHAL STYLE

Since the seventeenth century Mughal art and dress have been fashionable in the hills. For this reason it is rare to find buildings in the indigenous style represented in *pahari* paintings. Radha and Krishna desport themselves not beside timber-bonded towers or three-tiered pagodas, but within or without Mughal pavilions of white marble with onion domes and cusped arches.

Mandi, the prettiest little town in the Siwaliks, contains a large number of small temples in the Indo-Mughal style, starting with the royal shrine of Syam Kali on Tarna hill built in the seventeenth century by Raja Shyam Sen (reigned 1664–79). Subsequently many more such temples were built, some with *shikharas*, some with domes taking their place. There is often a cupola-crowned porch carried on three Bengali arches, the front one usually enclosing a charming little *torana* typical of the Mandi school. It consists of confronting musicians, each holding a vina, and beneath them confronting elephants' heads with a *mahout* sitting on each and holding the animal's trunk in one hand.

The latest temples of note in the Indo-Mughal style are at Tira-Sujanpur in the Kangra district, one dedicated to Siva built in 1793 and the other to Vishnu built in 1823 during the reign of the famous Raja Sansar Chand (1775–1823). They are both in the form of open pavilions of cusped arches and are among the few surviving monuments of this period to retain their contemporary decorative painting.

Mughal influence still continues in the hills as I discovered on a recent visit to the village of Sarahan in Outer Saraj (not to be confused with Sarahan in Rampur Basharh). Here the villagers have pulled down the temple cum *bhandar* and rebuilt it extremely well with an elaborate doorway of which the principal feature is a beautifully cusped arch.

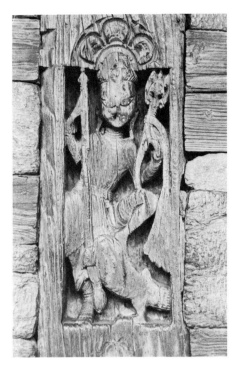

Fig. 109 Durga killing the buffalo demon (Mahisha), outer wall panel, Durga Dhanesvari temple, Nithar Dhana, Outer Saraj

Art in the Islamic Period

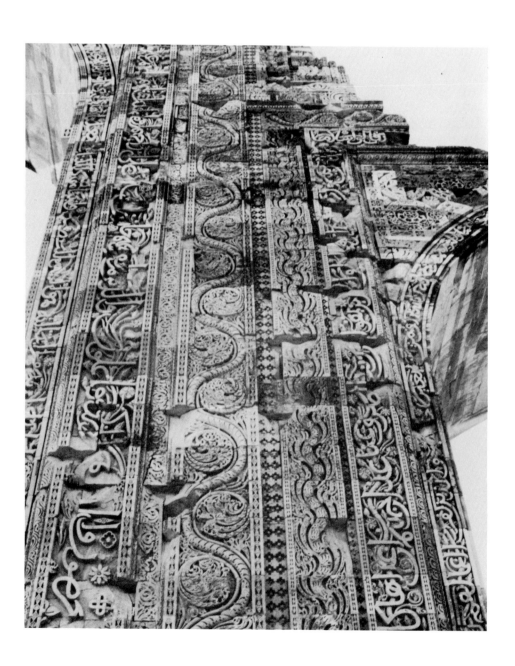

Fig. 110 Screen of Qutb al-Din Aybeg at the Quvvat al-Islam mosque, Delhi. 1199.

PETER ANDREWS

The Architecture and Gardens of Islamic India

Islam came to dominate Northern India gradually through a combination of invasion, immigration, expansion and conversion. Its first irruption in the Arab invasion of 711–12 was limited to the annexation of Sind. From the beginning it was proclaimed that those who became Muslims would enjoy the same rights as their Arab overlords. Entire tribes submitted, but by the end of the ninth century Islamic influence was limited to a few towns. The permanent colonization did not begin until, between 999 and 1027, a series of ruthless raids was undertaken by Sultan Mahmud from the Turco-Iranian empire centred on Ghazni, in present-day Afghanistan; these roused general antipathy, but some mass conversions were made, and a province was established in the Punjab. After the defeat of the Ghaznavids by the Ghurids, Lahore became their new capital, and it is from this period that the Iranian basis of Indo-Islamic culture was introduced, with Persian as the court language. In 1186 the Ghurids took over the Punjab, and transferred the capital to Delhi; this new occupation gave rise to the expansion of Muslim society under the Sultanate founded in 1210.

The founders of the new state were Central Asian Turks, including a most important element of slaves who, according to the customs of the time, could rise to the highest positions. Turks of various tribal origins, Alp-eri, Khalaj, and Qarauna, dominated the succession of dynasties that followed. Later, considerable numbers of Afghans moved in, and converts from the local population began to hold office. The Sultanate, consolidated from Bengal to Sind, could only be maintained at the cost of incessant campaigns against neighbouring Hindu principalities, which inevitably led to further expansion. By the second quarter of the fourteenth century, expansion into the Deccan was seen as a means of propagating the faith, by both conquest and proselytism. In about 1335 virtually the entire sub-continent was under the rule of Muhammad Tughluq, but the difficulties of controlling so huge an area were insuperable, and the empire shortly began to disintegrate into independent Muslim states.

As an egalitarian religion with a clearly defined code of civil rights, Islam was attractive to the underprivileged members of the Hindu community, especially those without caste who had not even been allowed to live within the cities, and professionals. A negative incentive was provided by the poll-tax levied on the non-Muslim population. The monotheism of Islam, when viewed with the pantheistic interpretation given it by certain Sufis, was not irreconcilable with

the current of Hindu thought represented by the *Upanishads*; the broad-minded and considerate attitude of such orders as the Chishtis therefore played an important part in effecting these conversions. It was countered by the conservatism of orthodox theologians, more particularly after the destruction of the centres of Middle Eastern civilisation by the Mongols, from 1220 onwards, made the preservation of traditional Islamic culture a matter of urgent concern. Indo-Islamic values thus remained dependent on a previously formed literature, and were carefully guarded against any assimilation of idolatrous practices from the natives. Nevertheless Muslim behaviour was affected by Indian practices, in such matters as meditation and social customs, while Indian religions adapted by making religious knowledge more accessible to all. The form of Islam remained Sunni in the north, though there was Shii influence in the southern sultanates, with links to the south of Iran.

Once the country had been invaded by Babur, and victory secured in 1526, reconstruction of an empire could begin again. The Mughals, despite their name, were the Chaghatay inheritors of the culture of Timurid Central Asia, and continued to speak Turki until the early eighteenth century. By the end of Akbar's reign, in 1605, the northern half of the sub-continent was once more under one rule. The need to accommodate cultural differences, ranging from the division into Iranian and Turkish factions at court to a wide variety of native influences, led Akbar to formulate a policy of 'Universal Toleration'; he abolished the poll-tax and secularized the administration. This tolerance was respected by Jahangir, with a slow return towards orthodoxy under Shah Jahan, who for example forbade the building or repair of Hindu temples. The demise of the syncretic culture is personified in the defeat of its champion, Dara Shikoh, by his brother, the rigidly orthodox Aurangzeb. By the end of the seventeenth century Aurangzeb's zeal had led to the conquest of all but the southernmost tip of India; once more, over-extension in an age of poor communications was disastrous for the central government, and led to a decline in power from which the Mughals never recovered.

The power of this succession of highly centralized states in both religious and civil spheres is expressed in their buildings: mosques on the one hand, and palaces, from which the administration was conducted, on the other. Tombs formed a more enduring monument to the dynasties.

Both mosque and mausoleum were made to satisfy requirements quite different from those of Hindu practice. Where the temple was a close, dark, womb-like structure in which the individual could be brought into private confrontation with his deity, the mosque was a place for congregational worship, not sacred in itself, but providing a clean, open area suitable for the communal prostration, *sajda*, that gave the building its name of *masjid*. In Arabia it had been adapted from a domestic courtyard lined with colonnades and cells at the sides: an arrangement that was well suited to the climate of India. The most essential element was a straight wall facing the direction of Mecca, for it was parallel to this that the faithful formed ranks to pray. There was no altar, no sanctum: only a semicircular niche, the *mihrab*, to formalize the direction, and to help reflect the prayer leader's voice to those behind him. It was along this wall that the colonnade came to be deepened into a prayer hall to provide shelter in bad weather, and shade for the smaller assemblies. Instead of figurative sculpture, there was a tradition of finely designed inscriptions, and abstract tracery.

The mausoleum had been as foreign to Muslim intentions as it was to the Hindu, but within a century or two of Muhammad's death (AD 632) it had been adopted in the Middle East from pre-Islamic monuments to enshrine first prophets and saints, then kings. It soon became associated with a dome representing the heavens. Below, the sarcophagus was aligned north and south, so that the corpse could face Mecca and a *mihrab* again showed the direction. In other respects the space was without any directional emphasis, and the plan could be square, round, or octagonal; the size, and particularly the height of a tomb was a matter of prestige.

Even these types acquired a specifically Indian character. Much of their fascination grows from the liveliness with which their builders fused elements from both Middle Eastern and local cultures, and the history of Muslim building in metropolitan India is to a large extent a series of adjustments to the strength of these influences not only from outside, but from different regions of India itself. The development of this inherently administrative architecture is steady enough to be seen as the gradual growth of a style.

The beginning is as yet unclear. Few remains have been attributed to the Arab occupation of Sind from 711. Some already display an adaptation of Indian forms to an Arab plan. The seventeen invasions led by Mahmud of Ghazni from 999 onwards have left us with less. If it is true that he built a tower and a mosque at Lahore, then they must have perished in the Mongol raid of 1241. Yet in Ghazni itself it seems that Indian craftsmanship was already being applied to the forms inherited from the Samanids of North-eastern Iran. The tomb of Mahmud himself is decorated with cusped horseshoe arches, a combination of forms characteristic of subsequent Islamic design in India.

It was the Ghurids who established the Muslim domination of Northern India, when Qutb al-Din Aybeg defeated Prithvi Raj in 1192, and conquered Delhi. Ghur itself, lying between Herat and Ghazni, was well placed to transmit influences from Khurasan and Transoxiania. Here too there is evidence of Indian craftsmanship in details of the little Masjid-i Sangi at Larvand.

Aybeg's overthrow of the Hindus is commemorated quite literally in the Masjid Quvvat al-Islam ('The Might of Islam') at Delhi, for it was built in 1197 on the plinth of one temple, with materials pillaged from twenty-seven others demolished by elephant power. As such it is a lapidary museum of roughly-assorted parts, with columns set one upon the other to attain the necessary height. The plan is of the Arab type with colonnades four bays deep for the prayer hall, three to the east, and two to the north and south. Some of the figurative carving was defaced and plastered over, but a surprising amount of Hindu and Jain work remains. The light columnar technique of contemporary Jain building was particularly suitable for mosques, where uninterrupted floor space was so important, and in theory at least a Jain temple could be converted simply by removing its central pavilion, to leave the peripheral cloister. The five domes over the prayer hall were also built with Jain methods, using an octagonal system of lintels to support successive rings of corbelling: a device that eliminated most of the horizontal thrust of a true vault. In each of the four corners of the mosque there was a square mezzanine for women, with the roof raised to form a clerestory above.

The result can hardly have satisfied Aybeg, for by 1199 he had added a great screen of five pointed arches as a façade to the prayer hall (Fig. 110). With its central arch rising twice the height of the others, this front is clearly derived

from Iranian work, such as the Ribat-i Sharaf on the road to Samarqand (1114 and 1154), or the Ghurid Shah-i Mashhad (1165). Yet in detail the Hindu influence is still dominant: the arches are peaked, and not built of voussoirs, but of corbelled courses; even the inscriptions proclaiming the divine command are set among sinuous, spiralling tendrils of astonishing vigour. The screen overwhelms the prayer hall, whose roof runs under the springing of the lower arches. In this contrast of scale it was to influence much of the work that followed, especially in Gujarat.

A much better-preserved mosque at Ajmer, the Arhai din ka Jhompra dated 1199–1200, displays the same combination of parts, but there is evidence of careful control by its architect, Abu Bakr of Herat. It is more spacious, better coordinated, and some elements, though Hindu in style, are specially made. Once again a screen was added to the prayer hall, this time by the Sultan Iltutmish in 1230 (Fig. 112). The cusping of the side arches, where the curve of the extrados follows the intrados, again recalls the Ribat-i Sharaf, though their treatment resembles the cusped outline of Hindu brackets: it is reflected in the fine marble mihrab. The reeded corner bastions and bold steps were soon adopted into the vocabulary, but two minarets on the screen were to remain unique for some 200 years.

In 1199 Qutb al-Din had built the first storey of an immense free-standing tower, the Qutb Minar, beside the Quvvat al-Islam (Fig. 111). Another three storeys, each with a corbelled balcony, were added by Iltutmish. The first, forty-seven feet in diameter, rises in a series of alternately angular and convex ribs set vertically in a pronounced taper; the second in convex ribs, and the third in angular ones. The fourth, to judge from nagari inscriptions, was originally round as it stands now, though it was later clad in marble and rebuilt. The robust solidity of these red sandstone faces is combined with an extraordinarily powerful upward thrust, stage upon stage, delayed and emphasized by the faceted balconies and bands of inscriptions. The design is wholly Islamic. A similar lower storey, now ruined, has been found at Khwaja Siyah Push in Sistan (twelfth century?); the second storey resembles the tower of Jar Qurghan in Uzbekistan (1108), and the superimposition of four stages from the brick tower of Jam (c. 1162–1201), at the Ghurid capital. As an image of the *axis mundi* (*qutb*), the tower was intended to cast 'the shadow of God over the East and the West'. It remains unrivalled in the Islamic world.

A square tomb immediately behind Iltutmish's extension of the Delhi mosque is thought to be his own (c. 1235; Fig. 113). Its dome, now fallen, must have been corbelled, for the squinch arches across the corners and the semidomes behind them are both corbelled in a thoroughly Indian manner, though the extreme angle is bridged by a triangular slab reminiscent of work in Khurasan. Externally the walls are plain, relying only on the contrast of grey stone with red; inside, the cubical space is enhanced with intricate carving on every surface. Both the articulation of the ornament and its framework of inscriptions are Islamic, yet the activity of the surfaces is inescapably Indian.

Ala al-Din Khalji's abortive attempt to enlarge the Quvvat al-Islam mosque is epitomized by the stump, 275 feet in girth and 70 feet high, of another reeded tower, the Alai Minar, which he had ordered to be built at twice the height and circumference of the Qutb. One part of the complex alone has reached us intact to show what he might have achieved. This is the southern gatehouse called the Alai Darvaza (1311), a cubic space with a true, voussoired archway in the centre

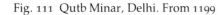
Fig. 111 Qutb Minar, Delhi. From 1199

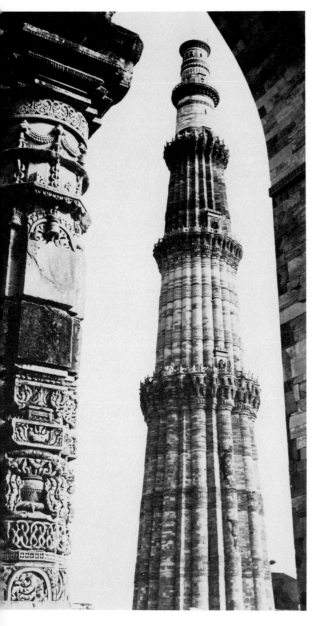

of each side,[1] and a dome overhead (Fig. 114). It can be recognized as a descendant of the Persian four-arched pavilion (*chartaq*); temporary structures of the kind had graced royal triumphs since the time of Qutb al-Din, and this was, appropriately, on the approach from the palace. Internally its symmetry is interrupted only by a rise in level towards the mosque. The transition from the square to an octagonal basis for the dome is achieved by compound squinches of pointed horseshoe arches in five concentric recessed planes, a device already used in Khurasan at for instance Qırq Qız near Termez (ninth-tenth century). The dome rises in a two-centred curve lightened at the top by a small hemispherical protrusion upwards. Its surface is smooth, save for some delicate outlining of the arches, but the red sandstone of the walls is entirely transformed below the springing by an intricate mesh of pattern in low relief, which extends confidently to geometric frets on the intrados. Outside, the change in level is masked by a sandstone podium carved with rosettes and trefoil meanders of still Hindu ornament. The dark red wall above is divided into carefully balanced panels framed by white marble in two storeys, and set with inlays of black marble and blue schist that betray a connection with Gujarati work. The central bay on the approach side originally rose higher than the adjoining parapets for distinction. The main arches are pointed horseshoes each with a cusped fringe of lotus buds edging the intrados to ease its outline against the glare, set within an outer arch of fluently inscribed marble. The flanking bays of the lower tier are arched with three successive planes, contrasting buds and cusps, and red with pink stone; their windows are veiled by lattices pierced with Islamic stars and hexagons, whose facets again disperse the brilliance of the light. Each arch is

[1]The first appearance of the voussoired arch is usually assigned to a dilapidated 'Tomb of Balban' (d. 1287) in Delhi, but there are no inscriptions or other means by which its identity can be confirmed.

Fig. 112 Screen of the prayer hall, Arhai din ka Jhompra mosque, Ajmer. 1230

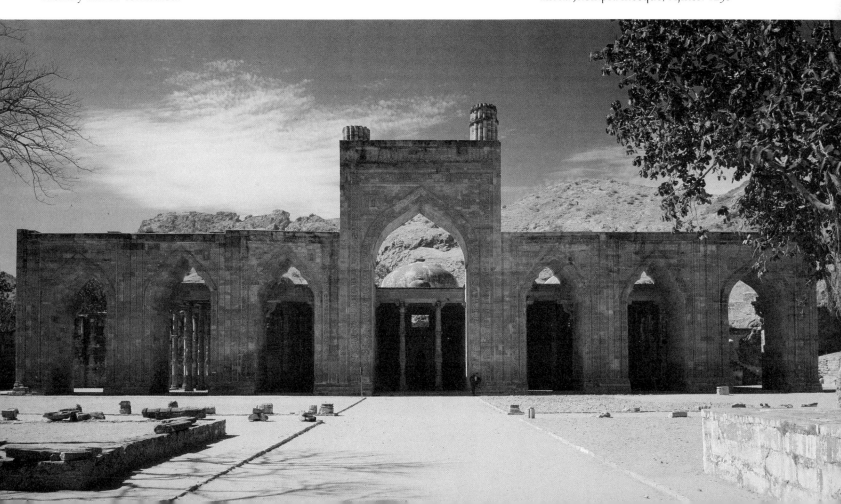

supported by graceful angle shafts. In the top tier are set pink panels carved into shallow niches of a Hindu type, with arches and shafts in miniature. Everywhere there is an intelligent play of red against white, of scrolling against calligraphy, of mass against fretwork. Above, the nipple of the dome is crowned with a Hindu *amalaka*. At the rear, the gate opens under an unexpected trefoil arch inscribed within a semicircle. It is a most accomplished building.

Little of this delight in surface was indulged during the remainder of the fourteenth century, under the Tughluq dynasty. Yet the combinations of elements that had come to be preferred in the thirteenth continued to be used, even if with a new severity. In Multan Ghiyath al-Din Tughluq had built himself a tomb before he founded the line at Delhi (*c.* 1315?); it was devoted instead to the saint Rukn-i Alam. Earlier tombs in Multan, such as that of Baha al-Haqq (d. 1262) were built in three distinct stages, a square chamber with plain battered walls, an octagonal zone of transition, and a cylindrical drum surmounted by a dome, and a massive finial. A model for this combination, with the same projecting bay for the entrance arch, is to be found in Khurasan, in such tombs as those of Abu Said at Mekhne (d. 1049),[2] and Alamberdar near Karkhi (d.

[2]Comparisons with Central Asian building are drawn from works in Russian by Pugachenkova, and Pribuitkova.

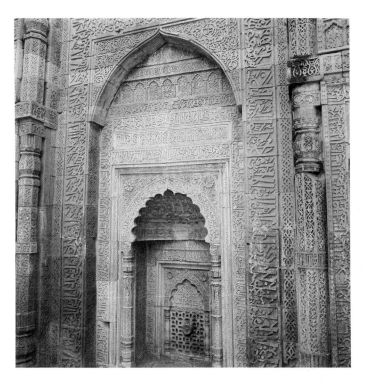

Fig. 113 Interior of the tomb of Iltutmish, Delhi. *c.* 1235

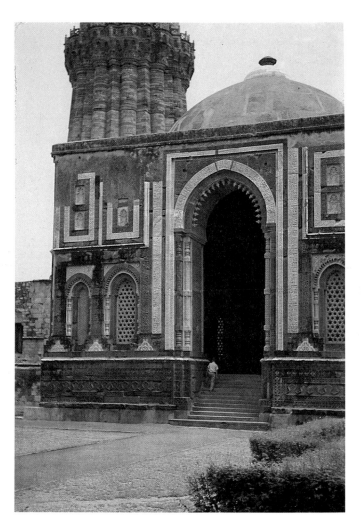

Fig. 114 Alai Darvaza, Quvvat al-Islam mosque, Delhi. 1311

1004). The new tomb was comparable, but its lower stage is octagonal instead of square, and the effect of batter is accentuated by tapered round buttresses at the angles, which are carried up above the merlons as domed tips. Here too there is a Khurasanian prototype in the eleventh-twelfth centuries. Internally the second stage houses a zone of sixteen sides where concentric arches for squinches and clerestory windows alternate. Outside and in, the tomb is remarkable for the finesse of its carved brickwork – for stone was in short supply in the Punjab – and for panels of blue and white tiles in relief.

The actual tomb of Ghiyath al-Din at Delhi (1325; Fig. 115), combines the forms from Multan with features recognizable as Khalji. Its polygonal fortified enclosure once delimited an island in a lake; though they run free of the tomb itself, these walls with their tapered bastions give it a prominence which recalls that of Rukn-i Alam. The tomb, however, is square in plan, with the usual three zones, of which the second octagonal stage is reduced to a minimum, and the dome, though similar, lacks the distinct drum usual in Multan. The red sandstone walls of its lower stage are strongly battered, at an incline of 75°, so that it seems all angles. The slight projection of the central arched bay resembles the front of the Jamaat Khana mosque; the contrasting bands or panels of white marble, the delicately merloned parapet, the lattice in the tympanum of the arch and the lotus buds on its intrados, and the shafts at its jambs are all in the local

Fig. 115 Tomb of Ghiyath al-Din Tughluq, Tughluqabad, Delhi. 1325

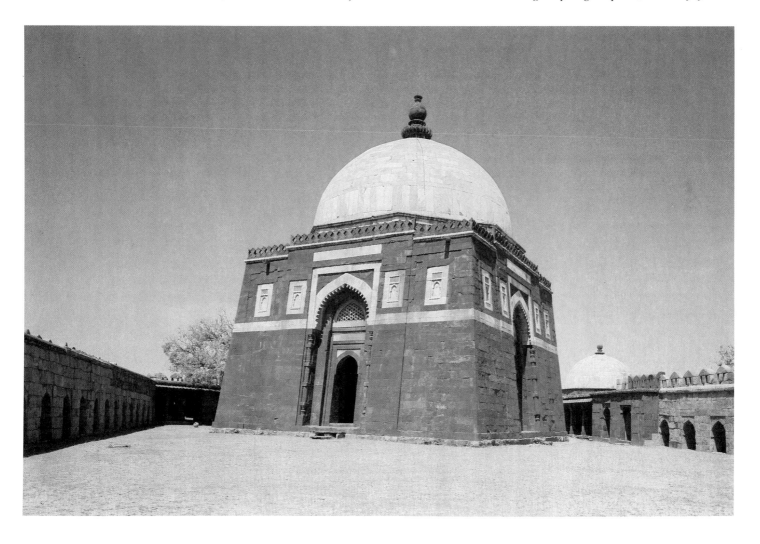

vocabulary. The contrast is carried further in the white marble sheathing of the dome, emphasized by vertical slabs round its base, and the large stylized water-pot of the finial in red. Only the upper part of the walls is ornamented, perhaps because the fortification screens the lower part from a distance, though this was also a characteristic of Khurasanian work. Unusual attention is paid to lintels, which divide the doorways from the arches containing them. This can be seen again in the form of the squinch arches, which like those in the Jamaat Khana at Delhi (completed 1325) are framed, and where the smaller arch is recessed under a crossbar. The dome remains unlit.

A description of the palaces at Delhi has been left by Ibn Battuta, who was constrained to stay in India from 1333 to 1341. The old palace of the Khaljis, which he calls Kushk-i Lal (Lalkot) was then abandoned, complete with its furnishings. Its plan seems to have been followed by Muhammad Tughluq in his new palace at Jahanpanah, the Dar Sara. There the first gate, leading into a court for general audience, held a band-stand from which the arrival of dignitaries could be signalled; there was an audience hall in the first court, with platforms on either side for the guard. Porters watched at a second gate, and the second court contained a large platform for the master of ceremonies, besides a large space for audience. A third gate, supervised by scribes, led to a hall known as Hazar Ustun ('The Thousand Columns'), built of wood, beautifully carved and painted, where the ruler held private audience. Here a vast marquee could be pitched over the audience court, surrounded by pavilions, and even artificial flowering trees made of silk in different colours were placed in rows leading to the Sultan's dais. It is plain that court ceremony had already reached a level of elaborate ostentation, and the organization of the precinct into areas of successively greater privacy was conceived as a theatrical setting for royal appearances. Of the buildings we are told only that the palace of Ghiyath al-Din had tiles gilded so that 'when the sun rose they shone with a brilliant light and a blinding glow'.

Such magnificence was not confined to permanent buildings. According to al-Umari, Muhammad used to go hunting with four portable wooden palaces loaded on 800 camels, each of two storeys with coverings of black silk embroidered in gold (to match his dragon standard), besides tents and trellis tents. In 1325 he had erected a wooden pavilion in three days for the reception of his father Ghiyath al-Din, which happened to collapse and kill him, some say through an intentional design fault, when elephants marched by!

The relative austerity of buildings from the reign of Firuz Shah (1351–88) can be attributed in part to economies forced by the excesses of the preceding reign, but as much to his own sense of simplicity, and his urge to reform; his interest in building was remarkable, and he even took care to repair the monuments left by his predecessors.

His most ambitious project, the new citadel Kotla Firuz Shah within his city of Firuzabad (1354), is now ruined. The palace took advantage of the cool sites on the bank of the Jumna, and his mosque there, raised on a basement storey, was connected on the north to a square pyramid of three arcaded storeys on which there still stands one of Asoka's monolithic pillars 'as a *minar* for the mosque of the faithful': proof that in India this was more a marker than a means for issuing the call to prayer.

Externally the larger mosques of this period resemble forts; they have heavy tapered bastions at the four corners capped with domes, parapets of heavy,

leaflike merlons, and strongly salient gateways flanked by matching but smaller bastions at their outer angles, with cannon-like pinnacles, *guldasta*, above the skyline. They are now the more forbidding for showing the coarse rubble schist of which they are made, but this was originally plastered and whitewashed. Several are raised on a high podium which can be used to house cells for shops, of benefit to the mosque because their rent supports its trust fund. Such raised mosques are characteristic of India, offering the advantage of fresher air currents in the heat. They appear to be a legacy from Jain shrines, such as those of Palitana.

A variation of this type in the Sanjar and Khirki Mosques, both of about the same date, has the courtyard traversed unexpectedly by extensions of the cloisters running from north to south, and east to west, to divide it into four equal squares left open. The device is almost certainly taken from Jain temple plans, such as those at Mount Abu (compare also Ranakpur, dated 1439), though the central, four-faced shrine is of course omitted, and groups of nine domes are placed over each of the intersections in lieu of the *sikharas*. Though convenient for the shade it gave, the plan hardly expressed the unity required in Islamic liturgy, and it was abandoned thereafter. The courts are surrounded with a continuous sloping eaves slab (*chhajja*) to throw monsoon water clear of the interior, an Indian element introduced, it seems, at this time. All these buildings depended on a quality of stuccoed surface and a use of brilliant colour which it is now impossible to assess.

A new and influential form of tomb was created for the Khan-i Jahan Tilangani (d. 1398–9) at Delhi. Though engendered by Multan, it is reputed to be derived from the Qubbat al-Sakhra at Jerusalem, for its octagonal chamber is surrounded by a verandah with three arches in each face, and a continuous *chhajja* below the merloned parapet. The central dome is surrounded in turn by eight smaller ones rising from the middle of each side of the verandah. It is enclosed within a bastioned wall as before.

The further evolution of architecture at Delhi suffered a hiatus with the wholly destructive invasion of Timur in 1398–9, including the sack of the city itself. Predictably he led away its artisans and craftsmen to Samarqand, and even took ninety elephant-loads of freestone as material for a mosque there. Many, however, must have fled, and their influence can be detected in the buildings of Jaunpur to the east, and of Mandu to the southwest. For almost the whole of the fifteenth century little was built at the capital except for a solemn series of royal tombs.

An octagonal type initiated by the Sayyid dynasty reached its consummation in the tomb of Sher Shah Sur (d. 1545) 500 miles to the east at Sasaram, through the agency of a Lodi architect, Aliwal Khan (Fig. 116). It is set in the middle of a great artificial lake, from which it rises on a stepped square plinth. On this the enclosure wall has been transformed into the sheer walls of a square terrace, with an octagonal domed pavilion at each corner, and little kiosks on balconies breaking out of the parapet. The mausoleum itself is then built in the usual three stages, though its walls are vertical, and the octagonal drum is taller than those at Delhi. The kiosks (*chhatri*) are placed at the angles rather than the mid side, so the usual *guldasta* pinnacles are dispensed with, and a single window can project from each face of the drum. A second tier of *chhatris* are poised on its roof around the dome. Within, the walls are articulated with eight recessed arches, sixteen with windows, then thirty-two blind ones, set on sills which bridge the corners

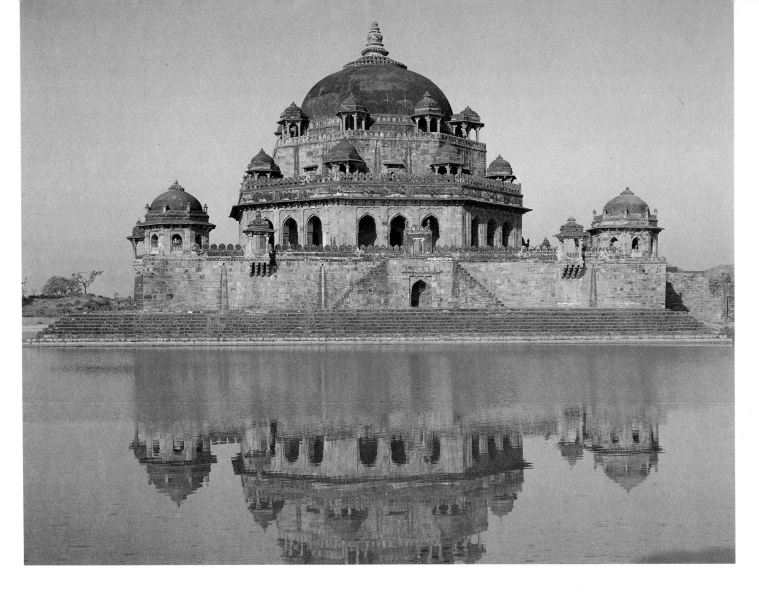

Fig. 116 Tomb of Sher Shah Sur,
Sasaram, Bihar. *c.* 1543

below on a single corbel, in a steady diminution of scale. The hemispherical interior of the dome is thus much better lit than its predecessors. Once the kiosk domes, the merlons, parapets, and spandrels were coloured in brilliant geometric designs, and the dome was white with a gilded finial. A causeway led over the lake, and reflection perfected the image of grey stone.

Another series of Lodi tombs, square in plan, is also derived from Tughluq prototypes. They remain unidentified except for popular names. The walls are now vertical, but still have the protruding central bay with its single archway containing a linteled entry, over which there is a small window. The walls on either side are divided by string courses into two or three registers in which corresponding tiers of arches are recessed, usually in two bays. They therefore have a tall appearance, as though in several storeys. Some have a kiosk on each corner, and in other details they follow the first series. Internally, however, they rise in a single volume, with squinches set in zones of eight, then sixteen arches. Carved plasterwork yields inscriptions and star patterns, with medallions in the dome. The grey masonry of the outside is enhanced by inserts of red sandstone and blue glazed tilework. Two examples of the type are dated to 1494 and 1497.

At one of these tombs, the Bara Gumbad, is the small mosque of Abu Amjad (1494), a single prayer hall of five arched bays (Fig. 117). The rear elevation includes an arcaded basement, and the projecting bay for the *mihrab* is placed

between tapering round buttresses like those at the corners, their upper part modelled with the alternating reeds of the Qutb, and finished with smooth *guldastas*. A projecting Hindu window is introduced to decorate each end elevation. The front, however, is unexpected, with strongly haunched arches whose width in the three central bays suggests the profile of the stilted domes above. Like its dome, the middle arch is higher than the others, and repeats on three recessed planes within a heavy salient frame. The flanking arches are recessed only once, those at the end being half the width, in a muscular variety of form. The extrados of each plane is inscribed with letters jostling amongst tendrils, and the spandrels burgeon with the countless fine facets of arabesques carved in the plaster which rises even between the *chhajja* brackets. The same spirited work fills the prayer hall, with rows of *mihrab* arches, and the corbelled pendentives above. A new motif appears in the relief of counterset trefoils around the base of each dome, and the full curves of the lotus finials are repeated on the buttress tips.

This same scheme is developed in the Moth ki Masjid (*c.* 1505; Fig. 119). Its larger scale is exploited in the replacement of the corner buttresses by polygonal turrets with two storeys of arcades, which serve no obvious religious purpose, and heavier oriel windows. The domes are more generously spaced over alternate bays. In this case the lateral arches of the prayer hall facade are recessed three times, while the outer plane of the central arch is made much taller, with a small window in its tympanum above the two remaining planes, creating an odd disturbance of scale. White marble is reintroduced for contrast with red stone and tiles. Light falls on the same recession of planes in the arches of the interior. The main dome is supported on squinch arches, but the lateral ones rest on a succession of oversailing lintels carved in imitation of stalactite pendentives as they had long been used in Iran.

Even after the Mughal triumph at Panipat in 1526, the progressive refinement of the type continued. Babur's arrival seems to have had little effect on building. Two mosques are attributed to him in that year, one at Panipat itself having a

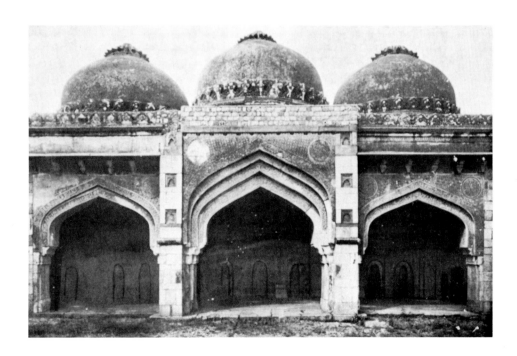

Fig. 117 Prayer hall, mosque of Abu Amjad, Bara Gumbad, Delhi. 1494

distinctly Lodi structure, but for the inclusion of nets of concave surfaces, typical of Timurid architecture, within the squinches. To a prince familiar with Samarqand and Herat, the work must indeed have looked quaintly provincial.

Humayun's new citadel of Din-panah, begun in 1533, was taken over by Sher Shah, then completed as the present Purana Qila under Akbar. The mosque there (which follows the same pattern) represents the transition to Mughal work (Fig. 118). The end bays, which break forward a little to strengthen the massing, plainly belong to the established tradition. The three central bays of the facade, in fine ashlar, show a much more minute sense of detail; the recessed planes are now combined with delicate angle shafts, and sophisticated moulding profiles for the frames. The arches are now taller in proportion, with a more relaxed curve at the haunch, and an almost straight incline to the crown. Each is now included within a higher one, but the arrangement is unsteady. The flat tympanum of the *pishtaq* (fronton) is filled with the first example of geometric marble mosaic in an Indo-Islamic building, probably in imitation of Timurid work. A hint of the experimental period to come is to be seen in the end bays, where arched cross ribs are backed by vaulting.

Octagons had begun to exert a particular fascination. In the tomb of Humayun (Fig. 123), built under the patronage of his Khurasanian widow (1561–70), the superstructure consists of four octagons of two storeys, whose wider faces contain deeply sunken frontal archways (*ivans*) rising the full height, and the narrower faces at the angles two superimposed arched recesses. Between the octagons, and set back in plan, a *pishtaq* rises on each side to a higher level, containing an even larger arched *ivan* whose height matches their parapets. These central *ivans* are recessed in semidomes in the Iranian manner, and their four-centred arches too have a continuous Iranian curvature. The octagonal space remaining at the centre rises in two tiers of arches sunk through the

Fig. 118 Prayer hall, Masjid-i Kuhna, Purana Qila, Delhi. *c.* 1535–60?

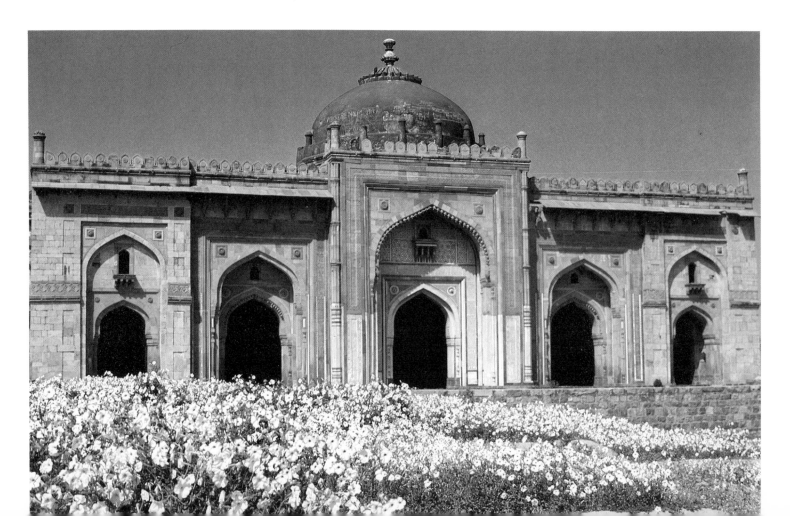

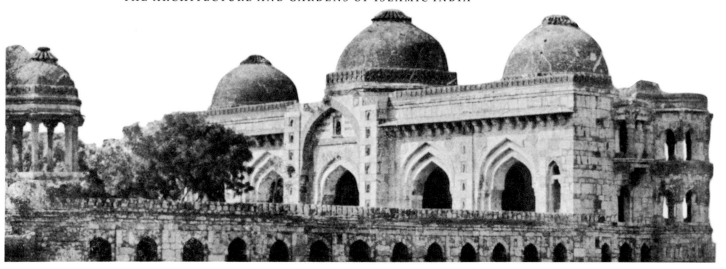

Fig. 119 Prayer hall, Moth ki Masjid, Mujahidpur, Delhi. c. 1505

thickness of the masonry, and a third of lightly recessed ones framing clerestory windows at drum level, with fine lattices. Squinch nets then articulate a shallow vault within the height of the tall cylindrical drum, above which a ribbed cavetto moulding sways out to the superb curve of the marble-clad dome. Its shape, not bulbous, but appearing so because of the moulding, is again Timurid. For the first time in India, the inner and outer dome surfaces have been separated for visual effect. The immediate prototype may well have been the small dome (1440–1) at Turbat-i Jam, where Humayun is known to have visited the shrine of his wife's ancestor in 1544. His exile (1540–55) thus resulted in the most coherent statement of the Iranian idiom in India, which is nevertheless pervaded by local traditions, especially in the substitution of red and buff sandstone and white marble trimmed with grey for the faience of Khurasan. Set on an impressive raised terrace, it achieves a calm, yet warm stateliness.

Humayun's tomb gains immensely from the beauty of its setting in the midst of a square walled garden, even if it now lacks the trees, flowers and running water which once gave it life. The ground, which adds eight times to the area of the central plinth, is first divided into four quarters by causeways running axially, and then by smaller paths into thirty-two square plots. The narrow channels flowing down the centre of each pass into tanks with platforms at each intersection. The causeways run to the semblance of a gate in each wall, the two real ones anticipating and framing the tomb.

Since the Quran is full of references to paradise as a garden, with running water, shade, fruit trees, and chaste companions, this is most appropriate as a setting for a mausoleum. Babur, familiar as he was with the immense terraced gardens of Samarqand, was totally dissatisfied with the orchards he found in India, wall-less, and above all without water channels. His own greatest contribution to Mughal design was in establishing gardens in the Iranian tradition, divided essentially into four by water courses in two directions (*char-bagh*: 'four gardens'). The need for these water channels, representing the rivers of life, to be raised for irrigation led to the establishment of terraces, often exploited visually with chutes having textured surfaces to ripple the water; elsewhere there were waterfalls that flowed in an even sheet over the edges of tanks. Platforms were raised several feet above the ground to allow their occupants, sitting under embroidered awnings, to look down on the pattern of

walks, beds, pools, and, as a miniature shows (Fig. 126), the ordered ranks of flowers. All this gave the Indian masons ample scope for their skill in finely chiselled borders, runnels, and parapets, to contain growth with symmetry: 'In every border rose and narcissus in perfect arrangement'.[3] Here the trees were planted in ranks; fruit trees, especially pomegranates, for life, and cypresses, originally for death (for they do not regenerate when cut), but in the Persian context more typical of graceful stature. These were often alternated, and sometimes purposely intertwined to demonstrate the interdependence of life and death, and the promise of resurrection. The practical aspect of these gardens, conceived as a refuge from the heat, and enjoyed for the fruit they yielded (at tombs this might be sold to support the endowment) was combined with a lyric symbolism with which all were familiar, and which recurs constantly in literature of the time.

In 1558 Akbar moved to Agra, where he established his capital at the brick fort previously built by the Lodis, rebuilding it on an unprecedentedly massive scale from 1565 onwards. The work is in the red stone so typical of his undertakings, and cut to so fine a finish that it was claimed a hair could not find its way into the joints. It is reported in the *Ain-i Akbari* to have comprised 'more than five hundred buildings of masonry, after the beautiful designs of Bengal and Gujarat, which masterly sculptors and cunning artists of form have fashioned as architectural models'. The synthesis was more than an aesthetic one, for it embodied a major preoccupation of Akbar's life: the need to find common ground between Muslim and Hindu, a source of unity which was later (1582) given expression in his 'Divine Religion'. Gujarat was not annexed to the empire until 1572, but it had been in a state of disturbance since the death of Bahadur Shah in 1537, and it is thought that craftsmen must have been attracted northwards by the prestige of the Mughals.[4] Another possible source for work in the western style was Malwa, captured in 1561.

Most of the court buildings erected by Akbar have been replaced, but two exist still. One, the Akbari Mahal, is in a ruined state, but the remaining part shows an exterior divided by raised vertical fillets into panels, each of which contains an aedicule with pronounced head and sill, framing a small arched niche. The motif is common to both Gujarat and Bengal, but its relentless repetition is peculiarly Bengali, and in this context, within a grid, explains the building's original name of Bengali Mahal.[5] The other harem building, the Jahangiri Mahal, is well preserved (Fig. 120). Its square court is surrounded by two tiers of *chhajjas*, each supported on elaborately carved stepped brackets, which are used again to frame the openings giving onto rooms at ground level. The rhythm of their outward movement gives the space immense vigour, essentially Hindu in feeling. The ceilings are built with slabs in an ingenious variety of methods, while that of the main hall is braced by diagonal struts of a decidedly Gujarati

[3]Zahir al-Din Muhammad Babur, transl. A.S. Beveridge, *The Baburnama in English* (London 1969), p. 532.

[4]J. Burton-Page, 'Indo-Islamic Architecture: a Commentary upon some False Assumptions' in AARP VI (Dec. 1974), p. 19.

[5]Cf. the Dakhil Darvaza, Gaur (*c.* 1465) or the Qadam Rasul Masjid, Gaur (1530) for the division into panels; the Adina Masjid, Pandua (1375), the Eklakhi Tomb, Pandua (*c.* 1425), or the Chhota Sona Masjid, Gaur (*c.* 1500) for the repetition of similar aedicules.

type, carved with rippling serpents that emerge from the mouths of elephants. Upstairs to the west, a small hall opening onto a court is bracketed with a row of peacocks holding snakes in their beaks. Much of the detail and layout seems to be based on the Man Mandir at Gwalior, much admired by Babur (recaptured 1559), and although some shapes, like the brackets, were anticipated by the Lodis, they are treated with an originality characteristic of Akbar's reign. The entire system is trabeated. It was obviously familiar to his Hindu consorts.

Nothing remains, however, of the formal audience chambers of the court, the open oriel of the Jharokha-i Darshan where the Emperor appeared to the public at sunrise, and spent four hours or more dealing with their petitions each day, the Hall of Public Audience where he held his *darbar* in the afternoon, or the Hall of Private Audience to which he retired for council. An image of the raised royal loggia used for the *darbar* before it was rebuilt by Shah Jahan can be found, with minor variations, in a set of miniatures[6] (Fig. 127). The Emperor sits in a kiosk of Akbari style, with a royal canopy slung above; a balcony allows the presentation of princes at the same level, and a railing divides courtiers of different ranks. The walls are plastered, and the doors are hung firstly with screens of fine canes wrapped in wool or silk to allow the passage of air, and then with silken blinds rolled upwards. Awnings were hung from masonry rings or poles passed through the eaves brackets, and both windows and verandahs could be shaded by the same system as the doors. The palace buildings we now see are mere skeletons, deprived of the soft furnishings which gave them useful life.

Nowhere is this more apparent than at Fatehpur Sikri, a city founded by Akbar in 1568 (Fig. 121). The great complex of its palace and mosque stand on an escarpment almost complete, for with the shift of imperial activity to the west, it

[6]In the Padshah-nama of Abd al-Hamid Lahauri in the Royal Library, Windsor.

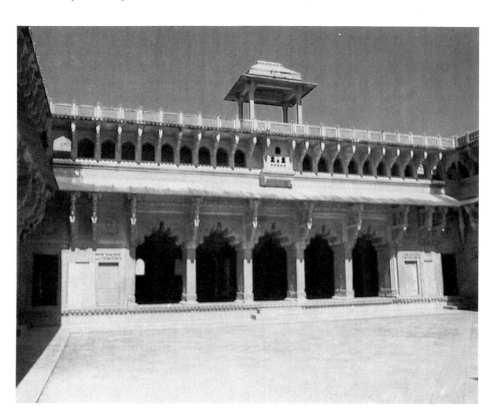

Fig. 120 Interior of the main court, Jahangiri Mahal, the Fort, Agra, Uttar Pradesh. *c.* 1570

was vacated in 1585 and left undisturbed, but for all its beauty, bare. The eclectic style is mature and self-sufficient, with little reference to the artistic criteria of Khurasan or beyond. The eagerness with which such variety of form is wrought out of stone vindicates the claim that Akbar's masons worked it with all the ease of a wood-turner. To a large extent it incorporates the Hindu features already absorbed into the Gujarati idiom, but combined with an exuberance of invention, and a practical system of construction based on posts, beams and panels which allowed rapid prefabrication. The buildings are arranged around great courts, stepped to fit the ridge, and their paved surface is an important part of the total architectural effect, for each building is placed upon it on a carefully defined low plinth which, with the drainage channels, pool and platform, fretted railing and precise rows of squared columns, achieves an astonishing neatness.

The Private Audience Hall is now extremely simple, with walled rooms surrounded by deep columniated verandahs, but the hipped roof of the three-storeyed private suite adjoining it ('Khwabgah') is carved in imitation of tiles, and the inner chambers show traces of extensive frescoes. At one time the carved fascias too must have been picked out in colour, as contemporary book-paintings show (Fig. 129). A wind-tower ('Panch Mahal') adjoining the harem exploits the simplicity of this trabeation in a series of five successively smaller rectangular floors, the lowest having eighty-four columns, and the top only four carrying a kiosk dome. Yet the columns on the first floor show a coquettish variety: none are alike. The Anup Tala'o Pavilion ('Turkish Sultana's House') is also an exercise in fantasy, with a lean-to verandah carved like a cottage roof, and its single small room alive with carving that flowers on every available surface – even the underside of the *chhajjas*. Outside the chevroned panels imitate the texture of matting, but the corner piers carry fruit trees in relief, and the dado inside shows forests inhabited by lions, pheasants and apes. The so-called 'Divan-i Khas', on the other hand, appears to embody Hindu cosmology in housing a single column bracketed out into a circular platform with bridges to the four corners of the building: its purpose is still disputed.

The Jami Masjid, given the site furthest south at the top of the ridge, is the first of the giant open mosques now typical of the Mughal cities; it was completed in 1571–2. Here the technique is subservient to an orthodox image of arcaded cloisters, *pishtaq*, and domes. The front of the prayer hall with its alternation of wide and narrow bays, and the spandrels of its arches thinner than the pillars rising through them, its long *chhajjas*, and the form of the pillars themselves, is clearly Gujarati in provenance. The hall itself, though, is organized in a new way, derived from the Atala Masjid (1376–1408) at Jaunpur. The domed spaces at the centre and to either side are each contained within walls pierced by arches so as to communicate with the intervening areas, which are roofed with slabs on bracketed lintels. The domes, of a Lodi type stilted very high, are singularly graceless, but the skyline is saved by a sprightly succession of identical *chhatris*, which on feast days were once hung with coloured cloth, with lamps inside. The lateral domes are ribbed inside, like those at Jaunpur or Champaner (*c.* 1500) yet have squinches of oversailing lintels. The *pishtaq* is of the type developed under Humayan in the Masjid-i Kuhna, with a deeply recessed *ivan*, made so tall that, as at Jaunpur, it entirely masks the main dome behind. Inside, the *mihrab* wall and the surrounding arches are richly inlaid with geometric mosaics of marble and tilework in blue, green and white.

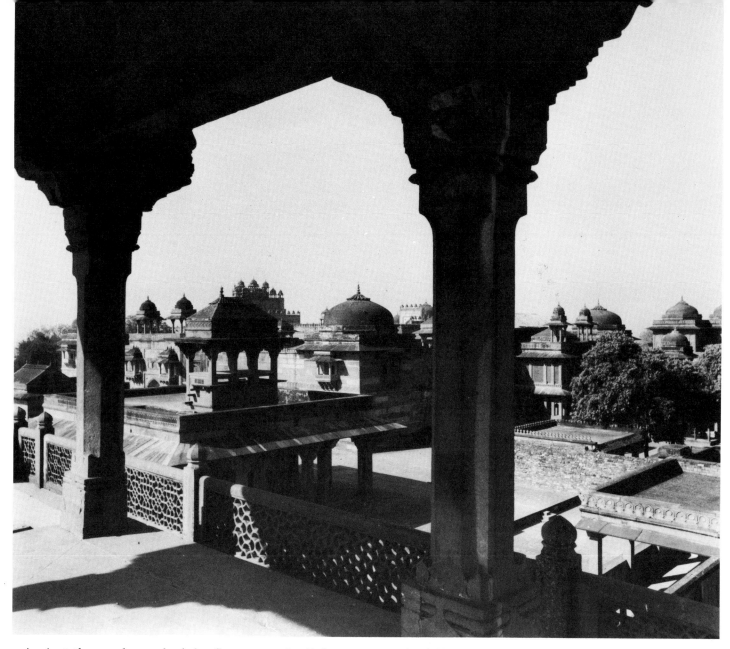

Fig. 121 View from the Panch Mahal over
the harem buildings, Fatehpur Sikri,
Uttar Pradesh. 1569–74

Against the sombre red of the flagstones, the little square tomb of Shaikh
Salim Chishti stands out in white marble candour (Fig. 122).[7] Its single,
finely-curved dome rises over a low octagonal collar, and its matching verandah
parapet, carved with a flowing trefoil, spreads out in the thin planes of a *chhajja*
that breaks forward in a porch on the southern side. In their shade the space is
boxed in with exquisite marble lattices set between the columns, each framed by
the slim outlines of an arch and its supports, and set off by the sinuous line of a
serpent bracket, infilled with the same lattice, that supports the *chhajjas*. Inside,
the light is softened by the facets of the tracery, casting delicate shadows on the
shining floor (Fig. 124). The outer walls of the tomb cell are relieved with blind
niches and calligraphy picked out in restrained black, but within the panels are
filled with painted flowers. The work had at first been sandstone (1580–1), but it
was reclad early in the reign of Jahangir (1605–6), and marks a change towards

[7]The dome was originally whitewashed, but clad in marble by the British administration
in 1866.

the smoothness of surface which was to characterize later building. In plan and massing it is closer to the tomb of Shah Alam at Ahmadabad (1532) than to that of Muhammad Ghawth as often claimed, and its dome to that of Hushang Shah at Mandu (d. 1435).[8] The pillars of the porch, with their multi-niched capitals, and shafts set on vases above flaring bases carved in petalled palmettes, are like those of the river front at the Jahangiri Mahal, suggesting that they too are of the new reign, as its name would claim.

At Sikandra, Akbar had begun his own tomb, and in 1608 Jahangir rebuilt at least the upper floor. The last of the great eclectic buildings, it had no successors, its most important contributions to development being in the use of octagonal bastions and cupolas at the corners of its great podium, and the experimentation with inlays, mosaic, and incised painting. Its pyramid of airy, arcaded platforms is broken forward into porches with kiosks that elaborate the effects in the tomb of Muhammad Ghawth (d. 1562) at Gwalior.

In the tomb of Itimad al-Dawla (1622–7) the transition to the more sensuous and refined manner of Jahangir's reign is complete (Fig. 130). It is significant that the building commemorates an Iranian immigrant, for its meticulous preoccupation with surface is a recognisably Iranian quality, here attributed to the influential taste of his daughter, the Queen Nur Jahan. So highly worked is the white marble, with its polished inlays of semi-precious stones, that it catches one's admiration almost before the form of the building. It stands square amid the lawns of its garden on a low terrace, whose very edges are picked out in inlay. The dark trees act as a foil. Four octagonal turrets at its corners rise above the line of the *chhajja* and latticed railing, turn to squat cylinders, and are capped

Fig. 122 Tomb of Shaikh Salim Chishti, Fatehpur Sikri, Uttar Pradesh. 1580 and 1605

[8]There is however some doubt as to whether the marble cladding of Hushang Shah's tomb is original.

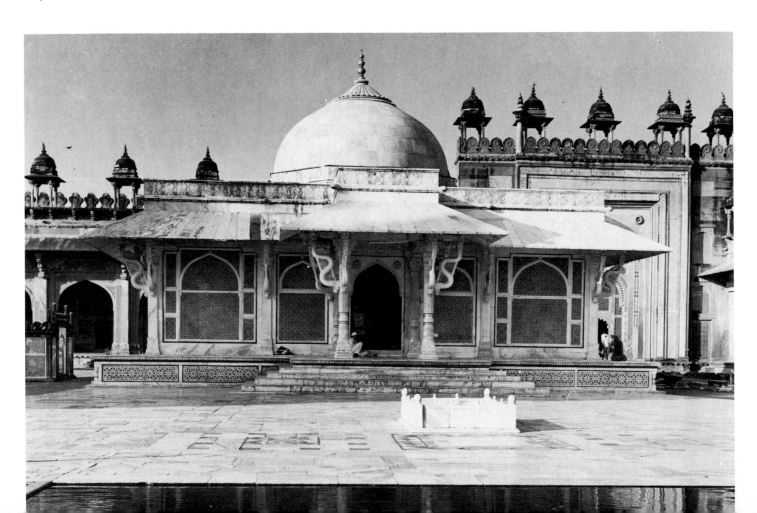

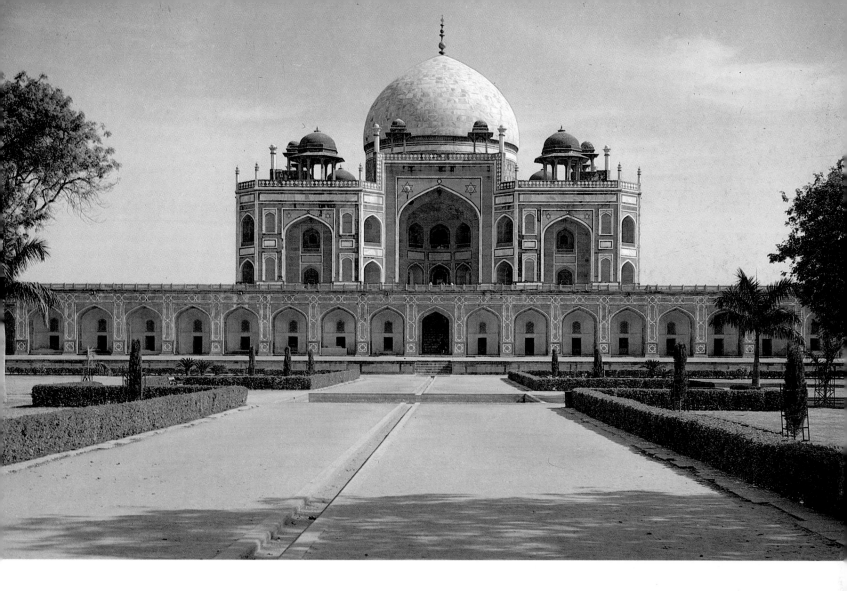

Fig. 123 Tomb of Humayun, Delhi.
1561–70

by domed kiosks whose round eaves match the circle of their balconies. Between them a square pavilion is sheltered under deep *chhajjas* and a low squared dome with four finials. The mass of the lower storey is penetrated only by three arches on each side, and two latticed lancets; the *pietra dura* work is framed by repeated vertical fillets above a continuous dado. The pavilion has three arched bays each side filled with large panels of latticing, but its solidity is restored in the tympana and scrolled spandrels. The spacing of *chhajja* brackets carefully accents the vertical frames at both levels. The central chamber on the ground floor is vaulted with elaborate tracery, and surrounds the cenotaphs with a charming series of paintings set in deep niches in the walls. The space within the upper pavilion is intimate in scale; the quality of light from its lattices is enchanting (cf. Fig. 125), and even the floor is inlaid with sweeping coloured tendrils around a second pair of tombs. Persian motifs are everywhere, in wine flasks and cups, cypresses and flower vases, but outside the inlay is chiefly geometrical. An extraordinary delicacy unites it all, and the continuation of the ornament on the jambs and under the arches completes it. The position of the turrets relates, of course, to Akbar's tomb, but their form may be developed from the Hiran Minar at Fatehpur; the pavilion is like the catafalque in Salim Chishti's tomb.

If the preference for marble surfaces had already been established under Jahangir, the emergence of a new means of expression under Shah Jahan

(1628–58) is none the less sudden and remarkable. Marble replaces sandstone as the apparent substance of a building, though red stone is still used in ancillary structures as a foil, and both are sometimes carved with identical motifs. Fine inlays are used to set off the grain of the marble, instead of the tessellated mosaic. The lucency of the material and its precision under sunlight, are exploited through a clean, sinuous contour in three characteristic elements, the cusped arch, the bulbous dome, and the Bengali vault.

The cusped arches adopted by Shah Jahan had almost the same form as those used long before by Iltutmish, springing from convex consoles, and rising within an almost semicircular extrados to a shallow ogee at the crown. As decorative line, such forms had already appeared in the niche patterns at Itimad al-Dawla's tomb, but their structural use appears to have been re-introduced either from Bengal, or from Bijapur, where they had a more pointed format.[9] Since the bulbous form of dome with *mahapadma* finial and foliation at the springing is also typical of Bijapur, and since it first appeared at Agra, in the Taj Mahal, after the siege (1631) and invasion (1636) of Bijapur,[10] it seems likely that this was the source.

[9] E.g. the Chhota Sona Masjid at Gaur (*c.* 1500); the Jami Masjid (1576) and the Zanjiri Masjid (1587) at Bijapur.

[10] Asaf Khan, father of Mumtaz Mahal, for whom the Taj was built, was in command of the siege only six months after her death. There he must have seen the recently completed Ibrahim Rauza (1628) outside the city wall, which as its inscriptions state was built for the Queen Taj Sultana.

Fig. 124 Marble screen in the tomb of Shaikh Salim Chishti, Fatehpur Sikri, Uttar Pradesh. *c.* 1605–6

Fig. 125 Khas Mahal, the Fort, Agra, Uttar Pradesh. *c.* 1636

Court histories of the time leave no doubt of the Emperor's close personal involvement in the design of the building projects he initiated, and he was fully aware of their value as monuments to his reign; references to his love of ornament and purity show that the marble was indeed chosen for the effect with which we associate it. One of the first acts of his reign had been to order the construction of halls with forty columns (*chihil sutun*) for the protection of his nobles at public audience in the palaces of Agra, Lahore, and Burhanpur. Before this they had been sheltered only by the awnings stretched out from the jharokha balcony. These had become extremely elaborate. Shah Jahan himself had used the New Year celebrations of 1628 as an occasion for displaying an immense two-tiered tent roof, surrounded by matching awnings, all of gold-brocaded velvet, called the Dal-badal, 'The Mass of Clouds'. Its massive poles were sheathed in gold and silver. This form, which was designed to present the monarch as the sun within the spheres, surrounded by his satellites, was developed at Agra until in 1635 it became the setting for the Peacock Throne.

The earlier buildings at Agra were looked on with distaste, and between 1631 and 1640 they were replaced with marble halls of an almost standard type; they are open through cusped arcades at the front and sides, surmounted by a *chhajja* and a parapet with *chhatris* at the corners. They are usually given the advantage of a breast-high podium, and wherever possible they are set along the river bank to benefit from the coolness as well as the view. Some have columns, often set in pairs round the periphery and quadrupled at the corners (as in the Panch Mahal at Fatehpur), while others have piers (cf. Fig. 132) whose faces can be carved or inlaid with the now omnipresent floral decoration. Where marble has not been used, the red stone is rendered with plaster polished to simulate it. Their ceilings are flat, and the interior panelled.

One of the most pleasing groups is the set of private apartments (*c.* 1636) at the Aramgah ('Khas Mahal'; Fig. 125). The central hall is fronted by a loggia, five bays by three, of eight-cusped arches with consoles springing from square piers.

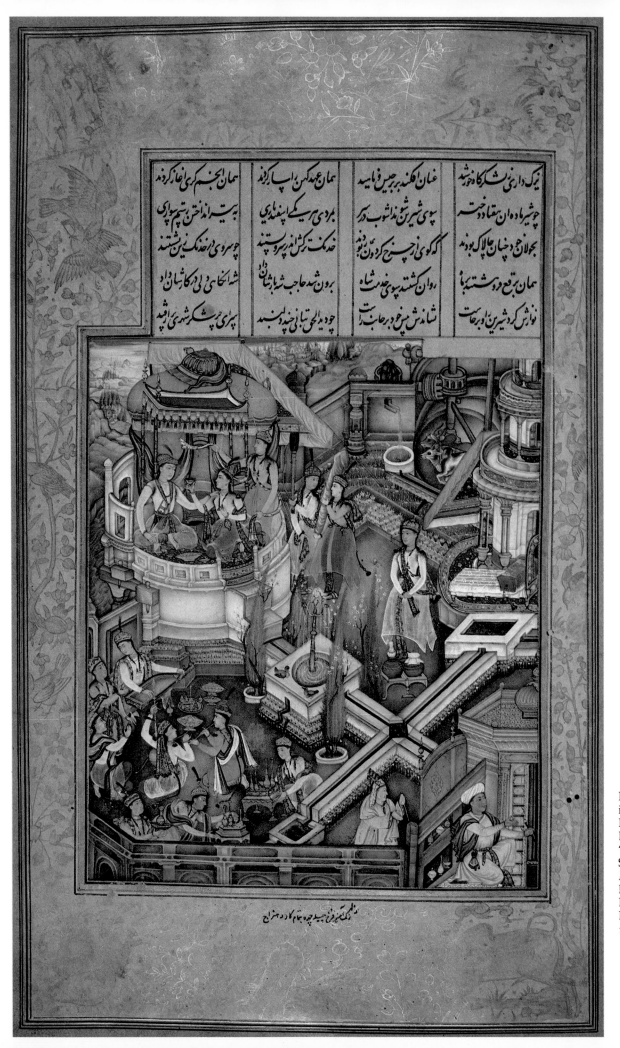

Fig. 126 'A garden in a palace' by Farrukh Chela and Dhanraj, from 'Khusrau and Shirin' in the *Khamsa* of Nizami, Mughal. 1595. London, British Library, Or. 12,208, fol. 65a

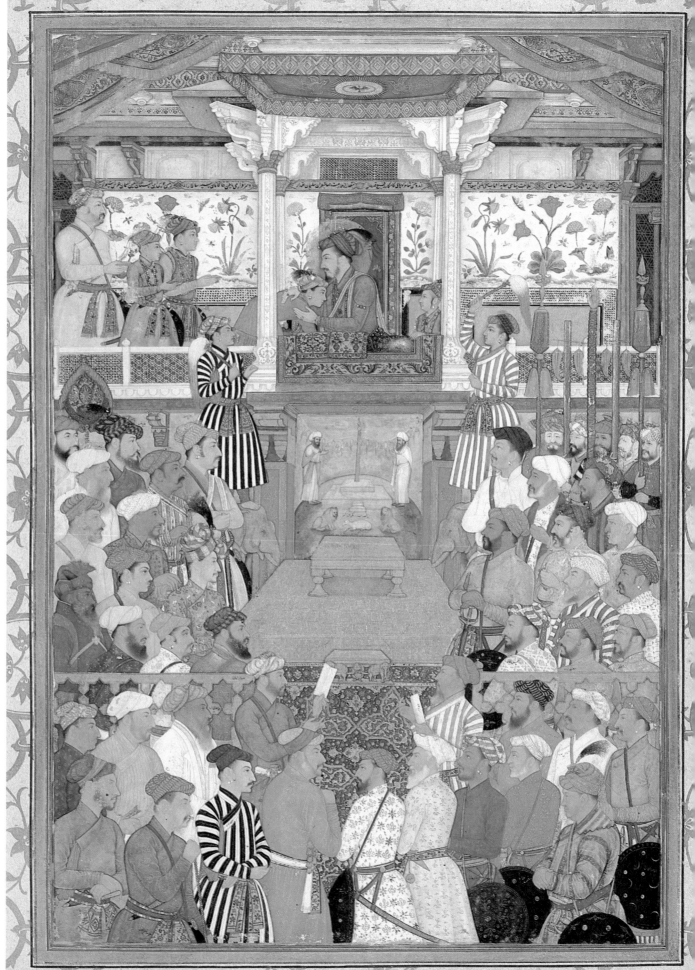

Fig. 127 'Shah Jahan receiving his sons with Asaf Khan at Agra in 1628' by Bichitr, *Shah Jahan-nama* (properly *Padshah-nama*). *c.* 1630. Windsor, Royal Library, fol 50b (p. 101). Reproduced by Gracious Permission of Her Majesty Queen Elizabeth II

دیوان شاه جهان باجا ودرصد نمودن رسه پسرا

Three plain arches lead to the interior through a wall patterned with niches in low relief, corresponding to three latticed windows opposite. The ceilings were once painted in gold and colours. This is flanked on either side by open Bengali pavilions whose sides are carved with the same cusped niches, and whose gilded roofs are armed with radiating finials along the arched spine. These are all of marble, and set on a marble terrace beside the river; on the inland side a tank is let into the paving with verges of sculpted trefoils and ogees. There they overlook the four classic parterres of the Anguri Bagh, which are subdivided by sandstone curbs to form interlocking cartouche shapes for flower beds. The women were given privacy by marble screens relieved by two-cusped arches of astonishingly simple elegance.

The great tomb complex of the Taj Mahal (1632–48),[11] built by Shah Jahan for his queen Mumtaz Mahal, represents the convergence of much of the preceding experience, coordinated to an extraordinary degree (Fig. 133). Its immediate models are Humayun's tomb and its successor, the tomb of Abd al-Rahim Khan-i Khanan at Delhi (d. 1626–7). From the first it borrows its basic plan, with diagonally linked corner chambers and chamfered angles, owing much of its success to the same contrast of the great arched recesses scooped out from its mass with the fullness of the domes above, large and small. From the second it takes the handling of the *pishtaqs*, kept flush with the wings on either side, and the placing of the *chhatris* close to the main dome with their eaves reduced so as not to detract from their association with it. The minarets are those of the Sikandra gateway (ultimately from the Chand Minar at Daulatabad, 1435), and the use of four at the corners of a podium is from Jahangir's tomb. And so with many details. The dome itself, bulbous and springing from a cable moulding, may have been drawn from an experiment at the Nagina Masjid at Agra Fort.

Yet the sum of these elements is handled with fresh insight. The great podium has no arcaded cells to distract the eye, but panels of blind trefoil arches. The minarets at its corners mark out an otherwise intangible space around the tomb, their balconies recognizing the height of its string courses and the springing of the dome. The flat surfaces, spandrels, dados and parapets, are inlaid with floral arabesques in miraculously natural colours or scrolled borders around sculpted panels; the hollowed surfaces of the tall *ivans* are of marble alone, carved into ribs and squinch nets, shallow cartouches and recessed arches. Such contrasts are effective everywhere: of the bland surface of the walls with the network of black joints in the minarets, of the smoothness of the dome with its deliberate alternation of broad and narrow courses, of the white Makrana marble with the red sandstone of the flanking buildings.

As usual, the tombstones lie in a crypt within the podium. The more public cenotaphs are set above them in the central octagonal space. Eight arches rise plain and grave around them, then another eight in a second tier, rounded with squinch nets into a vault eighty feet over the shining floor. Here too colour appears only in the spandrels and low on the dado borders, but the same exquisitely carved flowers provide subdued relief. The light, filtered through double screens of glazed marble, is diffused through recesses deep in the cool mass, where, high up, the side chambers and corner rooms interpenetrate all round. Unlike Humayun's tomb, no light comes from the drum, for it rises over the inner dome. Strangely, cusped arches play no important part in the structure.

[11]The structure may have been finished already in 1643.

Fig. 128 Jami Masjid, Delhi. 1648–50

The tomb itself is only the centrepiece of a much larger composition within a rectangular compound, set at its riverside end. The approach is essential to the effect. Through the gateway, whose row of *chhatris* on the skyline follows from the Buland Darvaza at Fatehpur, the tomb appears along one axis of a *charbagh* which, because it is freed from the usual building at its centre, can offer a group of tanks there to reflect the image. A cross axis ends at red stone pavilions instead of the orthodox false gates. Beyond the garden is a great red plinth, with the tomb in its centre, and on either side a mosque and its exact counter image, each of stone with three marble domes.[12] The tomb is thus associated with water, either in the canals and pools of the garden, or the river below, and it is contained by lesser suggestions of its dome on every prospect. The principle of reflection is paramount.

The largest enclosed mosque in northern India is the Jami Masjid at Delhi (1648–50; Fig. 128): it is of sandstone, with three bulbous marble domes. Its particular impressiveness is due largely to a very high podium built round a local

[12]These are very much like the Dai Anaga Masjid at Lahore (1635).

outcrop of rock, and panelled with blind arcades; three massive pyramids of steps lead up to the courtyard level, one on each side. The canted edge of this podium gives rise to a cloister which, instead of being walled in, is open to both outside and inside through a double colonnade united by long *chhajjas*: a treatment suggested perhaps by the Sultan Ghari madrasa (1231) near the same city. At the head of each flight of steps these horizontals are broken into by the block of a tall gateway. At each corner of the great courtyard the cloister turns at a square walled cell, on which a twelve-pillared *chhatri* rises above the roof line, echoed by files of little kiosks on the gateways. The cloister turns again at the west, and the prayer hall of eleven bays advances from it into the courtyard, thereby avoiding the cramped corners which spoil its counterpart at Agra (1644–49), and allowing room for the rise of a tall octagonal minaret at each of its front angles. (True minarets had first been used at the Mosque of Wazir Khan, Lahore, in 1634, but at each corner of the courtyard.) The central bay, much wider than the others, rises twice their height with a red-shelled *ivan* set between angle shafts whose marble lanterns echo those of the minarets. The

Fig. 129 'Akbar giving audience' by Husayn Naqqash and Kesu, *Akbar-nama*. *c.* 1590. London, Victoria and Albert Museum, IS 2–1896, 113/117

whole front is given a formal white marble facing, articulated with pink frames; the sandstone parapet and merlons are trimmed with white, and the minarets striped vertically. Above stone drums, the domes swell in marble sheathing streaked segmentally with pink: a pattern reversed with white lines in the *ivan* below. The hall is subdivided like that of Fatehpur, with massive piers below each drum, and the use of cusped arches is maintained throughout, even in the white outlines of niches laid in the red stone, or sunk in the marble of the hollowed *mihrab*, or patterning the floor in places for prayer. The setting back of these domed compartments allows the free development of the semi-dome in front. Inventive, expertly articulated, and well-proportioned as it is, the grammar of the building seems intruded upon by emphasis on what can only be called vegetable elements: the flaring of the minaret balconies, the lotus calyces of the lantern shafts, and the onion-like markings on the domes. In time this very floridity was to form the architecture of Oudh, but its whimsy here detracts from what might otherwise be majestic.

Fig. 130 Tomb of Itimad al-Dawla, Agra, Uttar Pradesh. 1622–7

Shah Jahan's most comprehensive undertaking, the Red Fort at Delhi (1638–48) may be compared to Fatehpur Sikri as the product of a single influence. Unlike Fatehpur and Agra, it was constrained neither by the limits of the site, nor by an existing enclosure and buildings. It therefore approximates to an ideal palace layout which had been formulated in Akbar's reign as the means of laying out the centre of the king's travelling camp. A formal axis has been established from the Lahore Gate towards the Jumna, west to east (Fig. 131). A vaulted bazaar street, an innovation from Baghdad, was flanked by arched cells on two levels on each side, with an open octagonal court in the centre. It led to the square of a large colonnaded courtyard, where all had to dismount and proceed on foot. The tank at its centre received a canal running north and south down the middle of a second arcaded street with cells for minor officials and guards, leading to the Delhi Gate. The main axis continued under a raised drum house, where the band blared forth five times a day, to the courtyard with the Hall of Public Audience on its far side, and surrounded by a single storey of arched cells for the quarter guard. Here the sovereign sat in audience at noon, surrounded by his nobles and courtiers within successive golden, silver, and red rails according to their rank, with the populace in the courtyard below. Tentage was still conceived as an integral part of the setting: from the inauguration onwards, marquee roofs larger and taller than the hall itself shaded the court, with ever-increasing extravagance.

Beyond this hall was the Imtiyaz Mahal ('Rang Mahal'), the largest of the harem buildings. Following the precedent at Agra, and long before of Firuzabad, the sites along the bank of the Jumna were reserved for the private apartments. An important cross-axis was therefore set up from north to south, in a continuous row of buildings between the river and gardens on the inland side: a

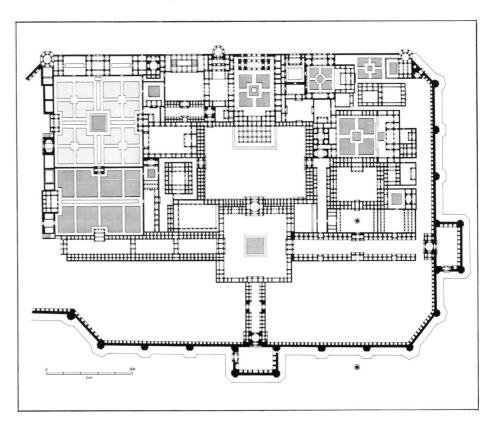

Fig. 131 Plan of the Red Fort, Delhi.
1638–40

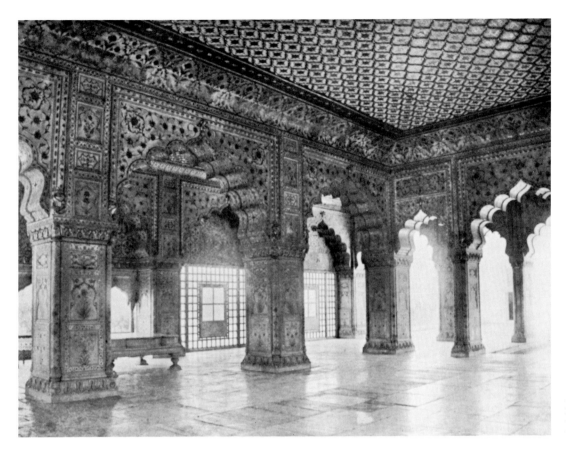

Fig. 132 Interior, Divan-i Khas, the Red Fort, Delhi. c. 1642

private world of shady retreats, cool terraces, and colonnades. These were served by an ornamental marble canal, the Nahr-i Bihisht ('The River of Paradise') supplied by a leat from the north down a chute, and passing through each of the palace pavilions in turn, with branches to garden channels and fountains. The Hall of Private Audience (Fig. 132) was for some reason displaced to the left of the main axis, within this row, reached by two successive courtyards from the corner of the public court: entrance was controlled by ticket.

As at Agra, the Public Audience Hall has a structure of cusped arches running across one another, set on the statutory forty columns. The capitals are now voluptuously florid. A recess in the centre of the rear wall holds a raised marble baldaquin, 'The Seat of the Shadow of God', the svelte curve of its Bengali vault sustained by four bellied pillars of the shape developed in the Nagina Masjid, and all inlaid with precious stones. In the Hall of Private Audience, the façade of five bays disguises the lack of arcuation in the large central chamber, as it continues only for the depth of one bay on all sides; the ends include arches of a smaller size for variety of rhythm. Its flat ceiling was once of silver inlaid with gold, and under it was set the Peacock Throne, transferred from Agra. The oblong piers are faced with marble and sculpted with angle shafts; their panelling is relieved with almost rococo flourishes to catch the light, or inlaid with extreme delicacy.

Further to the north, beyond the baths with their glass mosaics and sprays of rose water, lies the Hayat Bakhsh ('Life-bestowing') garden. It was a water garden: a square tank in the centre with forty-nine silver jets was surrounded by 112 more at the edges, fed from four radiating channels, each with another thirty

down its length. All was overhung with fruit trees close enough to interlace, and the beds were planted in purple and crimson. At either end of the cross channel, the supply tanks were hidden by pavilions for different seasons, with swelling columns of a full-blown lotus order, above the marble niches of waterfalls. Further west was the Mahtab Bagh ('Moonlight Garden') planted in paler flowers, lilies, narcissi, and jasmine within the rows of dark cypresses.

The garden is to these buildings as the soul is to the body, and the lamp to an assembly; and of the pure canal, the limpid water is to the person possessing sight as a world-reflecting mirror, and to the wise the unveiler of the secret world . . .[13]

Fig. 133 Taj Mahal from across the River Juman, Agra, Uttar Pradesh. 1632–48

[13]Inscriptions in the Khwabgah, Delhi Fort, dated 10581648, slightly adapted.

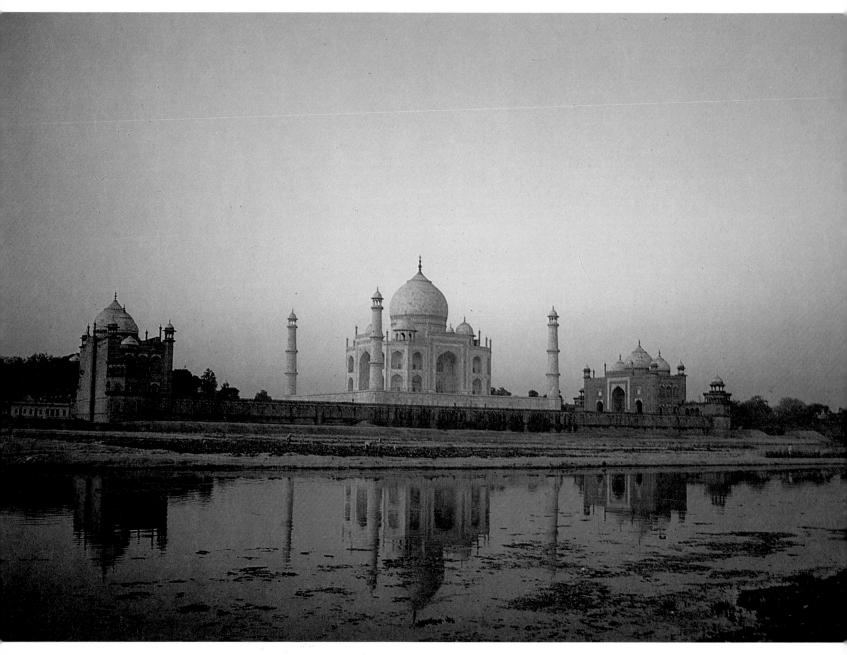

HEATHER MARSHALL

Painting in Islamic India until the Sixteenth Century

Effective Muslim rule in North India did not begin until the first half of the thirteenth century. Prior to this there had been considerable trade links between India and Central Asia; but the military conquest of North India may be regarded as a continuance of the Muslim Holy war against infidels, combined with a desire for plunder. Mahmud of Ghazni in 1080 was the first of these adventurers. Despite his plunder of towns and the destruction of Hindu temples in North India, he was at home a refined and educated patron. An awareness of these contrasting qualities is fundamental to an understanding of Islamic rulers of this period.

Such freebooting chiefs were undoubtedly attracted to India by the renown of its riches, resources, treasure and craftsmen. Politically and militarily North India was weak, suffering from disunity and clan rivalry. The Rajput princes in the North West were so preoccupied with their clan feuds, and familial intrigue, that they were incapable of meeting any serious external threat.

In 1192 the Ghurids defeated the Hindu chieftain of the Chauhan Rajputs, Prithvi Raj, at Tarain and established their authority in Delhi. This victory inaugurated a succession of Muslim sultans, who spent the next three hundred years imposing their alien ideology on a reluctant and intransigent Hindu majority. These sultans brought with them Central Asian women and Central Asian customs in food, dress and literature, together with a social order, in isolation from the infidel Hindu majority. British rule displayed similar characteristics , in its deliberate isolation of the 'Sahib-log' in the cantonment and the punctilious observance of English etiquette. Inevitably the Muslim Sultans made use of Hindu craftsmen, who responded with remarkable skill and adaptability. A Muslim ruling class encouraged the development of mercantile urban communities, with increased contacts with the neighbouring Islamic empires. Muslim painting in India from the fifteenth to the early seventeenth century was mainly limited to manuscript illustration. While maintaining close association with near Eastern Islamic artistic and literary fashion, the initial pictorial style was borrowed from indigenous Indian sources. To this were added elements, structural composition and colour usage inherited from a mature Islamic tradition.

In Persia, despite the barbaric destruction by the Turk Timur, miniature painting flourished in the fifteenth century. The ruthless Timur, and his

successors established settled courts, of elegance, refinement and sophistication. Timur laid waste Delhi in 1398, with the excuse that the contemporary Tughluq sultans were not good orthodox Muslims. This devastation of the central authority of North India caused the provincial governors of the Delhi Sultanate to declare their independence, reopen links with Persia, and encourage the growth of provincial patronage. Malwa Gujarat and Jaunpur, were renowned for their wealth and prestige in the fifteenth century.

Ahmad Shah, the independent Muslim ruler of Gujarat in 1420, inherited a kingdom, rich in resources, a well-placed sea-trading port, and an active and respected trading and banking community, with an abundance of craftsmen. Even today Gujarat is famous for its talented craftsmen and their skill in woodcarving and textiles. In the medieval period, even before possible inspiration from manuscripts brought by trade from the cultural centres of Persia, manuscripts were valued in this region. From the eleventh century the Chalukya and Solanki rulers had been sympathetic to the large community of Svetambara Jain monks living in Gujarat. The Jain lay followers had a considerable stake in the flourishing trade from seaports and overland routes through Malwa and Rajasthan to North India. To acquire spiritual merit, these wealthy brethren commissioned bronze sculptures and manuscripts to donate to the temples. The Muslim conquest of Gujarat in 1299, prevented the lavish display of Jain temple building in the main urban centres, but increased the production of manuscripts, which could be safely hidden and preserved.

These western Indian Jain illustrated manuscripts are the only form of Indian painting to have survived the Muslim invasion of North India. Paper was rarely used for these early manuscripts; palm leaf restricted their scale and format, and they show similarities to contemporary Jain sculpture in the angularity of their line, and minimal conceptual expression in the portrayal of deity and myth. There is a rejection of classical naturalism in the flow of body rhythm and movement, but the native colour sense of vivid red and blue persists. Reference to this painting is crucial for the understanding of the development of later pre-Mughal painting. Certain features found in Jain painting, the vivid simple colour combinations, the profile view, with the further projecting eye, the conceptual bias, all persist, and bear witness to the existence of workshops prior to any Islamic patronage.

Our knowledge of the development of manuscript illustration for the Delhi and provincial Sultanates, of Gujarat, Jaunpur, Malwa and Bengal is fragmentary. Contemporary literature mentions workshops engaged in elaborate wall painting in the time of Muhammad bin Tughluq, and the poet Amir Khusrau writes of his patron's predilection for manuscripts. There has also been in recent years the discovery of manuscripts that can be assigned to Sultanate patronage. These manuscripts show a dependence on the Islamic literary tradition for the choice of text, and on Indian indigenous sources for style of execution. An anthology of 1398, in the Turk ve Islam library in Istanbul, shows in its decorative, arabesque plant forms a remarkable similarity to the stone carving on the screen at the Sidi Sayyid mosque, Ahmadabad of *c.* 1515; the manuscript has only one figure subject and it may well be an isolated example of the work of an immigré Shirazi artist possibly for the Gujarat orthodox governor of that period, Muzaffar Khan.

Fig. 135 illustrates a story in the tradition of Persian poetry and Fig. 136 of Islamic fable. Fig. 135 can be attributed to the late fifteenth century, and

assigned to the courts of Delhi or Gujarat. Contemporary with this *Hasht Bihisht* of Amir Khusrau, are some *Shah-nama* pages in the Bharat Kala Bhavan, Benaras, and a *Sikandar-nama*, now in the Prince of Wales Museum, Bombay. The scene of the traitorous vizier shows the native Indian inheritance in the stiffness of figures, simple layout and colour use, but the figure types are of Persian origin. As well as Delhi and Gujarat, Malwa and Jaunpur became rich and sophisticated courts in the fifteenth century.

Fig. 136 can be tentatively attributed to Malwa. The vivid colouring shows a debt to the West Indian (Jain) tradition; but the figure types are of Persian derivation. Commerical workshops, accepting Jain, Hindu and Muslim commissions, may have given rise to the poor 'bazaar' quality of the work of the fifteenth century, while the rich Jain *bhandaras* (libraries) may have been able to support superior artists, who were free from an obligation to fulfil the demand for a prolific output for the market, which would have generally resulted in inferior production.

The early sixteenth century introduces a new tradition in Muslim painting that discards the conventions of the West Indian style. In sixteenth-century Persia, the Uzbek attack on Herat in 1507 caused craftsmen to flee and seek work in India. Trade increased with the Persian city of Shiraz, which had already become a centre for extensive commercial miniature production. Embassies between Persia and the provincial Indian Sultans bearing gifts and trade no doubt increased the availability of artistic manuscripts. Persian culture was held in high esteem, and the capital of Malwa, Mandu, imitated Persian custom in language, food and costume.

Fig. 134 'Oxen ploughing', *Miftah al Fuzula*, fol, 145R, Malwa. *c.* 1500. London, British Library, Or. 3299

The Turkman Shirazi decorative emphasis, and simplicity in figure relationships, with a characteristic treatment of grass and natural vegetation, is reflected in a Malwa cookery book, the *Nimat-nama* (Fig. 137); it was written for the sultan Ghiyath al-Din at Mandu (1460–1500), and illustrated for his son Nasir al-Din (1500–10). The strict profile view, the shape of the elongated eye, and some characteristic postures, reveal its Indian authorship. A *Bustan* manuscript, made for Nasir al-Din Khalji, now in the National Museum of India, shows the persistent popularity of Persian literature. Another contemporary Malwa manuscript illustrates a Persian lexicograph called the *Miftah ul Fuzula* (Fig. 134). It shows again strong Turkman influence in style and composition, with characteristic long stemmed flowers.

There has been a recent discovery of a *Sikandar-nama* manuscript (Fig. 140), commissioned in 1531–2 by Nusrat Shah, ruler of Bengal (1519–38). Nusrat's capital Gaur, was an international trading centre. The miniature painting in the manuscript reflects the style of Turkman court painting of the later fifteenth century at Tabriz and Shiraz in derivative Persian compositions; but it also shows local features in the depiction of a type of Bengal temple horse, and in Bengali architectural forms.

A ballad composed about 1370 for a Diwan of Firuz Shah Tughluq (1351–88) is called the *Laur Chanda*. It is a love story written in Eastern Hindi (Avadhi), and had very wide popularity. Fig. 138 is from a fine illustrated manuscript of the *Laur Chanda* housed in the Prince of Wales Museum, Bombay. This manuscript shows Persian inspiration, but its assimilation of both Indian and Persian features, and the fine calligraphy point to an established court atelier in the first half of the sixteenth century, possibly at Jaunpur. Persian influence is seen in the colour use and decoration, but the compositional division into panels is an

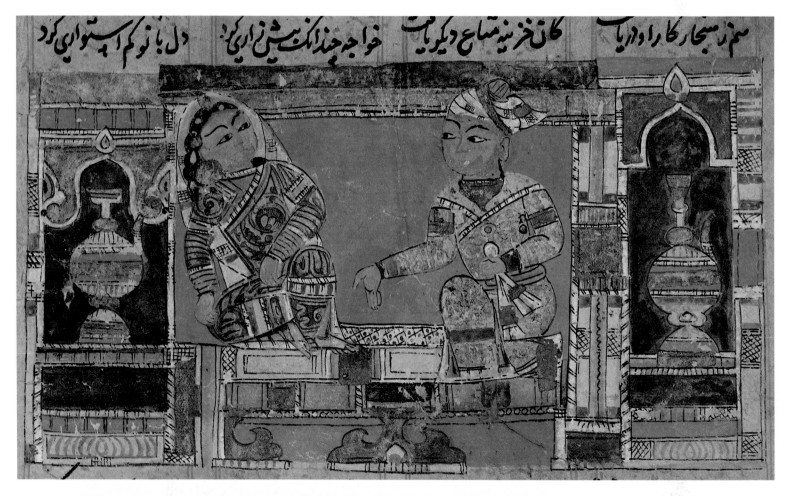

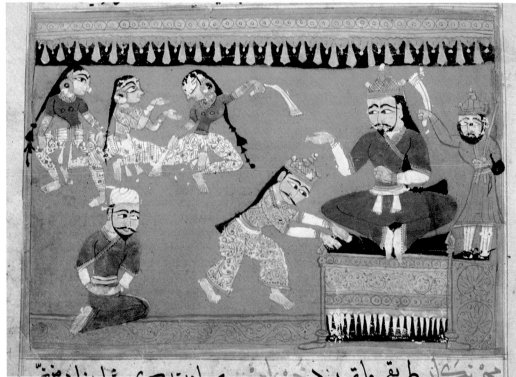

Above: Fig. 135 'The traitorous vizier repulsed by the queen', *Hasht Bihist* of Amir Khusrau, Delhi or Gujarat. Late fifteenth century. Washington, D.C., Freer Gallery of Art

Fig. 136 'Umar bin Hamza before his father', *Qissa-i Amir Hamza*, Malwa or Gujarat. Late fifteenth century. Berlin, Staatsbibliothek, Preussischer Kulturbesitz, Ms. or. fol. 4181, 167a

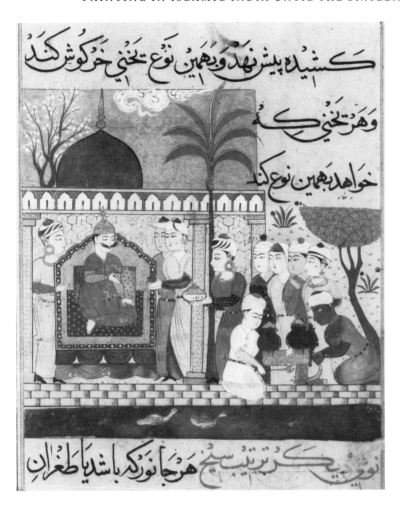

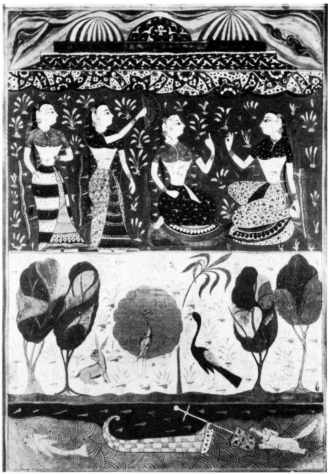

Indian conceptual device. Another copy of this ballad in the John Rylands library, Manchester, shows mannerisms that are closer to Rajasthani painting and it has been attributed to *c.* 1550.

The central authority of the Delhi Sultanate, in the early sixteenth century, was under the ineffective rule of the Lodi Afghans. In contrast, the provincial sultans and the Rajputs were gaining strength and initiative. Ibrahim Lodi's attempts to strengthen his central control, met with opposition from his provincial governors and fired the military pretensions of Rana Sanga of Mewar. In the central Asian provinces, descendants of Timur were ruling petty kingdoms engaged in vying with one another for territory and the prize of fortresses such as Kabul, Samarqand and Qandahar. Babur was the son of the ruler of the small kingdom of Ferghana. Almost losing his inheritance in an attempt to take Samarqand, he spent ten years in a freebooting existence, until he established a settled court in Kabul. This court became a renowned haven for learning, literature and the arts. In 1526 the opponents of Ibrahim Lodi invited Babur to lead an army to India, but they under-estimated Babur's charisma and strength. Babur defeated Ibrahim in 1526, and Rana Sanga in 1527, making himself ruler of Delhi, but his rule was of short duration. Babur in a remarkably sensitive and honest diary refers to the abundance of craftsmen to be found in India, but as yet no illustrated manuscript has been found that can be attributed to his patronage.

Left: Fig. 137 'The preparation of hare soup', *Nimat-nama*, fol. 18, Malwa. 1500–10. London, India Office Library

Right: Fig. 138 'Chanda in a garden', *Laur Chanda*, Jaunpur, Malwa or Mewar. 1525–70. Bombay, Prince of Wales Museum

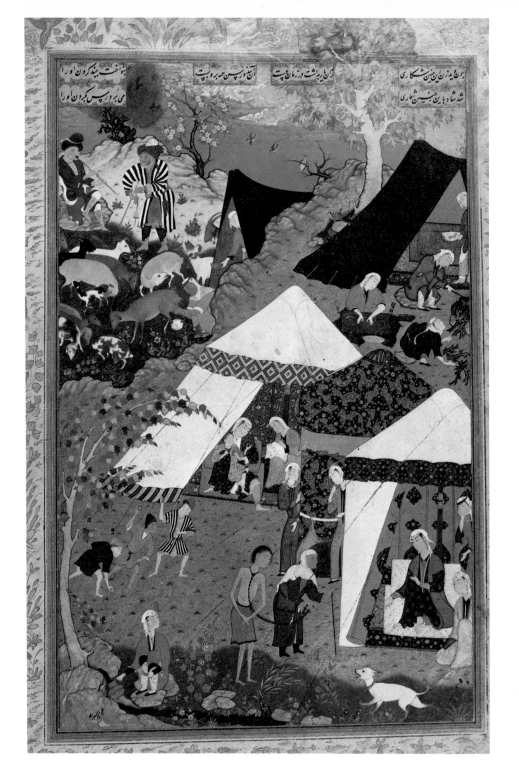

Left: Fig. 139 'Camp scene' by Mir Sayyid Ali, *Khamsa* of Nizami, fol. 157b, Tabriz. 1539–43. London, British Library, Or. 2265

Opposite: Fig. 140 'Alexander visits a hermit', *Iskander-nama* of Nusrat Shah, fol. 416, Gaur, Bengal. London, British Museum, Or. 13836

Babur's son Humayun had been educated in the cultural atmosphere of the court at Kabul; he ascended the throne in 1530. Humayun lacked the authority of his father to hold together the loosely knit kingdom. An Afghan general defeated Humayun and forced him to flee from India in 1540. Unable to seek asylum in Kabul, which was governed by his hostile brother Kamran, he was advised to seek aid in Persia. Humayun arrived in the Safavid court in 1543, and was there inspired by the architectural and cultural splendours. The Shah, Tahmasp, was a keen bibliophile and under his direction the classical restraint of Herati miniature painting had become more expressive of courtly elegance and

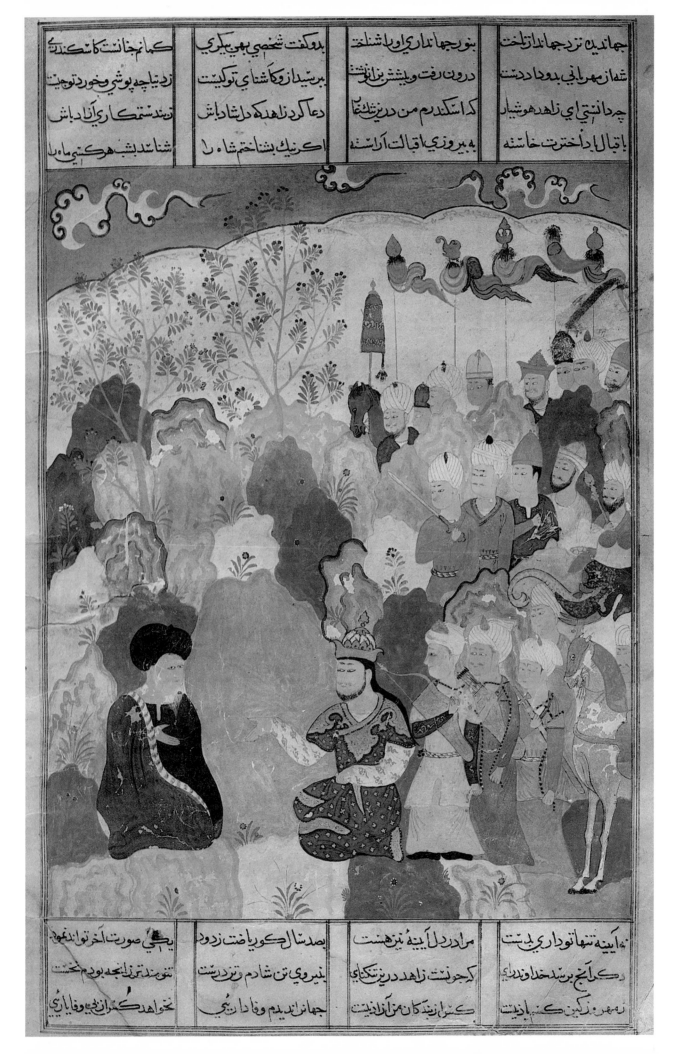

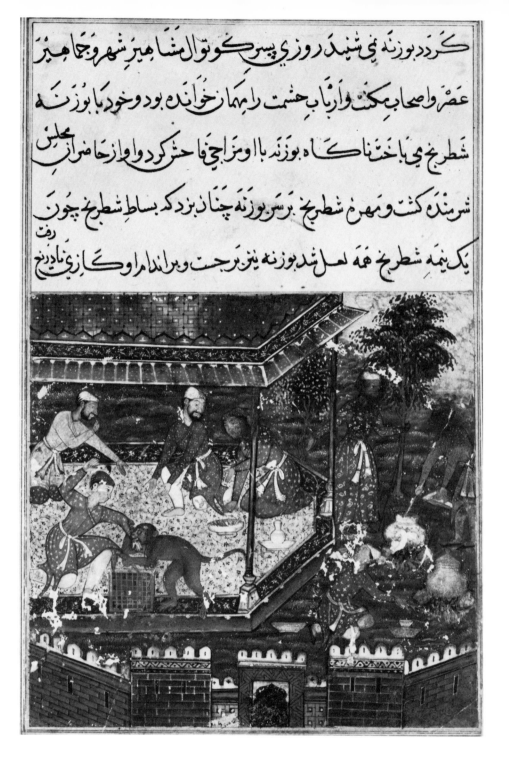

كرددبوزنه ني تنيد روزى پسر كوتوال مناميرشهر وجهانگير
عصروا صحاب مكث وارتابحشمت را يهمان خواند بود وخود با بوزنه
شطرخ مي باختناگاه بوزنده با او مزاجي فاحت كردوا واز حاضران مجلس
شرمنده گشت ومهره شطرخ برسربوزنه چنادبزدكه بساط شطرخ چون
يك نيمه شطرخ هوَه لعل شد بوزنه ينز رنجست وبراندام او كازي ناديده

Fig. 141 'The wounded monkey bites the
hand of the prince with whom he is
playing chess' by Dasvanta, *Tuti-nama*,
fol. 32b, Agra. *c*. 1570. Cleveland, Ohio,
Cleveland Museum of Art

refined mannerism. In middle life Tahmasp became increasingly puritanical and
Humayun's visit coincided with the Shah's growing hostility towards painting.
Humayun with Tahmasp's assistance established his own court in Kabul in 1545,
and invited the Safavid artists Mir Sayyid Ali and Abd al Samad to join him. Fig.
139 is an example of Mir Sayyid Ali's work in Tabriz. The artist's interest in genre
scenes, an unusual realism, together with a mastery of detail, may all reflect
Humayun's personal taste.

For five years a small atelier worked for Humayun in Kabul. The work from
this atelier shows clearly Persian, Safavid inspiration. A *Khamsa* of Nizami
manuscript, in an Indian private collection, contains a miniature which has been

attributed to the hand of the father of Mir Sayyid Ali, Mir Musavvir, who may have accompanied him to India. It also contains miniatures of the Bukharan school 1525–50. The attribution of such a manuscript to the patronage of Humayun suggests that Humayun may have enlarged his small atelier, making use of Indian artists on his return to Delhi, in 1555.

This policy of expansion was certainly continued by Humayun's dynamic son Akbar. Akbar's reputed illiteracy perhaps gave a greater incentive to the continued illustration of the popular Persian stories and fables. Two of his favourite stories are illustrated by Figs. 141 and 143, miniatures from the manuscripts, the *Tuti-nama* (story of the parrot) and the story of the Uncle of the prophet Mohammad, the *Hamza-nama*. The numerous illustrations in these manuscripts necessitated the rapid recruitment of artists from neighbouring provinces, which gradually came under Akbar's rule and authority. The supervision of this mixed atelier was still in the hands of Persian immigré artists.

Fig. 140 shows in the red and white striped dome and the panel division of the composition its relationship with the Indo-Persian work seen in the Prince of Wales Museum *Laur Chanda*. Other miniatures of the manuscript show in the simple formula for architecture; in a characteristic chequer pattern; in the female figure with the transpararent ohni and in the solid red background, an echo of the Hindu painting style of the Chaurapanchasika school.

A unique assimilation, consistency and an extraordinary vitality and original-ity is found in the manuscript of the *Hamza-nama*. The picture of the giant is a good example of this energy and expression of dramatic narrative, movement and brilliance of colour, together with an increase in the sophistication of design and composition that comes from Persian example and instruction. The rapid strides taken by the artists of the *Hamza-nama*, in the variety and complexity of design, suggest a new source of inspiration. A manuscript, once housed in the Mughal royal library, a *c.* 1440, Persian, Herati *Shahnama*, now on loan from the Royal Asiatic Society to the British Library, may well be the source of several features that make their first Mughal appearance in the *Hamza-nama*. Having assimilated the new imagery, the Indian artist's tradition of the visual embodi-ment of drama, seen in dance and puppetry, once more found its outlet in painting, inspired by the energetic enthusiasm of the young patron. In the *Hamza-nama* the Indian's innate sense of movement and form, seen in classical sculpture, once more finds expression in paint and rhythm.

Fatehpur Sikri, the Mughal capital, in 1568, was a fertile ground for ex-perimentation and the exchange of ideas between religious and scholastic doctrine. Akbar grew disenchanted with Muslim philosophy and literature and in 1582 commissioned a translation of the Hindu epics. In his mature years, a court biographer Abul Fazl wrote daily records of the courtlife. To celebrate the coming of the Muslim millenium, Akbar began to commission the writing and illustration of historical narratives. From 1580, a style gradually emerged that combined European techniques of perspective and the depiction of volume, with a Persian sense of balance and restraint. The number and variety of manuscripts being produced was tremendous. The atelier became streamlined in its organization, with different artists allotted specific tasks in the execution of the large scale manuscripts. The first historical narrative was a *Timur-nama* manuscript, now housed in a library in Patna. This reveals the vitality of the *Hamza*, but also shows restraint in the clear division of work in the paintings.

In 1585 the atelier's move to Lahore and the corresponding upheaval allowed

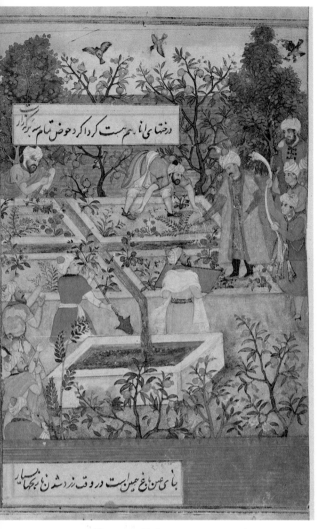

Fig. 142 'Babur supervising the construction of his garden', *Babur-nama*. 1589. London, Victoria and Albert Museum, I.M. 276–1913

Fig. 143 'Giant Zumurrud Shah attacking figures in an open courtyard', painted on cotton, *Hamza-nama*, Agra. 1562–77. Vienna, Völkerkundemuseum, acc. no. 8770

local artists to be employed. The atelier continued to produce works of classical Persian orientation, and a comparison of Figs. 144 and 145 shows the extent to which the school still depended for its inspiration on Persian examples. Manuscripts and tracings were still accepted as visual sources for the atelier. Alongside this traditional method of imitation, however, there is a new emphasis on portraiture and glorification of daily events. This is clearly exhibited in a lavish biography, commissioned by Akbar, the *Akbar-nama*. This was treated in a way that elevated, publicized and reflected his glory and courtly paraphernalia.

The earlier *Babur-nama*, the story of Akbar's grandfather, seen in Fig. 142 shows these tendencies. Fig. 147 is an illustration to the *Akbar-nama*, and is by a Persian artist in the Mughal court. It shows the synthesis and sophistication, the accuracy of observation, and the rich detail exemplified by this manuscript.

The existence of a lavishly illustrated *Khamsa* of Nizami in 1595, proves that Persian literature was still considered a suitable subject for extravagant commission. Fig. 146 is taken from this manuscript. By this time the artists of this traditional work abandon the popular miniature cycle, and combine refined detail with a greater assimilation of European volume and perspective. This revolution in painting, which departs from conventions in content, composition and function, finds its apogee under the discerning aesthete, the son of Akbar, Jahangir.

The patronage of Muslim painting in the south follows a somewhat different course from that in North India. The Muslim rule in South India was concentrated in the Deccan, the high plateau that stretches across the Northern part of the Indian peninsula. Here independent rule had its origin in the revolt of an Afghan general against Muhammad bin Tughluq, during Muhammad's abortive move south to Daulatabad. This Afghan general Hasan Gangu Bahmani set up an independent state with its capital at Gulbarga which continued from 1347 to 1482. The grandson of Hasan followed the Muslim tradition of the sultan with a love for refinement and literature. He encouraged literary pursuits and even invited the Persian poet Hafiz to visit his court from Shiraz. Links with Arabia, Persia, and neighbouring Khurasan were strengthened by the ruler's practice of inviting adventurers from these areas to counter dissension at court. Most of these newcomers introduced a strong shiite sympathy at court. Trade flourished, goods being brought by sea through the western ports. Internal division finally brought this Bahmani empire to disintegration in 1482, but out of the ruins arose independent kingdoms of the Barid Shahis of Bidar, the Qutb Shahis of Golconda, the Ahmad Shahis of Berar, the Nizam Shah of Ahmadnagar and the Adil Shahis of Bijapur. With the purpose of retaining their distinct character and independence from Delhi, these independent rulers encouraged continuing links with Persia, and a conscious imitation of its culture and literature.

In painting the earliest manuscripts that can be assigned to Deccani patronage show Persian or Bukharan derivation. Early patronage of Muhammad Quli Qutb Shah (1580–1611) can be seen in two miniatures in an American private collection and an Urdu anthology of the Sultan's own poetry undated, now housed in the Salarjang Museum, Hyderabad. They show a highly decorative style echoing the contemporary work in Shiraz. Indian features appear in some of the costumes and colour schemes and in the division of some of the miniatures into niche compartments.

Although the Golconda painting shows a Persian derivation, a manuscript

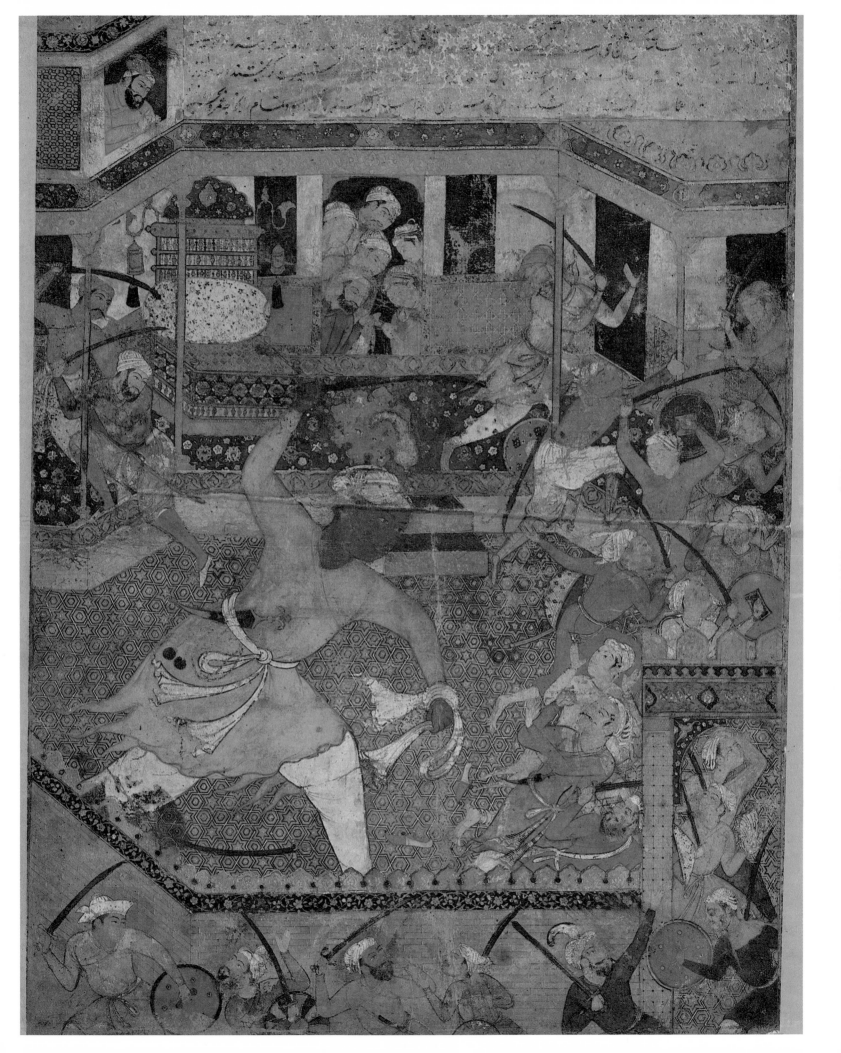

Left: Fig. 144 'Farhad carrying Shirin',
Khamsa of Nizami, fol. 70v, Herat. 1493.
London, British Library, Add. 25900

Right: Fig. 145 'Farhad carrying Shirin'
by Sharif, *Khamsa* of Nizami, fol. 73b,
Lahore. 1585. Keir Collection

attributed to the widow of Husayn I Nizam Shah of Ahmadnagar (1553–65), in praise of her husband's reign shows a dramatic change in style. It may be no coincidence that the Muslims defeated the Hindu Raja of the powerful neighbouring Hindu empire Vijayanagar, at Talikota in 1565. They inherited a kingdom, one of the richest in India, which had been responsible for an active school of painting deriving ultimately from the classical tradition of Ajanta and Ellora. The capture from this centre of artisans may explain the sudden emergence of a new distinctive style in the Deccan after 1565. A palette of brilliant and richer colour, a variety in depth of tone, and a decorative surface, interwoven in movement and rhythm, can be seen, together with the continuance of Persian features of the high horizon, the cypress, and flowering tree. There has also been a suggestion of stylistic links with the painting found in earlier manuscripts such as the *Nimat-nama*, done in Malwa.

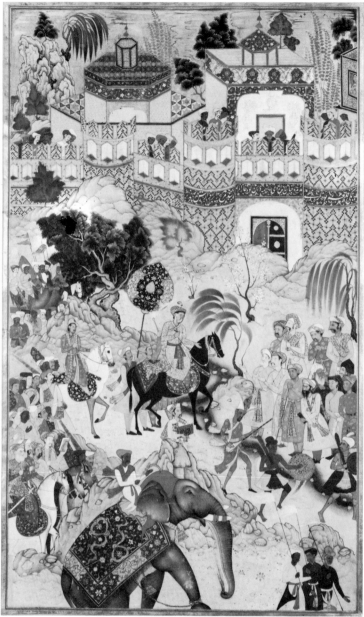

A beautiful *Ragamala* series, now in the National Museum of India, can also be attributed to a Hindu patron possibly a *zamindar* of the sultan of Ahmadnagar. By 1610, however, the Barid Shahis of Bidar and the Nizam Shahis of Ahmadnagar had been absorbed into the Mughal empire.

Fig. 148 shows a miniature from an early manuscript (1570) from Bijapur, a richly illustrated encyclopaedia known as the *Nujum al-Ulum*. Here the first patron was Ali Adil Shah (1558–80), and his successor Ibrahim (1580–1622) established a court of unparalleled luxury. The existence of a Bukharan artist active in his court, is shown by a manuscript in Patna signed by Yusuf and dedicated to Ibrahim in 1569, in which the miniatures are undoubtedly in a contemporary Bukharan style. By the late sixteenth century links with the flourishing Mughal court became more apparent. Fig. 149 reveals the growing sophistication and brilliant skill and mastery attained in Bijapur by 1620. The

Left: Fig. 146 'Sultan Sanjar and the old woman', *Khamsa* of Nizami, fol. 15v, Mughal. 1595. London, British Library, Or. 12208

Right: Fig. 147 'Akbar's entry into Surat' by Farrukh Beg, *Akbar-nama*. *c.* 1590. London, Victoria and Albert Musuem, IS. 2–1896. 117/117

Opposite: Fig. 148 'The throne of prosperity', *Nujum al-Ulum*, fol. 191r, Bijapur, 1570. Dublin, Chester Beatty Library

Right: Fig. 149 'Portrait of Ibrahim Adil Shah II (1580–1627)', Bijapur. *c.* 1615–20. London, British Museum, Or. Ant. 1937–4–10–02

influence of both Europe and the Mughal atelier is clear. The artist does not lose, however, a distinctive character, a refinement, a love for decorative detail, for dark colour contrasts, for an atmosphere of opulence, and for an emphasis on folds and vital rhythm in plant forms and costume. Exotic foliage and the jewelled quality of form in the dark background convey the richness and spice of courtly splendour. After 1627, this mystery of atmosphere is lost, and the portrait of Muhammad Adil Shah in the British Museum shows a weak ruler, solely a decorative study of strings of pearl and costume of rich brocade.

The influence of the Mughal court was also felt in later painting at Golconda. Golconda and Bijapur maintained their independence until 1686, but they paid tribute to the Mughals. Fig. 150 is a scene showing Abdullah Qutb Shah. It reveals Persian and Bukharan influence and can be dated 1629. The background, however, consists of horizontal bands which provide spatial division in an Indian manner. By the early seventeenth century, as at the Mughal court, painting was chiefly that of portraiture. The Mughal conquest of Bijapur and Golconda in 1686–7, extinguished the independence and eclipsed the splendour of the Deccani sultans, but cultural and diplomatic exchanges had already given rise to the hybrid style of the late seventeenth century, with its characteristic variety of portraiture following standard prototypes, but not losing the artist's personal sense of decorative phantasy.

Painting in the Deccan and at the Mughal court under Muslim patronage had been transformed from a private art of manuscripts illustrating classical Persian literature to an emphasis on portraiture and more realistic representation of nature. Painting no longer illustrated classical romances, but reflected the glory and esteem of the patron.

Fig. 150 'Dancing before Abdullah Qutb Shah'. 1629. London, British Museum, 1974–6–17–06–5

LINDA YORK LEACH

Later Mughal Painting

Akbar's establishment of a highly professional group of artists trained to illustrate manuscripts of history, fable, and poetry was followed by a period of patronage under his son Jahangir (1605–27), which was extremely active but less tightly organized. Jahangir gave varied individual commissions to his painters rather than manuscript assignments.

For many years as a prince, Jahangir had been an interested and even avid patron, so that when he succeeded to the throne in his middle thirties his knowledge of art was already well-formulated. With the escalation of his power and freedom as emperor his commissions increased in originality. From a present view, it appears that this time of imperial prosperity and stability offered maximum potential for a court patron to develop the arts. Jahangir possessed the right combination of sensitivity, judgement and initiative to be able to exert a very positive influence on his artists. These characteristics promoted significant stylistic developments, particularly in the field of human and animal portrait painting.

The fact that Jahangir inherited his imperial role while Akbar had consciously created his own position had an important effect on the miniatures produced in each era. Akbar, as a skilful politician, had been aware that painting was considered one of the privileges of rulership by his ancestors the Timurids and thus he had utilized the art as a manifestation of dynastic power. He perceived that others would accept his rule as successful if they were awed by the quality of its symbols. His son, by contrast, did little either from motives of political foresight or expediency. From his memoirs it is evident that Jahangir, unlike his father, viewed rule as a divine privilege bestowed by Destiny rather than as an employment necessitating will or effort. While his general concept of statecraft was thus extremely limited in comparison to Akbar's, Jahangir's approach to art was straightforwardly free of any consideration other than that of an aesthetic enjoyment to which his imperial position entitled him.

Posing as Allah's figurehead at the summit of an earthly pyramid, Jahangir took for granted the workings of governmental processes but ironically possessed such an avid interest in natural science that he pursued this spontaneously as if it were his true career. Despite his addiction to alcohol and opium, and with a sensual personality lulled by the opulence of his court, Jahangir's dedication to natural observation remained instinctive and single minded throughout his life.

In addition, painting was a serious means of expression, as is shown by contrast with various later works such as those commissioned by Jahangir's grandson Dara Shikoh. The painting of the Jahangiri era is sober, economical and austere despite great richness; little about it suggests the frivolous or merely charming. The fact that Jahangir always turned to painting in order to record his strongest impressions of nature demonstrates the significance he accorded this medium. He continually experimented with new ways by which these two absorbing passions could be blended. He not only expanded the range of natural history subjects with such ideas as the painting of one hundred Kashmiri flowers by Mansur, but he was also responsible for major evolutions of technique in this type of painting. Clear intellectual attention given to the details of anatomy or plant growth can be identified especially with his era and is the result of the emperor's many commands for artists to paint animals or flowers from life. Though birds, animals and flowers remain common themes of painting after his time, the early seventeenth-century honesty and purity of approach are not equalled even after the arrival of the British amateur naturalist patrons in India.

Jahangir's preoccupation with natural science seems first to have been expressed in hunting, but interests in animal distribution, size, performance and behaviour appear always to lie behind his enthusiasm for this pursuit. From childhood, recorders kept an exact account of his kills, and as a prince he commissioned a series of miniatures, all of similar composition which fulfill the same function (Fig. 151). Artistically this series shows the enlargement of objects and figures in proportion to the total paint area, an important evolution, which occurred after 1600 as more attention was concentrated on individuality. In contrast to Akbari hunts, this composition is awkwardly arranged but attractive design has been temporarily sublimated in the struggle for a new lifelikeness.

The year in which Jahangir first began ordering animal portraits is not specifically known; the commissions almost certainly begin prior to his accession. By an early date in the reign, very complex miniatures of this type were being produced by several artists. In 1607, for example, Jahangir was excited by the appearance of a Himalayan goat or *markhur* with towering curved horns, which he had never seen before. He ordered painters to do a portrait of a large specimen that had been shot and brought in by Afghani hunters.[1] The resulting painting by his artist Inayat is a close study of the animal skillfully indicating its weight, the differing textures of hair, and the fullness of the body (Fig. 152). The illusion of density in the long fur around the neck of the *markhur* owes something to the influence of Western art, but is exaggerated so that the paint surface acquires an extra abstract value distinct from Western models. At one point in his diary, Jahangir mentions that his artists were incapable of capturing animal movement well.[2] It is interesting that he himself was aware of this subtlety, yet, as in this case, the artists' deficiency frequently arose from the necessity of painting animals after death.

The other great preoccupation of Jahangir's artists was with the portrayal of the human figure. The intention to be naturalistic dominates Akbari works and is the basis for the achievements of Jahangir's artists who were increasingly able to convey the fleshy solidity of the human body. Their inspiration for this was

[1] Jahangir, *The Tuzuk-i-Jahangiri; or Memoirs of Jahangir*. Translated by A. Rogers and edited by H. Beveridge. London, 1909–14. I:113.

[2] *op. cit.* II:88–9.

European; Jahangir had some paintings and a large collection of Western prints, which are known to have been copied or paraphrased by miniaturists and enlarged for wall decoration as well as obviously providing a source of ideas for figure modelling and positioning[3].

A trait associated with the Northern Renaissance tradition which was familiar to the Mughal emperors is that of portrait psychology. The imperial court was thick with intrigue, and Jahangir, feeling that he was often disillusioned both by enemies and so-called friends, attempted various methods of assessment. The most direct evidence of the fact that he expected paintings to reveal personality is shown by his requests for portraits of foreign rivals in order that he might judge their characteristics. He also must have had certain standards for the studies of his own courtiers with which his best artists could comply. The limitation of their style arose because of the means they were forced to employ in the representation of *durbars* and other court scenes – procedures that were similar to those used by Inayat in his recreation of the dead *markhur* – since many events were reconstructed after they had taken place. Though Jahangir immediately commanded an artist to depict courtiers gathering at a presentation of rare animals from Goa in 1612, his 1605 accession seems to have been portrayed only in 1618.[4] Artists apparently gathered information from the news writers always present in the court and recreated happenings by combining previous portrait sketches of each individual.

Once this procedure is evident, the source of the artist's inspiration becomes obvious because certain heads are out of scale or awkwardly in profile. There must have been an incredible collection of drawings kept for such a purpose in Shah Jahan's and Aurangzeb's reigns as well as in the Jahangiri era. Often in the eighteenth century either the sketch was coloured and mounted as a painting in its own right or artists did an eighteenth-century version from the earlier model, but by that time without a comparable understanding of imperial grandeur.

In a scene assembled after the fact, Jahangir's artists were forced to produce a convincing illusion against great odds but were remarkably successful as is demonstrated by the naturalism of Fig. 153. This is a composition that belongs to the group of illustrations painted for Jahangir's memoirs, *Jahangir-nama*. The scene shows the Emperor receiving the submission of a captured rebel following the insurrection of his eldest son in 1606. The confidently treated faces register differing emotional states vividly; the poses are convincingly varied, and there is a genuine feeling of the pressing crowd encircling the Emperor.

While the scene may have little relation to what actually took place at Sikandra in 1606, the artist is extremely skilled in conveying the illusion of the event though he was faced with an entirely different reality after a ten to fifteen year lapse of time. For example, the nobility and vitality of the young Emperor are convincing although the artist was undoubtedly familiar with the aging Jahangir who had a coarsened face and much heavier body.

Anachronisms that occur in recreated scenes can be a means of determining the date of a miniature. In this case, the architecture shows that the painting

Fig. 151 'Jahangir inspecting dead animals on the hunting field', Allahabad. *c.* 1600–4. Dublin, Chester Beatty Library, ms. 50.1

[3]Ettinghausen, R., 'New Pictorial Evidence of Catholic Missionary Activity in Mughal India', *Perennitas*, 1963, p. 390–1.

[4]Jahangir, I:215 and II:20.

Left: Fig. 152 'Himalayan *Markhur*' by Inayat, Wantage Album. *c.* 1607. London, Victoria and Albert Museum, IM 138–1921

Right: Fig. 153 'Capture of a Rebel', *Jahangir-nama. c.* 1615–20. Dublin, Chester Beatty Library, ms. 34.5

must have been done after 1609 when Jahangir ordered his father's tomb to be rebuilt as it appears here.[5] The accomplished style implies a slightly later date of 1615–20.

The evidence of Jahangir's own writing is that he considered the illustration of the *Tuzuk* as a great undertaking. At present the work, which is certainly central to the Jahangiri period, is not as well known as it should be. Because Jahangir's commissions for the book were erratic and not well defined in the diary itself, there is confusion over which illustrations originally were intended for this compilation. For example, it is a question whether the portrait of the *markhur*, which has nothing to do with Jahangir's court life, was actually intended to illustrate the memoirs even though the animal was described in these pages by the Emperor. Presumably since Jahangir filled the *Tuzuk* with natural science he intended the illustrations to follow themes more personal or intellectual than

[5]*op. cit.* I:152.

144

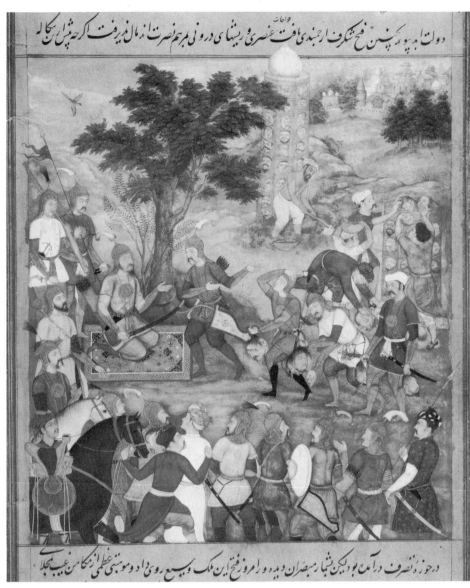

Left: Fig. 154 'Raja Birkramajit' by Bichitr, Kevorkian album. *c.* 1616. New York, The Metropolitan Museum of Art, 55.121.10.1

Right: Fig. 155 'The Construction of a tower of heads after the defeat of Da'ud of Bengal' by Manohar, *Akbar-nama. c.* 1605. Dublin, Chester Beatty Library, ms. 3.50

political. The known *Tuzuk* pages are widely scattered and many have suffered enormous damage; others have been heavily retouched so that their superlative quality is obscured. It is a combination of these factors that has contributed to an underestimation of the manuscript.

Despite the fact that most of Jahangir's artists are quite individual, exact documentation of their works is sometimes more difficult than for Akbari painters who participated in the major datable manuscripts inscribed by a librarian with artists' names. As has been mentioned, Jahangir desired works of a masterpiece status generally without sequential relationships. Frequently these were left unsigned. The imperial memoirs give better information about the subject-matter of paintings than about Jahangir's artists. The Emperor generally records his commissions as going to unspecified painters on call at the time when various incidents took place. From such descriptions, it appears that at any hour artists were available for the imperial summons and that this small flexible group had been substituted for the guild-like studio consistently

illustrating books during Akbar's reign. According to the *Tuzuk*, even at the beginning of the reign Jahangir had acquired the habit of taking painters with him on the long trips that occupied much of his time.

In part, the artistic giants of Jahangir's era can be visualized as personalities because most of them had family ties with Akbari painters or had begun their careers in the Akbari studio. For example, Manohar was the son of Akbar's great painter Basawan. He began working at a young age in the Akbari studio and incorporated many of his father's traits into his miniatures, but by 1600 had developed several styles more consistent with his abilities and the demands of the new era (Fig. 155).[6] Like him, Govardhan, Bishndas and Abul Hasan – all favoured painters of Jahangir – are known to be from families that had older members serving as artist teachers. All these painters are thus recognized as having developed in relation to a comparatively short but already strong dynastic tradition. The painter Bichitr (Fig. 154) is the only major Jahangiri artist whose early development is totally unknown.

In 1618, Jahangir mentions that he had termed Abul Hasan 'Nadir al-Zaman' ('The Wonder of the Age'), and that this painter, who had been in Jahangir's own household since childhood, had no rival. Jahangir then praises Mansur, his nature painter, as being of unique ability in his own specialization.[7] While Abul Hasan is thus elevated to a preeminent position, he was also part of a group that worked within a certain generally accepted definition of naturalism. Bichitr, Govardhan and Manohar may not have been his equals in Jahangir's estimation, but they were all strong original artists not to be confused as followers of the Emperor's favourite. There seems to have been a flow of talent generated by the artists' associations with one another, which promoted the rapid developments of the period.

Bichitr's extant works are complex and formal; none can be postulated to be an early artistic attempt. He and Abul Hasan worked along parallel lines many times, but Bichitr's work is more cool and precise. Fig. 152 is an example of one of the paintings parallel to Abul Hasan's style; it is the portrait of Prince Khusrau's closest and most trusted confederate, the Hindu courtier Bikramajit. Surrounded by luxuriant flowers in a grassy field, Bichitr's courtier is much like a portrait of Shah Jahan himself painted by Abul Hasan at about the same date.[8] While Shah Jahan is attired in red and orange, Bikramajit is done as a study of white tones on white subtly indicating the restraint of Bichitr's contrasting nature.

Govardhan was a master of several styles, the best of which epitomizes the sensuous aestheticism that was part of Jahangir's own nature. Fig 156 is a love scene of extraordinary textural sensitivity – the muted carpets, the luminosity of skin tone and of sky are all very typical of Govardhan's genius.

Important among the miniatures associated with these artists during Jahangir's late reign are the allegorical glorifications of his imperial role. Stylistically these works reflect the Mughal acquaintance with Baroque art; the idea of the allegory came from Western religious sources as well as from the English

[6]see Pinder-Wilson, R., *Paintings from the Muslim Courts of India*, London, 1976, cover.

[7]Jahangir II:20.

[8]Gascoigne, B., *The Great Moghuls*, New York, 1971, p. 186.

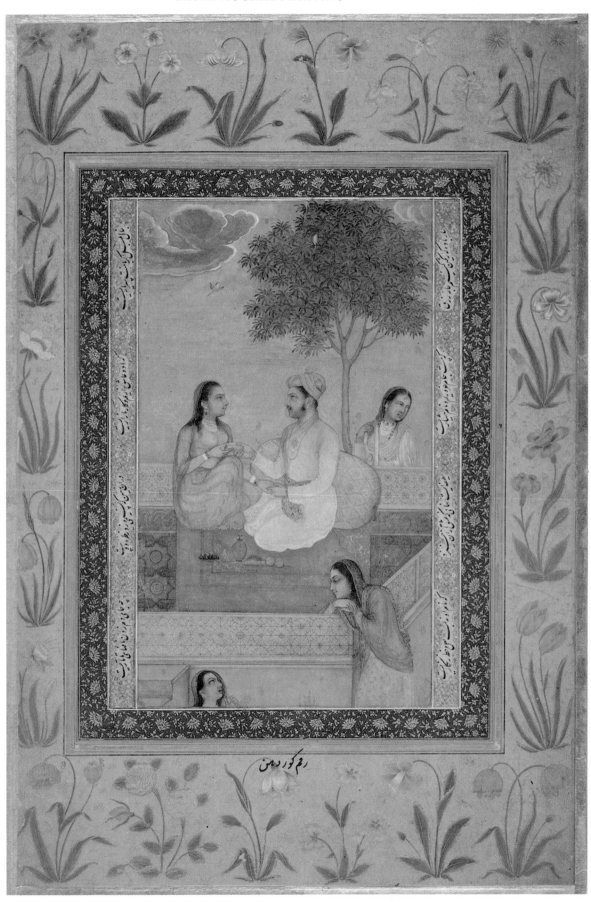

Fig. 156 'Parviz and
women' by
Govardhan, Minto
album. *c.* 1615–20.
Dublin, Chester
Beatty Library, ms.
7A.2

ambassador Sir Thomas Roe whose letters mention the gift of a Western antique allegorical theme.[9] Baroque influence on the miniatures is shown in broader brushwork, in more grandiose forms and in such details as the turquoise skies with fleecy clouds. The composition of these paintings is often unappealing as the demands of the allegory take precedence over visual coherence, but they are intricate and opulent studies. The painters were by this time acquainted with the Western system of perspective and apparently felt themselves sufficiently versed in its principles to play games of wit. In an allegory by Abul Hasan, angels come alive in a fantastic carpet and grasp the gold throne in front of them; the scrollwork of throne and carpet become inextricably twined and the painting is flattened in a manner that is very puzzling at first glance.[10].

In the early years of Shah Jahan's reign painting continued as if the character of the patron remained unchanged. Jahangir's artists, notably Bichitr and Govardhan, retained the high standards that they had already reached, producing some fine pictures, many now mounted in a series of royal albums. Shah Jahan had been briefly interested in painting as a young man, but architecture and jewel collecting were his intensive preoccupations. As a result, he must have expended far less personal energy than his father in directing miniaturists and to have instead been an aloof, formal and impersonal patron.

The royal albums mentioned above were probably begun at Jahangir's request shortly after 1620 though certain miniatures chosen for inclusion go back to about 1600. The borders of this album series (Minto, Wantage, Kevorkian, Jaipur) are flowered in a manner that came into vogue as decoration sometime after Jahangir's spring visit to Kashmir in 1620.[11] One of the earliest works done in Shah Jahan's reign and mounted in this series is a royal portrait of the new emperor with his sons, whose youth indicates a date of about 1627, following the death of Jahangir (Fig. 157). The picture is one of several in the albums showing Shah Jahan set off by elaborate imperial symbols such as the globe originally adapted from European painting by Jahangir. Other miniatures reproduced from these royal albums are Figs. 152, 154 and 156.

Balchand, the artist of the scene, had been doing pictures since 1604, but his early works are very tentative attempts. His drawing has little spirit and his figures, with rosebud mouths and soft faces from a Persian prototype, lack characterization. Balchand, however, grows as an artist and concludes his career with very substantial compositions, including excellent portrait studies, for the manuscript of the *Shah Jahan-nama* (these are inscribed as being done in his old age).[12] He, and more especially his brother Payag, are the two older artists whose strength emerges in Shah Jahan's reign. Like Balchand, Payag began to paint late in Akbar's era but seems to have received sporadic commissions. His

[9]Roe, *The Embassy of Sir Thomas Roe to India 1615–1619*. Edited by W. Foster. London, 1926, p. 214.

[10]Gascoigne, p. 129.

[11]The Minto album is divided between the Victoria and Albert Museum and the Chester Beatty Library; the Wantage album is in the Victoria and Albert; the Kevorkian album is divided between the Metropolitan Museum and the Freer Gallery. For the evolution of border decoration, see Skelton, R. 'A Decorative Motif in Mughal Art', in *Aspects of Indian Art*, edited by P. Pal, Leiden, 1972, pp. 147–52.

[12]*Shah Jahan Nama*, fol. 72v, fol. 91v.

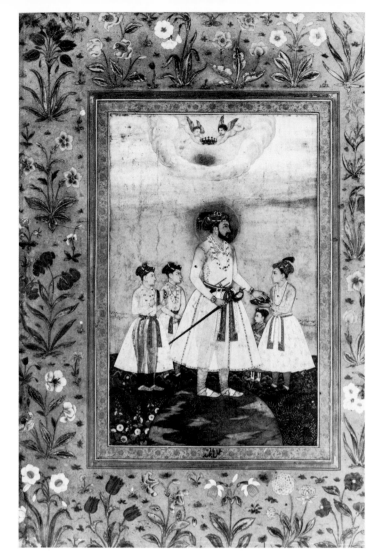

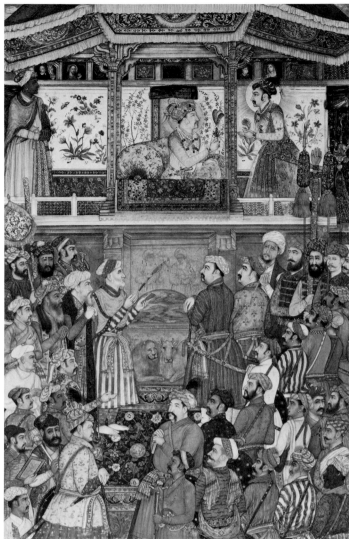

work was less recognized than that of Balchand; that he did not attract Jahangir's attentive, well-trained eye is surprising in retrospect. Unfortunately, though Payag's late work in the *Shah Jahan-nama* is some of the most brilliant and original done under Shah Jahan, he was eclipsed by his brother, as attested by his signatures merely identifying him as Payag, the brother of Balchand.[13]

His genius lies in several recurring aspects of his work. Most significant is his adaptation of chiaroscuro effects from European tradition. Many of his paintings are night scenes with some figures half lost in shadow and others brought into dramatic prominence by the flicker of fire or candle light. A further distinctive element of his paintings is the landscape settings whose precise details seem to come from awareness of Northern Renaissance art, possibly from Dürer. Fig. 160 a siege scene from the *Shah Jahan-nama*, is filled with billowing smoke creating shadowy effects typical of Payag; in the left foreground is a small grassy area characteristic of the artist's landscape treatment. Payag did a further painting of the Qandahar struggle also intended for the *Shah Jahan-nama* with many of the same traits such as a clouded atmosphere, a massed crowd of soldiers and skeletons of long dead warriors hidden in the landscape.[14]

Left: Fig. 157 'Shah Jahan and his sons' by Balchand, Minto album. *c.* 1627. Dublin, Chester Beatty Library, 7A.10

Right: Fig. 158 'Jahangir receiving Khurram at Mandu after his return from the Deccan in 1617' by Payag, *Shah Jahan-nama*, fol. 194r. *c.* 1640. Windsor Castle, Royal Library. Reproduced by Gracious Permission of Her Majesty Queen Elizabeth II

[13]*Shah Jahan Nama*, fol. 101v, fol. 194r.

[14]Beach, M., *The Grand Mogul*, Williamstown, Mass., 1978, p. 82.

Two other *Shah Jahan-nama* compositions (Figs. 127 and 158) by Payag, court scenes that show his tremendous versatility, are richly opulent compositions of textile patterns reflecting Shah Jahan's love of ornate surfaces and brilliant colouration comparable to his beloved marble inlays or jewellery.

Payag has done an extraordinary group of faces in a manner characteristic of his style with such supple features that they sometimes verge on caricature. In the *Shah Jahan-nama*, the humanism and interest in psychology present in Jahangiri works tend to be superseded by technical brilliance. Activity on the surface of paintings such as Payag's becomes more exciting in its own right as colour and jewel-like pattern are emphasized.

The painted architectural decoration of the court in Fig. 158 is fascinating since it accurately corresponds to several contemporary descriptions but does not survive except in miniatures. Jahangir loved to place European religious pictures, especially of the Virgin, in many parts of his palaces; here they appear in niches above his head, below which Payag has represented what is probably a painted rather than an inlaid wall decoration of flowering plants.

Fig. 159 'Dara Shikoh on horseback'. *c.* 1633. Keir Collection

While the bound section of the *Shah Jahan-nama* manuscript is at Windsor Castle, many scattered pages exist that were for some unknown reason excluded from this portion. The omission is puzzling because the quality of these pages is superior to some in the volume added at a later date. These pages in harsh styles possibly added at the end of Shah Jahan's reign during his imprisonment by Aurangzeb mainly enlarge compositions originally intended for one side of the page. Pages are difficult to date because they are in a variety of styles, some quite eccentric with influences from provincial areas such as Kashmir.[15]

The artists of the *Shah Jahan-nama* form an interesting group collectively demonstrating how much is still to be learned about the Mughal studio during this reign. The names of a few painters like Daulat reappear after a period of anonymity. The careers of other artists (Abid, Ram Das) are just beginning to emerge in this century through discovery of a few of their works. Further painters are still otherwise unknown to us but have accomplished styles and must have been regularly dependent on imperial patronage (Tir Dast, Bulaqi).[16]

Shah Jahan's favourite son and intended heir Dara Shikoh (Fig. 159) is better known for dedicated patronage of painting than is his father, yet the works associated with his name do not have the richness of those produced for Shah Jahan. Many in the album given by Dara to his wife in 1641/2 are very stiff productions. Among them are plant studies that lack the organic quality of Jahangiri work; Fig. 161 is an example of one of the most pleasing nature miniatures in this India Office album but even it is a decorative rather than a powerful anatomical portrayal.

It has been usual to perceive a decline in Mughal painting after Jahangir's death, which increases in momentum during Aurangzeb's reign (1658–1707) because of his strict Muslim opinions on the arts. While this generalization seems to have validity, it is also simplified. As mentioned, painting during the first part of Shah Jahan's era continued in the Jahangiri tradition with almost no break. In addition, though Shah Jahan was not an enthusiastic patron himself, the royal albums and the *Shah Jahan-nama* contain crucial innovative miniatures

[15]*Shah Jahan Nama*, fol. 204v and 205r.

[16]*Shah Jahan Nama*, Ram Das (fol. 48v), Abid (fol. 93v), Tir Dast (fol. 173r), Bulaqi (fols. 123v and 124r).

quite different from those that could have been produced under Jahangir. Furthermore, Aurangzeb's hostility toward painters and painting did not emerge until about 1680 when he announced his religiously motivated prohibitions on art and also moved away from the great artistic centre of Delhi to pursue his Deccani wars. Little is known about his personal activity as a patron during the first part of the reign but certainly there are paintings of quality that are stylistically attributable to the period between 1660–80. It seems likely that patronage broadened in these years to include more commissions by the nobility; there was probably a gradual dispersal of painters as well as the more sudden exodus from Delhi in 1680. Fig. 165 for example that shows a noble hawking is a miniature by an extremely able painter aware of developments in the rendering of landscape, but the subject matter may indicate that he worked outside the imperial court.

Left: Fig. 160 'Siege of Kandahar in 1631' by Payag, *Shah Jahan-nama*, fol. 101v. *c.* 1640. Windsor Castle, Royal Library. Reproduced by Gracious Permission of Her Majesty Queen Elizabeth II

Right: Fig. 161 'Bird in a landscape', Dara Shikoh album. *c.* 1630. London, India Office Library, fol. 9v

Fig. 162 'Mughal prince in a mosque leading Friday prayers', the Large Clive album, fol. 38a. *c.* 1720. London, Victoria and Albert Museum, I.S. 133–1964

Toward the end of the century, artists were still producing miniatures, especially portraits or landscapes, showing a certain amount of interest in naturalism; however, there was also an increasing tendency for them to stylize pattern and conventionalize line. For example, Fig. 164 is a vividly elegant miniature representing the climax of a type of mannerism seen in nascent form in the *Shah Jahan-nama*. Over the years, artists had reworked the formal imperial portrait until important decorative symbols of status like rugs and textiles achieved a maximum of dramatic impact.

Another of the many means by which the artist abstracted his forms is shown in Fig. 162, which gives an opposite effect; here outline has been purged of all naturalistic or accidental effects and lengthened to its ultimate extent so that contours appear extremely clean. This type of line is a particularly significant aspect of paintings to the end of the Muhammad Shah era and is related to the Guler/Kangra style of the Pahari region.

The tendency toward conventionalization by Mughal painters results from a combination of factors; artists working for a single, perceptive patron like Jahangir who demanded a variety of original subjects and used European painting as a criterion for achievement were forced into experimentation; they became accustomed to stretching beyond the limits of previous work to earn their patron's approval. In addition, the political system and their positions in it were relatively secure. However, the political and economic stresses of later Mughal rule ruptured the stability of the artist's position; this became obvious in 1680 when Aurangzeb terminated centuries of cultural activity in Delhi, leaving artists in the area to adjust on their own initiative. The contention, intrigue and degeneracy surrounding the weak-willed rulers of the following years worsened their insecure situation. Artists, who were forced to work for noble or politically influencial patrons whose ambition was only to acquire paintings for status,

adapted their styles to decorative conventionalization in order to produce more quickly paintings which could be readily understood by a variety of patrons. In addition, this conventionalization brought Mughal painting into conformity with the strong Indian craft tradition.

Excessive limitation and repetition of subject-matter also became habitual about 1680. Among the repeated compositions, many depict harem scenes, which seem to mirror the desire of the age to seek material enjoyment in the face of vast social and political problems. Despite the unfortunately great number of conventional scenes produced, more and more successful individual pictures are coming to light from the era. These rise above the general level and stand out by virtue of such factors as observant characterization of figures. For example, genre had been a type of subject-matter inherent in sixteenth-century Mughal painting and developed by such Jahangiri artists as Govardhan; these scenes continued into the eighteenth century, and sometimes the artists were delightfully free in their manner of depicting elements of Indian society as, for instance, in Fig. 163 with these yogis at a feast.

Muhammad Shah (1719–48) had a long though corrupt and weak reign whose superficial harmony was disrupted by the 1739 Afghan invasion and sack of Delhi. Of the paintings and drawings remaining from his era, many are portraits of the emperor himself, sometimes wooden but often strikingly composed and pleasantly informal. Fig. 168 of the young ruler watching dancing girls, pro-

Fig. 163 'Servants bringing melons and fruit to drugged yogis'. *c.* 1700–20. Cleveland, Ohio, The Cleveland Museum of Art, 71.90

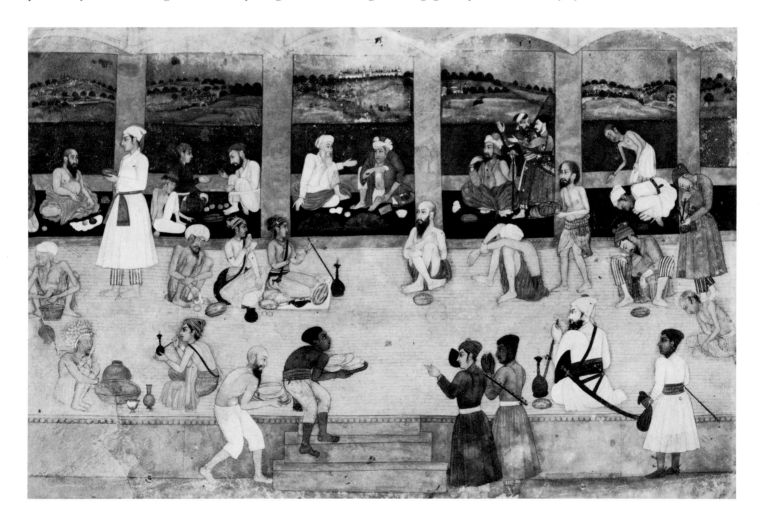

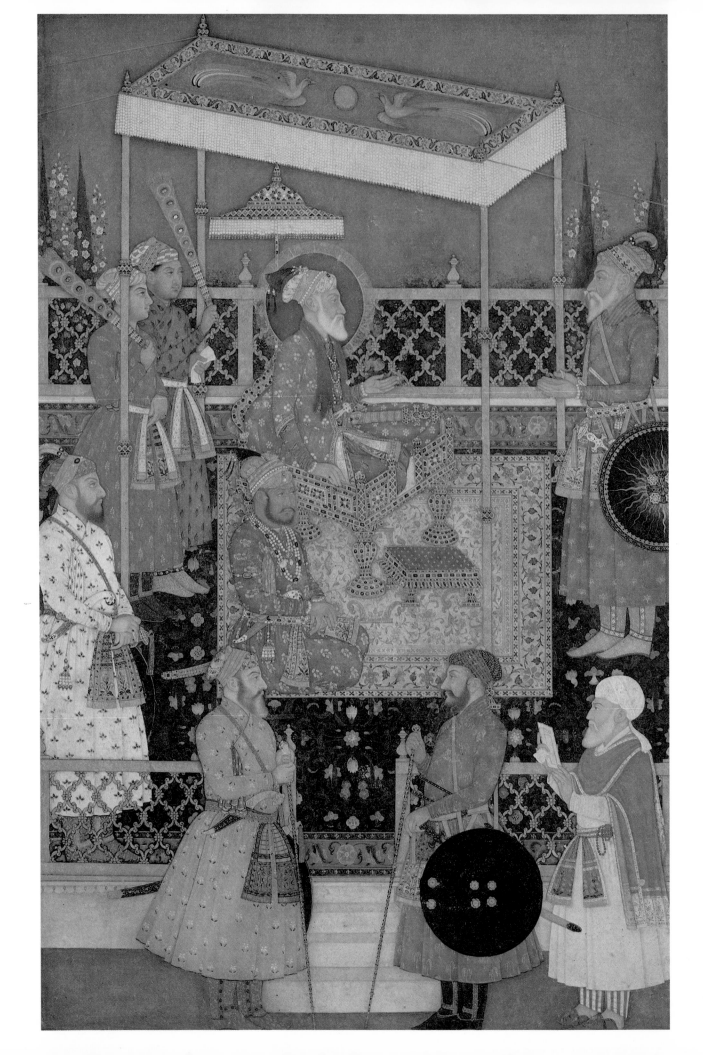

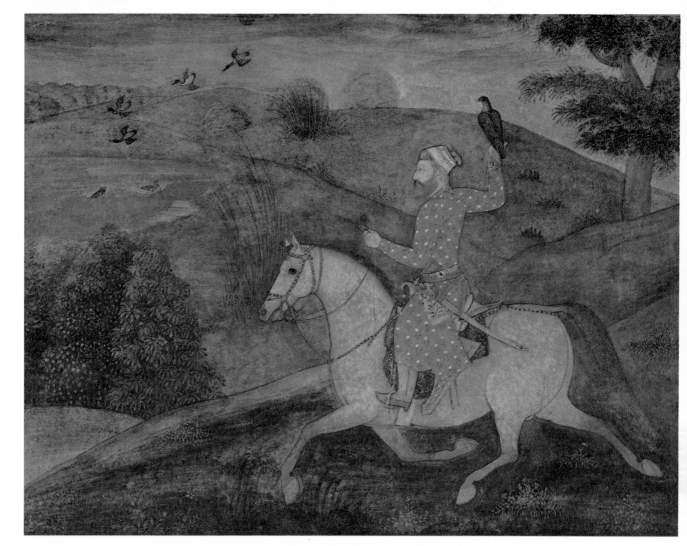

Fig. 165 'Noble hawking on horseback'. *c.* 1660. London, India Office Library, J 67–2

Fig. 166 'Women by a stream at night watched by two noblemen', school of Mihr Chand, Lucknow. *c.* 1760. Dublin, Chester Beatty Library, ms. 34.17

Opposite: Fig. 164 'Aurangzeb and courtiers' attributed to Bhawani Das. *c.* 1710. Dublin, Chester Beatty Library, 34.7

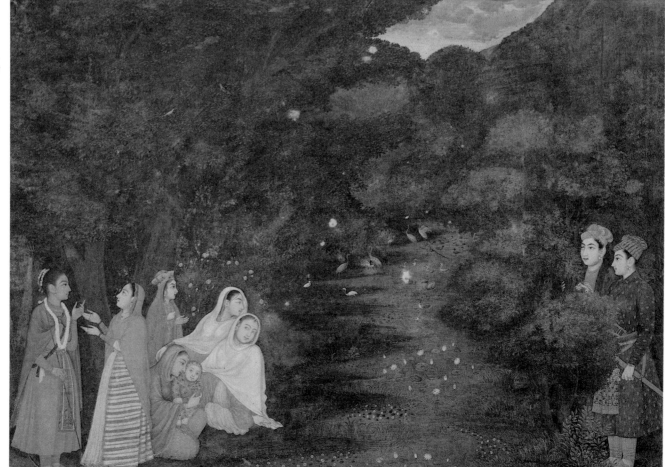

duced at the beginning of his rule, is a good indication of the quality that would be achieved by his artists throughout the long reign. Among the significant aspects of these paintings are the rhythmic though sometimes rigid drawing, the large pictorial dimensions and the extensive employment of white pigment. The latter characteristic particularly is an influence on the miniatures of the later eighteenth century, which include Mughals in sparkling white costumes depicted against backdrops of large white palaces.

In the second half of the eighteenth century, eclecticism is pervasive. While the combination of influences from the past and from European or Deccani painting may have begun as a search for new meanings in the medium of painting, it ended in tired playfulness. The two best known artists of this era, Mir Kalan Khan and Mihr Chand, are both eclectics with followings of lesser artists dependent on their styles. Both artists worked for Muhammad Shah and then gravitated to the provincial capital of Lucknow. In this era when Delhi had been plundered and stripped of influence, the provincial capitals of Lucknow and Murshidabad as well as Rajput centres were attractive to artists.

Mihr Chand, whose father was a thoroughly conventional artist, had studied older paintings and was capable of producing approximations of Shah Jahani genre scenes, courtier portraits and so on. Many works of his school have certain characteristic trademarks, however, such as rows of small bushes (see Fig. 169),

Fig. 167 'Baz Bahadur and Rupmati', attributed to Mir Kalan Khan, Lucknow. *c.* 1760. London, British Museum. 1920–9–17–016

which are purely the invention of the eighteenth century. He seems to have made a genuine attempt to vitalize a flagging tradition by turning to the great resources of its past, but his school was better able to paraphrase than truly to utilize older works in creating new stylistic currents. When Mihr Chand and his followers are working totally in their own idiom, they are capable of producing miniatures of lyrical charm such as the night scene of Fig. 166 which includes sensitive colouration and careful treatment of figures in an appealingly enigmatic romantic narrative.

Mir Kalan Khan is a much wilder, less pleasing artist whose capricious imagination created works of surrealistic fantasy probably appealing to bored or jaded patrons seeking novelty. He makes strange combinations of European allegories with myths of Persian or Indian literature (Fig. 167). The small figures, exaggerated shading, and strange lighting of these scenes are typical of this artist.

As the power of the East India Company spread across India, various British with diverse interests in painting came to the subcontinent bringing knowledge of English watercolours, devotion to the picturesque and often an interest in nature. Of the latter, many hired Indian artists, training them to some extent in European techniques suitable for rendering birds, animals and plant specimens. The most notable commissions were produced for Mary Impey, wife of Chief

Fig. 168 'Young Muhammad Shah watching dancing girls, the Large Clive album, fol. 64b. *c.* 1725. London, Victoria and Albert, I.S. 133–1964

Justice Sir Elijah Impey in the 1790s. That the Impeys must have enjoyed purely Indian nature painting and possibly were also aware of its great history is evidenced by miniatures such as Fig. 169, once in their collection.

This beautiful painting depicting a hibiscus is a fitting summation for the chapter on Mughal painting as it combines several influences from the past into a single study recalling the best aspects of the long tradition. The hibiscus is done with the simplicity of a Jahangir composition, yet its gold ground and the rich red of the flowers have a dramatic quality characteristic of the Deccan. Only the treatment of the ground proves the picture to be an eighteenth-century Lucknow production. It is fitting that this superb evocation of a flower should recapitulate a great past. The Emperor Jahangir might have been pleased to know that something of the spirit that pervaded Mansur's flower paintings was recaptured more than a century after his death.

Fig. 169 'Hibiscus', Lucknow. *c.* 1760. Dublin, Chester Beatty Library, ms. 45.8.

ANDREW TOPSFIELD

Painting for the Rajput Courts

When northern India fell under the dominion of successive Turkish and Afghan dynasties from the thirteenth century onwards, the existing native schools of court and monastic painting were all but extinguished. The Hindu royal patrons who had maintained the surviving cultural traditions of the Gupta and later periods were almost all swept away. The great Buddhist teaching monasteries of eastern India were likewise devastated by the iconoclastic Muslim invaders, and the graceful Pala style of manuscript illustration, which they had nurtured and which was itself the chief inheritor of the classical style of Ajanta, was to survive only in the safety of the Himalayan regions. The Muslim Sultans themselves, insofar as they patronized painting, gave support only to styles deriving closely from Persian example.

During this unpropitious period the one indigenous pictorial traditon which continued to flourish was that patronized by members of the wealthy merchant classes of western India who were devotees of the Jain religion. From as least the eleventh century they commissioned illustrated copies of the principal Jain scriptures in great numbers, with the purpose of acquiring merit for themselves. The most prolific and conservative centres of production were in Gujarat and southern Rajasthan, while regional variants of the style also developed around Delhi and Gwalior, in Malwa and in eastern India. It is in character with the ascetic and world-denying tenor of Jainism that these illustrations preserved little if anything of the naturalism and sensuous grace of the classical tradition. Indeed they represent the culmination of the already well established tendency of post-Ajanta painting towards a more conceptual style, with increasingly linear and two-dimensional forms; a characteristic convention of Jain paintings is the protrusion into space of the further eye of the human face seen in profile. This tendency was magnified by the western Indian artists' mass production of a very limited repertoire of iconographically standardized texts, which led to the repetitive and cursory delineation of stereotyped compositions. Nevertheless, the restless, wiry angularity of their outline drawing, together with the bold, flatly decorative use of a limited colour range, with bright red backgrounds, rich textile patterns and embellishments in gold, can give Jain paintings a hieratic splendour and visual energy of their own. Moreover, these same basic stylistic conventions, seen for example in an early fifteenth-century *Kalpasutra* illustration (Fig. 170), with its red background, stylized bedchamber and typical

accumulation of space-filling minor details, were by the end of the century to be revivified and adpated to more varied and expressive ends by artists working in a new and more fertile idiom.

In contrast to the profusion of Jain manuscripts that have been preserved to the present day in monastic libraries, the surviving documents of this new style are very rare, and reliably inscribed examples rarer still. As a result its origins and major centres of production are still matters of conjecture. Its beginnings in the fifteenth century can be deduced from the freeing influence that it exercised indirectly on a number of Jain manuscripts and book-covers, whose drawing shows a fresh vitality and begins to shed the archaic further eye. The crabbed and hidebound Jain style was hardly capable of such innovation by itself, and it is probable that the creative impulse for the new development derived from the resurgence of popular devotional cults in northern India at this time, in particular those of the Mathura region, which centred on Vishnu's incarnation as Krishna, the youthful, dark-skinned cowherd god, celebrated for his destruction of malignant demons and for his love play with the milkmaids of the Braj country. With its rounded, fluent drawing and enhanced sense of dramatic movement and emotional atmosphere, the new style of illustrative painting was a counterpart of the vigorous vernacular literatures, rooted in the poetry of *bhakti*, which were also evolving at this period. Their ardent devotional spirit is fully shared by a painting of the adoration of the infant Krishna by his foster-parents and fellow-villagers (Fig. 171), a page from the most exuberant and inventive of the known illustrated manuscripts in the style. Its setting, with a conventional pavilion with a red interior, is in a sense an expansion of the earlier, schematic Jain composition (Fig. 170), but its strong colour harmonies and symmetrical grouping of gesturing figures and sympathetically arching trees are far more sensitively executed and dramatically conceived.

An important quality of the style is its use of pictorial conventions that are almost pan-Indian, comparable forms being found at different periods in manuscripts and scroll-paintings of both popular and court quality from Bengal, Orissa and from parts of southern India. In its early sixteenth-century north Indian form the style was also practised very widely, for example at Mandu, Chitor, Amber, Gwalior, Delhi and possibly in the Uttar Pradesh region and the Punjab Hills. It is therefore difficult to classify it as a strictly local tradition. However, it is hardly possible that the confident and highly finished quality of some of the known series, notably the famous illustrations of the *Chaurapanchasika*, Sanskrit verses celebrating the clandestine romance of a princess and a thief, could have been attained without the sustained patronage of at least one independent Hindu court with longstanding cultural traditions. Such patronage could only have been offered at this time by the Rajput kingdoms of western India, whose acknowledged leaders were the Sisodia rulers of Mewar; other Rajput clans included the Rathors of Marwar, the Kachhwahas of Amber and the Haras of Bundi. Inasmuch as the new style of painting to a large extent determined the subsequent local styles of these areas from the early seventeenth century, it is convenient to call it the Early Rajput style, while bearing in mind its still wider dissemination.

The Rajputs, or 'sons of kings', had originally entered India from the north-west during the first millennium AD and had established kingdoms in a region that later came to be called Rajasthan, 'the abode of kings'; other Rajputs were subsequently driven by the Muslim invasions northwards into the Punjab

Fig. 170 'Queen Trisala reclining', from a *Kalpasutra* manuscript, Gujarat, 1404. London, Royal Asiatic Society, Tod ms. 34, fol. 17a

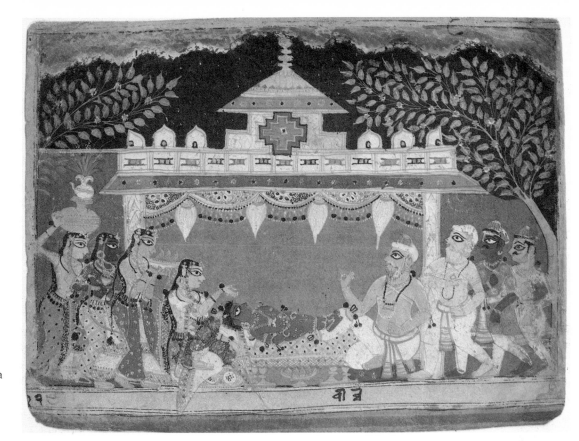

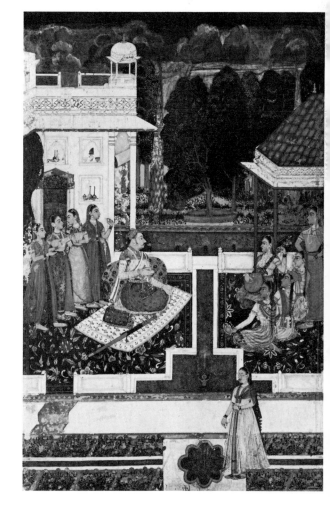

Top: Fig. 171 'The adoration of the infant Krishna', from a dispersed *Bhagavata Purana* manuscript, Rajasthan (?). *c.* 1525–50. Private collection

Bottom: Fig. 172 'Maharaja Jaswant Singh listening to music', Jodhpur. *c.* 1660. Melbourne, National Gallery of Victoria

Hills, where another group of minor kingdoms became established. Like previous immigrants from Central Asia the Rajputs were assimilated into the all-embracing Hindu social system as Kshatriyas or members of the warrior caste, and in later centuries they were foremost both in resisting the incursions of the Muslim Sultans and in preserving the surviving traditions of classical Hindu culture at their courts. They have been proverbial in India ever since for their reckless courage, and for a code of honour and chivalry upheld equally by their men, who would court death in any desperate cause if honour compelled it, and by their women, who more than once immolated themselves in mass suicides to evade capture and dishonour. A perhaps unfounded but indicative story is told by the seventeenth-century French traveller Bernier about Maharaja Jaswant Singh of Jodhpur, whose portrait (Fig. 172) shows him respectfully attended by his ladies as he listens to a musical performance. He is said on one occasion to have returned to his palace after fighting a valiant but unsuccessful battle, only to find the gates closed in his face by his wife, a princess of Mewar, on the grounds that he should have preferred death on the battlefield to the humiliation of defeat. As a rule, however, Rajput noblewomen of the later period led a highly restricted life within the *zenana* quarters of the palace, their main diversions being their devotions, games and pastimes and the celebration of the many popular festivals in the court calendar. The concentration on romantic and erotic themes, whether overt or in a sublimated Vaishnavite guise, in the later literary and pictorial culture of the courts is in part at least due to the rigidly circumscribed sexual mores of Rajput society.

As patrons, the Rajputs not only preserved earlier scholarly and artistic traditions, but themselves initiated new work. It may well have been at courts such as that of Maharana Kumbha of Mewar (reigned 1433–68), himself a musicologist and author of a commentary on the *Gita Govinda* of Jayadeva, that

illustrations of conventional literary and rhetorical themes, such as *ragamala*, the depiction of visualised musical modes, or *nayakanayikabheda*, the classification of ideal types of lovers, were first developed. The *Chaurapanchasika* and several related series may indeed have been painted in Mewar at a somewhat later date. However this may be, it is clear that these series established what became the fundamental idiom of later Rajput illustrative painting, in which, following an ancient precedent, the gods and their consorts are frequently shown as princes with their ladies, and vice versa; both inhabit the same timeless, poetic world.

A complementary and equally important thematic strand in Rajput painting, that of court portraiture and genre scenes, is alien in origin and without precedent in the Indian artistic tradition. Its emergence by the middle of the seventeenth century as a distinct parallel stream to the established traditions of mythological illustration at several Rajasthani and Hill courts was entirely a result of the pervasive cultural influence of the Mughal court. In his campaigns to extend and consolidate the empire first won by his grandfather Babur, Akbar had conquered almost all of the Rajput kingdoms by the 1570s, ensuring their loyalty by taking the rulers into the imperial service and by marrying into their families. In this way the rulers of Amber (later Jaipur), Jodhpur, Bikaner, Bundi and other courts attained a new political prominence. Mewar, which had long been the paramount Rajput power, continued a solitary guerilla resistance until its eventual capitulation in 1615; but it remained thereafter more aloof and isolated from external affairs than its more compliant neighbours. Following their submission, the Rajput rulers were obliged to spend part of their time – in some cases, most of it – in attendance at the Mughal court, where they inevitably learned to adopt many of its customs and fashions, among them a growing taste for the imperial style of painting. Originating in a brilliantly eclectic fusion of Persian and native Indian stylistic elements, with a steadily increasing European influence, the Mughal style had been formed by the personalities of Akbar and Jahangir. Both were men of original and inquiring minds, with the same observant eye for the peculiarities of man and nature that their forbear Babur had revealed in his vivid memoirs. Markedly occidental in spirit in its refined naturalism and its emphasis on portraiture and historical record, the Mughal vision stood in complete antithesis to the poetic conventions of Early Rajput painting. As its influence began to reach the Rajput courts themselves, it tended either to modify or, in a few cases, to supersede the existing local styles. In general, this influence proceeded in two distinct phases. The initial source, strongest in the early seventeenth century, was the so-called Popular Mughal style, a hybrid, sub-imperial idiom mainly employed for Hindu mythological and poetical themes. A later and ultimately more profound influence was that of the fully developed Jahangir and Shah Jahan period style of portraiture, which had begun to be practised or at least imitated by local artists at many Rajput courts by the middle of the seventeenth century. However, these successive influences produced widely varying results at different centres, in accordance with the relative strength of indigenous traditions and with local geographical and political factors, such as marriage and other ties with neighbouring courts. Another, less palpable influence on local styles was the particular *genius loci* of the different states, and especially their landscape, which could vary between rolling hills, mountains, temperate jungle and arid desert. The most important factor of all, however, was the patronage of the individual ruler, whose informed or occasionally inspired interest was needed to sustain the creative

vision of his artists, themselves usually anonymous artisans of low social status.

In this manner a profusion of local – or, in some cases, hereditary family – styles came into being both at major courts and minor fiefs (*thikanas*) in Rajasthan, Central India and the Punjab Hills between the seventeenth and nineteenth centuries. These numbered perhaps more than a hundred in all, and partly as a result of the dispersal or continuing obscurity of the old princely collections, very few of them have yet been studied at all methodically. Many Rajasthani *thikana* styles have only recently been recognised, and more will undoubtedly come to light. It is for this reason unlikely that any comprehensive history of Rajasthani and Central Indian painting can be written for some time to come; while any overall view of Pahari, or Hill, painting must also rely excessively on speculation, given the paucity and controversial nature of the existing documentation. In the following account some of the major and best attested Rajput styles are discussed briefly from the point of view of the remarkable cultural synthesis that they represent. A creative tension between Mughal sobriety and technical refinement and Rajput poetic feeling and exuberance of colour and line is implicit to some degree in all of them. As a rule the innovatory Mughal elements, which had been formed in the insulated and alien microcosm of the imperial court, were before long adapted and trans-formed by Rajput artist and patron together in accordance with their own vision, rooted in their common participation in the traditional culture and seasonal life of their own people. This constant regeneration at a folk level ensured the continuing vitality of Rajput painting down to the nineteenth century, while other more refined court styles lapsed into inanition.

Of the seventeenth-century Plains schools those flourishing in the Central Indian provinces of Malwa and Bundelkhand show the most direct continuation of pre-Mughal conventions. A typical *ragamala* page, showing *Vilaval ragini*, who is personified as a lady adorning herself as she eagerly awaits her lover (Fig. 173), makes use of a simplified composition of flat colour areas, with a reverberation of red and blue characteristic of this series. In Udaipur at this time the Early Rajput idiom, of which as Mewar it had almost certainly been an important centre, had been modified by dilute Popular Mughal elements in the work of Sahibdin, the leading painter in the time of Maharana Jagat Singh I (reigned 1628–52). Sahibdin's debt to Mughal painting is seen in his slightly stiff and academic figure drawing and in an increased compositional facility. But his vivid palette contains none of the muddy and adulterated hues of normal Popular Mughal work, and his interpretation of Hindu mythological themes is wholly sympathetic. His finest later work exists in a *Ramayana* manuscript of 1649–53 with illustrations by several hands. In his depiction of the storming of Lanka, the stronghold of the many-headed king Ravana, by Rama and his monkey allies (Fig. 176), Sahibdin combines with dramatic effect such archaisms as the schematic rendering of the fortress against a red background and a skilful disposition of the fighting figures deriving from his knowledge of Mughal compositional technique. So successful was Sahibdin's synthesis of these disparate elements that his style remained the orthodox model for the many thousands of mythological illustrations that continued to be produced at Udaipur, in increasingly ossified form, down to the nineteenth century. Elsewhere in Rajasthan, in Marwar, Amber and Bundi for example, comparable local idioms of *ragamala* painting and other types of manuscript illustration were also practised during the seventeenth century. Although all of these shared a

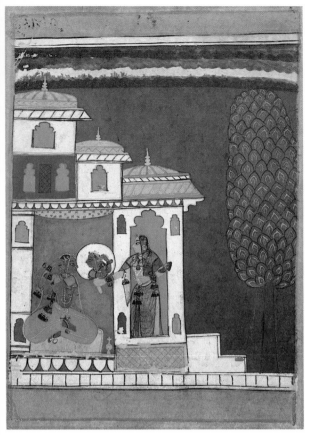

Fig. 173 'Vilaval ragini', Malwa. *c.* 1640. London, British Museum, 1924–12–28.03

Fig. 174 'A go-between calls Krishna to Radha' by Nuruddin, from a series of the *Rasikapriya* of Kesav Das, Bikaner. 1687. Private collection

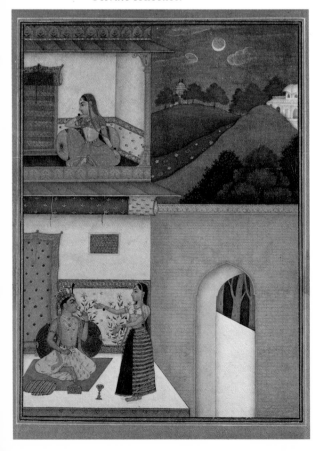

common Early Rajput background, a number of regional differences are noticeable, such as a comparatively strong Mughal element in the Bundi style and a contrast between the muted, somewhat muddy palette used in the desert region of Marwar (to the west of the Aravalli chain which bisects Rajasthan) and the vibrant primary colours of paintings from the more temperate eastern regions, such as Mewar and Bundi.

Meanwhile the rulers of these same regions, who had spent varying periods at the imperial court, were beginning to introduce Mughal-trained artists skilled in portraiture and court genre painting to their own courts. A small group of surviving portraits of Maharaja Jaswant Singh of Jodhpur (reigned 1638–78), of which the scene of a music party in his *zenana* is a fine example (Fig. 172), are almost entirely Mughal in their execution. Even so, the portrayal of the ruler himself tends to be less psychologically revealing than it might be in a purely Mughal painting. Rajput portraiture typically seeks to affirm the dignity of its subject as an ideal, heroic type, rather than to lay bare the qualities and weaknesses of a particular individual in the post-Renaissance European manner that had been admired and emulated by Akbar and Jahangir. At most courts portraiture and manuscript illustration coexisted as separate streams, each retaining its own conventions, though usually with some degree of cross-fertilization. A notable exception to this rule was the isolated court of Bikaner in the north-western deserts of Rajasthan, where by the end of the seventeenth century imported Muslim artist families were working in a strongly Mughal style with some affinities with the painting of the Deccani courts recently conquered by Aurangzeb. The Bikaner painters brought the same refined naturalism both to court portraiture and to their interpretation of Hindu mythological themes, which as a result can seem unpersuasive and lacking in the potency of the more robustly conservative Rajput styles. However, a typical illustration by Nuruddin from a series of the *Rasikapriya* of Keshav Das, a conventional rhetorical work classifying types of lovers and amorous situations, does succeed in integrating Mughal technique with Rajput feeling for emotional atmosphere (Fig. 174). The artist's play of architectural planes and colour harmonies and his rendering of the still, nocturnal landscape almost anticipate the serene, unworldly mood of illustrations of the same text painted by Pahari artists at Guler and Kangra nearly a century later.

By the beginning of the eighteenth century portraiture and its related themes had become well established throughout Rajasthan, even at Udaipur, the most traditionalist and independent of the Rajput courts, where it first appeared around 1670. Its main phase of development there occurred under Maharana Amar Singh II (reigned 1698–1710), the most discriminating of the later Mewar rulers as a patron. Amar Singh employed artists who assimilated Mughal and Deccani elements into the local style without over-refining it or vitiating its coherent vision. In one of the masterpieces of his reign, he is seen seated with his nobles in formal durbar in a luxuriant garden, hurling missiles of coloured powder in celebration of the spring festival of Holi (Fig. 175). The picture's documentary intention after the Mughal fashion is seen in the way in which each of the figures, from the nimbate ruler down to the attendants and musicians, is portrayed as an individual and named in a lengthy inscription on the reverse.[1] Paintings of this type, often of unusually large size, continued to be

[1] See Topsfield, *Paintings from Rajasthan*, p. 62.

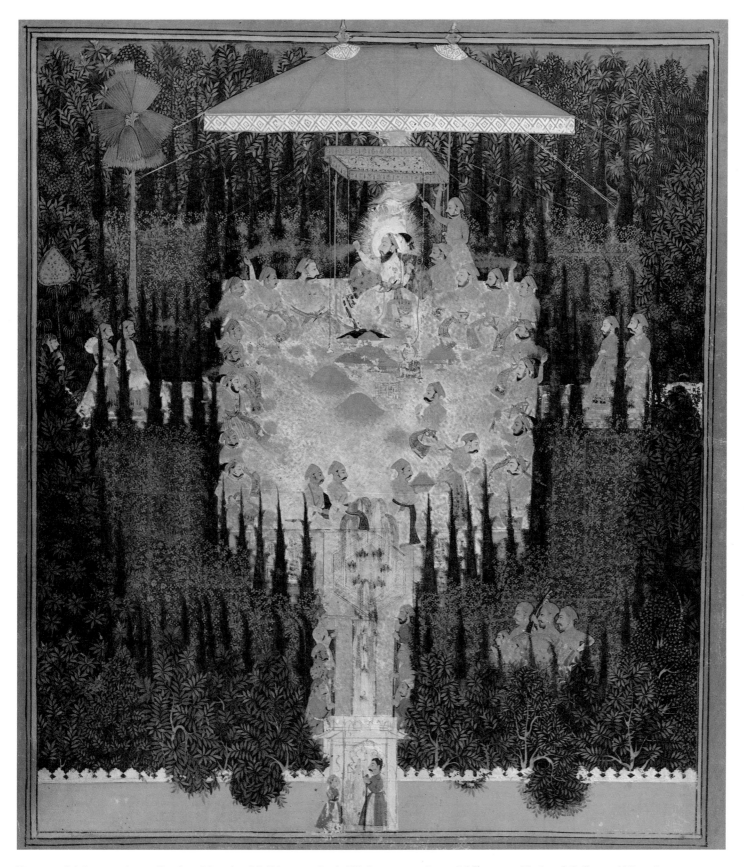

Fig. 175 'Maharana Amar Singh celebrating Holi in a garden', Udaipur. *c.* 1708–10. Melbourne, National Gallery of Victoria

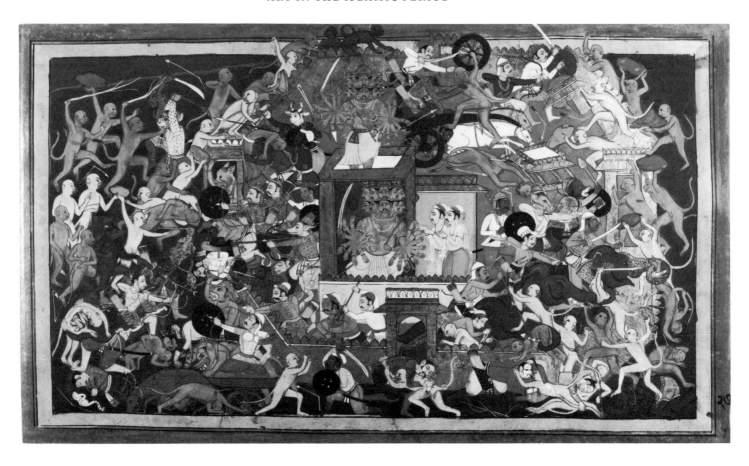

Fig. 176 'The storming of Lanka' by Sahibdin, from a *Ramayana* manuscript, Udaipur. 1652. London, British Library, Add. 15297(1), fol. 27

produced in great numbers at Udaipur until the 1760s. Later examples, by less skilled artists, make up in panache and inventiveness for what they lack in delicacy of technique.

As the central Mughal power fell into decline following the death of Aurangzeb in 1707, the dispersal of imperial artists to the provinces, which had begun in his reign, also accelerated, particularly after the sack of Delhi by Nadir Shah in 1739. The effects of this movement on the Rajasthani schools were more local than general. The Rajput courts themselves were falling prey to the expansion of the Marathas from the south, whose depredations eventually reduced them to a state of economic ruin that was only averted by their acceptance of British protection in 1818. Two courts that received Mughal-trained artists were Jaipur, which lay closest to Delhi, in the later eighteenth century, and, more conspicuously, Kishangarh, where the rulers' patronage of Mughal style portraiture in the first half of the century gave way to a highly distinctive manner of mythological painting (Fig. 177). Its chief subject-matter was scenes of the courtship of Krishna and Radha, set in the familiar palace and lakeside settings of Kishangarh itself, transfigured as the eternal Vrindaban. Created by the artist Nihal Chand for Maharaja Savant Singh (reigned 1748–64), himself a poet and an ardent devotee of Krishna, this bold adaptation of the jaded contemporary Mughal court idiom relies for much of its effect on extreme linear distortions of the human figure, especially a curving elongation of the eyes. In its early phase the style is far more lyrically expressive than, for example, Bikaner mythological painting. Before long, however, the Kishangarh

artists over-reached themselves, and their work often degenerated into a cloyingly sentimental mannerism much emulated by artists producing fakes for the tourist market in India today.

A comparable transformation of an originally Mughal theme of court ladies in the *zenana* is seen in a late eighteenth-century picture from Bundi, in the south-east corner of Rajasthan (Fig. 180). The chill palette of similar Mughal terrace scenes here serves to offset the hot colouring of the cushions and women's dresses, while the curving rhythms of the figure drawing and the exaggerated pouting of the pigeons, which the ladies contemplate as symbols of their absent lovers, create an atmosphere of muted erotic feeling. By this time Bundi artists had a long tradition of assimilating Mughal influences to their own expressive needs. Several *ragamala* series painted at Bundi in the seventeenth century show a reworking, in a more indigenous style reflecting Early Rajput conventions, of the iconographies of a prototype series painted by Mughal-trained artists in 1591; a similar process of assimilation is seen in Bundi portraiture from the period of Rao Chattarsal (reigned 1631–59) onwards. In its later phases Bundi painting is often scarcely distinguishable from that of the neighbouring offshoot court of Kotah, and even from work produced at several minor courts dependent on these two main centres of the Hara Rajputs. It is likely that artists moved more freely between these courts than seems to have occurred elsewhere in Rajasthan, as is suggested, for example, by a *Hitopadesa* manuscript of 1761 in the British Library.[2] It is illustrated in a style associated by recent scholarship with Kotah, but is ascribed to the artist Dhano, a resident of Bundi, working for Raja Jai Savant Singh.

The most distinctive feature of the Kotah school, which flourished until well into the nineteenth century, is the exceptional vitality of its drawing. In a large picture of huntsmen on horses and elephants capturing a wild elephant under a tree (Fig. 179), the monkey-infested rocks, trees and bamboo thickets are imbued

[2] British Library Or. 13934.

Fig. 177 'The sage Sukadeva addressing King Parikshit', Kishangarh. *c.* 1760. London, Victoria and Albert Museum, I.S. 556–1952

Fig. 178 'Maharaja Dalel Singh shooting boar at Gajner', Bikaner. Late eighteenth century.
London, British Museum, 1959–4–11.02

Fig. 179 'An elephant hunt', Kotah. *c.* 1740. Dublin, Chester Beatty Library

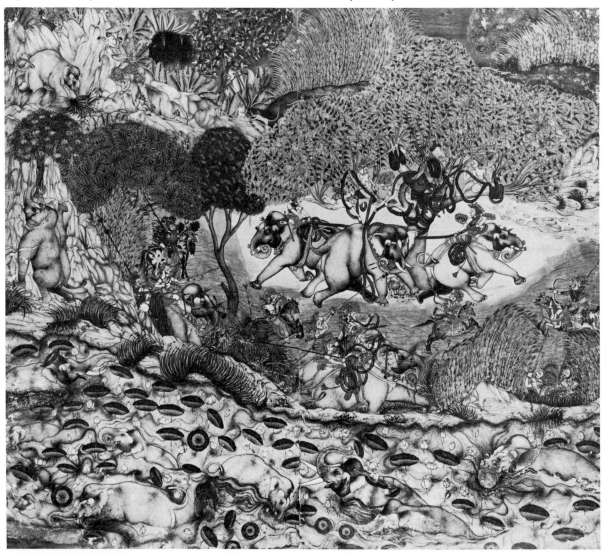

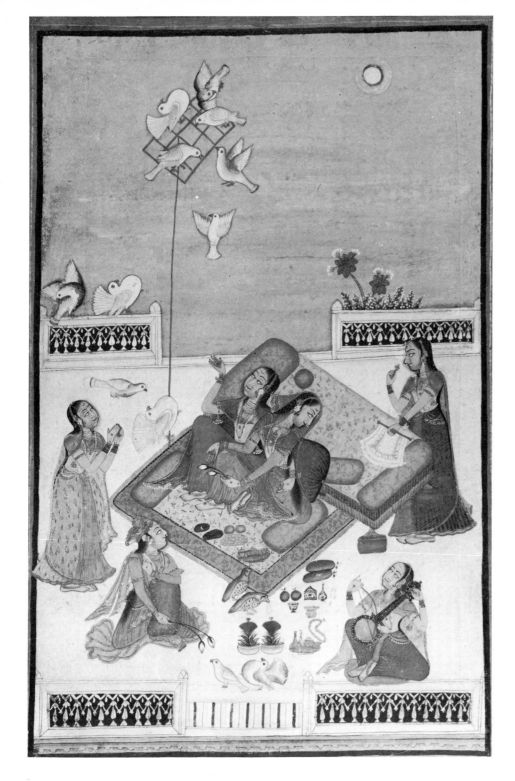

Above: Fig. 181 'A dancing-girl in the role of Krishna', Jaipur. *c.* 1800. New York, the Metropolitan Museum of Art, 18.85.2

Fig. 180 'Ladies watching pigeons on a terrace', Bundi. *c.* 1770. London, Victoria and Albert Museum, I.S. 96–1952

with a restless energy that complements the tumult of men and beasts in the central clearing and the frolicking of the wild elephants in the foreground lake, whose water seethes in linear whorls and surges. In complete contrast to this display of spontaneous exuberance is a large coloured drawing of a dancing-girl in the role of Krishna as a youthful, jewel-bedecked prince, originally one of a group of life-size cartoons for wall-paintings in the palace at Jaipur (Fig. 181). With the distillation of its subject into precisely modulated outline drawing, the sparely accentuated facial features relieved by the decorative detail of jewellery and ornaments, it creates a no less powerful image, classical in its restraint.

However, both pictures in their different ways remain equally Rajput in character.

In the absence of further strong Mughal stylistic influences, a similar reassertion of Rajput values also occurred in Jodhpur and Bikaner painting in the eighteenth century. A picture of a Bikaner prince shooting boar from the roof of a lakeside pavilion celebrates the almost ritual quality of the hunt in Rajput life (Fig. 178). While the Raja impassively discharges his flintlock, the rest of the scene is all tranquillity, with groups of conversing retainers and a poetically evocative background with thickly-leaved trees, heavy rain-clouds and flights of sarus cranes. In the early nineteenth century Jodhpur painting especially became more formalized as native Rajput elements in it became increasingly dominant. A simple composition of Maharaja Man Singh seated in a garden (Fig. 182) is made dramatic by the bursting forms of the banana trees, echoed by the stiffly flared ladies' skirts, which are a convention of the period. This bold and lively conception is as far as it could be from the studied refinement of the seventeenth-century painting of Maharaja Jaswant Singh (Fig. 172).

In spite of this late flowering at many of the Rajasthani courts, little new inspiration was forthcoming by the middle of the nineteenth century, for Rajput society was itself stagnant and played out. After the treaty with the British in 1818 the Maharajas had had their economic and political stability restored at the price of their independence. More than their predecessors, the new rulers of India sought to direct and reform the administration of the princely states. In their impotence the Rajputs could only live on bardic tales of their past glories, so that for several decades more the traditional pattern of life was preserved. A painting from the small court of Sitamau in Central India is a late testimonial to the seldom publicised relationship between a Rajput patron and his artist (Fig. 183). While the ruler, Raj Singh (reigned 1802–67),[3] stands in a palace courtyard attended by servants and members of his family, the artist Far Chand has depicted himself discreetly observing and recording the scene for his master's future pleasure. This traditional relationship was however gradually being undermined by the novel allurements of European drawing techniques and, above all, of photography. Although some artists made brave and often inspired attempts to assimilate these new fashions, the court styles were effectively moribund by the end of the century.

Although occurring over the same period and presenting many analogous features, the development and eventual decline of painting at the Rajput courts of the Punjab Hills proceeded, so far as is known, independently of that of the Plains schools of Rajasthan and Central India. The two areas are separated by the broad belt of the Punjab plains, and there seems to have been only limited intercourse between them, and no known movement of artists. The Pahari styles followed their own distinct pattern of development, which to some extent was conditioned by the tightly clustered concentration of the thirty-five hill kingdoms within a narrow band of the Himalayan foothills, only three hundred miles long by a hundred wide. Communication between courts was closer than in the wide expanses of the plains, and it has been shown that members of one influential hereditary artist family based at Guler could between them encompass most of the major courts in their travels. For this reason, although about two-thirds of the hill courts are believed to have patronized painting at some

Fig. 182 'Maharaja Man Singh in a garden', Jodhpur. c. 1830. England, private collection

[3] I am indebted to Mr Robert Skelton for this information.

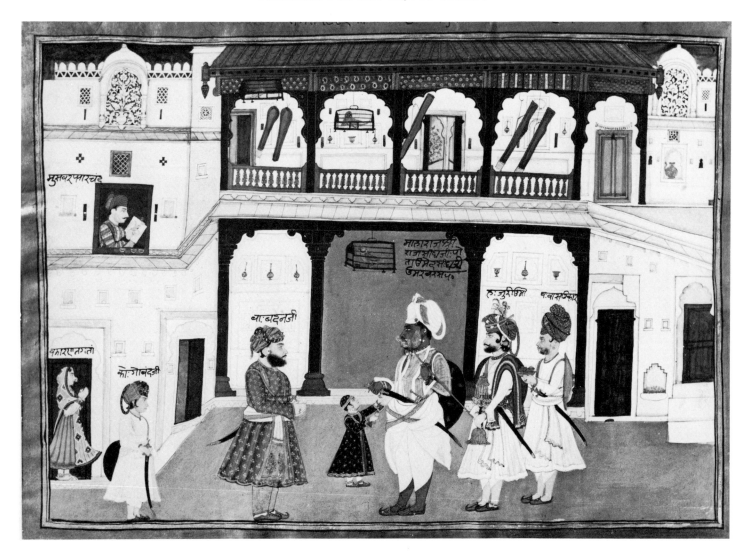

Fig. 183 'Maharaja Raj Singh in a palace courtyard' by Far Chand, Sitamau. 1847. England, private collection

time, it is sometimes misleading to classify the leading styles and their variants by fixed regional locations. Even the most classic phases of Pahari painting, such as those associated with the courts of Basohli and Kangra, are still very poorly documented and open to some conjecture. Nevertheless, it can be said that the general and local conditions that gave rise to the various hill styles are similar to those prevailing in the Plains; these included comparable political and geo-graphical factors as well as the quality of patronage of individual rulers. Likewise, on a fundamental cultural level, the major developments in Pahari painting also depended in varying degrees on a continuous assimilation of Mughal influence to indigenous traditions and to the more poetic Rajput vision. However, perhaps as a result of their relatively undisturbed isolation, the main hill styles achieved at their best an intensity of expression, an early vehemence and a later mellifluence of colour and line, that was seldom equalled in Plains Rajput painting.

The development of Pahari painting before the second half of the seventeenth century remains obscure. It is a matter of recent debate whether the widespread Early Rajput style may also have been practised in the Hills, thus providing a common background with the main Rajasthani and Central Indian schools. It

Fig. 184 *'Vinoda raga'*, Mankot. *c.*
1710–20. London, Victoria and Albert
Museum, I.M. 66–1930

Fig. 185 'Raja Kirpal Pal smoking',
Basohli. *c.* 1690. Dublin, Chester Beatty
Library, 58.1

does appear that a residual indigenous stylistic tradition, showing affinities with contemporary Nepalese painting, was concentrated in a northern, interior belt between the Jammu region in the west, including the states of Mankot and Basohli, and the Kulu region in the north-east. The evidence for early Mughal influence is as yet uncertain. Like their Plains counterparts, a number of the Pahari princes were obliged to visit the Mughal court, and these contacts had given rise by the second half of the seventeenth century to hybrid styles of portraiture based on Shah Jahan period conventions. It is also now thought that more strongly Mughal-derived styles, comparable to that of Bikaner in the Rajasthani sphere, were practised at Mandi and Bilaspur in the seventeenth century. But it remains unclear how the boldly expressive Basohli style, first seen in a series of the *Rasamanjari* of Bhanudatta, could appear at this time fully formed and without known antecedents. In a page from this Sanskrit treatise on lovers and their emotional states, a neglected lady arriving at the deserted trysting-place shows her distraction by her inability to chew the betel-leaf that she holds (Fig. 186). The compositional elements, with a stylized bedchamber framed by trees, flat colour areas and a red background, recall Early Rajput conventions. But the Basohli artist has characteristically interpreted this stock literary subject with unusual dramatic power through his taut draughtsmanship and bold play of fiery colours offset by the chill white of the chamber interior. In many early Basohli paintings this controlled vehemence of colour is further enriched by the decorative use of iridescent green fragments of beetle wing-case. The confident strength of this early phase of hill-painting is further shown by its ready assimilation of Mughal portrait themes, notably at Mankot and at Basohli itself under Raja Kirpal Pal (reigned *c.* 1678–93). His portrait, in which he is shown with alertly staring eye holding his *huqqa* tube aloft against a hot yellow background, typically reveals more of the Rajput stereotype than the individual himself (Fig. 185). Something of the same effect is seen in a later *ragamala* painting from Mankot, depicting *Raga Vinoda*, whose name means 'joyous' or 'light-hearted' (Fig. 184). Although the drawing shows an increasing Mughal delicacy, the gesticulating group of nobleman and ladies evokes a sense of decorously contained abandonment matched by the contrast of reds and yellows with the cooler tones of muslins and carpet. Another important variant of the Basohli style developed at Kulu, at the north-eastern end of the Hills. The 'Shangri' *Ramayana* series of *c.* 1690–1710 by several hands introduces further expressive distortions in its drawing technique, while in Kulu *ragamala* paintings especially rich colour harmonies add to the feeling of emotional tension. This intense and sometimes eccentric spirit was to inform Kulu painting in all its phases (Fig. 187).

In this first phase of Pahari painting, the Mughal influences reaching the Hill courts had been for the most part absorbed by indigenous traditions. However, from the second quarter of the eighteenth century a profound change was brought about by the increasing numbers of artists trained in Mughal techniques, some of whom must be assumed to have come seeking refuge from the political chaos in the plains. One prolific family of artists in particular, that of Pandit Seu and his descendants, played an important part in this revolution. A Basohli *Gita Govinda* series of 1730, painted in part by Manaku, one of the sons of Seu, is already milder in expression, with squatter, more placid figures, than the earlier *Rasamanjari* illustrations. The family was however based chiefly at Guler, and it was at this court under Raja Govardhan Chand (reigned 1741–73) that a

Fig. 186 *'Madhya vipralabdha nayika'*, from a series of the *Rasamajari* of Bhanu Datta, Basohli. *c.* 1660–70. Private collection

remarkable final flowering of Rajput painting developed. In contrast to some of their Rajasthani counterparts, the Guler artists wore their acquired Mughal techniques lightly, transmuting them effortlessly into an imaginative vehicle for the romantic and devotional themes that formed their main subject matter. The painting of a lady contemplating a hawk – an allusion to her absent lover – shows a new sinuous grace in the treatment of the female form, a subtle balance of compositional elements and a more delicate heightening of the atmosphere by the red background area broken by two attenuated cypresses (Fig. 190). Both the Guler idiom and that of Kangra which succeeded it evoke an ideal, aristocratic world of physical grace and self-absorbed serenity which is in keeping with the traditions of classical Indian painting.

The peregrinations of artists between courts soon led to a wide dissemination of variants of the new style. One of the most remarkable developments was the new versatility brought to the art of portraiture by Nainsukh, another son of Pandit Seu. Nainsukh's technical accomplishment suggests that he may have received training at Delhi before the invasion of Nadir Shah. During the 1740s and 1750s he worked for Raja Balwant Singh of Jammu,[4] recording the ritual

[4]An alternative view, that Balwant Singh was a prince of the minor house of Jasrota, has been proposed by Prof. B. N. Goswamy.

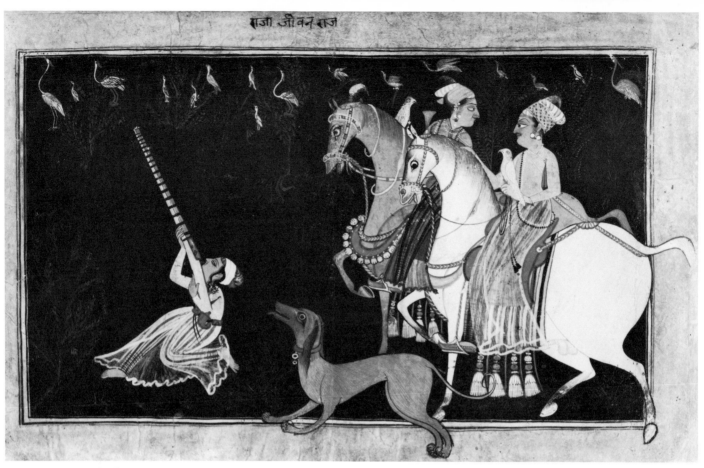

Fig. 187 'Baz Bahadur and Rupmati riding at night', Kulu. *c.* 1720. Collection of Mr Michael Archer and Mrs Margaret Lecomber

Fig. 188 'The demon Sambara carrying off the infant Pradyumna', from a *Bhagavata Purana* series, Basohli under Guler influence. *c.* 1760. Private collection

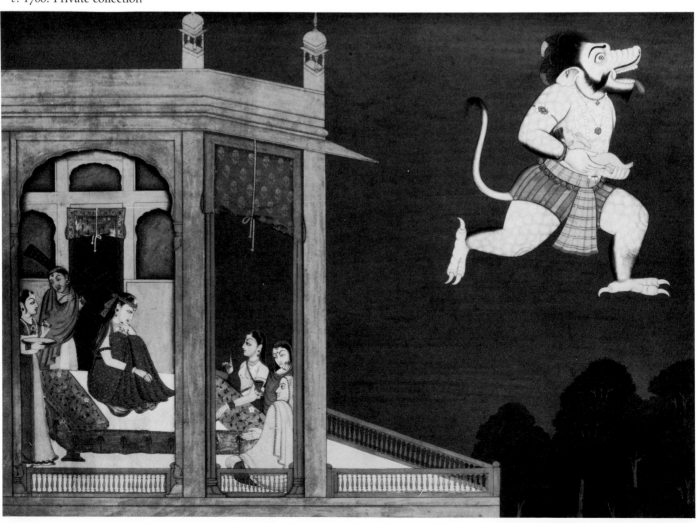

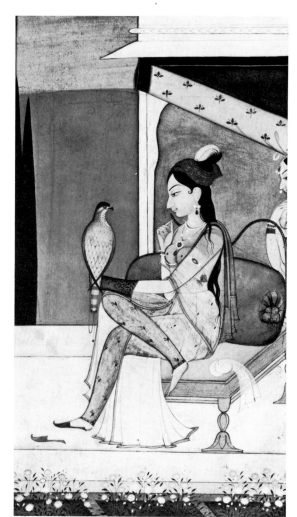

observances and habitual pastimes of his patron's daily life in superbly drawn and coolly coloured pictures, which are exceptional in Indian portraiture for their informal intimacy and their elements of pathos and humour. He would depict Balwant Singh hunting, listening to music, inspecting horses and paintings, writing, performing his devotions, or, more quirkishly, as a tiny solitary figure seen in a window or standing on the roof of a huge palace. Nainsukh's delicate colour sense appears in his painting of a Jasrota prince riding through a field of mustard flowers against a cool blue-green background (Fig. 192).

By about 1770 artists working in the Guler idiom were dispersed throughout the Hills. At Basohli, where Nainsukh continued to work until his death in 1778, his influential style mingled with that previously established by his more conservative brother Manaku in a series of the *Bhagavata Purana* (Fig. 188). At Garhwal a distinctive variant of Guler painting endured until the Gurkha occupation of 1804–14 and for some time after. However, the culmination of the Guler tradition occurred at Kangra under Raja Sansar Chand (reigned 1775 –1823), the last of the great Pahari patrons. When the English traveller Moorcroft found him, near the end of his life, living in a state of relative poverty after the successive loss of his power to the Gurkhas and Sikhs, Sansar Chand still continued to support several artists as well as 'a *zenana* of three hundred of the most beautiful women of his country'.[5] Portraits of Sansar Chand, showing him in durbar or taking his ease, are largely conventional in manner. His artists' major achievement lay in their inspired interpretations of the classic Vaishnavite texts, as well as *ragamala* paintings and romances such as *Nala Damayanti*. In a series of *Gita Govinda* illustrations, showing the first maturity of the style, the love play of Krishna and Radha is depicted with tender passion in an idyllic version of the undulating Kangra landscape (Fig. 193). The further accentuation of the curvilinear rhythms of the Guler style, on which Kangra drawing relies for much of its effect, is seen in a more advanced form in a picture of ladies playing Holi (Fig. 189). By the end of Sansar Chand's reign, however, the beguilement of

Above left: Fig. 189 'Ladies celebrating Holi', Kangra. 1788. London, Victoria and Albert Museum, I.S. 9–1949

Above right: Fig. 190 'The lady with the hawk (Saveri ragini)', Guler. *c.* 1750. London, Victoria and Albert Museum, I.S. 178–1950

Below: Fig. 191 'Maharaja Gulab Singh', Sikh style, Lahore. *c.* 1846. London, Victoria and Albert Museum, I.S. 194–1951

[5]Quoted in W.G. Archer, *Indian paintings from the Punjab Hills*, p. 262.

Fig. 192 'A Jasrota prince on a riding expedition' by Nainsukh, Jammu. *c.* 1754. London, Victoria and Albert Museum, I.S. 7–1973

Fig. 193 'Krishna adorning Radha's breast', from a *Gita Govinda* series, Kangra. *c.* 1780. Private collection

the early style had deteriorated into a sentimental mannerism. The independence of the Pahari courts had by this time been undermined by the Gurkha invasions, followed by the domination of the plains-dwelling Sikhs, who annexed one kingdom after another. The Sikhs themselves for a time gave patronage to an enervated style of portraiture, one of the few outstanding examples of which is a study of the formidable Maharaja Gulab Singh (Fig. 191). But after the final defeat of the Sikhs in 1849 the British assumed effective control of the Hill states, whose remaining artistic traditions disappeared with the courtly way of life that had given rise to them.

MARK ZEBROWSKI

Decorative Arts
of the Mughal Period

Although Indian craftsmen were – and are – famous throughout the world for the beauty and technical brilliance of the objects they produced, very little is known about Indian decorative arts of any period. Surviving objects from millennia of civilized history in India, whether of wood, brass, jade, glass, cloth or precious metals, are surprisingly rare. The monsoon climate, where seasons vary drastically in temperature and humidity, has wrought havoc on textiles and carved or inlaid wood. Metal objects have been periodically melted down and recast because of wear or changes in fashion. Moreover, with the exception of a group of Mughal jades, few Indian objects bear any identifying inscriptions. When they do turn up, therefore, they are often tantalizing documents of the unknown.

Before cotton fragments were recovered from the cemetery at Fostat in Egypt, no examples of the pre-Mughal Indian textiles, famous throughout the ancient world, were known. Rare objects in ivory and wood also exist mainly because of their early export from the subcontinent's damaging climate. Though Indian brass vessels and steel swords were well known articles of trade in the medieval period, there are today no examples that can be definitely assigned to an Indian provenance (in contrast to hundreds of examples of inscribed metalware from the Muslim Middle East).

To explain the decorative arts in sixteenth-century India, it is necessary to understand the political transformations that had taken place since 1200. The principal change was the arrival of Muslim rulers from Central Asia and Afghanistan. They replaced the upper structure of Hindu governmental institutions with an Islamic framework mainly based on Iranian example. They imported a literary culture in Arabic and Persian and a visual aesthetic, that derived its standards from the eastern Islamic world. But the conquerors employed Indian craftsmen, and Islamic taste was soon conditioned by their practice. Both the Sultans of the numerous Muslim states and the Hindu princes shared this common taste.

The period from the sixteenth to the eighteenth century was one of the most brilliant in South Asian history, when great kingdoms were either Muslim or greatly influenced by Muslim culture. Babur, a Central Asian Turkish prince, founded the Muslim Mughal empire in northern India, and by the late seventeenth century it had conquered almost all the subcontinent. In the

western desert regions, the Hindu Rajput states, feudatories of the Mughal empire, evolved brilliant schools of painting, partly derived from the Mughal court style. In the Deccan, Muslim Shiite Sultans, great patrons of the arts, expanded their kingdoms against the Hindu Vijayanagar Empire.

Europeans contributed a third element to the Hindu-Muslim amalgam of styles. The Portuguese were decisively established at Goa by the first decade of the sixteenth century. Dutch, English and French trading centres developed on both coasts during the seventeenth century. European craftsmen, particularly jewellers, worked for the Mughal emperors who were passionately fond of European art of all kinds. Indian craftsmen copied European models to please their patrons and gradually absorbed certain decorative motifs and shapes.

This mixture of Middle Eastern, Indian and European influences created a brilliant new aesthetic, which spread to nearly the entire subcontinent, affecting the taste of Hindus and Muslims alike. Objects of this period are much more plentiful than from earlier times, although poorly understood when compared to Far or Middle Eastern artifacts. We are only just beginning to appreciate both the stylistic changes that occurred during these two centuries and the regional differences in taste. We can still scarcely differentiate certain Indian objects from eastern Iranian prototypes. Tinned copper vessels, for instance, decorated with exquisite arabesques and Persian or Arabic inscriptions, were made in north India and the Deccan for Muslim patrons. Yet their characteristics are so little understood that they have been excluded from this study.

It is important to realise that the decorative arts of this period existed to give beauty and opulence to articles of everyday household use. This essay has selected certain types of objects required by Muslim society and shows their specific uses; it then discusses, where possible, the changes that these objects underwent in form and decoration throughout the centuries. To do this, splendid examples of one class of object are grouped together, such as the *huqqa* or water pipe, in various media: jade, glass, bidri and brass. These materials, varying in provenance and preciousness, characterize different geographic regions and social levels. A Mughal emperor would probably have used huqqas made of jade (Fig. 205) whereas a Deccani Sultan was more accustomed to using bidri ones (Fig. 201). The less affluent smokers were accustomed to using brass huqqas (Fig. 202).

Decorative objects, with the exception of a few jades inscribed with their imperial owners' names, cannot be definitely connected to the Mughal court through inscriptions. This situation contrasts markedly with that of Mughal paintings, which are often inscribed with the names of known court artists. Therefore, we have dated these objects in a very tentative manner, on the basis of connections with the style of Mughal paintings and architectural ornament, by comparison with Persian examples and with representations of similar articles in Mughal paintings. Such objects were not necessarily made for court use but were generally influenced by court taste. We have chosen objects not for their opulence but for their brilliance of design.

Magnificent flowers adorn most objects and textiles of this period. A notable exception is the mother-of-pearl inlaid furniture, probably produced in Gujarat. The intricate patterns consist of elegant arabesque and boldly erect palm trees entangled in masses of writhing creepers, as on a beautiful box in the Victoria and Albert Museum (Figs. 194 and 196). The mother-of-pearl is cut into the appropriate shapes, and inlaid into a bed of black lacquer upon a surface of

Fig. 194 Teakwood casket, inlaid with mother-of-pearl, Gujarat. Seventeenth century. London, Victoria and Albert Museum, no. 155–1886

Fig. 195 Teakwood writing cabinet, inlaid with ivory, Gujarat. Seventeenth century. London, Spink and Son, Ltd

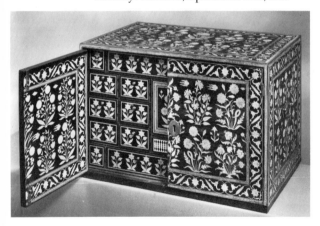

teakwood. The unusual designs are related to the architectural ornament of the mosques of the medieval Muslim kingdom of Gujarat before the Mughal conquest and are especially reminiscent of the pierced stone screens in the Siddi Sayyid mosque in the capital city of Ahmadabad (*c.* 1515).

In soft light, the mother-of-pearl inlay glitters in irridescent tones like the wings of a butterfly. Unfortunately, the material is almost as fragile, for the wooden base is apt to warp, throwing off and shattering the delicate inlay. The craft's fragility must account for its present day rarity, especially in India. Much was probably manufactured for the Ottoman Turkish market. But the industry was clearly not working solely for export. Seventeenth-century European travellers to the subcontinent confirm that the kingdom of Cambay (Gujarat) was the centre of this craft: desks, tables, backgammon boards and coffers were manufactured there. Within India they were once so common that there was almost no place without them.

Inlaid mother-of-pearl decoration survives in India, not on portable objects, but only as architectural ornament. Three surviving examples, all inlaid wooden canopies erected over Muslim saints' tombs, were almost certainly manufactured in Gujarat. They are at Sarkhej, near Ahmadabad (1451); at Fatehpur Sikri over the tomb of Shaikh Salim Chishti, erected not at the saint's death in 979 A.H. 1571–2, but early in Jahangir's reign (*c.* 1606); and the tomb of Shaikh Nizamuddin Auliya in Delhi. Inscriptions on the Delhi canopy state that it was erected in 1017 A.H. 1608–9 by Shaikh Farid Bukhari, Murtaza Khan, a prominent Mughal nobleman. Since he was governor of Gujarat at that time, and decorated several buildings in both Gujarat and Delhi while governor, it is reasonable to assume that the canopy for Nizamuddin was made in Gujarat and sent to Delhi. As has been noted, the full impact of the irridescent inlay can only be appreciated in the dark interior of the tomb where the mother-of-pearl sparkles like stars in the night, just as the verse proclaims, 'Murtaza Khan above his grave/Set up a canopy like the heavens.'[1]

Sober in decorative effect compared to the mother-of-pearl articles, and certainly less rare, are surviving examples of ivory inlaid furniture (Fig. 195).[2] Most are writing cabinets constructed of strong unpolished wood over which a veneer of teakwood has been pasted. Designs are excised in the veneer and then filled with pieces of ivory, usually glued, though they are sometimes fixed with brass pins.

Such writing cabinets entered the collections of European aristocratic houses in the seventeenth and eighteenth centuries, and they usually rest on stands of European origin. In India, however, they were invariably placed on the floor; Indian miniature paintings show cabinets of identical design, although many are lacquered or painted rather than inlaid. The damaging effects of the climate and the general lack of consideration for decorative objects of any age in India must account for their virtual disappearance from the subcontinent. Only one ivory inlaid writing cabinet has so far come to light there; it is in the Prince of Wales

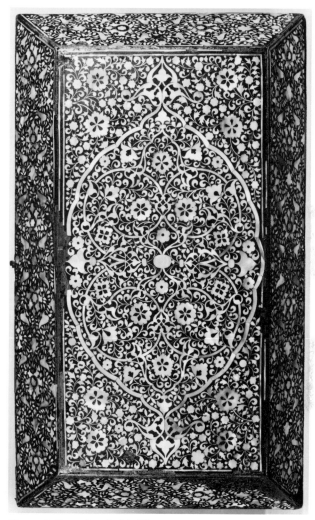

Fig. 196 Top of casket in Fig. 194

[1]Simon Digby, 'Mother of Pearl Inlaid Furniture of Gujarat: a 17th century Indian Handicraft', unpublished, p. 6. Examples of this rare craft are in the Victoria and Albert Museum, two private collections in England, the Ashmolean Museum, Oxford (on loan), the Pitti Palace, Florence, and the Topkapi Saray, Istanbul.

[2]Simon Digby, 'A Seventeenth Century Indo-Portuguese Writing Cabinet', *Bulletin of the Prince of Wales Museum*, Bombay, No. 8, 1962–4, pp. 23–8.

Museum, Bombay, formerly in the collection of Nawab Sir Salar Jang of Hyderabad.

Surviving examples of this craft probably date from the seventeenth century. The overall design of the cabinets, despite great variation in size, is consistent: a square or rectangular box with seven or eight drawers, the central one the largest, the whole facade covered by a richly decorated front flap. The motifs of the ivory ornament are diverse, resulting from changes in decorative fashions during the seventeenth century. Different idioms were also probably determined by the particular market – whether Indian, Middle Eastern, or European – for which the object was manufactured, as in the case of the Golconda painted cottons.

Cabinets of the first half of the seventeenth century have freer, more crowded decoration than later ones. Figural scenes are common: elephant combats, hunting, dance performances and picnics on raised platforms under trees. The figures wear costumes fashionable during the reigns of Akbar (1556–1605) and Jahangir (1605–27). Parts of the ivory inlay are occasionally stained a light shade of pink or green.

Cabinets of the second half of the seventeenth century have the elegant restrained decoration of the reign of Shah Jahan (1628–58). Orderly rows of windswept flowers alternating with Chinese clouds are common, as seen on the right-hand door of Fig. 194. Polychromy has disappeared; the flowers have a new pale purity, like those of the carved marble dados of the Taj Mahal. Another sort, with multicoloured geometric decoration in the centre of each panel, resembles Syrian and Iranian marquetry and may have been produced for southern European and Middle Eastern markets. The provenance of these beautiful boxes is unknown: Sind, Gujarat, Goa and the Deccan have all been suggested. Whatever their origin, it must be admitted that the style of European writing cabinets, especially Iberian ones, has influenced their design.

A much smaller box (8.7×13.7 cm) in the Victoria and Albert Museum displays a strikingly different style and medium. Painted and lacquered papier maché, with ivory trimmings, it may have served as a jewel casket. Gently lyrical scenes cover the top and four sides. They depict a European gallant fluting, a drowsing princess dreaming of her absent lover, a courtesan dancing in a flower filled grove (Fig. 197), an adolescent prince enthroned and a beautiful young girl reaching into a tree while breezes play with her diaphanous robes. Muted colours and exquisitely refined draughtsmanship create a mood of dreamy sensuality. The style is identical to Golconda painting of the last quarter of the seventeenth century. The painter must be Rahim Deccani, who, although trained in the Deccan, may have worked in northern India and Iran. A painting on paper, signed by him, in the same style as the box, is in the Chester Beatty Library, Dublin.[3]

It is usually assumed that the craft of lacquer painting was imported into India from Iran no earlier than the Mughal period; but again, the present lack of early examples may result from the damaging monsoon climate or our inability to distinguish Iranian from Indian examples. In any event, by the second half of the seventeenth century, Indian production was already beginning to influence the palette and figural types of Iranian lacquer pieces, which increasingly have

[3]Douglas Barrett, *Painting of the Deccan*, London, 1958, pl. 10.

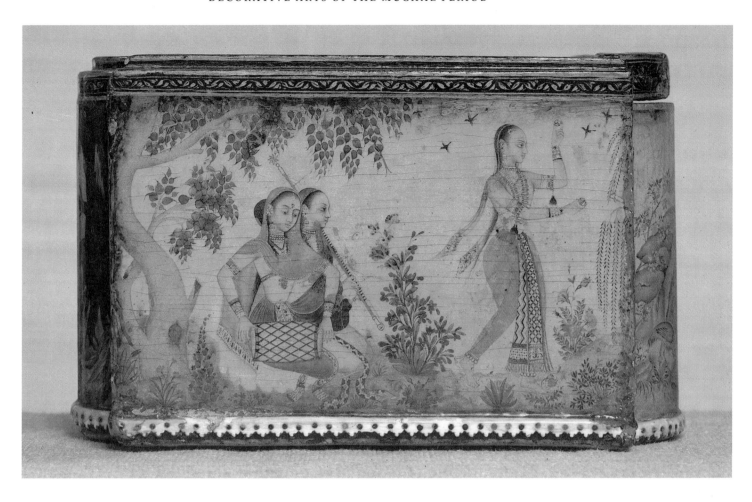

an Indian, especially Deccani, flavour. Rahim Deccani may have gone to Iran and influenced craftsmen there.[4]

A Mughal painting from the latter part of the reign of Aurangzeb (1658–1707) depicts a group of sumptuously decorated household objects laid out before a young prince (Fig. 198). He relaxes on the side of a well near a jungle while his army awaits his return. Three women have dropped and broken their pots in amazement at the prince's beauty. He may be a member of the imperial family, for his halo – half sun, half crescent moon – is identical to Jahangir's in a portrait in the Freer Gallery of Art.

The objects are typical of an aristocratic Indian household of the seventeenth century (Fig. 199). On the extreme right is a round blue and white ceramic *huqqa*, or water pipe. It may be of Chinese porcelain manufactured for the Indian market, or possibly Persian or Indian faience. Round huqqas like this one invariably rested on rings of the same material for stability. These rings derive from village examples made of rope and used for earthenware waterpots. Two such rings lie to the left of the large pot in the upper right of the painting. The huqqa bowl and ring rest, in turn, upon a large tray with an upturned edge. The

Fig. 197 Lacquered papier maché jewel casket, painted by Rahim Deccani, Golconda, Deccan. Late seventeenth century. London, Victoria and Albert Museum, no. 851–1889

[4]Two lacquer pen boxes, both probably painted by Rahim Deccani, were sold at auction in Paris, Hôtel Drouot, 28 mai 1975, lots 170 and 170 bis. One was signed by Rahim Deccani, the other dated 1706–7. Their style, although more Iranian than the Victoria and Albert box, clearly derives from Deccani painting.

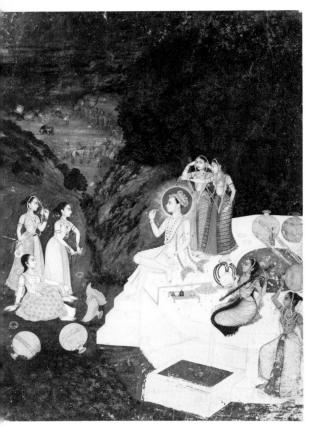

Above: Fig. 198 'A prince at a well', gouache and gold on paper, North India. Late seventeenth century. Private collection

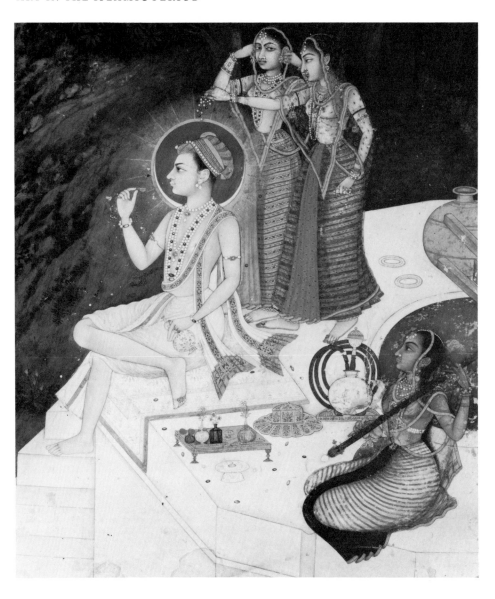

Right: Fig. 199 Detail of Fig. 198

one in the painting may be heart shaped; round ones are also known. To the left of the huqqa is a multisided domed box – possibly of enamel or inlaid metal – which fits onto a tray. Such boxes hold *pan* – the rolled betel leaf stuffed with lime and spices, which Indians chew as a *digestif* – and are called *pandans*.

The prince holds a wine flask in his left hand, which is of the same shape as seventeenth century rose water sprinklers, *gulabpash*, which were used for sprinkling rose water upon arriving guests. Just beneath the table is a spittoon, *paikdan* in northern India, *ugaldan* in the Deccan, of faience or porcelain. This vessel, perfectly shaped for its function, has a wide brim and a small hole in the centre, which leads to a hollow bell-shaped chamber beneath.

It is necessary to discuss here an Indian craft called bidriware, from which come some of the most important surviving metal articles of the Mughal period. Bidriware is a uniquely Indian sort of metalware, although it derives in taste, and partly in technique, from the opulently inlaid metal objects of Mamluk Egypt, Syria and Iran before the fifteenth century. Most 'late' Islamic metalware of the sixteenth and seventeenth centuries, especially in Iran and India,

combines sweeping forms of great simplicity and elegance with inexpensive materials. Not so bidriware. The base metal is an alloy of zinc, copper, lead and tin, richly inlaid with silver. Many earlier pieces (before 1700) are inlaid with copper and brass also, alone or together with silver. The object is given an acid bath after the inlay is applied, turning the background metal a rich, lustrous black, which contrasts beautifully with the yellow or white inlay.[5] The Muslim Sultans of the Deccan (fourteenth–seventeenth centuries), were great patrons of the craft, at the capital of Bidar, from which its name derives. The workshops there probably supplied articles for households all over India and varied their designs accordingly. No inscribed or dated pieces, before the mid nineteenth century, have come to light so that the dating of bidriware is tentative, based on comparison with other decorative arts or with ornament in miniature paintings. Most surviving pieces of bidriware are nineteenth century. Eighteenth-century pieces are rare, seventeenth-century pieces still rarer. In all early pieces the silver inlay is remarkably thick, and the brass inlay, unlike European brass, is of excellent quality and very heavy. As the craft certainly dates from well before the Mughal period, we can expect eventually to find pre-seventeenth-century articles. Bidriware, in a very different style, was also produced at Lucknow and in Bihar during the eighteenth and nineteenth centuries. The Victoria and Albert Museum possesses an excellent and varied collection of the craft.

Two splendid bidri trays, used for holding spherical huqqas on rings, can be dated to the seventeenth century (Figs. 200 and 206). The heart-shaped tray, Fig. 200, may be of the same shape as the one beneath the huqqa in the painting of a Mughal prince at the well (Fig. 199). Differing from the customary silver inlay technique this piece has been entirely overlaid with a thick sheet of silver, out of which the design has been cut, exposing the black base metal underneath. The technique is known as *aftabi*. Brass has been inlaid with great restraint in the spaces between the flower petals. The round tray (Fig. 206), a brilliant essay in yellow against black, is one of the very few bidri articles that is entirely inlaid in brass. In fact the heavy brass inlay may have an admixture of gold. The energy of the over all pattern and the rhythmic sway of the individual flowers immediately bring to mind the ornament on buildings and textiles of the reign of Shah Jahan.

A round bidri huqqa bowl and ring of about the same date, in a private collection, is more Deccani in taste (Fig. 201). The flowers bend and twist with an almost explosive energy. The rich colour contrasts – stems and leaves in bright yellow brass, flowers in silver against a black background – exude a feeling of opulent excess that is typically Deccani but alien to Mughal restraint. Round huqqa bowls like this are depicted in Mughal and Deccani paintings of the second half of the seventeenth century and the first few years of the eighteenth.

A superb green glass huqqa bowl decorated with golden poppies is in the collection of the British Museum (Fig. 204).[6] It is of the same general shape as the bidri example (Fig. 201) but the more formal character of the flowers suggests a later date, probably *c.* 1700. At least two other glass huqqas of comparable quality are known, probably from the same workshop. One, in the Cleveland

Fig. 200 Bidri tray, inlaid with brass and silver, Bidar, Deccan. Seventeenth century. Private collection

[5]A.R. Choudhury, *Bidriware*, Salar Jang Museum, illustrated catalogue, Hyderabad, 1961.

[6]Ralph Pinder-Wilson, 'A Glass Huqqa Bowl', *British Museum Quarterly*, XXV (1962), pp. 91–4, pl. XXXVII.

Fig. 201 Bidri huqqa bowl and ring, inlaid with brass and silver, Bidar, Deccan. Seventeenth century. Private collection

Fig. 202 Bidri basin, inlaid with brass and silver, Bidar, Deccan. Seventeenth century. Private collection

Fig. 203 Brass huqqa bowl, chased and inlaid, Punjab or Punjab Hills. Early eighteenth century. Private collection

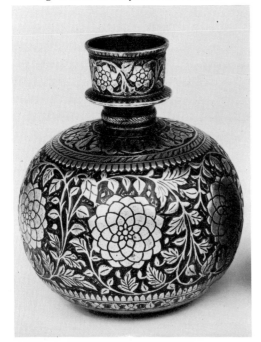

Museum of Art, has very similar poppies painted in gold upon a blue background;[7] the other in the Victoria and Albert Museum has a diaper pattern of golden leaves on a green background.

Very little is known about the history of Mughal glass, or in fact Indian glass of any period. The group of glass objects that our huqqa represents must have been manufactured in north India, perhaps Delhi, for important Mughal and Rajput patrons. None of the surviving vessels, however, bears any identifying inscriptions. Seventeenth-century Indian paintings depict round glass huqqas and, even more frequently, long necked coloured bottles arranged in wall niches. Such bottles are known to have been produced at Shiraz in Iran during the Safavid period, but, considering their frequency in Indian paintings, an Indian production is also likely. Other vessels, such as flower vases, cups and beakers bear such typically Mughal ornament that an Indian origin seems logical. However it has been suggested that many such 'Mughal' pieces were actually imported from Europe or the Middle East and then decorated according to local taste in India.[8]

The most sumptuous huqqas to have survived are in jade, undoubtedly produced for royal patrons. A round jade huqqa combines splendid simplicity of form with brilliant colour and precious materials (Fig. 205). The bowl is of light green jade, inlaid with spinach green jade, forming a leafy trellis pattern, and flowers of cabochon rubies and lapis lazuli. Gold wire outlines the flowers and foliage. A pair of identical huqqas, mounted for William Beckford on French eighteenth-century ormolu stands, is in the British Museum. A very similar piece is in the Victoria and Albert Museum, although the flowers in the lower two thirds of the base have been reset at a later date. A fifth jade huqqa, the only one to have retained its supporting jade ring, is in the collection of the Maharana of Mewar. In all these examples, costly workmanship and materials have produced, in a typically Mughal way, objects of great classical restraint.

Far less luxurious, but possessing the same robust form, are two chased brass huqqa bowls, both in a private collection. One has a bold arabesque design coupled with full blown lotuses (Fig. 203); the other has an Islamic *mihrab* design enclosing flowering rose plants. Late seventeenth- and early eighteenth-century paintings from the Punjab Hills often depict princes smoking similar metal huqqas that seem to be made of brass or silver. Several nearly identical huqqas in the Victoria and Albert Museum probably come from the Punjab Hill towns of Kangra and Nurpur. A likely location for the workshop responsible for this craft is Lahore. All these huqqas bear traces of a dark green, almost black composition – possibly lac – on the etched background between the decorative motifs.

The two brass huqqas probably date from the early eighteenth century. A date later in the eighteenth century cannot, however, be excluded since the demand for archaistic round forms continued in provincial areas throughout the eighteenth century. In the urban centres of the north Indian plains and the Deccan, however, fashions in huqqa shapes changed dramatically during the third and fourth decades of the eighteenth-century. The round form gradually 'merges' with its ring base to form a flat-bottomed bell shape without a separate ring, as in a splendid silver-gilt huqqa inlaid with sparkling blue enamel datable to the

[7]Stuart C. Welch, *The Art of Mughal India*, New York, 1963, pl. 80.

[8]Simon Digby, 'A Corpus of "Mughal" Glass', *Bulletin of School of Oriental and African Studies*, University of London, Vol. XXXVI, Part 1, 1973, pp. 80–96.

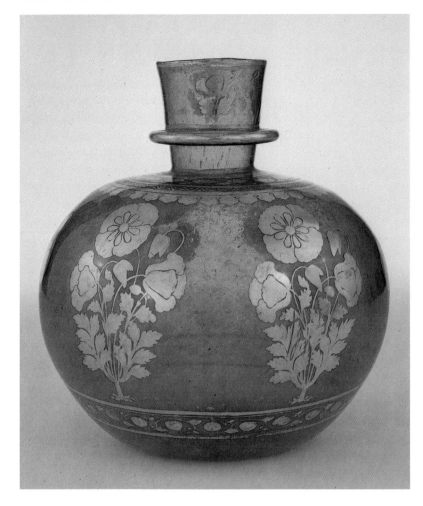

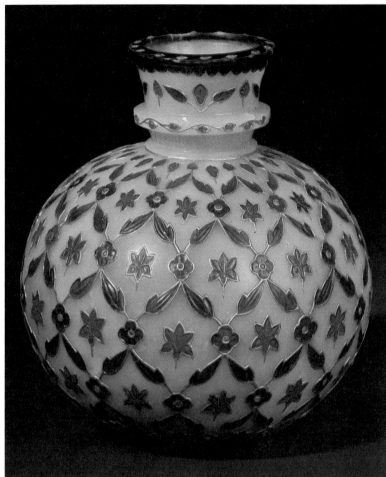

second half of the eighteenth century, which is in the Victoria and Albert Museum (Fig. 207). In the nineteenth century the bell shape splays out even more emphatically at the bottom.

Pandans, containers to hold the Indian delicacy of rolled betel leaf called *pan*, are frequently depicted in seventeenth- and eighteenth-century miniatures. They are usually simple, round domed boxes of inlaid brass, gold, jade or bidriware. Two such seventeenth-century bidri *pandans*, inlaid with silver and brass, with perhaps an admixture of gold, are in a private collection.[9] Unlike huqqas, we cannot yet establish the chronological changes that took place in the form of *pandans*. A distinguished copper enamel *pandan* (Fig. 214) resembles the multi-sided example depicted in the painting of *A Prince at a Well* (Fig. 199). Delicately gadrooned in shape, it is covered with lilac blue enamel that contrasts subtly with the brown silhouettes of copper flowers. The overall effect is as fragile and organic as a patterned egg shell. The plants sprout so freely and realistically from heart shaped rocks that a date during the first half of the seventeenth century is likely. While the technique on the outside is champlevé enamel, inside the domed cover the enamel is cloisonné. Yellow and blue cypresses recall the traditional colours of Indian tilework as in the forts of Gwalior and Lahore.[10]

[9]F. Galloway, M. Spink and B. W. Mohamed, *Islamic Art from India*, (Spink and Son Sale Catalogue), London 1980, colour plate 9.

[10]Exhibited in the 1931 Exhibition of Persian Art in London, Case 309.C, the box was predictably described as 'N.E. Persia, XVII century (?)'.

Above left: Fig. 204 Gilded glass huqqa bowl, Delhi (?), North India. *c.* 1700. London, British Museum, Or. 1961–10–16–1, bequeathed by Louis C.G. Clarke, 1961

Above right: Fig. 205 Jade huqqa bowl, inlaid with lapis lazuli, rubies and gold, Delhi (?), North India. *c.* 1700. Private collection

Below: Fig. 206 Bidri tray, inlaid with brass, Bidar, Deccan. Seventeenth century. Private collection

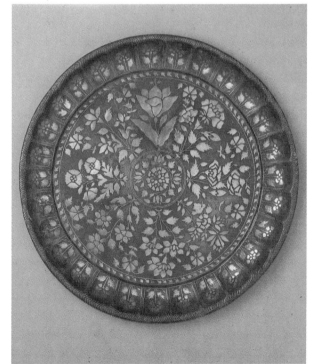

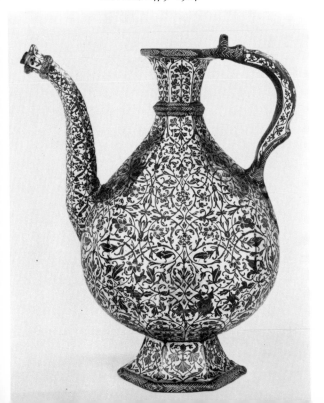

Fig. 207 Silver-gilt huqqa bowl, inlaid
with enamel, Bidar, Deccan. Second half
of the eighteenth century. London,
Victoria and Albert Museum, I.S.
122–1886

Fig. 208 Bidri ewer, inlaid with brass and
silver, Bidar, Deccan. Seventeenth
century. London, Victoria and Albert
Museum, 1479–1904

Noticeably absent from the well appointed scene in *A Prince at a Well*, though indispensable to every Indo-Muslim household of means, are a ewer and basin. The ewer, called *aftaba*, invariably accompanies a matching basin, called *tasht* in north India and *sailabchi* in the Deccan. They are used for washing hands. A servant pours water from the ewer over his master's hands into the wide, shallow basin below. One of the finest surviving ewers of the Mughal period is a bidri example in the Victoria and Albert Museum (Fig. 208). Like the heart-shaped tray (Fig. 200), it is entirely covered with a sheet of silver from which floral arabesque has been cut, revealing the background metal. The design is so like that of the tray that both pieces must have formed part of a sumptuous set of household articles, produced in a Deccani workshop in the mid or late seventeenth century. Although the Persian inscription, dated 1400, on the ewer has been faked it should not permit doubts to be cast upon this genuine seventeenth-century piece.

The classic Indian basin shape is represented by an unusual bidri example in a private collection (Fig. 202). Rich and majestic, the floral arabesque closely resembles, both in motifs and robust feeling, the carpet patterns and architectural ornament of the early seventeenth century. The Ottoman Turkish *chintamani* pattern in brass beneath the rim contrasts starkly with the arabesque. The basin, which can be dated to the first half of the seventeenth century, perhaps as early as 1600, is one of the earliest known pieces of bidri. Eighteenth-century basins, though still elegant, are often squatter and more compressed in form.

Very little is known about Indian hardstone carving, especially jade, before the Mughal period. Agate is known to have been carved in Gujarat, and crystal was used for Buddhist relic caskets, Jain images and Hindu *lingas* in ancient and medieval times. But no jades can be definitely assigned an Indian provenance before Jahangir's reign. It has been assumed, therefore, that Jahangir imported jade carvers, or the necessary technology, from outside India. Significantly, however, the techniques used in India for carving agate, crystal and jade are identical, suggesting the existence of a correspondingly ancient jade technology. Some writers believe all 'Mughal' jades were manufactured in China for the Mughal market, other scholars look westward.

Whether or not jade production existed in pre-Mughal times, it underwent a remarkable spurt in the Mughal period. Recently Pinder-Wilson and Skelton have shown that the earliest Jahangiri pieces remarkably resemble Timurid examples and that Jahangir owned many Timurid jades.[11] This strongly suggests that the impetus for jade production came not from the East but from the domains of the Mughals' Timurid ancestors whom they consciously sought to emulate. Despite foreign influences, however, the best Indian jades show a love of simple organic shapes – evocative of flowers or fruit – which could only be work of Indian born craftsmen faithful to a uniquely Indian vision.

One of the most striking Mughal jades is the Shah Jahan cup in the Victoria and Albert Museum (Fig. 209). Immaculately white like the marble architecture erected by Shah Jahan, it represents the classic moment of Mughal taste, in which the boldly austere sweep of earlier Mughal design has made a certain

[11]R.H. Pinder-Wilson, 'A Persian Jade Cup', *British Museum Quarterly*, vol. XXVI, Nos. 1–2, 1963, pp. 49–50; Robert Skelton, 'The Relations between the Chinese and Indian Jade Carving Tradition, the 14th to the 18th Century', *Colloquium on Art and Archaeology in Asia*, No. 3, University of London, 1972, pp. 98–110.

concession to soft sensuality without altogether succumbing to it. A small Persian inscription, engraved on the side of the cup, gives the date, which corresponds to 1657, and the name of the owner – *sahib-i-qiran-i-sani*, 'The Second Lord of the Conjunction', a title that Shah Jahan adopted from his ancestor Timur. The Chinese gourd shape, the European acanthus foot and the Middle Eastern goat's head have all been transformed to produce a consummately Mughal object.

A carved rock crystal bowl in the Victoria and Albert Museum provides another example of the splendid severity of seventeenth-century design (Fig. 210). The elongated stalks of lily plants emphasize the divisions in the gadrooned shape, while their elegantly drooping flower heads define the cup's upper edge. A superb agate cameo, unique among Mughal hardstone carvings, is in the Bibliothèque Nationale, Paris (Fig. 211). It depicts Jahangir slicing through a lion with one sweep of the sword in the symbolic, ancient Middle Eastern gesture of royal prowess. The craftsman, by manipulating the depth of carving, has used the natural grain of the stone to depict the victorious emperor in pristine white and the threatening animal in a mellow honey tone.

It would be impossible to attempt here an even partial survey of the wide range of Indian textiles of the sixteenth to the eighteenth century. In a country of such intense specialization of crafts, the variety of textile form, ornament and technique is staggering. The character of Indian patronage also encouraged diversity. Hindus and Muslims required, in part, different kinds of fabrics for the differing patterns of their daily lives. Clothes, floor coverings, tents and wall hangings were decorated with painted, printed, stencilled, embroidered, woven or other kinds of pattern.

The knotted carpet is not indigenous to India where the monsoon climate is highly destructive to such textiles. However the life style of Muslims, and many Hindus, in the Mughal Empire and the Deccani kingdoms naturally included the use of carpets, an indispensable part of Islamic life. The Mughals probably invited Persian craftsmen to begin their court production in the sixteenth century. With a few exceptions, the earliest known Mughal carpets date from the seventeenth century, and by that date, a strong local flavour had already evolved. A design of upright flowering plants is common, usually against a red ground, but is unknown in Iranian carpets.

However, the carpets depicted in the paintings of the reign of Akbar (1556–1605) show arabesque ornament against a dark blue or green background. A fragment of just such a carpet, with a dark blue background, is in the Musée des Arts Décoratifs, Paris (Fig. 212). Although it has been assigned to the Sultanate period, a more likely date is late sixteenth or very early seventeenth century. Already there is a typically Indian tendency toward an empty background against which realistic depictions of plants and animals – more plastically rendered than in Iran – stand out in great clarity. Gently curving arabesques terminate in leaves, flowers and animal heads. The latter resemble the animal heads of Mughal dagger hilts in steel, jade and ivory.

A prayer-rug of the second quarter of the seventeenth century, in the Thyssen – Bornemisza collection, Castagnola, reflects the striking metamorphosis which had just occurred in Mughal architectural ornament (Fig. 215). The buildings of Akbar's reign are usually constructed of red sandstone richly carved with floral arabesques. Shah Jahan, however, preferred milky white marble buildings carved or inlaid – in colourful semi-precious stones – with large, naturalistic

Fig. 209 Shah Jahan's wine cup, white jade, Delhi or Agra, North India. 1657. London, Victoria and Albert Museum, I.S. 12–1962

Fig. 210 Carved crystal bowl, Delhi, North India. Mid-seventeenth century. London, Victoria and Albert Museum, 986–1875

Fig. 211 Jahangir killing a lion, agate cameo, North India. Jahangir's reign, 1605–27. Paris, Bibliothèque Nationale, Cabinet des Médailles

Fig. 212
Fragment of
knotted woollen
carpet, North
India. Late
sixteenth or early
seventeenth
century. Paris,
Musée des Arts
Décoratifs, inv.
5212

Fig. 213 Painted
cotton coverlet,
Golconda,
Deccan. *c.* 1640.
New York, the
Metropolitan
Museum of Art,
28–159–2

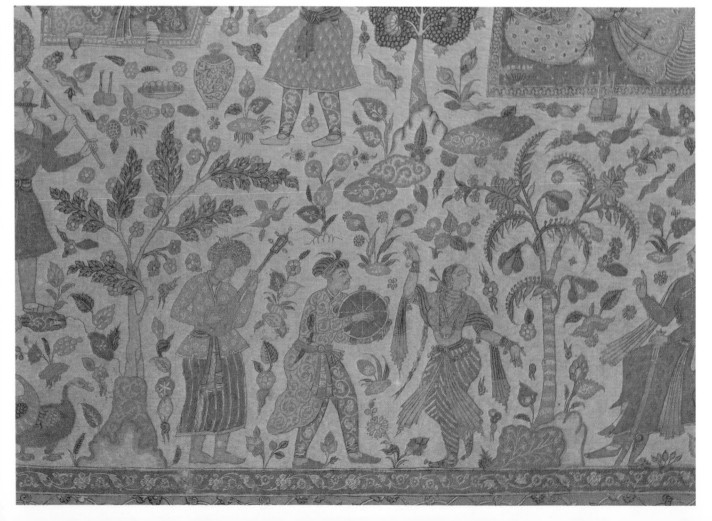

flowering plants, strongly influenced by the designs of European herbals. The Thyssen carpet combines a superbly energetic design with a glossy fineness of weaving that resembles velvet. The large flowering plant, wispy Chinese clouds and a mihrab setting compose a classic Indo-Islamic design. Eighteenth-century versions of this design are more formal.

Many regions in the sub-continent have produced painted cottons for wall hangings, coverlets, clothing and floor coverings, more suitable in the hot, humid climate than knotted carpets. The painted cottons with which Europe has been most familiar were those manufactured on the Coromandel coast in southeastern India, then a part of the Deccani kingdom of Golconda. Most surviving examples date from the seventeenth and eighteenth centuries. They were painted, using dyes applied free hand and with stencils, not only for the local Deccani market but for north India, Iran and Europe. In India they were much in demand as dress material for *jamas* (coats) and *patkas* (waist sashes) as well as for palace and tent hangings. In Europe they were fashionable for wall coverings and bedspreads. To suit the export markets there was often a charming admixture of European and Persian motifs to a basically south Indian aesthetic.[12]

A miniature coverlet in the collection of the Metropolitan Museum of Art, New York, was probably painted either for the Mughal or the local Deccani market (Fig. 213). The scenes depicted show far less European influence than usual. Pattern books were sent out to the cotton painters from Iran and Europe. Here, however, designs must have come from the Deccani court ateliers, for we see figures that are strongly related to known Deccani miniatures. Given the relationship to early seventeenth-century Deccani painting on paper, a date of *c.* 1640 is probable.

Before the use of carpets became widespread, Indians usually used cotton floor coverings, as attested by innumerable scenes in Rajput and Mughal paintings. A superb floorspread in the Victoria and Albert Museum, over thirty feet in length, has four rows of poppy plants arranged in opposing pairs, surrounded by a green border. The outlines of the poppy plants are stencilled, and details have been added free-hand in a complicated process of mordant and resist dyeing. This floorspread, which came from Jaipur, may have been produced in Rajasthan or Khandesh about 1700.[13] Its style reflects the elegant inlaid ornament of the white marble architecture devised for Shah Jahan (see pp. 113–15).

[12]John Irwin 'Golkonda Cotton Paintings of the early Seventeenth Century', *Lalit Kala*, No. 5, April 1959, pp. 11–48; idem., *Origins of Chintz*, London, 1970.

[13]John Irwin and Margaret Hall, *Indian Painted and Printed Fabrics*, Historic Textiles of India at the Calico Museum, Volume I, Ahmadabad, 1971, No. 23, pl. 9.

Fig. 214 Champlevé enamel and copper inlaid pan box, North India. First half of the seventeenth century. Private collection

Fig. 215 Woollen prayer rug, North India, Second quarter of the seventeenth century. Castagnola, Thyssen-Bornemisza collection

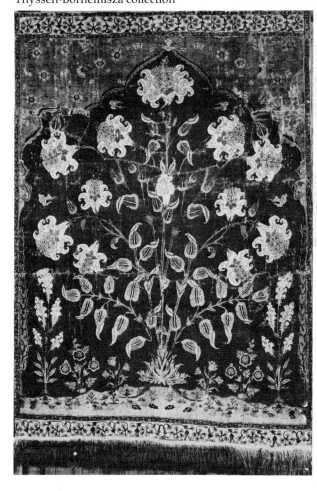

This article would have been impossible to write without the help of the following colleagues: John Robert Alderman, Helen Angus Topsfield, Simon Digby, Michael Goodhuis, Howard Hodgkin, Bashir Mohamed and Robert Skelton. Simon Digby was particularly generous with his time and knowledge; his explanation of the themes and problems inherent in researching Indian decorative arts is present in the introductory paragraphs of this study and gave to it both scope and direction.

Modern Art

Fig. 216 Street in Balikondalo, Orissa

STEPHEN HUYLER

Folk Art in India Today

The subcontinent of India is vast, now organized into four nations, but comprising thousands of separate cultural entities. Indian history evolved through an interplay of divergent beliefs, and through a myriad of kingdoms and empires undergoing constant change. As each new ruler gained ascendency and established a court, he encouraged the production of symbols of his wealth, objects to bring out his affluence and to display his power. The style and manner in which these items were made depended upon local traditions, the influence of outside sources (either brought in with new regimes or to them through trade and political contact), and the invention of new styles. The other chapters of this book discuss many of the finest examples of this court art: paintings, sculpture, applied arts, and architecture, produced almost exclusively under royal patronage. However, each of these courts ruled over a predominantly rural people, poor economically, but still rich artistically. This chapter tries to portray some of the results of those rural South Asian craft traditions.

Although each court and surrounding city had its particular artists and craftsmen who developed and implemented its own special styles, very often throughout Indian history labour was drawn from neighbouring villages. Craftsmen known for their traditional talent were brought great distances to build a temple or palace, or to carry out interior decorations and make utensils. They would complete their commission as required, and then usually return to their villages. In much the same way today, tribal labourers from central India will travel a thousand miles to Assam for seasonal work, yet keep their family and household in the village in which they were raised.

Artistic influences drawn from the sub-continent are found in most classical art, and their interplay is intriguing. The first obvious example of this rural influence is seen in the elaborately carved friezes on the gateways and balustrades of the early Buddhist stupas at Sanchi dating from the second century BC. The treatment of stone implies equal mastery in carpentry and wood and ivory carving. Following Sanchi, each subsequent kingdom or empire created its own sense of style often adapting elements derived from less sophisticated sources. While these rural elements are recognized in classical art, the reverse effect upon village art is rarely noticed. The itinerant craftsman, returning to his village, must have brought with him insights and techniques

that he learned while he was among court artists. Consequently, rural Indian art is a reinterpretation of traditional forms, with some classical influence, yet moulded to a provincial social context.

Before discussing contemporary village crafts and their significance in village life, it is important to understand their historical relevance to the artistic periods discussed in other chapters. The state of 'folk art' in India today is the result of an amalgam of indigenous and international influences. Examples of decorated pottery have been found in excavations from the late Stone Age in the fifth millenium BC, while sculptures as well as vessels in terracotta, copper and bronze are attributable to Neolithic, Chalcolithic, and Harappan cultures beginning in the period of 2500–2000 BC. The Harappan culture, based in the Indus Valley with its largest centres at Harappa and Mohenjodaro, is believed to have extended its empire as far as the Persian Gulf. In this period, the layout of towns and the development of architecture was quite advanced. Towns were divided into sections for different craftsmen, much as towns and villages have since been similarly apportioned throughout history. While Vedic texts refer to the respected social position of craftsmen, especially woodcarvers, metal workers, potters and weavers, major craft discoveries from archaeological excavations are quite sophisticated pottery in a variety of styles and slips, dating from the Vedic period onwards. In India today, similar forms of pottery, produced by almost identical means, are still being made. Although this prehistoric craft is thoroughly documented, few parallels have been drawn to contemporary crafts.

Historically, India has been a major source of trade goods throughout the civilized world since the time of the Egyptians and later Babylonians. Besides precious stones and metals, and various woods, scents, and spices, Indian trade provided cotton and silk, well woven and highly prized. Greek dependencies formed in the Punjab after Alexander's death encouraged trade with the Mauryan empire, whose craft production was described by Kautilya and Megasthenes in the fourth century BC. During the reign of the Mauryan emperors village craftsmanship appears to have gained social respectability equivalent to imperial art. Greek influence spread further into the Gangetic plain during the next five hundred years, while trade routes opened directly with Rome and China as improved navigation began to utilize the monsoon winds. In an anonymous Greek writing of c. 95–130 the *Periplus of the Erythraean Sea* and in other Roman accounts by Pliny (77), and Ptolemy (c. 150), Indian wares imported to the Roman Empire are described in detail: such as cotton, muslin, linen, and ivory, as well as jewellery, pearls and beryl. Similarly, China is an important source of information about early Indian crafts. With the rise of increased Chinese interest in commerce, coupled with expanding conversion to Buddhism, notable travellers during the Gupta period, among them Fa hsien (399–414) and Hsuang tsang (629–45), wrote detailed descriptions of contemporary living conditions in India with vital accounts of crafts and craftsmen of the day. These include detailed city and house plans, as well as references to metal sculpture, wood and ivory carving and printed and brocaded textiles. The *silpa-sashtras*, written by Brahmans beginning in the fifth century, were thirty-two craft manuals intended as guidelines for the social order and design ideals of artisans. Trade with Europe from the Roman and, later, Sassanian empires continued through the Pallava and Chalukyan periods.

Beginning in the eighth century in the northwest, Islamic Arabs became major carriers of trade to and from India. Their interests were generated by two quite

separate means: merchants making use of their very highly developed knowledge of the monsoons (that is trade winds) and establishing coastal ports; and military invasions thrusting into the Sind and Gujarat with the consequent seizure of wealth and power. While in the south the Cholas, from the ninth through to the thirteenth century, increased trade with Southeast Asia and China, in the north the Ghaznavids and Ghurids extended their empire from what is now Afghanistan through to Delhi and the Gangetic plain by 1196. With a free flow of trade throughout the world of Islam reaching as far as Spain, the impact upon urban and rural craftsmanship in India was obviously immense.

As Islamic tradition (*hadith*) forbade figural representation, use of geometric and calligraphic designs became highly refined, and reflections of its high stylization are still noticeable in examples of village art throughout India. In the south, Tamil culture had reached its golden age; it regulated craftsmanship precisely and produced socially honoured results. Artisan guilds had lost their earlier prominent position in the north, but retained their dignity in the south.

The Portuguese from 1498, were the first modern European power to acquire trade with India. By securing a good relationship with Vijayanagar, they established ports and coastal factories for trade, above all in textiles, all along the western coast during the first half of the sixteenth century. Once again, Europe had independent contact with Indian artistry, which was gradually accelerated during the next four hundred years. Catholic Portuguese influence remains in coastal village handicrafts to this day.

The Mughal empire of the sixteenth and seventeenth centuries fostered the zenith of village artistry, as well as laying the groundwork for its disintegration. With Islam dominant, Hinduism and its social traditions was forced into introspection, centred on the temple. The caste system, with craftsmen at its lowest end, was more strongly enforced. The Mughal aristocracy, however, gave major patronage to the arts so that masses of craftsmen converted to Islam in order to benefit. Mughal support of *bhakti* (devotional exercises) and their gradual tolerance and approval of the passionate quality of Indian art led to a liberalization of Islamic traditions, which resulted in a blending of Islamic and Hindu styles. The craftsman was often imported from rural villages, and a consequence of this was that he affected village design on his return. Foreign trade greatly accelerated during these two centuries. Although Indochinese and Portuguese merchants held a virtual monopoly of coastal trade in the sixteenth century, other European powers, the Dutch, followed by the English and French, emerged shortly after. In the latter half of the seventeenth century, ports all along the Indian coastline opened successively to European trade. Thus came a demand for goods, and, as preindustrial India was still 98% rural, the products of village craftsmen throughout the subcontinent supplied the overseas market. Indian wares flooded European shops and wholesalers, fashions for these exotic styles were created in every field. Fabrics were among the most important: chintz, calico, gingham, muslin, silk, satin, velvet, brocade, quilts, embroideries, and carpets. Other important marketable items were jewellery, gold and silver ware, brassware, cabinetry, arms and armour. English, French, Portuguese, and Italian travellers of that period kept detailed accounts of artisan communities with valuable descriptions of their products.

During the eighteenth century, the grip of the Mughals in India weakened. The small Hindu and Muslim states that came to power in their wane were for the most part not strong. European mercantile forces began to vie with each

other for a larger grip on the Indian economy, and, by 1790, England had gained almost complete control. The newly acquired wealth pouring into Britain from her Indian and other colonial business concerns, provided the basis for the industrial revolution. No longer was the west dependent upon India for its finished crafts. Nineteenth-century ingenuity combined with British labour produced the same items in England at a cheaper cost. The Indian village craftsman, so encouraged in the previous two centuries by worldwide demand, was left with only local clientele. Britain wanted raw materials for its English manufacturers and cheap labour for the hundreds of factories in the newly industrialized Indian cities. With this new centralized economy, and the greater emphasis on urbanization and cheap production, rural India again diminished in importance, and its craftsmen grew increasingly impoverished. Despite these governmental and social trends, nineteenth-century British India also produced valuable research into both the traditional craft structure of India and the processes in which crafts were made. Never before had so much intense effort been applied towards documenting all aspects of Indian culture, and many of these accounts remain the finest descriptions of Indian rural crafts. The twentieth century brought a new realization of the drawbacks of over-industrialization. British India began to adopt measures to protect its decimated crafts, while museum collections, begun in the previous century, were enlarged and catalogued.

Since independence in 1947, the Indian government has assiduously encouraged the production of marketable village crafts by traditional means. However admirable these programmes are, modernization is inevitable. With overpopulation and poor economic conditions coupled with continued urban emphasis on industrialization, full-scale utilization has been restricted. The requirements of contemporary mass production have altered the quality of many handcrafts, and the earning capacity of the village craftsman is increasingly threatened. Nevertheless, close to any city in India it is possible to find a proliferation of handicraft items that are unique to that area. In these places not only does the layout of streets and the architecture differ from those of the urban environment, but also the shape and decoration of such items as carts, doors, beds, baskets, pots and toys. The Indian people are extremely creative, and find innumerable ways to enhance the design of functional objects. Within each small village, the craftsmen have introduced slight variations in many of the forms of articles for daily use. Considering India as a composite of several hundred thousand villages, one begins to respect the multiplicity of design. In a world of widening horizons, the lack of exposure of the majority of Indian folk art is surprising. The vast rural districts of South Asia still hold an enormous reservoir of unnoticed village crafts.

Rather than attempting to list and categorize this enormous variety in a short chapter, I will try to present a few examples of rural art in a small context: a microcosm as reflective of the macrocosm.

I have chosen the village of Balikondalo in Puri District, Orissa, with a few comparative examples from other areas, to illustrate traditional craftsmanship in contemporary rural India. Although the designs and application of many articles in use in Balikondalo are unique to this district, tens of thousands of villages throughout the subcontinent could be used for a similar purpose. Orissa, on the northeastern coast, directly below Calcutta, is less documented, or congested with tourism, than most states in India. An ancient and proud people, the

Oriyans were able to restrict the attention of both the Mughal and British empires. The majority of people are Hindus, although their protected mountain regions hold the largest tribal population in the country, and the larger cities include many Muslims. I have picked, as my example, a purely Hindu village; but a Muslim or mixed Hindu-Muslim village would make an equally viable case study.

The main highway is half a mile from Balikondalo and connects the famous temple of Konarak six miles away with Bhubaneswar, thirty-seven miles away, and Puri, forty-five miles distant. Five other villages surround Balikondalo within a radius of two and a half miles, while the nearest market town of Gop is only three miles.

The majority of settlements in India, whether villages, towns or cities, are aligned with the poles and the sun's axis. Balikondalo is no exception. Settlement patterns throughout South Asia, as elsewhere, depend upon geography and climate, but are most strongly regulated by sociological prescriptions. North-western Hindu houses are clustered to form a defensive, fortress-like grouping concentrated upon its centre. Muslim villages in central India are more irregularly arranged, close-knit with narrow streets; while southern Hindu villages exhibit wide streets laid out in a loose grid pattern of blocks of houses. Balikondalo, as in most coastal Orissan villages, consists of a main road running east-west with smaller lanes branching intermittently at right angles (see Fig. 217). Caste laws, and the consequent division of labour, have designated separate portions of the village to be inhabited by distinct castes. The majority of Balikondola's total population, which was 632 in 1979, are potters, or *Mudli Kumbhars*, who live in two large clumps to the east and the west. They number sixty families. Seven Brahmin families live at the centre, while two families of fishermen, *Khoibata Behera*, one family of washermen, *Dhoba*, and one family of Untouchable (*harijan*) basket-makers, *Domo*, live on the outskirts.

Paddy fields and coconut groves encompass Balikondalo, and an abundant water supply has interlaced the area with ponds, canals and ditches. Members of the potter families also farm, cultivating not only the main crops of rice and coconuts, but subsidiary crops of peanuts, potatoes, and some green vegetables as well.

The architecture of dwellings in India is governed by climate and availability of materials; but it also varies according to the social tenets of race, caste and class. Even within one village, architecture often differs in each caste section. In Balikondalo, although locally fired bricks are used in some modern houses, most houses have mud-dung walls. They are roofed with a base of fan palms laid on a gable fretwork of wood beams and surfaced with a thatch of sheaves of hay. This thatch is practical in an area where there are frequent cyclones, as it can be readily replaced at almost no cost. It overhangs a raised verandah, parallel to the street, and stretching usually between terraced buildings, as shown in Figs. 216 and 218. In potters' houses the entrance is usually through a single door in the stable and milling room, into a small courtyard. The courtyard is the primary area of activity where most of the women's work is performed, and meals are cooked, except during the monsoon. Behind the courtyard, or sometimes radiating from it, are the sleeping quarters, the storerooms, a monsoon kitchen, and a small walled garden. As in most areas of India, large extended families live together. Often, as in Fig. 219 the interior of the house is split into two 'flats' so that each smaller family may care for itself. However, as the family works

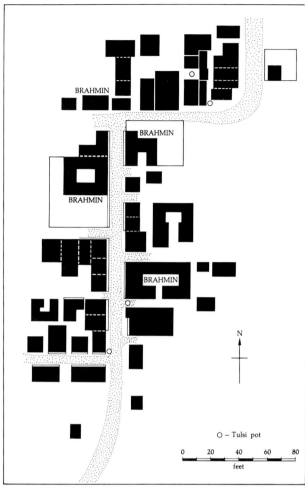

Fig. 217 Street plan of Balikondalo, Orissa

Fig. 218 Houses at the edge of Balikondalo, Orissa

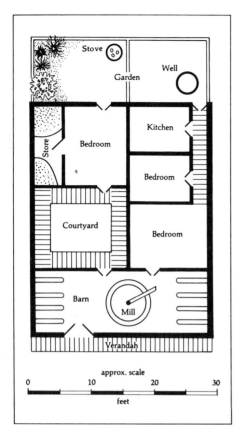

approx. scale

0 10 20 30

feet

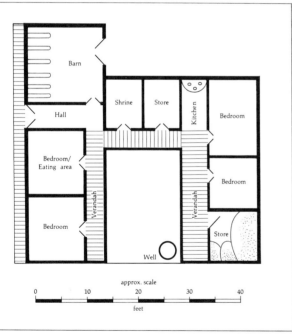

approx. scale

0 10 20 30 40

feet

Fig. 219 Floor plans of two houses in Balikondalo, Orissa

together, it shares the stable, mill, main courtyard and well. The bedrooms are small and bare, with mats, quilts and blankets piled in one corner. The rooms best protected in the house are the storerooms, with large daubed rice and grain bins gracefully sculpted and painted with geometric or floral designs. The Brahmins' houses are more spacious and are constructed of local brick. One enters through a small hallway into a big courtyard encompassed by a sheltered verandah. Off from the verandah strong, enforced doors give access to the bedrooms, storerooms, kitchen and private shrine. The rooms are furnished with simple bed, tables and chairs. The courtyard serves as an area for drying and sorting the produce gathered by the Brahmins' many tenants, as well as for recreation and for schooling the family. Behind the house is a walled barn and stable containing a small garden. The architecture shown in Fig. 222 from Udayagiri, Madhya Pradesh, is important as an example of the vast diversity of rural Indian architecture. The courtyard is on the left-front, just off the street, with a stable and women's separate sleeping quarters to the right. The main building is built on two floors, with storerooms on the top floor, reached by an exterior staircase; and all the roofs are surfaced with locally-made terracotta tiles.

Wall-painting is the earliest known form of Indian art. Recently research has disclosed prehistoric painting in rock shelters throughout central India, and the tradition continued until the nineteenth century. Although the cultures that produced these paintings are not documented, stylistically similar paintings may be found upon the walls of the houses of present day tribes such as the Saora, on the southern Orissa-Andhra Pradesh border, and the Warli in Maharashtra. These people use them as a religious form of medicine and to propitiate their gods. Hindu wall-paintings and floor designs, probably originating from the same tradition, are drawn in rural villages all over India. Usually made by women as ritual protection (*vrata*) for the home, they are called variously *rangoli*, *kolam*, *alpona*, or *chita*. While floor designs are created in every southern village, as well as in many areas of the Deccan and the Gangetic plain, wall-paintings are found in isolated pockets in Gujarat, Bihar, Bengal and Orissa. In Puri District, *chita* are made on the walls outside the main door, with a lime and rice powder base and commerical dyes added for colour. They are usually painted by the family's eldest daughter on Thursdays only during the harvest months of Margashira, Pusha and Magha (15 November until the end of January). Their purpose is both to entice the god to enter the house and as protection against evil spirits. Friezes and sculptures created for similar purposes are often seen below, and on either side of, the doors of classical temples throughout India. Figs. 220 and 221 portray Balikondalo *rangoli* made for the festival honouring Lakshmi during the rice harvest in early December. The painting in Fig. 220 represents two trees of life, each branch supporting a stylized lotus, symbol of Lakshmi, goddess of wealth and protector of property.

Fig. 221 is much more symbolically elaborate. Completely painted in white, which is often used for such work, it depicts a rectangular temple, which encloses two elephants worshipping a lotus (a local interpretation of the Gaja-Lakshmi found in classical art), with repeated symbols of the goddess above and on either side. In contrast, Fig. 223 from Bundi, Rajasthan, is an example of the prevalent style of wall-painting in Rajput families. Prepared under commission by a local male painter, it is intended to honour the owner's ancestors and provide a symbol of heroic strength as protection for his home.

Carved doors and doorways are another example of craftsmanship in Balikon-

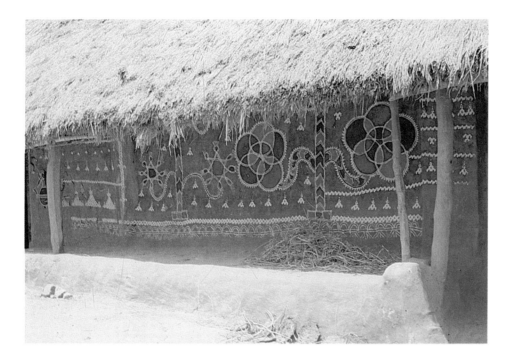

dalo. They are made on consignment by the carpenters, or *Moharona*, (from the village of Bedpur, only half a mile away) who build the framework for each house. The designs are purely decorative in tradition, though the craftsman may include religious symbols among the element he chooses. Fig. 224 illustrates a typical new example: a double door divided into four pairs of panels. The top pair depicts elephants, the second highly stylized peacocks, and the bottom two lotus in different stages of bloom. The fluidity of design and execution suggests a standard of craftsmanship that is no longer frequently patronized. As wood deteriorates rapidly in such a humid climate, this ancient tradition is most

Top left: Fig. 220 *Rangoli* of two trees of life, Balikondalo, Orissa

Bottom left: Fig. 221 *Rangoli* of a temple with two elephants worshipping a lotus (Gaja-Lakshmi), Balikondalo, Orissa

Top right: Fig. 222 Courtyard of a house in Udayagiri, Madhya Pradesh

Bottom right: Fig. 223 Wall painting of horseman, Bundi, Rajasthan

Fig. 224 Double door with carved panels made at Bedpur, Orissa, and *in situ* at Balikondalo, Orissa

Fig. 225 Carved door with bronze mounts, in Dariapur, Ahmadabad, Gujarat

obviously exemplified in more durable stone, as in nearby Konarak. I have chosen a doorway from Dariapur, near Ahmadabad, Gujarat, to portray a different style of door decoration (Fig. 225). The highly carved lintel, in pure Gujarati style, frames a *Ganesh*, the elephant god, who is placed in this position above many doors in Gujarat to bring prosperity to the home. Built in about 1800, the door is braced and studded with bronze, its beauty complementary to its strength.

Although many household articles are gradually being replaced by commercial and often synthetic substitutes, in Balikondalo most cooking and storing wares are still handmade. While all local pottery comes from Balikondalo, the nearby village of Balokhati produces traditional brassware: pots, bowls, containers, and utensils. Fig. 226 shows one of Balokhati's seventeen braziers holding a molten bar of brass, which his two sons hit alternately with wedge-shaped mallets, tediously flattening it in a process of reheating, pounding, and cooling. The brass plate is then cut, shaped, and welded to form a water pot identical to the one in the lower right hand corner of the illustration. The shape, size, substance, and decoration of water pots differ from village to village throughout India, comprising a fascinating variety to the traveller's eye. Yet almost no attempt has been made to document this rapidly disappearing craft. Fig. 227 is a photograph taken at the Raja Kelkar Museum in Poona, of a collection of another of the many types of Indian metal vessels: the *lota*, a small water pot used in religious rituals or for ablutions. Of the many examples of *lotas* found throughout India, the one on the bottom row, fourth from the right, is from Balokhati.

The baskets in Fig. 228 were made by *harijan* craftsmen in the village, the *Domo*. Basketry is a handicraft made locally in almost every village in India. Though perhaps not remarkable, it is still an important part of traditional culture, and its variations are worthy of notice. The basket to the left is made of coiled river rushes and has a metal hinge and clasp so that it might contain valuables. The square basket, of a plait weave, is used for storing herbs and spices. The *Domo* of Balindondalo, as well as making such small household baskets and fishing baskets, weave huge baskets of split bamboo that form containers on large bullock carts used to gather crops. Although in some other parts of India basketry may be whimsical and brightly coloured, such as the dolls and toys made in Bihar, it is purely functional and woven in natural colours in Orissa.

Historically textiles have always been of paramount importance in the Indian economy. In most of India today, machine-woven cottons, silks, and synthetics are rapidly replacing the village handloom industry. Even where government sponsorship and foreign demand has encouraged the weaving and decoration of homespun fibres by traditional means, the requirements of speedy production have reduced the quality of craftsmanship. Although there are no longer weavers in Balikondalo and its neighbouring villages, as there would have been fifty years ago, hand-woven cloth is still predominantly worn by the village women. Unlike those in most other states, Orissan handlooms have improved in quality and design during this century. Saris, yardage, and household items of outstanding quality in silk and cotton are readily available at affordable prices in all villages and give stiff competition to the machine textile industry. Fig. 229 illustrates four such cotton saris worn by the village women of Balikondalo. The two saris on the left were both woven in Nuapatna, in adjacent Cuttack District, while the third one is from Barpali, and the fourth one from Bolangir. The design

on these textiles is produced by a difficult technique called *ikat*, which involves tie-dyeing the weft threads in the desired colours and spacings prior to weaving so that when woven the result is an intricate, wavy pattern. Most often the field of the sari is plain with an elaborate *ikat* border. Traditionally Orissa has not been known for its heavy brocades or embroideries, as have many other areas of India; however, mention should be made of the cotton appliqués, or *chandua*, produced by the *Darwazi*, or tailor caste, of Pipli, twenty-four miles from Balikondalo. Sewn mostly now by machine, these colourfully decorated canopies and umbrellas are used in religious and social festivals throughout India and recently have a large foreign market. In Balikondalo *chanduas* provide shelter both for weddings and for the gods' palanquin during festive processions.

Whereas western lifestyles in the past two centuries have grown increasingly secular, most aspects of life in an Indian village are still regulated by religious ritual. As part of their daily *puja*, or worship, Vaishnavite Hindus must chew the

Left: Fig. 226 Brazier shaping a molten bar of brass into a pot, in Balokhati, Orissa

Top right: Fig. 227 Different types of *lota*, brass water vessels. Poona, Raja Kelkar Museum

Bottom right: Fig. 228 Two baskets made in Balikondalo, Orissa

leaves of the sacred tulsi plant (an Indian basil). In most parts of India, this herb is planted beside the house, often in a quite ordinary pot. But since the bush is holy in some areas artistic traditions have developed for adorning its container. The *Mudli Kumbhars* of Balikondalo have excelled in this craft (see Fig. 230). Their normal occupation is to throw the water pots, cooking vessels, oil lamps, and well linings required by Balikondalo and the surrounding villages. Each tier or section of the tulsi vessel shown was also begun on the foot-propelled potters' wheel. While still damp, its elaborate architectural and figural decorations were formed and added by hand. The result is a superb rural interpretation of a classical Orissan temple, with the donor couple depicted at the base, an ancestor on horseback in the centre, and addorsed leonine forms on the upper ledge flanking the Mandiracharuni, the gods that guard the four directions. While functional pottery is thrown all year round, figural pottery such as this is made and fired only during the monsoon months, so that the humidity will protect it from cracking. Fig. 231 portrays another clay tulsi pot, which, resting on a burnished mud and clay base, is itself shaped like a village woman. It conforms to an almost archetypal image, found in dolls and bronzes throughout India, and was made by the *Kumbhars* of Bipoda, a very remote Kutiya Khond tribal village in Phulbani District, Orissa.

Also made by the Balikondalo *Mudli Kumbhars* are the terracotta horses in the Saivite temple on the edge of the village (Fig. 232). In another ancient ritual of probably pre-Aryan origins, terracotta figurines, usually horses, are similarly placed under trees in rural villages in many districts of South Asia. In Balikondalo, as elsewhere, the spirit of the gods of crop fertility and personal health, Gomidevata, are believed to rest in the trees. The votive horses, or *thakuranis*, are provided as vehicles for these gods, so that they might ride at night to protect the fields and visit the infirm. While in other parts of India the quality of these clay horses is often quite refined, those made in Balikondalo are crude, modelled entirely by hand, with little effort applied to their design. The shrine itself is typical of all rural Indian villages. A square, arched shelter of white-washed stucco, it houses several sacred stones and well-worn images.

Above: Fig. 229 Cotton ikat saris woven in Nuapatna, Barpali and Bolangir, Orissa

Below left: Fig. 230 Clay vessel for the sacred Tulsi plant, Balikondalo, Orissa

Below centre: Fig. 231 Clay tulsi pot made by the Kumbhars of Bipoda, Orissa

Below right: Fig. 232 Votive terracotta horses, Balikondalo, Orissa

The male village Brahmins are the *pujaris*, or caretakers, of its stone carvings of Ganesa (left), Pandabasuni, Siva (centre) and Nandi (right). They receive daily offerings of food, flowers, and oil in worship, or *puja*, rubbing the images and stones with the oil, daubing them with holy red and adorning them with flowers, continuing a ritual performed identically by their ancestors for count-less generations. The stone lion, *narasimha*, a favourite guardian at the front of Orissan shrines, is clearly reminiscent of the lions of Konarak.

Every Hindu home in India has its sacred spot for worshipping the gods. In a wealthy house, this may be an elaborate shrine equipped with finely-made inherited sculptures and paintings of the family's gods. A very poor family may have simply an amulet and an oil lamp to aid in its daily *puja*. Fig. 233 is a photograph of the private images of one of the two wealthiest Brahmin families in Balikondalo. They are under the strict preserve of the family matriarch, who officiates their *puja* and acts as liaison between them and the family and villagers. It is a Vaishnavite shrine, dedicated to Krishna as Gopalji, and all the images and accroutrements are associated with his worship. On the left is Krishna as Venogopala, playing the flute, next is Gopalji, and the two to the right are Navanita-Krishna, in his dancing pose. In the front-centre is a *charmukta* (four headed) linga flanked by four *salagramas*, black fossil ammonites worshipped as symbols of Vishnu. The images are clothed, as are those in most shrines of rural India, and adorned with hibiscus blossoms. All four bronze images were probably cast in Puri in the eighteenth century. The dais on which they stand is another example of woodwork made by the local *Moharonas*. Once a year, in March, it is placed in a beautifully carved and canopied palanquin and carried on the villagers' shoulders on a visit through the neighbouring com-munities as a celebration of spring. In contrast, each of the four tiny figures in Fig. 234 is a representation of Parvati, wife of Siva and the goddess of the home. Each is from a different potter's household in Balikondalo, made to be worshipped both in the home and while travelling. The two of bone have been carved by family forebears. The two of bronze were probably made by an earlier Balokhati brazier in lost wax (cire perdue). Although rural sculptures are often regarded as crude and unsophisticated, they frequently exhibit a charm and sensitivity lacking in more refined pieces. For example, the jewellery on the smallest Parvati has been painstakingly added with tiny pieces of silver wire.

No list of Indian folk arts can be adequate because of the inconceivable vastness of the subject. In this brief portrait I have attempted to describe the condition and relevance of Balikondalo's crafts to the villager as well as implying their tremendous diversity throughout the subcontinent. Each craft results from the combination of local and outside traditions. The design of a contemporary tulsi pot is adapted from a twelfth-century temple, whose own design was a blending of indigenous and imported architectural styles, executed by craftsmen coming from local rural villages like Balikondalo. Stemming from ancient traditions, Indian crafts have always played an integral part in the larger sphere of Indian art, influencing classical styles and worldwide commerce, and, in turn, reflecting that which they influenced.

Fig. 233 Brahmin household Vaishnavite images, Balikondalo, Orissa

Fig. 234 Two bronze and two bone images of Parvati (goddess of the home), Balikondalo, Orissa

Modern Painting since 1935

Fig. 235 *Hill women* by Amrita Sher-Gil (1913–41), oil on canvas. 1935. New Delhi, collection of Vivan Sundaram

Modern Indian art is an outgrowth of European colonization and by the same circumstance it is hybrid, split at the root. Its history, at one level, is a tracing of how colonial consciousness authenticates itself, converting social antinomies into a dialectic. At the stylistic level also it acquires real significance in this perspective.

Personal and cultural identities are always reciprocally determined; for a subject people they must be seen to hinge together in a fateful sense. In India the need for a national identity arose even as the intelligentsia assimilated the modern concept of a unique individuality. In the pioneering figures of modern India, cultural traditions of a precolonial past and an emergent nationalism coalesce to inform the very quest for selfhood.

Such a quest may be unevenly sustained. It is certainly problematic. The alternatives to this ambivalent formation of a modern Indian identity come from two quite divergent sources: from the tradition and its powers of mystical fusion, which Coomaraswamy sought to reawaken, or from a revolutionary integration in a future egalitarian society. Although they do not state it in these terms, most contemporary Indian artists stand poised between these ideological options. We should consider the recurrent, somewhat dogged theme of *Indianness* in this context.

The Mexican mural movement of the 1920s proves what can be achieved by artists with a vision that matches the nationalist ideology. Perhaps only a revolutionary breakthrough can succeed in invigorating dormant creative energies in this way. Not much can be said on behalf of the actual art produced in India in response to the nationalist movement. However, by the middle of the 1930s, a few artists were able to shake loose the moribund academicism of the Anglo-Indian art schools and the chauvinism of the Bengal revivalists. These artists attempted a 'synoptic' self-image for India.

Amrita Sher-Gil (1913–41), half-Hungarian and trained in Paris, identified herself in a Gauguinesque spirit with the poor in India: the peasants became her veritable ancestor gods. Her romantic tangle with India, in which the Indian peasant might easily have become the martyr, was resolved with remarkable intelligence (Fig. 235). Indeed, she foresaw those numerous dilemmas of sentiment and style that Indian artists would experience for the next three decades. Avid for colour, she understood how traditional Indian painting

counterposes the sensuous and decorative uses of colour. At the same time she shed her academic competence in favour of an economical, stylized delineation; and was beginning to use the narrative format of Rajput miniatures to portray the cloistered reverie of the women in *zemindar* households. She died before she was thirty.

The relationship of Binode Behari Mukherjee (1904–80) to India is more pragmatic than Sher-Gil's, and also in many ways more comprehending. His profoundly democratic view of the Indian tradition is expressed in a mural at Santiniketan that narrates the story of the medieval saint poets of India (Fig. 236).The saints are submerged in a tumult of numerous workaday lives of the people. In turn these holy vagrants, metaphors for the liberated soul, transform by their presence the humblest vocation into a pilgrimage. Giving form to the value of *flux* and *freedom* in the framework of Indian metaphysics, Mukherjee also puts the traditions of art to contemporary use. Individual characterizations derive from modes of representation in Mughal miniatures; the surging compositions of figures moving in and out of the open maze of architectural props resemble the ancient stone-reliefs at Sanchi. In several ways the mural presents a great procession: it establishes a vast continuity by deriving from tradition a narrative that has contemporary historical value.

Through the next three decades, Maqbool Fida Husain (b. 1915), a favourite on the Indian art scene, puts his eclectic imagination more directly in the service of a new India – 'Nehru's India' and makes the villager a mascot figure in the moment of social change. Leaving aside what may seem the bad faith of the liberal vanguard towards the peasant, it must be recognized that the festal optimism with which Husain treats him has something to do with that brave spirit by which the villager survives – for his folklore, his gods and his ritual celebrations all aid him in the business of survival (Fig. 237). Stylistically,

Fig. 236 Detail of *The medieval hindi saints* by Binode Behari Mukherjee (1904–80), fresco. 1946–7. Santiniketan, Hindibhavana

Husain's sources are many and varied. He can make the seemingly cavalier combination of Expressionism and Indian classical sculpture work. In the same way, with an enviable boldness he has been able to create a *type* of the Indian villager that no subsequent artist can ignore.

Against this background of Indian images we shall place the more introvert artists. There are conventions of perceiving the inner world; an individual makes the psychic journey with the aid of available cultural 'models'. The Indian intelligentsia adopted the Romantic model quite early in its encounters with Western literature. The model has persisted insofar as *modern* art has its roots in the Romantic movement.

For over a century modernization in India has proceeded in a fitful and haphazard manner. As feudal culture disintegrates an undeveloped version of bourgeois culture comes to replace it. Going through the ultimate straits of alienation the working class can, in its historical role, revolutionize the process. The middle-class intelligentsia – artists among them – have, on the other hand, access to certain well developed modes of interpreting a world that is becoming remote at every step. An affiliation with Romanticism has provided the modern Indian artist with a framework to comprehend his alienating circumstance and to acquire the identity of a rebel. This self-image is reinforced by the existentialist critique of bourgeois values that underlies modernist art and literature. Were we to judge the best modern artists in India simply by their work we should be impressed by their understanding of the contemporary world and their need to seize hold of its anguish.

Rabindranath Tagore (1861–1941) turned to painting in his old age, and the doodles and smudges with which he began, the rich rough chiaroscuro of inky lines, took on figural shapes that appeared in time to be the residue of an exalted life viewed as if from beyond the grave. There is some resemblance with the Symbolists in Tagore's naive clairvoyance as an artist, and it is logical that his work prefigures the sombre portraits of the succeeding generation of Indian artists. This generation linked itself quite consciously with Expressionism.

With the first exhibition of the Bombay Progressive Artists' Group in 1948 Francis Newton Souza (b. 1924) launched Indian art in virtually one stroke into its modernist phase. Charging the scene with the spirit of rebellion – with the Devil, and Picasso, as principle protagonists – Souza turned his personal sense of outrage into an act of creation. The result is a repertoire of villainous characters superbly delineated, in a line that is tough and bristling like a beast's contour, the better for us to recognize the human world for what it is. But alongside his menacing portraits – priest, tycoon and whore – there are the equally compelling paintings by Akbar Padamsee (b. 1929) of the prophet (Fig. 238) and the beloved. And though the two artists share the expressionist framework their aesthetics differ greatly. Padamsee condenses the figure into a bed of paint, transfixing it in the irradiating glow of deep-set hues, and the visual mode has a corresponding spiritual effect: illumined as if in self-knowledge, the figure abides in solitude with awsome poise.

Tyeb Mehta (b. 1925) completes the existential triangle by adding anxiety to the diabolic imagination of Souza and Padamsee's aspiration to grace. The dark brushstrokes massed to form the figures in Mehta's earlier paintings are slowly cleared, and the palette is brought to a bold brilliant pitch. At the same time the body begins to split as though by a cleaving axe and the dismembered image is

Fig. 239 *Diagonal IV* by Tyeb Mehta (b. 1925), oil on canvas. 1973. Bombay, Gallery Chemould

worked towards a classical equilibrium. Wedged into a geometrical colour-schema the figures, tumbling headlong and embodying an eternal scream, no longer portray actual violence. They become formalized icons of terror (Fig. 239).

The decision to depict social violence was taken by a few artists of this same generation – Satish Gujral (b. 1925) and Ram Kumar (b. 1924) in particular. After his stay in Mexico during the 1950s, Gujral's fiery, Orozco-inspired paintings depict the agony of political refugees; Ram Kumar, adapting the expressionist mode to his socialist beliefs, portrays the fear in the lot of the urban worker. At this time there are feelings of protest in both painters, indications of struggle in the protagonists of their pictures. The ideological implications are, however, subsumed within that broad modernist framework where political partisanship is charged with a personal rage, and even as its social causes are condemned *suffering* is exalted.

But the expression of suffering seems to follow a different course with the Indian artist. His obvious attraction to romanticism is probably related to the narcissistic self-involvement that characterizes the Indian psyche. However, major differences arise in this comparison with the romantics. In the Hindu ideal of *moksha*, all the reinforcements of the ego carefully put together since childhood, especially the elaborate system of differentiation between the I and the Other, are meant to be undone. The threatening nature of the Other

Opposite top: Fig. 237 *Between the spider and the lamp* by M.F. Husain (b. 1915), oil on board. 1956. Bombay, collection of the artist

Opposite bottom: Fig. 238 *Prophet III* by Akbar Padamsee (b. 1928), oil on board. 1955. Bombay, collection of the artist

dissolves through the aim of unitary consciousness. Precisely for that reason, confrontation – which the Western romantic precipitates in the figure of the rebel – is prevented. In India it is the liberated individual more than the liberator who occupies the pride of place. If our foremost modernist painters – with the exception of Souza – tend to deflect the typically romantic quest, to chasten the expressionist language, and to avoid confrontation, it is very probably from some deep-set cultural predisposition.

By the time they were about forty years old, many painters of the 'Progressive' generation who had been inclined towards Expressionism purged their pictures of the subjective tension that usually accompanies the figure. Padamsee and Ram Kumar, for example, and their colleagues, Raza and Gaitonde, had confirmed their tendency towards a nature-based abstraction by about 1960.

Besides the Abstract Expressionist conventions brought home by these artists, an informal abstraction resembling Taschisme, and in the rare instance a pristine geometry, has been explored by Indian artists. In the best among them, Mohan Samant, Arpita Singh and Nasreen Mohamedi, for example, abstraction has led to an acute feeling for the medium and an admirable flexibility and control of the image.

Even the less remarkable artists on the Indian scene have learnt to paint abstract pictures with a surface finish and a professional look. At the same time, however, something resembling an art for art's sake ideology has come into existence. And though the notion of aesthetic autonomy is as old as that of commitment, the former position is frequently hailed as a kind of emanicipation for Indian art. In part this is the belated influence of cold war propaganda where 'cultural freedom' comes to be equated with the international avant-garde of abstract art.

If we consider that the social circumstances, however these are mediated, are never neutral and then consider the disarray in the cultural front of the Indian Left and the hard facts of the economy – within a decade of Independence, capitalist development unaccompanied by structural changes had resulted in the flow of the increased surplus into luxury consumption, baring deep-set contradictions and with that political cynicism – it should not surprise us that by about 1960 figurative art with a *pronounced content* appeared somewhat stranded.

What emerged now was a new phase in the quest for national identity. More than a mere polemic between two generations this development in the 1960s should be seen with reference to a spate of national liberation movements all over the world and the emergence of a 'native' consciousness: the concept of negritude was revived by Frantz Fanon in Algeria; Cuba and Vietnam brought revolutionary substance to the post-colonial consciousness. The political situation in India was not militant but the ideological spin-off from liberation politics was probably felt. Indeed, this sentiment probably served to deflect attention from the serious problems at home. At any rate, India's pride of place in the Third World nations – Nehru's achievement – was not jeopardized until much later. And, coincidentally, Nehru it was who inaugurated in 1963 the exhibition of a new group of artists: the Group 1890. The preface for their catalogue was written by Mexico's ambassador to India, Octavio Paz, famous Surrealist poet and ideologue for the intelligentsia of the Third World. The leader of the Group and the author of their manifesto was an erstwhile communist turned painter. Individual members of this Group were not more radical than their predeces-

sors. But the historical situation offered the possibility, and the need, for enlarging the horizons of Indian art from anti-imperialist perspectives. The concepts of progress, internationalism and the avant-garde, all of which together constitute the substance of modernism, came to be revaluated.

The Group 1890 brought to the forefront a generation of new artists, among them Swaminathan, Jeram Patel, Gulam Sheikh, Himmat Shah whom we shall presently consider. These artists probably shared only one basic assumption: the importance of the unconscious, and therefore of spontaneity and improvisation, in art. The surrealist principle thus came to occupy a central place, but it was Paul Klee's playful version of Surrealism that was preferred because it led them to their native art.

At the ideological level it is by no means accidental that the turn toward indigenous sources and the adoption of the surrealist principle should have coincided. There is a strange agreement of *attitudes* between the Indian tradition and Surrealism on the role of the unconscious. Traditional Indian culture encourages the individual to enter the flux that flows across from the sources of the archaic self, through mythical and magical worlds, to the cosmic unknown. Thus in Hindu metaphysics intuition and empathy are accorded a superior place to the processes of reason. The potential *yogin* must distil and transform the passions, but not through repressive self-control. He is guided into elaborate and subtle forms of sublimation by means of which he and the community contain the seeming entropy of the unconscious. The predilections of the Indian artists concerned with the surrealist principle conform quite remarkably to the psychic modalities that are revealed from an examination of the tradition. This is apparent from the interest of the artists in the occult; in a conspicuous eroticism; and in versions of nature mysticism.

Satisfying occultist propensities by offering an imagery at once surreal and abstract, Tantrism has proved especially alluring to contemporary Indian artists. However, while it claimed a large number of adherents, by the early 1970s neo-Tantrism displayed the typical traits of an occultist revival: an indiscriminate array of esoteric motifs and sexual grotesqueries.

For the original Tantric artist his area of coloured ground and the spatial disposition of the symbols is as important as their coded meaning since meditation is invited on the basis of these vivid and ingenious configurations. Contemporary artists with a good formal grasp have managed to use Tantra to some advantage, for example K.C.S. Paniker (1911–77) who derives from it a visual short-hand with quasi-spiritual implications of the kind found in astronomical charts and horoscopes, scribbled over with script and signs (Fig. 240). His many followers in Madras, however, convert this mostly into a decorative practice. The more interesting are the younger artists like Barwe and Manjeet Bawa, who take from Tantra the enchanted element and feed it into the broader stream of fantasy; and then channel that, like the Calcutta painter Ganesh Pyne, into dream narration. But then they are not neo-Tantrics.

There is usually an exchange of symbols between the occult and the erotic in any given cultural system. Tantrism is the prime source of a great amount of phallic imagery in Indian art to which a number of contemporary artists are conspicuously attached. Strictly speaking, the *linga* mythology does not express the erotic impulse – a generative and life-affirming impulse. The *linga* symbol is at the same time chaste and fertile; it is a form of the self-centred libido; and it helps to confer psychic invulnerability and self-esteem. It would not be wrong to

Fig. 240 *Words and symbols* by K.C.S.
Paniker (1911–77), oil on canvas. 1968.
Madras, collection of Mrs Paniker

Fig. 241 'Untitled' by Jeram Patel (b.
1930), ink on paper. 1974. Baroda,
collection of the artist

assume that the phallic image serves a similar psycho-social function for the
contemporary artists. Compare any of the artists who use this image with Souza
– and many of them owe a debt of language to him – and the difference is
obvious. Souza's Christian upbringing and Western domicile make him see the
erotic in the context of sin. Jeram Patel (b. 1930), developing a method that
resembles automatic writing into a masterly skill expresses terror and the
paranoid fear of dismemberment (Fig. 241); but the phallic imagery drawn out in
the raw or dug out by a blow-torch from layers of wood has nothing whatever to
do with love or morality; nothing to do even with the Other. It is concerned with
the self, and a reinforcement of the ego.

In this respect Laxma Goud (b. 1940) presents, within a period of ten years, an
artistic integration of a most remarkable kind. An orgiastic profusion of phallic
images have been transformed to become, in the most tender sense, human (Fig.
242). With a classic reticence he etches figures endowed with a true erotic
impulse, lovers in whose reciprocity he has defined his own mature identity. It
is an ancient but vulnerable identity, for the lovers in the primordial woods are
the shepherds from his province, and their presence is confirmed by the Indian

Fig. 242 'Untitled' by K. Laxma Goud (b. 1940), etching. 1976. Hyderabad, collection of the artist

pictorial tradition where the continuing theme *is* love in the ambient glory of nature.

For Indian artists seeking modes of transaction between man and nature Indian miniatures offer the most splendid array of metaphors and a range of pictorial structures that express the bond between Indian life and landscape. For nature in Indian painting is not remotely majestic, as it is often in European or even Chinese painting; it is expressly sympathetic to human feeling: nature often serves as a composite metaphor for human emotion, especially the erotic emotion. Landscapes in the miniatures, are, moreover, in the best sense ornamental – for to perceive the earth as so richly adorned is to give praise to God.

There have been contemporary adaptations of their pictorial structure and particularly in the use of colour, but few artists have used the miniatures as directly as Gulam Mohammed Sheikh (b. 1937). He has used them specifically to structure personal memory; to give it the quality of a story recounted through symbols (Fig. 243). Portraits of great spreading trees as one finds in Mughal miniatures stand there for all the world like fabled creatures, and the angels

Fig. 243 *Return home after a long absence* by
Gulam Mohammed Sheikh (b. 1937), oil
on canvas. 1974. New Delhi, collection of
Ram and Bharati Sharma

hover above the cloistered courtyard of his childhood village. The correspond-
ences between Sheikh and Laxma Goud are evident.

J. Swaminathan (b. 1928), comes by a somewhat different route – from a
primitivist and quasi-Tantric 'formalism' to a set of images that conform
outwardly to the ingredients of landscape but in spirit approximate what we
may call nature mysticism. Along this route the *numen* is as it were unloosed
from specific icons and replaced in the heart of nature causing the landscape to
shine forth. The colour-field has a quality of immanence and the tree, bird and
mountain floating in the illumined space appear more like metaphors of an
inspired reverie (Fig. 245). In the rare picture Swaminathan succeeds in
endowing phenomena with a quality of resplendence that elicits wonder and
thus *praise*.

We arrive now at the point that leads beyond the occult and the erotic to
feeling states more nearly like spiritual rapture, arising from a participative
delight in nature. What is interesting is that a number of artists from the

preceding generation are led along the track of European abstraction to somewhat similar positions. Thus Raza and Gaitonde and Ram Kumar, in using the available devices of colour-saturation, seek to achieve a kind of *aura* in their landscape-based abstractions; and in the transformation of Akbar Padamsee's landscapes to the 'metascapes' he paints today there is an intelligible continuity of intention that covers the ground between romanticism and nature mysticism.

All this has ideological implications. Can the mystical outlook lead to a visionary art today? It will be recalled that the original Tantric option is subversive, and that the poet mystics of medieval times were radicals in a hierarchical society. The Indian tradition offers modes of dissent that span, by startling acts of imagination, the metaphysical and the social spheres. Contemporary artists attached to their spiritual heritage have a choice beyond spurious occultism, beyond nostalgia and acquiescence, to an art that seeks transcendence *via* individual experience, that accepts no short-cuts in the arduous passage to that unique vision which illuminates *as it unsettles* the given world.

Underlying these various options for an indigenous art there is an experimentation with language, often simply with visual 'speech', and the peculiar anonymous *écriture* of primitive and village arts. Primitivism implies a reactivization of a creative principle lost to sophisticated civilizations; it also means that aesthetic and consequently social values are reconsidered. The question of *language* becomes a question of ideology and ultimately of identity itself.

As far back as the 1930s, Jamini Roy (1887–1972) had introduced into Indian art the desire, and the possibility, to 'return' to an archaic innocence through folk art. In the 1960s, artists shoring up the archaic residue of the unconscious – *via* Klee and Miró – begin connecting it once again to the ritual art of the Indian villager. The actual resemblance with folk forms varies. Madhavi Parekh (b. 1942) is the only artist who falls in direct line with the folk art of her native Gujarat, particularly in the way she uses the decorative principle to compose the picture, giving the picture-space a dense surface vivacity (Fig. 246). Himmat Shah (b. 1933) has gone on to actually work the surfaces in the way little shrines are made in homes and on the wayside to lodge the local deities (Fig. 244). If the geometrical convergence of the tinsel knobs over the silvery surface is meant to catch the gleam from an invisible icon it is a make-do arrangement such as a village craftsman will make, lovingly enough but without undue fastidiousness since the holy is always at hand and requires no very solemn environment to manifest itself.

Fig. 244 'Untitled' by Himmat Shah (b. 1930), plaster, silver paper and aluminium on board. 1973. New Delhi, collection of the artist

In contrast to artists wanting to restore the magical qualities of form by way of folk art, K.G. Subramanyan (b. 1924) is interested in the functional integrity of folk art – he places its ingenious methods as much at the service of the content as of the form of his work. Kneading, smoothing, folding the clay like an archetypal potter he makes terracotta reliefs that use a pantomime manner of telling stories, which are sad, satirical, and gory. His glass paintings confirm his affiliation with *pata* paintings of eastern India, especially in their later version at Kalighat. Like them, Subramanyan has devised a set of bold, swift, alluring conventions to serve his repertoire of flamboyant women (Fig. 247). But in his brilliant game of pun and parody with popular art forms, he also brings home the Matisse tradition of extending in a playful act the vocabulary of pictorial signs – decorative and semantic – to make art a viable and living *language*. And this is perhaps the most urgent need in Indian art today.

Above: Fig. 245 *Gati sangati* by J. Swaminathan (b. 1928), oil on canvas. 1974. New Delhi, collection of Mr and Mrs Dev Raj Wadera

Fig. 246 *Sea opera* by Madhavi Parekh (b. 1942), oil on canvas. 1975. New Delhi, collection of Roberto Luiz Assumpcao de Araujo

Fig. 247 *Sundari* by K.G. Subramanyan (b. 1924), watercolour and oil on glass, backed with gold paper. 1980. New Delhi, collection of Vivan Sundaram

There are other, younger, artists who select the popular conventions of figural representation, cutting down the spiritual stance about the tradition. There is Jogen Chowdhury (b. 1939), who takes on the stereotype, like Subramanyan, from his native Bengal – the respectable *babu* and the sweet-faced seductress, frequent figures in the Kalighat pictures (Fig. 248). And he turns their profane humour, usually an admonishment against vice, into a more ambiguous irony bordering on a predilection for disease, which characterizes so much modern art. A minutely worked texture in ink and crayon gives to the figures a festering body, and the series of portraits, sentimental and funny and provocative, convey the secret processes of social corruption.

But no one has made a virtue of our hybrid culture more than Bhupen Khakhar (b. 1934). Taking the popular calendar pictures, going back from these to Company School paintings, and further back to those odd, *genre*-type miniature paintings from different schools, Khakhar is decidedly on the side of the vulgar against the elite; and on the side of the inbetween man: defunct householder, lumpen hero, old sinner (Fig. 252). He lavishes much care and a superb colour sensitivity in painting the bizarre splendour of our provincial towns, in the heart of which the protagonist is enshrined, like a deity in the holy city, or a humble saint surrounded by vignettes of his life-story. Khakhar's imagination has all the necessary cunning to fit together pun after pun from art

Fig. 248 *Nati Binodini* by Jogen Chowdhury (b. 1939), ink and pastel on paper. 1975. New Delhi, collection of the artist

history; and he has enough social insight to speak the truth no other artist has spoken about urban India.

There have been relatively few Indian painters whose work reflects a conscious political position but several painters since Sher-Gil and Binode Behari Mukherjee are conscious enough, and convey something of the quality of *social existence* in India. A younger generation of figurative artists, prominent since the mid 1970s, is now beginning to tie up the loose ends of the radical impulses scattered along the preceding decades.

With his series of paintings describing social predators and their victims, Krishen Khanna (b. 1925) links his own generation of artists – Ram Kumar, for instance – with the new figurative art of the 1970s. But while he expresses himself in plain visual prose, the moral framework of good and evil, and the emotional modalities of pity place him nearer his expressionist contemporaries. Younger painters, in contrast, try to avoid both the reification *and* the romanticization of the human figure, and approximate generally to the long realist tradition.

Take Gieve Patel (b. 1940) for example. If he paints the red-turbaned worker who belongs to the field, the barren hills, and the tin shed in the wilderness, which is a notational evidence of 'civilization', the spatial intervals in the picture itself must convey the measure of that belonging. With Patel objectivity is the first proof of respect for the other (Fig. 249). Vivan Sundaram (b. 1943), on the other hand, makes an intervention in the life-scenarios of people but from a political position and with something of a voluntarist urgency (Fig. 250). Spatial dislocations precipitate the contradictions depicted, and the colour surfaces, worked to dazzling effect, force back the viewer's gaze in order that he read the message. The means are unorthodox, full of visual surprise; the image is didactic.

Beginning as an expressionist, Nalini Malani (b. 1946) has trained herself into objectivity insofar as it allows her to perceive the pattern of destinies at work with her protagonists. She sees the urban Indian woman through various stages of self-awareness, weaving a dense psychic web to sustain her precarious identity. Now she is moving into more complex narration where the choices

Fig. 249 *Figure in a landscape* by Gieve Patel (b. 1940), oil on canvas. 1976. New Delhi, National Gallery of Modern Art

plotted within the middle-class family may be seen as a paradigm for the degree of self-determination achieved within a larger social order (Fig. 251). Malani favours modes of representation that allow intensive distortion but minimum stylistic idiosyncrasies. This is also true of Sudhir Patwardhan (b. 1949). But while his recent paintings have the even precision of certain new realist paintings, he is more direct in the expression of sympathies than Malani. This paradox makes sense when we take into account Patwardhan's political position and his choice of protagonist. The working-class man can be painted in all conviction of his physical presence since he is able to sustain the hardness of social fact, even as he reveals unabashed his faith, or *will*.

There is, here, a cohesive group of figurative artists and a decidedly *social* art

Fig. 250 *Guddo* by Vivan Sundaram (b. 1943), oil on canvas. 1980. New Delhi, collection of the artist

Fig. 251 *His life II* by Nalini Malani (b. 1946), oil on canvas. 1980. Bombay, Pundole Art Gallery

Fig. 252 *Death in the family* by Bhupen Khakhar (b. 1934), oil on canvas. 1978. London, Victoria and Albert Museum, I.S. 45–1979

with a new attitude of objectivity. But what could be the meaning of objectivity in the Indian context? Not to violate the subject that is already dispossessed with pity or satire; to keep the chords of sympathy between the self and the subject intact in such a way that one does not, out of guilt, assume the responsibility of the other person while yet opting for solidarity. Perhaps we should call this an objective partisanship.

It is, then, towards a position of moral and political conviction that such objectivity must work. But it should not have to adopt some preconceived notion of Realism. Objectivity here refers as much to a regard for the historical facts as an imaginative summation of situations, lives, persons. Any structural innovation is expressly useful if the attempt is to render reality in such a form that human beings may master it: a social art is significant if it confirms the possibility of *praxis*.

Bibliography

General Books

Ashton, Sir Leigh (ed.), The Art of India and Pakistan, London, 1953.

Barrett, D.E., and Gray, Basil, Indian Painting, Geneva, 1963; London, 1978.

Basham, A.L., The Wonder that was India, London, 1974.

Coomaraswamy, A.K., The Dance of Siva, New York, 1918.

————, The History of Indian and Indonesian Art, New York, 1927; reprint 1965.

————, Yakshas, 2 vols., Washington, 1928–31; 1 vol. New Delhi, 1971.

Daniélou, A., Le Temple Hindou, Paris, 1977.

Kramrisch, S., The Art of India, London, 1954.

————, The Hindu Temple, Calcutta, 1946.

Rowland, B., The Art and Architecture of India: Buddhist, Hindu, Jain; London 1956; revised edition 1967.

Saraswati, S.K., A Survey of Indian Sculpture, Calcutta, 1957.

Sivaramamurti, C., The Art of India, Paris, 1974; New York, 1977.

Zimmer, H., Myths and Symbols in Indian Art and Civilization, New York, 1946.

————, The Art of Indian Asia, 2 vols., New York, 1955.

Prehistory

Allchin, B. and R., The Birth of Indian Civilization, London, 1968.

Brooks, R. R. and Wakankar, V.S., Stone Age Painting in India, Yale, 1976.

Gordon, D.H., The Prehistoric Background of Indian Culture, Bombay, 1958.

Piggott, S., Prehistoric India, London, 1950.

Sankalia, H.D., Prehistory and Proto-history of India and Pakistan, New Delhi, 1974.

Wheeler, Sir Mortimer, The Indus Civilization, Cambridge, 1968.

Wall-painting

Dey, Mukul, My Pilgrimage to Ajanta, and Bagh, Oxford, 1950.

Rowland, B. and Coomaraswamy, A.K., The Wall Paintings of India, Central Asia and Ceylon, Boston, 1938.

Sivaramamurti, C., South Indian Painting, New Delhi, 1968.

Snellgrove, D.L., ed., Image of the Buddha, UNESCO, Paris and London, 1978.

Yazdani, G., Ajanta, 4 volumes, Oxford and London, 1931–1955.

The Sculpture and Architecture of Northern India

Bachhofer, L., Early Indian Sculpture, Paris, 1929.

Chandra, P., Stone Sculptures in Allahabad Museum, Varanasi, 1971.

Chandra, P., Studies in Indian Temple Architecture, 1973.

Foucher, A., L'art gréco-bouddhique du Gandhara, Paris, 2 vols., 1903–23.

Harle, J., Gupta Sculpture, Oxford, 1974.

Kak, R.S., Ancient Monuments of Kashmir, London, 1933.

Krishna Deva, Temples of North India, New Delhi, 1969.

Lee, S., Ancient Sculptures from India, Cleveland, 1973.

Marshall, Sir John and Foucher, A., 3 vols., The Monuments of Sanchi, Calcutta, 1940.

Pal, P., Bronzes of Kashmir, Graz, 1975.

Shah, U.P., Studies in Jaina Art, Benares, 1955.

The Sculpture and Architecture of Southern India

Barrett, D.E., Early Cola Bronzes, Bombay, 1965.

————, Early Cola Architecture and Sculpture, London, 1974.

Harle, J.C., Temple Gateways in South India, Oxford, 1963.

Lippe, A., Divine Images in Stone and Bronze, Met. Mus. Journal, New York, vol. 4, 1971.

————, Early Chalukya Icons, Artibus Asiae, vol. 34, 1973.

————, Some South Indian Icons, Artibus Asiae, vol. 37, 1975.

————, Indian Mediaeval Sculpture, Amsterdam, 1978.

Sivaramamurti, C., Royal Conquests and Cultural Migrations in South India and the Deccan, Calcutta, 1955.

————, South Indian Bronzes, New Delhi, 1963.

Soundara, Rajan, K.V., Early Temple Architecture in Karnataka and its Ramifications, Dharwar, 1969.

————, Indian Temple Styles, New Delhi, 1972.

————, Early Pandya, Muttaraiyar and Irukkuvel Architecture, Varanasi, 1975.

Srinivasan, K.R., Temples of South India, New Delhi, 1972.

————, Temples of Later Pallavas, Varanasi, 1967.

————, Cave Temples of the Pallavas, New Delhi, 1964.

Scrivnivaan, P.R., Bronzes of South India, Bull. of Madras Museum, 1963.

Western Himalayan Hindu Architecture and Sculpture

Harcourt, A.F.P., The Himalayan Districts of Kooloo, Spiti and Lahool, London, 1871.

Goetz, H., The Early Wooden Temples of Chamba, Kern Institute, Leiden, memoirs No. I, 1955.

Singh, M., Himalayan Art, UNESCO, Paris, 1968.

Jettmar, G., Die Holz-Tempel des Oberen Kulu Tales, Wiesbaden, 1974.

Chetwode, P., Temple Architecture in Kulu, JRAS, Oct. 1968.

————, Kulu, the end of the habitable World, London, 1972.

————, Drawings by John Nankivell; temples of the Western Himalaya, Architectural Review, Feb. 1973.

————, Traditional Hindu Architecture in the Western Himalaya, in Arts of Himachal, Simla, 1975.

The Architecture and Gardens of Islamic India

Brown, P., Indian Architecture; Islamic Period, Bombay, 1942.

Burton-Page, J., Indo-Islamic Architecture: a commentary on some false Assumptions, AARP, VI, London, 1974.

Crowe, S; and Haywood, S; The Gardens of Mughal India, London, 1972.

Flynn, V.J.A., and Rizvi, S.A.A., Fathpur Sikri, Bombay, 1975.

Jairazbhoy, R., An Outline of Islamic Architecture, Bombay, 1972.

Marshall, Sir John, The Monuments of Muslim India, in Cambridge History of India, III, Cambridge, 1928.

Nath, R., Some Aspects of Mughal Architecture, New Delhi, 1976.

Wheeler, Sir Mortimer, Five Thousand Years of Pakistan, London, 1950.

Tatsuro, Y., Takifusa, T. and Matsuo, A., Delhi; architectural remains of the Delhi Sultanate Period, (*in Japanese*), Tokyo, 3 vols., 1967.

Painting in Islamic India until the sixteenth century

Barrett, D.E., Painting of the Deccan, London, 1953.

Chandra, P., The Tuti-nama, Graz, 1976.

Glück, H., Die indischen Miniaturen aus Haemsa-Romanes, Vienna, 1925.

Khandalavala, K. and Chandra, M., New documents of Indian painting: a reappraisal, Bombay, 1969.

Pinder-Wilson, R., Paintings from the Muslim Courts of India, London, 1976.

Welch, S.C., Imperial Mughal Painting, New York, 1977.

Later Mughal Painting

Beach, M.C., The Grand Mogul: imperial painting in India, 1600–1660, Williamstown, 1978.

Binney, Edwin 3rd, Indian miniature painting from the collection of the Mughal and Deccani schools, Portland, 1973.

Brown, P., Indian Painting under the Mughals, Oxford, 1924.

Ettinghausen, R., Paintings of the Sultans and Emperors of India in American collections, New Delhi, 1961.

Gascoigne, B., The Great Moghuls, New York, 1971.

Jahangir, *The Tuzuk-i-Jahangiri*, translated by A. Rogers, edited by H. Beveridge, 2 vols., London, 1909–14.

Kühnel, E. and Goetz, H., Indian Book Painting from Jahangir's album in the State Library, Berlin, London, 1926.

Welch, S.C., The Art of Mughal India, New York, 1963.

Painting for the Rajput Courts

Aijazuddin, F.S., Pahari Paintings and Sikh portraits in the Lahore Museum, London, 1977.

Archer, W.G., Indian Miniatures, London, 1960.

————, Indian Paintings from the Punjab Hills, 2 vols., London, 1973.

————, Visions of courtly India, Washington, 1976.

Beach, M.C., Rajput Painting at Bundi and Kota, Ascona, 1974.

Binney, E. 3rd, and Archer, W.G., Rajput paintings from the collection of E. Binney, Portland, 1968.

Chandra, M., Jaina Miniature Paintings from Western India, Ahmadabad, 1949.

Chandra, P., Indian Miniature painting, Madison, 1971.

Coomaraswamy, A.K., Rajput Painting, 2 vols., London, 1916.

Ebeling, M., Ragamala Painting, Basel, 1973.

Khanadalavala, K., Pahari Miniature Painting, Bombay, 1958.

————, Chandra, M., and Chandra, P., Miniature Paintings from the Sri Motichand Khajanchi collection, New Delhi, 1960.

Pal, P., The classical tradition in Rajput painting, New York, 1978.

Randhawa, M.S., Kangra paintings on Love, New Delhi, 1962.

Skelton, R., Indian Miniatures, Venice, 1961.

Topsfield, A., Paintings from Rajasthan in the National Gallery of Victoria, Melbourne, 1980.

Welch, S.C., A Flower from every Meadow, New York, 1973.

———, Indian drawings and painted sketches, New York, 1976.

——— and Beach, M.C., Gods, Thrones and Peacocks, New York, 1965.

Decorative Arts of the Mughal Period

Choudhury, A.R., Bidriware; Salar Jang Museum, Hyderabad, 1961.

Digby, S., A Corpus of Mughal Glass, BSOAS, vol. 36, 1973.

———, A seventeenth century Indo-Portuguese writing cabinet, Bul. of the Prince of Wales Museum, Bombay, No. 8, 1962–4.

Irwin, J., Golkonda Cotton Paintings of the early Seventeenth century, *Lalit Kala*, No. 5, 1959.

———, The Origins of Chintz, London, 1970.

——— and Hall, M., Indian Painted and Printed Fabrics, 2 vols., Ahmadabad, 1971–3.

Pinder-Wilson, R., A Persian Jade Cup, BMQ, vol. 26, 1963.

———, A glass Huqqa bowl, BMQ, vol. 25, 1962.

Skelton, R., The relations between Chinese and Indian Jade carving tradition, the 14th to the 18th century, *PDF Colloquies* No. 3, 1972.

Folk Art in India Today

Ahuja, S., Indian Settlement Patterns and House Designs, AARP, vol. 15.

Anand, M.R., Treasures of everyday Art; Raja Dinker Kelkar Museum, Bombay, 1978.

Bussaberger, R.F. and Robins, B.D., The everyday Art of India, New York, 1968.

Elwin, V., The Tribal Art of Middle India, Oxford, 1951.

Fabri, C., History of the Art of Orissa, Bombay, 1974.

Fischer, E. and Shah, H., Rural Craftsmen and their Work, Ahmedabad, 1970.

Kramrisch, S., Unknown India: ritual art in tribe and village, Philadelphia, 1968.

Maury, C., Folk Origins of Indian Art, New York, 1969.

Mehta, R., The Handicrafts and Industrial Arts of India, Bombay, 1960.

Mookerji, A., Crafts Museum Catalogue, New Delhi, 1962.

Reeves, R., Cire perdue Casting in India, New Delhi, 1962.

Saraswati, B. and Behura, N.K., Pottery techniques in Peasant India, Calcutta, 1964.

Varma, K.M., The Indian Technique of Clay modelling, Santineketan, 1970.

Modern Painting since 1935

Archer, W.G., India and Modern Art, London, 1959.

Bartholomew, R.L., and Shiv S. Kapur., Husain, New York, 1971.

Coomaraswamy: Selected Papers. (2 vol.) Edited by Roger Lipsey, Bollingen Series LXXXIX, Princeton University Press, 1977.

Kakar, Sudhir, The Inner World: A Psycho-analytic Study of Childhood and Society in India, Oxford, 1978.

Kapur, Geeta, Contemporary Indian Artists, New Delhi, 1978.

Mullins, Edward, Souza, London, 1962.

Subramanyan, K.G., Moving Focus: Essays on Indian Art, New Delhi, 1978.

Sundaram, V., and Geeta Kapur, G.M. Sheikh and K.G. Subramanyan., Amrita Sher-Gil, Bombay, 1972.

Glossary

Amalaka: ribbed ring stone; component on top of northern sikhara, below finial.

apsaras: celestial nymph.

asvamedha: horse sacrifice; a ceremony performed by kings to ensure welfare.

Bhagavata Purana: the Puranas are the Hindu sacred books of mythology and epic. Among the most important is the *Bhagavata*, a chronicle of Vishnu the tenth section of which deals with the life of Krishna. There were many vernacular translations from the Sanskrit from the 14th century onwards.

bhutas: sprites or goblins.

bidri: a kind of alloyed brass metalwork made especially in Bidar.

Bodhisattva: a living being who has vowed to achieve *Bodhi* (enlightenment) but stays in the world to help other men.

chaitya: a Buddhist shrine.

chauri: a fly-whisk.

charbagh: literally 'four gardens'; the traditional lay-out of a palace garden.

chhatra: an umbrella, symbol of royalty.

chartaq: a dome bearing square building.

chintamani: a pattern common in Turkish art consisting of a triangular arrangement of three balls alternating with two wavy lines, which represent a stylised cloud pattern of Chinese origin, whence the name derives.

chintz: cotton cloth imported to Europe from India, originally painted, later dyed. Literally 'variegated' from Hindu *chint*.

durbar: imperial public audience.

devakoshtha: niche on the wall of a shrine.

Gana: the army of sprites and goblins.

garbagriha: the sanctum or cell of a temple where the image of the god stands.

Gita Govinda: Lyrical recitative on the life of Krishna by Jayadeva (13th century).

gopura: principal gateway to a temple complex.

griva: literally 'neck'; the clerestory below the sikhara of a temple.

hara: 'garland': a string of miniature shrines around a main shrine.

ivan (eywan): a tall open portico or vaulted hall open to a courtyard.

jama': Indian court dress with full skirt with waist sash, fastening on the left for Hindus, on the right for Muslims; of Rajput origin.

jami: the principal congregational mosque of a city.

jataka: 'birth story'; stories of the previous lives of Sakyamuni Buddha.

jharoka: balcony of a hall of audience at which the ruler showed himself.

Kalpasutras: the lives of the Jinas.

Laur-chanda: ballad composed by Maulana Da'ud in about 1370.

linga: the phallic representation of Siva.

Lotus sutra (Saddharma Pundarika sutra): Lotus of the True Law; a fundamental text of Mahayana Buddhism.

Mahayana: 'The Great Vehicle'; a later development of the Buddhist crede but the form adopted in all central and northern Asia.

makara: a mythical marine monster common in Indian art from Gupta on.

mandapa: the pillared hall of a temple.

mihrab: niche in the *qibla* (directional) wall of a mosque indicating the direction of Mecca to which Muslims turn for prayer.

mithuna: male and female couple.

murti: the specific form of a deity.

nag; nagini: male and female serpent deities of lakes and rivers.

Narasimha: the man-lion *avatar* (incarnation) of the god Vishnu.

nayaka: types of heroes and heroines in the Hindu literature of love.

Padmapani: 'the lotus-handed'; a form of the Bodhisattva Avalokitesvara.

pahari: of the hills: the schools of painting of the Punjab Hills.

pat, pata: a painting on cotton cloth.

pitha: a pedestal or base.

prabha: light or glory; hence a halo.

pradakshina: circumambulation.

prasada: palace; a temple building, generally pyramidal in shape.

ragamala: a garland of musical modes; personified by princes and ladies. Poems describing the thirty-six musical modes.

Ramayana: classical Sanskrit epic in the final version of Valmiki; the Hindu vernacular version by Tulsi Das (1532–1623) is often illustrated in Pahari painting.

Rasamanjari: a Garland of Delights; Sanskrit poem by Bhanu Datta (14th century).

rathas: 'chariots'; monolithic shrines of South India.

rishi: Sage, saint or anchorite;

sakti: the female energy of a deity; potency, or the active principle.

sikhara: the roof or spire of a temple.

stupa: a funeral mound; especially that raised over Sakyamuni's relics; hence a symbol of his essential form and so the principal Buddhist symbol.

sukhanasa: 'nose'; arched opening on the side of the upper storey of a temple.

tantra: 'treatise'; the mystical 22 volumes of discourses from the esoteric Buddha circle; also, in Brahminism, the instructions given by Siva to Parvati.

Tara: female Bodhisattva.

thakur: a Rajput feudal lord.

tirthankara: 'saviour'; one of the twenty-four Jain patriarchs.

torana: a decorative top-piece to a gateway; also the gateway itself.

tuzuk: memoirs; journal.

Upanishads: Scriptures of the early Brahmanic period *c.* 800–600 BC.

vihara: a Buddhist monastery.

vimana: the complete Hindu temple; sanctuary and attached porches.

yaksa; yaksi: tree spirits, male and female; associated with fertility.

yali: leogryph, horned lion.

yogi, yogini: an ascetic; a heavenly witch or sorceress.

zenana: the female apartments of a household.

Index